ART OF THE AZTECS

HENRI STIERLIN

ART OF THE AZTECS

AND ITS ORIGINS

RIZZOLI NEW YORK

Translated from the French,
L'art aztèque et ses origines
by Betty and Peter Ross
French language edition:
© 1982 by Office du Livre, Fribourg
English translation © 1982 by Office du Livre

First published in 1982 in the United States of America by:

*R*IZZOLI INTERNATIONAL PUBLICATIONS, INC.
712 Fifth Avenue/New York 10019

Library of Congress Catalog Card Number: 82-50424
ISBN: 0-8478-0441-0

Printed in Switzerland

Table of Contents

Introduction

The subject of this book is the pre-Columbian art of Mexico, with the exception of the Olmec and Maya cultures, these having already been discussed in a volume entitled *Art of the Maya.* The present work, *Art of the Aztecs,* constitutes a whole, not only historically but also geographically, in that it covers an area of Mesoamerica comprising the heartlands of present-day Mexico, bounded in the north by the southerly fringes of the deserts and steppes (i.e. roughly the 23rd parallel) and, in the south, by the Isthmus of Tehuantepec.

Chronologically it begins with the early art of sedentary cultures round about the middle of the second millennium and covers the three thousand years of pre-Columbian civilization prior to the latter's collapse under the onslaught of the Spaniards in the second decade of the sixteenth century.

While this book and the volume on Maya art relate to approximately the same period, the two regions concerned are in each case quite distinct, their only common ground being the Olmec country which, adjacent to the western Maya sites and to the State of Oaxaca, will be seen to assume considerable importance with the flowering of the Monte Albán culture, otherwise known as Zapotec. A startling word, this, to those unacquainted with the pre-Columbian peoples and the civilizations of Mexico. For the picture presented by the Indian world with its multitude of pre-Hispanic cultures is a baffling one and not easily assimilable. Popularizing works have paid scant heed to the peoples of the New World. Only the Mayas, Aztecs and Incas (all too often confounded with each other) have penetrated the barriers of a kind of reserve—or, to use the psychiatric term, scotomization—whereby the white man blinkers himself to his rôle in and responsibility for the brutal destruction of the great pre-Columbian civilizations. He refuses to recognize those cultures which fascinate and yet nag at him like a bad conscience; he refuses to distinguish between those of the northern and those of the southern hemispheres; he refuses to enter what is supposedly the specialized domain of the arts of Ancient America and, last but not least, refuses to tackle such 'barbarian'-sounding names as Zapotec, Mixtec, Toltec, Totanac and Huastec.

This is not to suggest that it is an easy domain to master, for in the first place the science upon which it is based is relatively new so that much still remains obscure and, in the second, the universe it represents is baffling in as much as it reveals a form of cultural development far removed from the 'canons' of the Mediterranean, not to say the civiliza-

tions of the Old World. To European eyes it is a universe of innumerable paradoxical situations, for its pre- or proto-historical character persisted throughout most of its evolution, and this at a time when the West already possessed, as it had done for centuries if not millennia, a writing able to transmit a voluminous literature and historiography. The lack of such vital sources means that our knowledge of pre-Columbian Mexico is confined to archaeological data and it is only in respect of the final phase that we can draw on the Mixtec and Aztec codices, as also on the testimony of the chroniclers of the Conquest.

A glance at techniques and resources will suffice to illustrate the above disparities and the unevenness of this type of evolution when compared with European cultures. For instance, the Pre-Columbians possessed neither the wheel nor the lathe, yet could boast a developed architecture and urban organization. They evolved an agrarian civilization based on maize which they knew how to select, but they had no draught or pack animals for the transport of heavy objects. These lacunae, these shortcomings, are a surprising feature in peoples who constructed vast capital cities not only on the high plateaux, but also in the lowland jungles and who evolved an art that is often both grandiose and refined. Yet these same peoples continued to live largely in the Stone Age in which the rôle of metal remained negligible, even in the military and technical spheres.

Another disconcerting feature of these pre-Columbian peoples—this time in the sphere of iconography—is the proliferation of deities in their mythology. These beings, more often terrifying than endowed with profound humanity, inhabit a pantheon of grimacing, inscrutable forms of which the rites and cults assume a cruel, not to say bloodthirsty aspect, involving as they did repeated and extensive human sacrifice of a singularly gruesome kind.

In short, the pre-Columbian world is not readily accessible; it has no obvious charm, nor does it inspire love at first sight. And yet the impression of strangeness, the sense of revulsion even, may turn into admiration should the effort be made to overcome this initial barrier and to comprehend these men of the New World. The reward for that effort will be access to a whole new branch of humanity, an approach from the inside, through art, to a universe which complements our own, enriching it with countless new facets and original departures.

A Note on the Title

The title of this book, *Art of the Aztecs,* might be taken to imply that, as artists, the Aztecs were comparable in importance to the Mayas. Such is by no means the case. For of all the forms of expression peculiar to pre-Columbian civilizations Aztec art is, perhaps, the most harsh and austere, not to say morbid. If, in this study, we have turned for our eponym to that bloodthirsty people, it is for a number of reasons which call for elucidation. First, as anyone will agree, the name 'Aztec' is unusual in that, unlike those of the other cultures of Mexico, it is widely disseminated and familiar to a vast public. It is a charismatic name, undeniably evocative and rich in connotations. We have therefore sought to relate to a familiar denominator the series of artistic forms peculiar to the seven or eight great civilizations of the New World.

There are various reasons why the Aztecs should be the most famous of the pre-Columbian peoples. To begin with, they were the last to arrive on the Mexican historical scene before the irruption of the white man, and it was they whom the Conquistadors encountered upon landing there early in the sixteenth century. The Aztec warriors of the Tenochtitlán emperors put up a ferocious resistance to the invaders who were to turn the country, cradle of one of the New World's great military civilizations, into a lucrative colony called New Spain.

For by a quirk of fate the power of the Aztecs was at its height at the very time when, in 1519, Cortés first set foot in Mesoamerica. In less than a hundred years they had gradually subdued the surrounding territories and now held sway over most of the civilized regions of Mexico, from the vast, arid wastes of the north, whence they had sprung, to the Isthmus of Tehuantepec, and from the Gulf of Mexico to the Pacific Ocean. Thus they found themselves masters of the pre-Columbian world in the northern hemisphere—with the exception of the Maya region which had already entered into a decline several centuries before—and naturally came to be regarded by westerners as the prime representatives of Mexican civilization. By the sixteenth century, therefore, the Aztecs were the acknowledged leaders of the Indian nation. Chroniclers speak of their courage, of their heroic resistance, but also of the bloody sacrifices they offered up to their 'idols' and which so greatly offended Christian sensibilities. They were no less famous for their gold and jewellery, some of which elicited the admiration of no less a man than Albrecht Dürer, while their institutions aroused the interest of Montaigne to whom they did not seem in any way barbarian. Sixteenth-century missionaries such as Motolinía, otherwise known as Fray Toribio de Benavente *(Historia de los Indios de la Nueva España),* and Fray Bernardino de Sahagún *(Historia general de las Cosas de la Nueva España)* were at pains to salvage, as far as could then be done, the history and customs of the last of the Pre-Columbians.

Finally, the Aztecs were the last scions—shattered by the muskets of the West—of the autonomous development of Mesoamerica. For Europeans they embody the most notable phase of what was a disparate course of social development in the New World. This is not to suggest that they also represent the most refined of the pre-Columbian civilizations. As has been pointed out elsewhere, the Aztecs do not mark the apogee of the arts in Mexico any more than do the Incas in South America. For 'final phase' and 'most highly developed phase' are not necessarily one and the same thing. While this ultimate stage of Indian independence before the Conquest is characterized by its imperialist, i.e. religio-military and despotic outlook, the prior existence of great, and aesthetically far richer, theocratic cities should not be left out of account.

The success of Aztec imperialism in gaining control of the whole of ancient Mexico (save for the lands of the Mayas) justifies us in comprising among its origins all the other cultures which had come into being in that area. A long period of development spanning more than a quarter of a millennium preceded the appearance of the Aztecs on the high plateaux of Mexico. Here they established themselves by force of arms and rose unchecked until they held sway over all other civilized peoples, thus achieving the unification of the Mesoamerican territories under a single power.

This gradual emergence of advanced pre-Hispanic cultures went hand in hand with that of pre-Columbian art in its various styles and forms. The distinctive phases—Formative, pre-Classic, Classic and post-Classic—may assume the most diverse aspects, just as do the regions in which those cultures arose: the Gulf Coast with its impenetrable jungle; the *tierra templada* or sub-tropical zone with its rich luxuriant vegetation, comprising the lower foothills of the sierras; the relatively dry and temperate high plateaux at the centre of the country; the rugged massifs, intersected by rich valleys, of Oaxaca; the semi-desert steppes of the north and of the *Occidente*; the Pacific littoral flanked by partially irrigated plains, and so forth.

It was here, in this land of high cultures, an area of some 500,000 square kilometres, or roughly the size of France, that the Indian peoples speaking different languages and evolving diverse techniques and forms of expression established themselves around a few big centres. Broadly speaking, all may be described as predecessors of the Aztecs who, towards the end of the fifteenth century, became masters of the whole territory.

Focal Points of the Pre-Columbian Cultures

Towards the middle of the second millennium B.C. there began a long period of development which witnessed the flowering of many pre-Classic cultures and culminated early in the first century with the emergence of the great centres which were to constitute the focal points of the Classic era. Their names are well known—Teotihuacán , 'place of the Gods' on the high plateaux close to what is now Mexico City; Cholula, not far from Puebla; Monte Albán, also a religious capital, built where the three fertile valleys of Oaxaca converge and finally, El Tajín, in the jungle near the Gulf of Mexico. Round about the eighth century A.D., after the collapse of these Classic capitals and of their satellites, new rulers arose, and with them 'Epiclassic' and post-Classic cities, notably Tula, Mitla, Xochicalco, Teotenango, Cacaxtla and Cempoala. Some time before 1300 the Aztecs appeared on the scene and established a capital, Tenochtitlán, on Lake Texcoco. From 1430 they experienced a period of expansion lasting almost a century and halted only by the arrival of the Spaniards. By then, however, virtually all the high cultures of Mexico had become subject to the imperialism of the Aztec military orders.

Such, in very brief outline, is the development discernible in the complex history of the pre-Columbian peoples of Mexico—a history, moreover, which still requires a great deal of elucidation. In accordance with that outline this book has been subdivided into chapters as follows:

I. The origins of pre-Classic art: first appearance of pottery derived from the style of the Gulf Olmecs.

II. Teotihuacán, parent civilization of the high plateaux: emergence—with the sites at Cuicuilco and Cholula—and apotheosis of Classic architecture and urban planning in the place of the gods.

III. From Xochicalco to the Toltecs: these cultures, notably that of Tula, take over from Teotihuacán after its collapse. Discussion of recent finds at Teotenango and paintings at Cacaxtla.

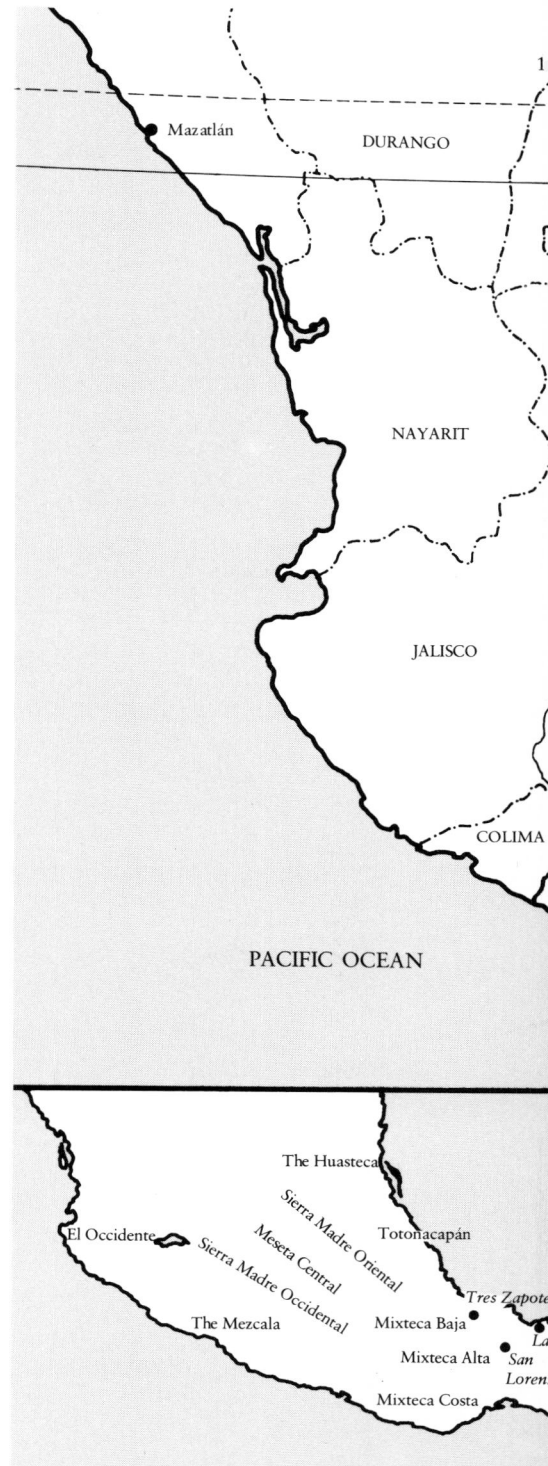

Map of pre-Columbian Mexico showing the sites mentioned in the text. Bottom left, the principal sites in the Maya zone.

◎ Archaeological sites, category 1
○ Archaeological sites, category 2
◉ Modern towns, category 1
● Modern towns, category 2
· Sites mentioned
△ Volcanoes
⋈ Pass

1 Chalchíhuites	13 Tepetzintla	25 Ajálpan
2 La Quemada (Chicomoztoc)	14 Aparício	26 Coxcatlán
3 El Opeño	15 Pueblo Viejo de Perote	27 Teotitlán del Camino
4 Ihuatzio	16 Cerro Montoso	28 Tlaxiaco
5 Tzintzuntzán	17 Tierra Blanca	29 Cerro Yucuyacula
6 Chupicuaro	18 Ignacio de la Llave	30 Tilantongo
7 El Naranjó	19 Alvarado	31 Coixtlahuaca
8 Tamuín	20 Nopiloa	32 Colhuacán
9 Panuco	21 San Andrés Tuxtla	33 Zaachila
10 Tamiahua	22 Los Tuxtlas	34 Tlacolula
11 Huilotzintla	23 Coatzalcoalcos	35 Dainzú
12 Tuxpan	24 Tepexi el Viejo	36 Tutútepec

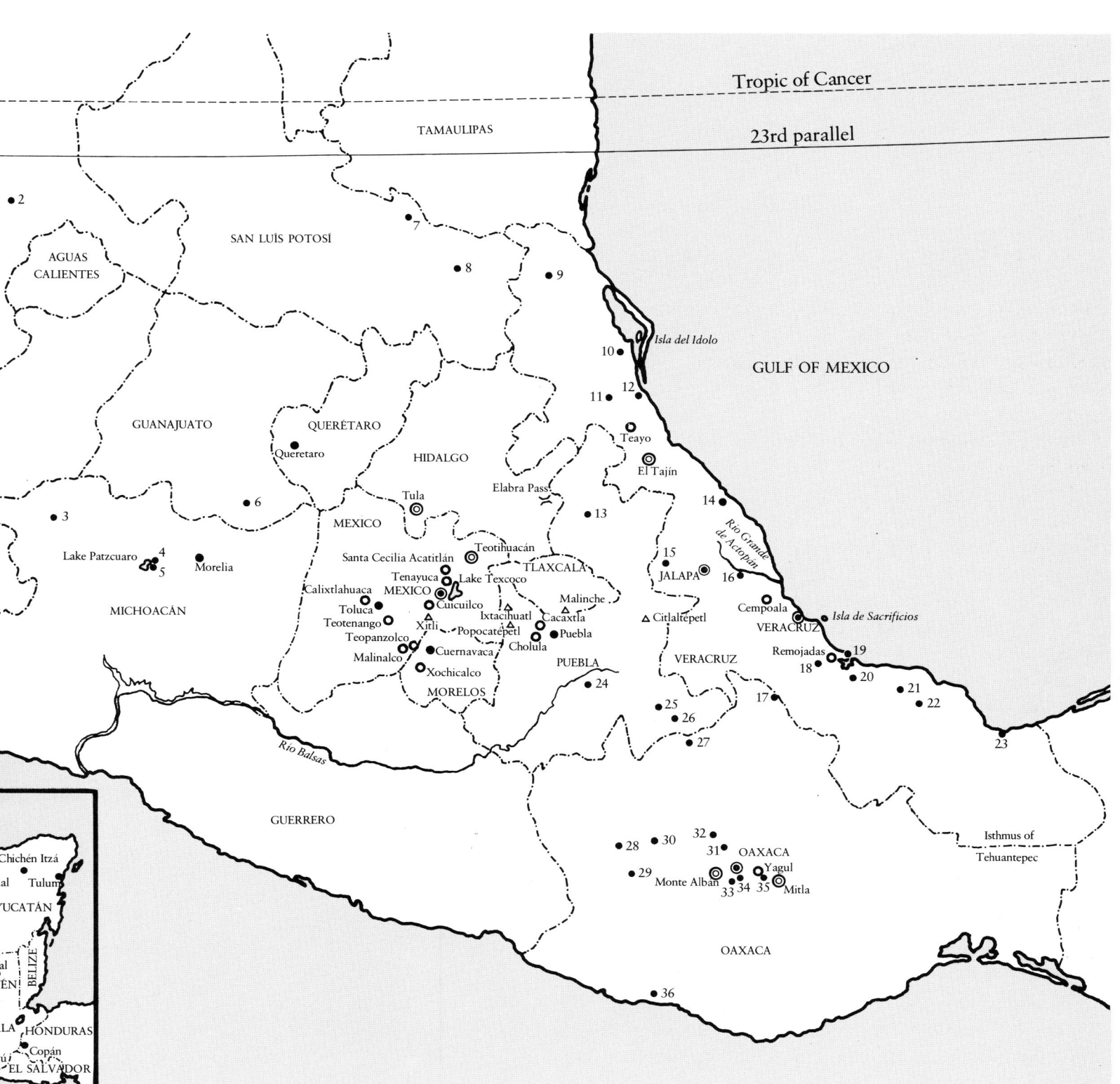

IV. The sacred precinct at Monte Albán: a Classic centre in the mountains of Oaxaca. From carved stelae and Danzantes to ceramic funerary urns.

V. The Mixtecs of Mitla and Yagul: a new people comes to the fore in Oaxaca, characteristics of this period being the refinement of palace architecture and an exceptional efflorescence of the jeweller's craft. Their history is recorded in pictographic codices.

VI. El Tajín, Classic metropolis in the jungles of the Gulf: from early Remojadas pottery to the stone symbols of the ball-game. The post-Classic cities of Cempoala and Teayo.

VII. Cultures of the North and South: from Huastec sculpture to the baked clay figurines of Colima, Jalisco and Nayarit. Emergence of the popular art of the *Occidente*.

VIII. The mounting power of the Aztecs: the establishment of a vast military empire over all the peoples of Mexico. The heyday of Tenochtitlán and its destruction by the Spaniards.

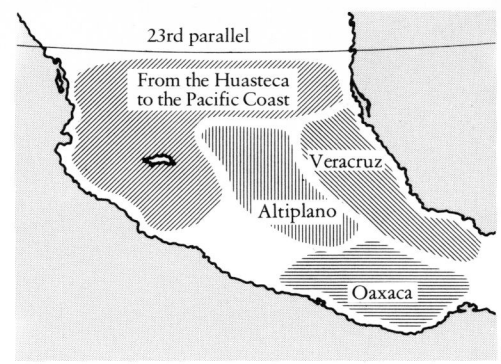

Map of the regions covered by the different chapters in the book. Starting at the centre (Chapters I to III), we proceed south (Chapters IV and V), then east (Chapter VI) and, still in an anti-clockwise direction, north-west (Chapter VII). The Aztec era (Chapter VIII) embraces the whole of pre-Columbian Mexico.

Geographically speaking, the first three chapters are devoted to the civilizations of the high plateaux, the next two to the uplands of Oaxaca, Chapters VI and VII to the cultures of the region between the Gulf and the *Occidente,* while Chapter VIII, our final chapter, is concerned with the Aztecs and their attempts to unify the country.

It is a wide canvas and in it we seek to characterize the various pre-Columbian peoples of Mexico by emphasizing the phenomenon of art which, indeed, provides the key to the civilizations of the New World. It is considered in the light of techniques, of socio-historical development and of local peculiarities.

We shall endeavour to interpret the works of these pre- or proto-historical cultures (always remembering how small was the rôle played here by rudimentary systems of writing), with a view to determining their significance. To that end and in order to discover what are the styles peculiar to each region, we shall discuss all the domains of plastic expression namely, painting, sculpture, pottery, architecture and urban planning. The better to understand the rôle of the artifacts brought to light by archaeological excavations, we have elected to interpret concrete examples, illustrating these with our own photographs especially taken for this book, both on the sites themselves and in the principal museums in Mexico City, Jalapa and Oaxaca. Plans, maps and drawings help to elucidate the modus operandi. Based on standard graphical conventions they serve as an indispensable guide, notably in the sphere of architecture and urban planning. Having taken into account not only the latest publications but also the most recent archaeological discoveries, we have been able to draw up a new balance-sheet of the legacy left us by the Indians who created the great agrarian civilizations of Mesoamerica. For it was these sedentary peoples who evolved the beliefs and myths to which the artists gave visible form, immortalizing the deified cosmic forces and the sovereigns who personified them. They built huge cities, erected colossal pyramids and dug opulent burial chambers for their high dignitaries, the custodians of all knowledge.

It is the adventure of these men, who evolved independently of their counterparts in the Old World, that constitutes the theme of this survey; it demonstrates how great was the diversity of means employed by humanity to raise itself to the level of civilization, to escape an ephe-

meral destiny and to mark the passage of time with those signposts we are attempting to read today, namely works of art.

That, indeed, is the rôle of these pre-Columbian masterpieces thanks to which forgotten peoples find a voice and take their place in the consort of nations, thus enriching our image of Man.

The Rediscovery of the Pre-Columbians

Yet it is only comparatively recently that the various pre-Columbian cultures have been rediscovered. Indeed, the process is still not complete, for the soil of Mexico conceals countless riches which may invalidate the knowledge already acquired. Not until the nineteenth and twentieth centuries have archaeological excavations rescued from oblivion the civilizations which antedated the Aztecs by as much, in some cases, as two millennia.

In fact the past hundred years or so have witnessed the confluence of two different and mutually invigorating streams—on the one hand, in response to the ever more pressing questions posed by history, we have the nascent science of archaeology and of the techniques of excavation, on the other, the awakening of Mexican nationalism and of a whole people in search of its own identity. Throughout the convulsions of one of the most terrible revolutions of modern times, from 1910 to 1920 and in the years that followed, this quest of a nation seeking its autochthonous roots by relating to its pre-colonial past was instrumental in promoting what can only be described as Mexico's archaeological vocation.

In its attempt to rediscover Indian cultures this quest often assumed a socio-political character that found an echo in the restoration of dignity implicit in the election to the Presidency of a son of the people, Benito Juarez, whose terms of office lasted from 1861 to 1862 and 1867 to 1872. In the present century Lázaro Cárdenas, who was of Indian origin, assumed the Presidency.

However, it behoves us to remember that the initial work was done by outsiders from Europe and America who prospected and administered the sites. Soon they were joined, and eventually replaced, by noted Mexican archaeologists—men such as Alphonso Caso, Manuel Gámio, Miguel Covarrúbias, José Garcia Payón, Alberto Ruz, Ignacio Marquina, Ramón Piña-Chan and Ignacio Bernal.

This preoccupation with the pre-Hispanic past reached a peak in 1963 with the construction of the admirably equipped Museo Nacional de Antropologia e Historia de Mexico, a monument testifying to the glory of things Mexican. It is the joint work of the architect, Pedro Ramirez Vasquez, and its first director, Ignacio Bernal, who together succeeded in making it a model of modern museum design.

I. From Early Origins to Pre-Classic Art

In Mesoamerica the New World is not simply a world newly discovered by the West; it is also geologically new, still unstable, in process of formation, shaken by terrible earthquakes and ravaged by severe volcanic eruptions; it is a world whose plateaux may be inundated by streams of lava or catastrophic floods and whose lowlands, with their impenetrable expanse of luxuriant vegetation, are hostile to human settlement.

Lying on the same latitude as the Sahara, the high plateaux in which the pre-Columbian civilizations flourished would be arid were it not for their altitude which moderates the climate, and the precipitation caused by the two chains of mountains flanking them, the Sierra Madre Oriental and the Sierra Madre Occidental, whose well-watered slopes favour the rapid growth of the great forests of conifers and deciduous trees peculiar to the *tierra templada*.

Mexico, a country of deeply carved reliefs, is defined by four vertical zones, rising from sea-level to an altitude of nearly 5,500 metres in the volcanic peaks of Popocatépetl and Ixtacihuatl, and to 5,700 metres in Citlaltépetl, thus forming what might be described as the 'roof of Meso-america'.

1) The first zone, at sea-level, is humid and tropical and, especially on the Gulf Coast and on the Pacific Ocean, comprises great forests consisting mainly of species such as mahogany, cedar and hevea whose growth is favoured by heat and constant humidity. To penetrate this dense jungle and establish clearings for crops the early cultivators made use of the slash and burn method.

2) The second, sub-tropical, zone on the flanks of the mountains and in valleys whose altitude varies between 800 and 1,800 metres, possesses an abundant flora in what is a very hospitable and well-watered stretch of country. So varied and numerous are the trees and plants that grow there, and so greatly do they admit of exploitation by man, that the region might be likened to a gigantic green-house.

3) The third zone comprises the high plateaux (Meseta central) flanked by the two chains of the Sierras. Lying at between 1,800 and 2,600 metres, this area is temperate and the rainfall comparatively low, mainly as a result of the disastrous deforestation effected during the first millennium A.D. by the inhabitants of the great cities of antiquity. Such little snow as falls there quickly melts.

4) Above these plateaux is a fourth zone, the *tierra fria*, bounded by the winter snow-line, where nights are chilly even in summer. It is a thinly populated region because less attractive to settlers than the two

1 Hollow ware from Atlihuayán (Morelos) depicting a squatting ball-game player. This work of Olmec type, dating from the Middle pre-Classic era (*c.* 800 B.C.), shows a figure wearing a helmet and the skin of a jaguar whose powerful claws may be seen on the shoulders and thighs. The Olmec style is particularly evident in the treatment of the eyes and of the protuberant, drooping mouth. Height 21 cm. National Museum of Anthropology, Mexico City.

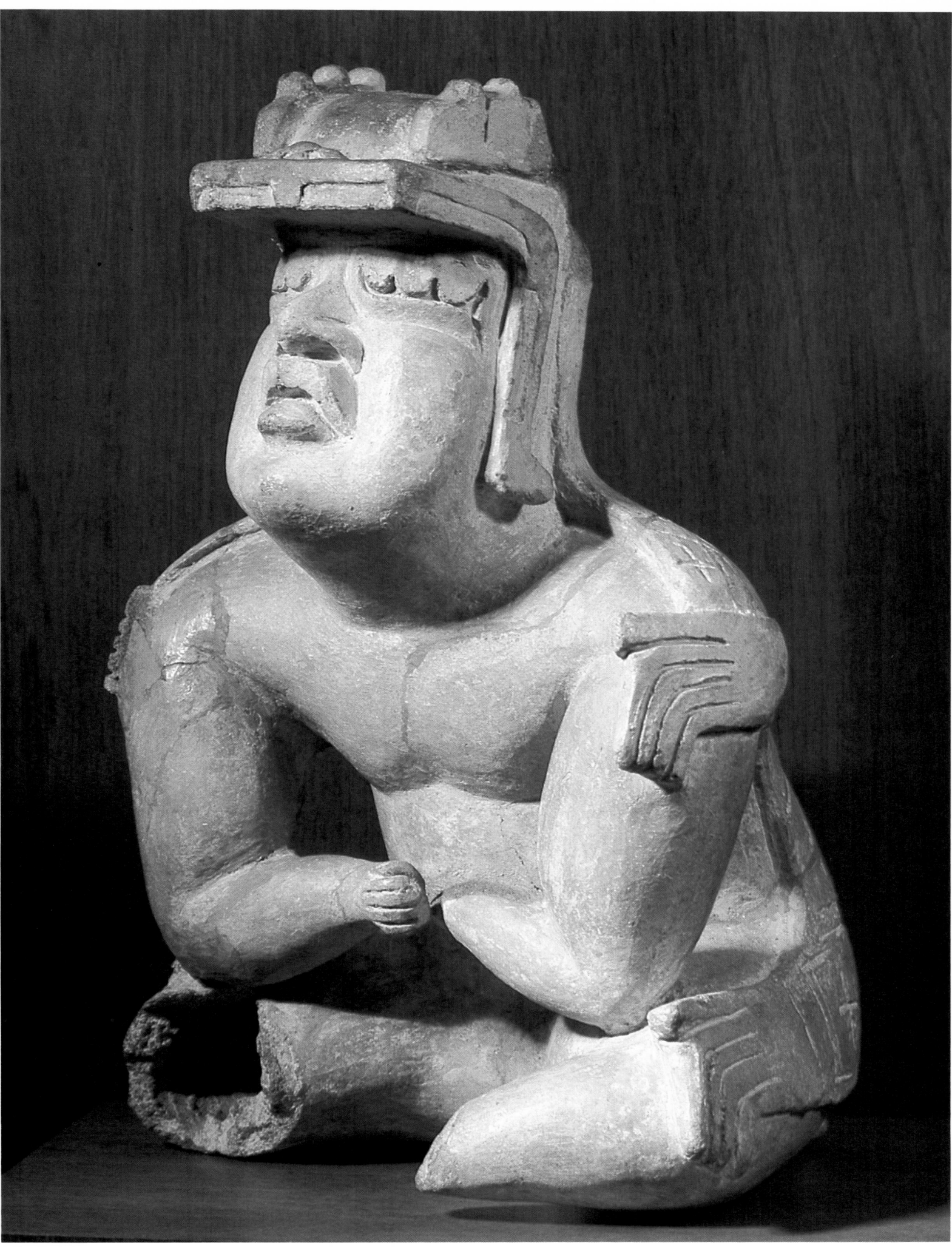

1

intermediate zones. Here the upper limit of the forest does not rise above 3,800 metres while on the southern slopes the eternal snows are confined to altitudes of 4,800 metres and over.

Natural Resources

The various regions of Mexico discussed above provided man with relatively important mineral, vegetable and animal resources which contributed to the emergence of the pre-Columbian cultures. Besides clay, from which the Indians made adobes or sun-dried—not baked—bricks for rural use, we should cite the various types of stone, in particular volcanic rocks such as basalt, trachyte and obsidian; also limestone, granite, quartz, diorite and jade, not to mention those varieties favoured for their hardness, colour or translucency.

The exploitation of gold, silver and copper occurred relatively late, three millennia later than in the Near East. These minerals were used not so much for tools as for the manufacture of ceremonial objects and ornaments. Iron, however, was unknown until the arrival of the Spaniards. Here mention should also be made of bitumen, used as a black pigment by east coast potters and also valued for its waterproof properties.

In Mexico obsidian played much the same rôle as did flint in Europe. The properties of this natural glass of volcanic origin early attracted the attention of man and served for the manufacture of implements and weapons. It was also much prized in the barter trade with other parts of the country.

While the tropical jungles and the mature mountain forests provided ample timber for the builder and the craftsman, vegetable foods of various kinds were also available. The staple food plant was maize which is known to have been domesticated as early as 5000 B.C. Starting with wild species barely three inches high the Pre-Columbians produced, by selection and hybridization, a number of strains of which some were adapted to the high plateaux and some to the tropical regions. Thus maize, whose rôle in America is that of wheat in the West and rice in the East, formed the basic foodstuff of the sedentary Indian populations.

Their food plants also included black beans, pimentos, marrows, avocados, cacao, sweet potatoes, the maguey plant (an agave from which pulque, a mildly alcoholic drink rich in protein, was made), tomatoes, guavas, papayas and other fruits including, at a later date, the pineapple. Other vegetable products were cotton, flax, and the fibres of the maguey and yucca, not to mention the bark of the amate which provided a kind of paper for manuscripts. Here we should also cite tobacco, as well as the numerous medicinal and aromatic plants that went to make up the Pre-Columbians' pharmacopœia.

The greatest deficiency of the New World lay in the field of its animal resources. The mammoth, the mastodon, the elephant and the horse disappeared or were perhaps exterminated by man as early as the Pleistocene era. There was little game, either big or small, available to the Mesoamerican hunter who, besides the wild boar, jaguar and deer, pursued the wild rabbit, armadillo, manatee and many kinds of bird, the most important being the wild turkey, the parrot and the quetzal. He also fished and caught turtles.

The only animals to be domesticated by the Mexican Indians were the dog, the turkey and the bee. They possessed neither cattle, poultry nor goats and hence did not go through the pastoral stage which, in the early Neolithic era, assumed such importance in the West. Thus the society that was to raise itself to the level of civilization was relatively unpampered by nature in as much as it lacked the animals and plants so crucial to the progress of the Old World. The Pre-Columbians are all the more praiseworthy for, having regard to the difficulties confronting these cultures, the results they achieved were of a very high order.

Population

Man was the last to arrive on the American scene, and his appearance marks the beginning of pre-history. Some 25,000 years ago, in the Paleolithic era, men of Mongol type made their way into America from the easternmost tip of Asia over the ice barrier which was their hunting ground and formed a kind of causeway across the Bering Strait. Living much as the Eskimos do, but armed with weapons of polished stone, they pursued their prey, the polar bear, the seal and the reindeer, as it migrated from one continent to the other. They must have made this passage during the last great Glacial epoch (the later Wisconsin), possibly on the latitude of the Polar Circle between the Chukchi (USSR) and Seward Peninsulas (USA) where the strait, never more than 80 kilometres wide, is punctuated be the Diomede Islands. Again, these hunters might equally well have crossed 1,500 kilometres further south by the Aleutian Islands which, being ice-bound, formed a link between Kamchatka and the Alaska Peninsula proper, a route that would have enabled them to by-pass the far north which, in the Ice Age, was even more devoid of life than it is today. These migrations may have gone on for centuries if not millennia. Small groups formed wandering hordes which, as others came up behind them, pressed on until in the end they

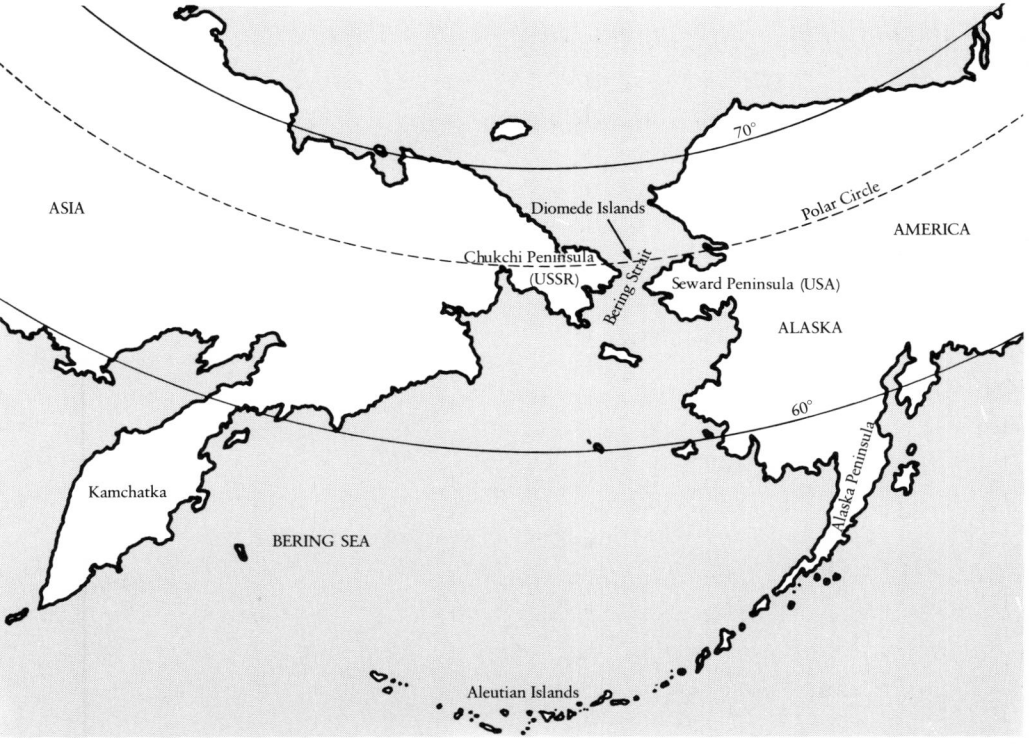

Map or eastern Siberia and Alaska, the regions crossed by immigrants en route to the American continent.

17

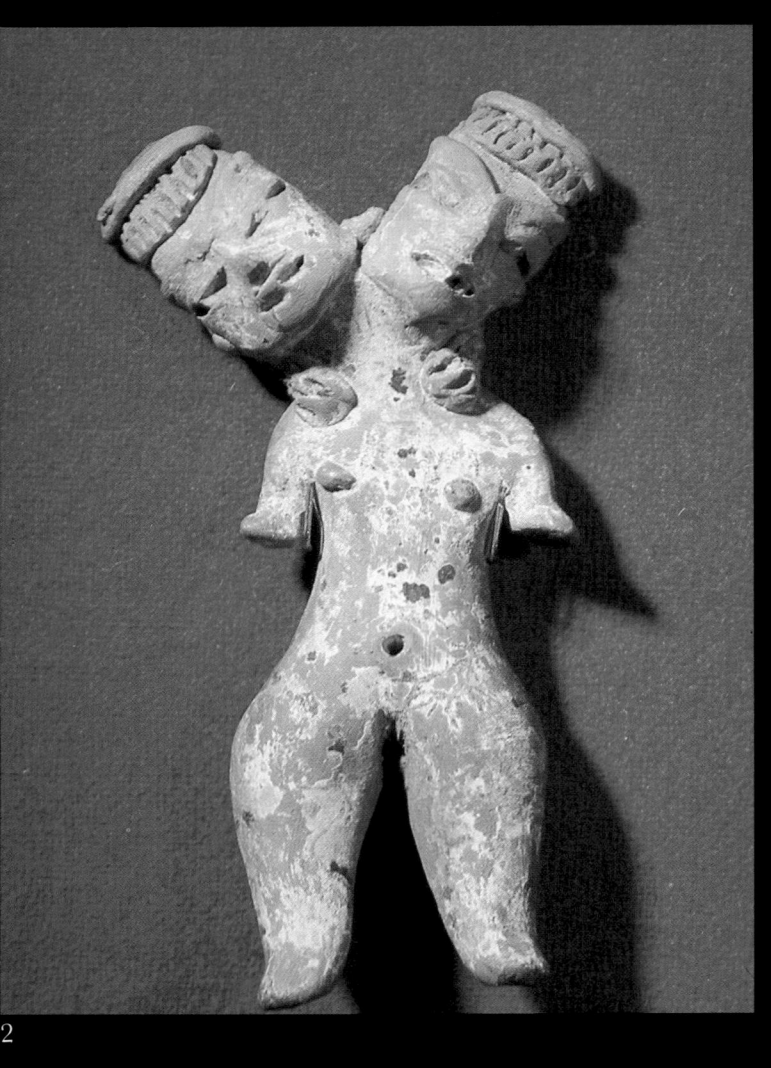

2

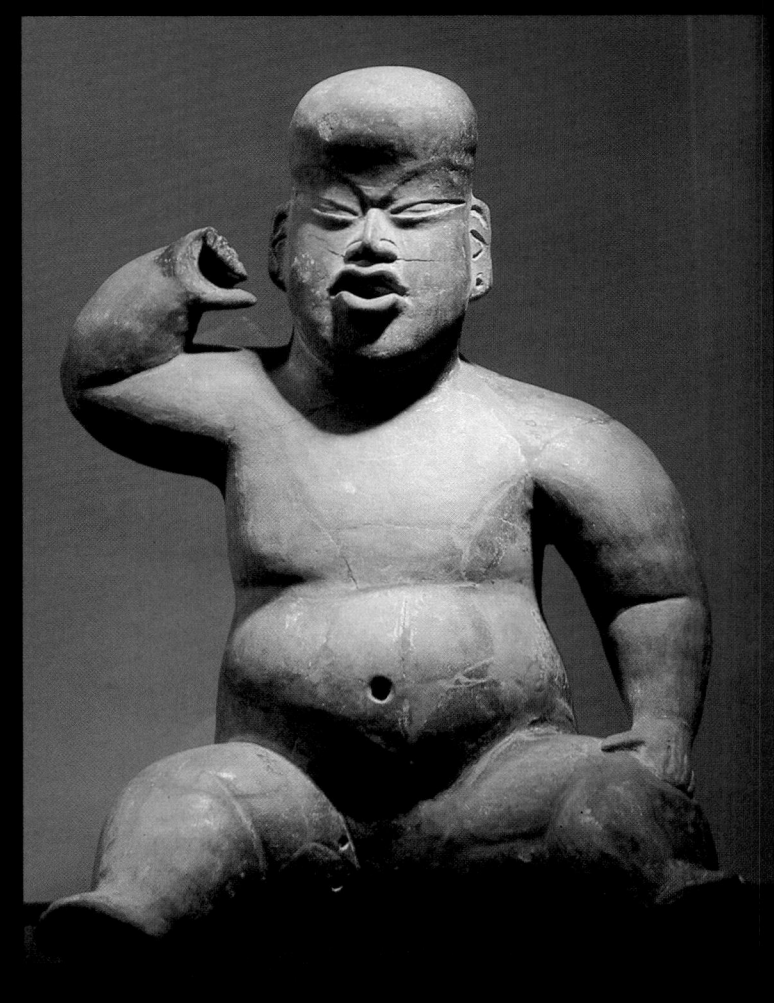

3

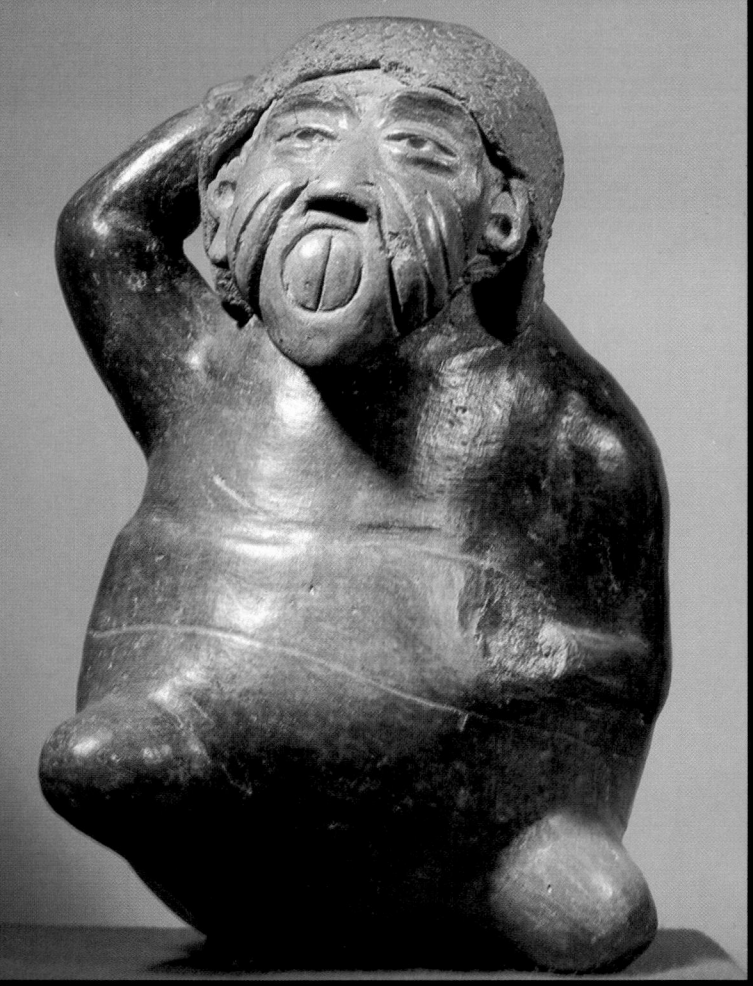

4

5

populated the whole of the two Americas, as far as and including Tierra del Fuego.

It would seem that the East-West movement of Asiatic peoples towards America ceased at the end of the Paleolithic era, that is when some of the immigrants were beginning to abandon a nomadic in favour of a sedentary life. For in the Neolithic period the differences between America and Asia—where rice was soon to be cultivated—were so great as to preclude the possibility of sustained intercourse.

Some scholars maintain, however, that these East-West population movements continued almost until the dawn of our era. While this theory cannot be dismissed out of hand, such movements could not have contributed very materially to the population of America, nor could they have exerted any decisive influence on pre-Columbian cultural development. The deficiencies already noted in the New World—for instance the absence of the wheel, lathe and plough, of food plants such as wheat or rice and of the domestic animals kept by pastoral peoples—are only explicable if migration, with its regular intercourse, had ceased before the Neolithic era or at any rate before the latter's urban phase. For we know that by that time relations were being maintained between South, Central and, indeed, Mesoamerica by vessels plying up and down the Pacific coast—proof that sea transport and navigational techniques had already been developed. Now this should have permitted exchanges of seed and the import of various types of animal. Yet nothing of the kind in fact took place. Once her sedentary cultures had come into being, and if we disregard certain puzzling coincidences in the aesthetic sphere, America was to remain cut off from the rest of the world.

The Neolithic Revolution

In America, in the fifth millennium B.C. (i.e. almost thirty centuries later than in the Near East) there occurred a phenomenon, dubbed by historians 'the Neolithic Revolution', that was of fundamental importance to human society in that it changed man's whole mode of existence. Previously he had been wholly dependent on hunting and food-gathering and thus condemned to follow the migrating game or to move into the hills with the ripening of the various fruits and berries. But now he abandoned that nomadic life which had precluded both a fixed abode and the accumulation of possessions. Indeed the Neolithic revolution went hand in hand with the discovery of agriculture, binding men to the land they were thenceforward to cultivate.

The early farming communities selected certain types of plant whose seed they sowed and whose growth they tended until harvest time. Thus stocks of food could be accumulated to see them through to the following season. Involving as it did the appropriation of land, this process brought to an end the always precarious existence of the nomad, though the food reserves essential to the group's survival still had to be protected against predators. Nevertheless, settlement around arable plots made for more rapid advance.

In these early societies of the agrarian type the first manifestation was the dwelling-house, a primitive structure of mud and thatch. Next came the hamlet or village in which cultivated parcels of land were exploited by a tribal farming community whose organization differed radically

2 Terracotta from Tlatilco (State of Mexico) of a two-headed personage probably symbolizing the dualist principle in a very schematized style. It dates from the beginning of the Middle pre-Classic era (c. 1200–1000 B.C.). These female figurines relate to the agrarian deities. Height 11 cm. National Museum of Anthropology, Mexico City.

3 Hollow ware figure of Olmecoid type from Tlapacoya (State of Mexico); Middle pre-Classic (c. 900 B.C.). These 'fat baby' figurines are typically Olmec. Height 41.5 cm. National Museum of Anthropology, Mexico City.

4 Middle pre-Classic anthropomorphic pot in black lustred ware from Tlatilco (State of Mexico), depicting an old man with forked tongue. Height 22 cm. National Museum of Anthropology, Mexico City.

5 Middle pre-Classic anthropomorphic pot in black lustred ware from Tlatilco (State of Mexico), depicting an old man with forked tongue. Height 22 cm. National Museum of Anthropology, Mexico City.

from that of their nomadic forbears and whose way of life was further modified by a series of important innovations. First came the domestication of the dog, already begun during the later phases of the nomadic hunting existence and soon to be followed by that of the turkey and of the bee, whose honey was the chief sweetener among primitive societies. In some respects, the association of man with certain animal species does not represent a complete break with a nomadic past in which hunter and hunted had lived, as it were, in a state of symbiosis. Thus, amongst the Pre-Columbians, the dog was no longer a companion useful in the chase, but an animal bred for its meat like the turkey.

Next came technical innovations, beginning with the use of ground and polished stone for pointed and cutting implements—hence the name Polished Stone Age sometimes used to denote the Neolithic era. The most notable advance, however, lay in the discovery of ceramics. At first the clay was simply baked under a brushwood bonfire, but later it was fired in a kiln, thus permitting the pieces to cool down slowly which minimized the risk of breakage. The pottery was made without the help of the lathe—a later, Spanish, import.

By now a simple form of loom had been invented for the weaving of vegetable fibres. Baskets were also being made, hence the word 'Basketmaker' applied to a primitive type of culture found in northern Mexico and in the south of the United States.

Revolutionary though they were at the time, these technical acquisitions in the field of agriculture were circumscribed. Pre-Columbian America was never to possess the plough, if only because the absence of draught animals precluded a form of tillage that would have involved excessive physical effort. Moreover, cereals such as wheat, barley and rye were unknown, so that the question of the one-crop field did not really arise.

Indeed, the agriculture practised by American Indians has always been of a very rough-and-ready nature, their implements being the digging stick and the dibber. Maize, beans and plants of the marrow family habitually occupy the same plot—a practice which, incidentally, finds favour in the eyes of modern agronomists who believe that it helps to preserve the fertility of the soil.

On the other hand, the Indians learned how best to exploit land of widely differing types. In water-logged country they had recourse to drainage and, in arid regions, to certain forms of irrigation. Again, they succeeded in developing a kind of lacustrine agriculture on 'rafts' of humus that floated on the surface of the water. In mountainous areas they sometimes grew their crops on terraces supported by low dry-stone walls.

The Birth of Knowledge

These advances went hand in hand with better provision for the morrow thanks not only to the accumulation of food stocks but also to the rearing of turkeys and dogs for their meat—a more reliable means of supply than hunting. However, agriculture was now the dominant factor in all human activity and, by imposing its own rhythms, gave rise to new imperatives. A knowledge of the seasons is necessary if the cycle of seed-time and harvest is to be seen as a function of rainfall. This in turn calls

6 Hollow ware acrobat from Tlatilco (State of Mexico). This strange piece is in similar vein to the ball-game player in Plate 1, but with less marked Olmecoid characteristics, and bears witness to remarkable technical expertise. Dating from the Middle pre-Classic era (c. 800 B.C.), it measures 22 cm. National Museum of Anthropology, Mexico City.

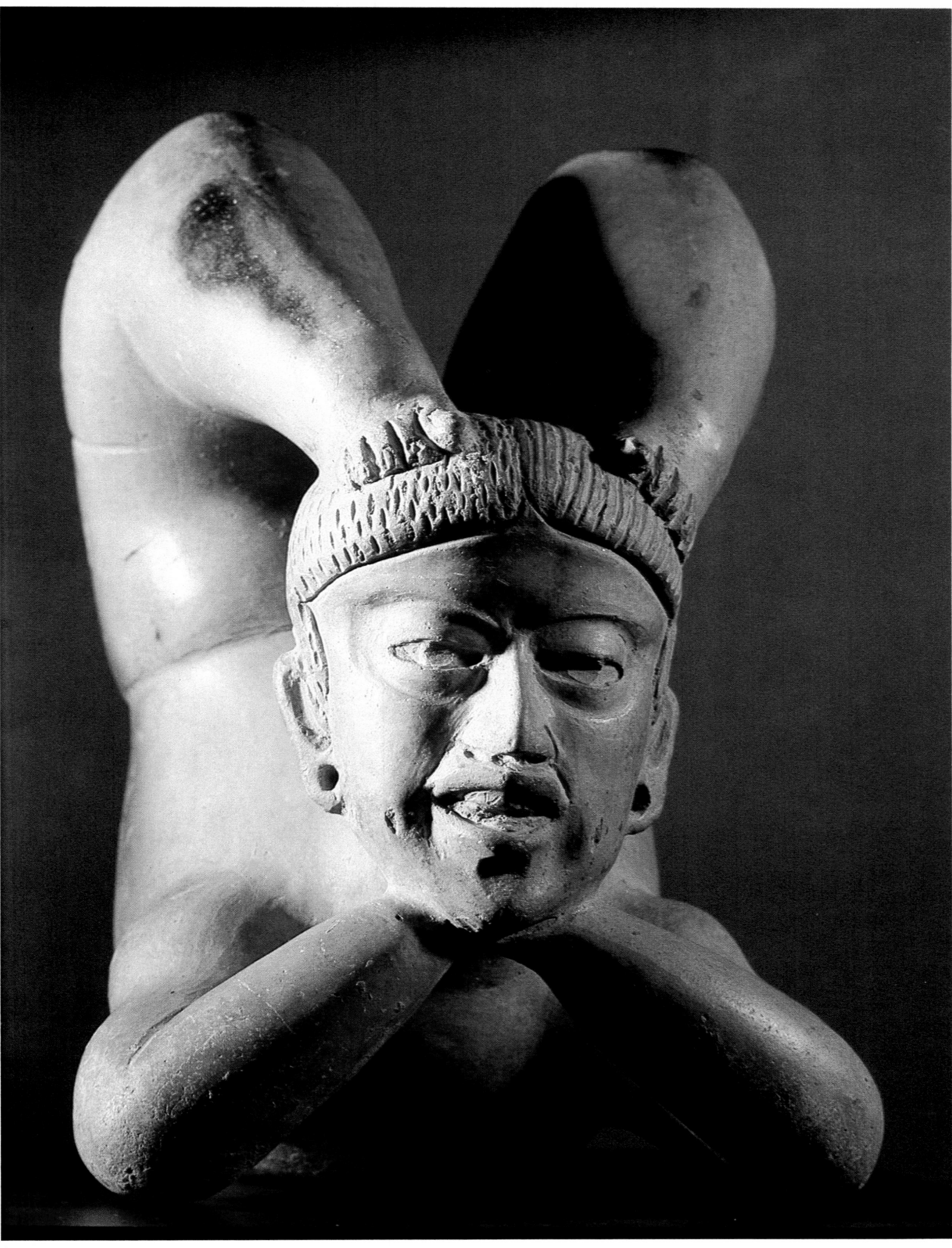

for observation of the stars, an assessment of the number of days in the year, the ability to foresee the recurrence of seasonal events, in other words, a calendar.

True, the Paleolithic hunter had also to be conversant with the rhythm of the seasons as it affected the habits of game. But he simply followed his prey, whereas the farmer was forced to look ahead, anticipating when best to sow, for if he did so too early the seed, starved of water, would not germinate and, if too late, would fail to ripen before the rains returned, causing the ears to rot on the stalk.

For this reason an accurate calendrical system was of prime importance to the cultivator. It presupposes at least a modicum of mathematical knowledge and a means of calculating the passage of time by a division into periods similar to our months and weeks. Scrutinizing the firmament, a comparatively easy matter in a region where skies are often cloudless and nights clear, or allowing a field to lie fallow after a given number of harvests so as to avoid exhausting the soil—all this suggests a more refined and accurate idea of time, while the creation of new conceptual tools in turn furthered the growth of knowledge.

In addition to the external world of 'scientific observation' there arose another world of beliefs, of divinities personifying the forces of birth, death and resurrection suggested by the cycle upon which the farmers' lives depended. In other words, a pantheon was elaborated, which differed according to region and need. In the jungles of the Gulf Coast the sun was necessary if the land was to dry out after the torrential tropical rains, and was personified by a deity who was sometimes associated with fire. On the high plateaux at the centre of the country, on the other hand, the main concern of the cultivators was the advent of beneficial showers, and the god they revered was therefore first and foremost 'he who commands the rain'.

The Priestly Caste

But the other forces of nature also played their part in this divine universe which governed the existence of men and to which they addressed prayers in the expectation that their hopes and desires would be fulfilled and disaster averted. The correct formulations, gestures and offerings, however, were known only to a few of their number.

In agricultural settlements these spiritual entities, the gods, came increasingly to be accorded a hovel or hut, similar to that of the villager, where propitiatory words were pronounced and offerings deposited. Here a kind of shaman enacted the procedures of an imitative magic and pronounced invocations and incantations—in short, created the rudiments of a ritual and a form of worship. Subsequently the hut dedicated to the higher powers was given greater prominence by being sited on a platform. As time went on this platform increased in size until it reached its culmination in the awe-inspiring pyramids of the Classic period.

Further proof of the belief in spiritual forces is provided by the burial of the dead and by funerary practices which sometimes involved the laying of grave offerings alongside the body. Belief in an after-life manifested itself in cults of the dead whose final resting place would before long be identified with the community's sanctuary.

7 Hollow ware child's head from Tlatilco (State of Mexico), of late Middle pre-Classic date. An interesting feature is the polychrome treatment of the hair which is indicated by zigzag cuts. The face, with its slit eyes and filed teeth, betrays unmistakable Olmec influence and emits a sense of mystery. Height 16 cm. National Museum of Anthropology, Mexico City.

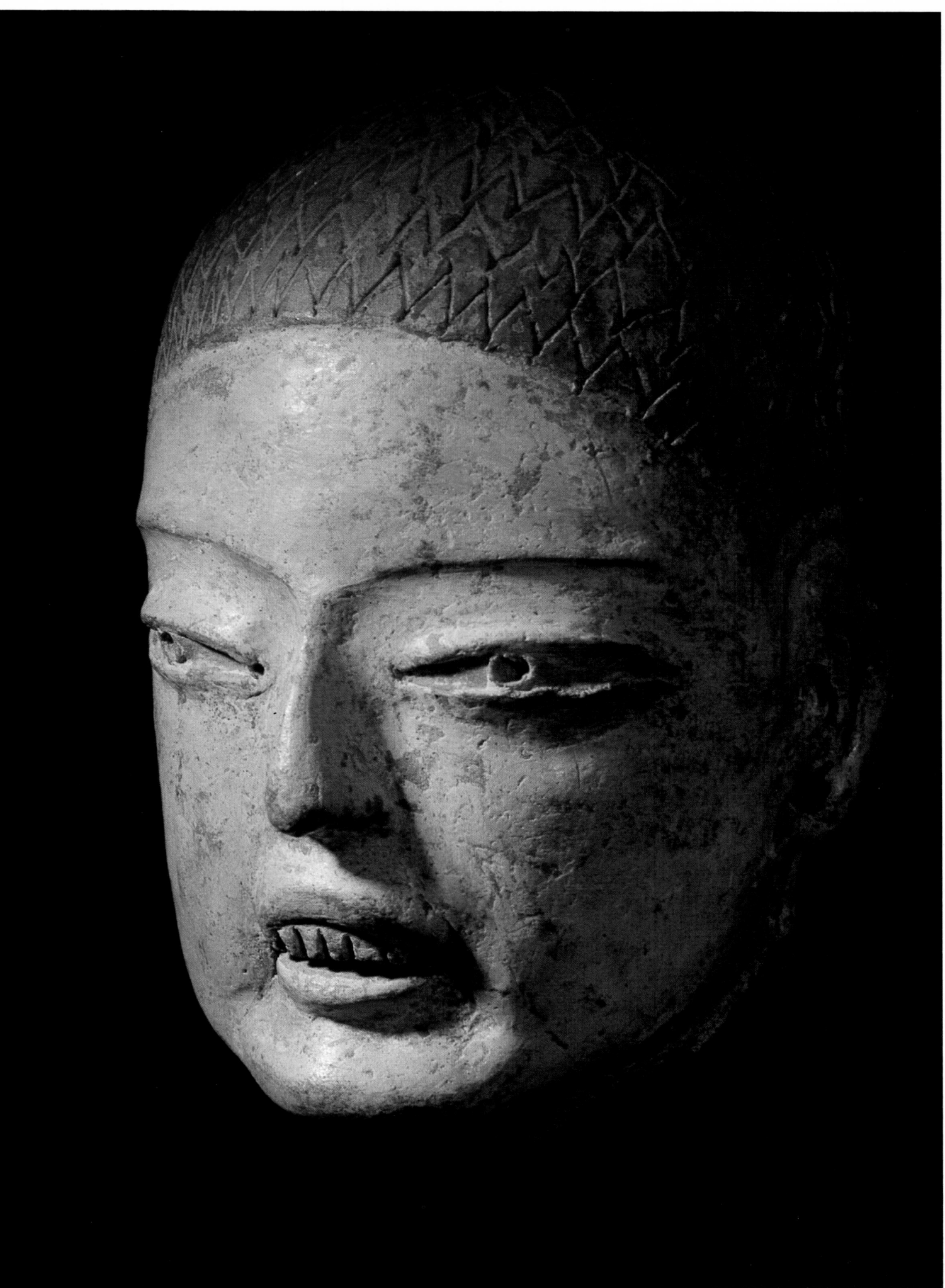

Here, then, we have evidence of the founding of a religion, albeit a primitive one, and the establishment of a caste of priests, the custodians of knowledge, since it was they who were responsible for the creation of a calendar of feasts at which propitiatory rites were performed to ensure the success of the crops.

Indeed, it may well have been the very existence of a food surplus that emancipated certain individuals—the priests—from the otherwise obligatory duties of hunting, gathering and cultivating and enabled them to devote themselves entirely to a less mundane and more contemplative existence. The rôle played by this body of clergy gained rapidly in importance until its members came to occupy a dominant position in agrarian civilizations, so much so that they took over the reins of government and thus became more powerful even than the warriors and landowners.

The development briefly outlined above gathered momentum in the second millennium B.C., which we have called the Formative Period. It was followed by the pre-Classic period between about the fifteenth and third centuries B.C., when actual villages grew up around the pyramids. A steady improvement in living standards went hand in hand with the division of labour and with specialization on the part of a few groups forming classes of craftsmen. Amongst these were the potters who soon displayed skills that lent aesthetic value to their works. Even before the first millennium B.C. ceramics could boast some genuine masterpieces, testifying to the lofty spiritual preoccupations of society as a whole. This pottery was early used as a medium of exchange and as such might sometimes be carried great distances. Thus added impetus was given to a movement based on a form of commerce which had already existed in earlier periods for specific commodities such as obsidian. But such intercourse also fostered the growth of communities far larger than the hamlet or village. Thus there arose a few big centres of religious and economic importance which became focal points for the accumulation of wealth. Some were also places of pilgrimage for a whole people, who would flock to these great sanctuaries.

Here it should be pointed out that while this cultural development was taking place south of the 23rd parallel, the populations of northern Mexico and what is now the United States were developing much more slowly, some, indeed, remaining at the Paleolithic stage until comparatively late and forming a reservoir of nomadic peoples who posed a constant threat to the security of sedentary communities. In periods of severe drought, for example, these hunters and gatherers would descend on agricultural settlements and plunder their storehouses.

Such, then, was the background to this period of which the Lower or Formative stage begins towards the middle of the second millennium and develops into Middle pre-Classic between 1300 and 800 B.C. It was within an as yet rural framework that the first artistic manifestations, the first preoccupations of an aesthetic nature began to emerge.

The Birth of Art

The life of many materials is relatively so short that virtually nothing remains save pottery to bear witness to that search for perfection. For terracotta, unlike wood carvings or textiles or basket-work, can survive

thousands of years of burial in moist arable ground from which virtually all other evidence of human activity has vanished without trace. Indeed it is no accident that archaeologists should have chosen ceramics as their chief means of dating sites going back to the Neolithic era. From its earliest beginnings to modern times, pottery has provided a continuous flow of documentary evidence which experts have been able to classify by the stratigraphic method, distinguishing the various phases by differences in technique.

It is therefore in the sphere of ceramics, so indispensable to our knowledge of the past, that we find the first portents of art. What is particularly striking about this pre-Columbian Mexican pottery—as soon as it betrays an aesthetic concern by its use of decoration, representation, anthropomorphic motifs and even portraiture—is the remarkable maturity of forms. These works are defined by a plastic density and a felicity of execution of a remarkable kind, and are expressed in an idiom at once confident, coherent and homogeneous. And that homogeneity is no less apparent on the high plateaux than it is on the Gulf Coast, for it is the product of the stylization introduced by the first great pre-Columbian civilization—that of the Olmecs.

Olmec civilization originated on the shores of the Gulf in a tropical region that in no way seemed to favour the emergence of a high culture. Part of our book, *Art of the Maya,* was devoted to that culture, many aspects of which still remain shrouded in mystery and we do not propose to dwell on them here. The question of the Olmecs is indeed a thorny one. Some experts maintain that they originated in the swampy region north of the Isthmus of Tehuantepec, while others see them as having come from the mountains of Guerrero. Whatever the case, their main development took place round the sites of La Venta, San Lorenzo and Tres Zapotes. Situated in waterlogged country covered with dense jungle and traversed by Amazon-like rivers, these were the earliest capital cities of the pre-Columbian world.

Soon, however, ceramics in the Olmec style—and here we return to our theme—began to appear on the high plateaux. Whether this happened as a result of barter, a movement of potters towards the central zones in response to demand, or victories won by Olmec tribes whose ascendancy would thus have extended to the neighbourhood of what is now Mexico City, remains an open question. But we cannot rule out the possibility that the Olmec or Olmec-related style was disseminated far beyond the confines of its country of origin. From other examples— drawn, it is true, from quite different regions and evolutionary stages, for instance, Attic pottery in the world of antiquity—we know that nothing, save perhaps gold, travels with such ease. At certain periods there has been a veritable craze for utilitarian objects, some almost qualifying as true works of art, a craze that often resulted in a two-way traffic in commodities. There is no reason why the same should not apply to Mexico, nor why, given the originals which inspired the potters of the high plateaux, we should not concede the emergence of pieces in the Olmecoid style, just as the products of Athens were imitated by Etruscan potters and minor Italiot masters. For at the dawn of pre-Columbian civilization, the land of the Olmecs was as much of a beacon as was Attica to the Greek world.

It is an undeniable fact that the best ceramic pieces of Central Mexico in the Middle pre-Classic period (between 1300 and 800 B.C.) bear the

stamp of the Olmecs. They testify to a sharing of conventions with the lowlands. This common vocabulary explains the perfection of the fine hollow ware products of Tlatilco and Tlapacoya, in the neighbourhood of Mexico City; rather than a new departure, they are the consummation of Olmec forms whose technical superiority had enabled them to penetrate the highlands. For it is always the more advanced culture which prevails over the less advanced, as it were by 'artistic colonization'. It seems highly probable that this is what happened in Central Mexico. In their encounters with Olmec traders seeking the semi-precious and hard stones that were unobtainable in the swampy districts of La Venta and San Lorenzo, the upland farmers eagerly bartered these raw materials for manufactured goods, in this case pottery.

Types of Pre-Classic Pottery

It seems probable, then, that in the Valley of Mexico this art had already come into being before the arrival of Olmec forms. Yet its first manifestations are certainly not as evolved as the latter. Consisting of small, highly schematized solid figurines with short arms and legs, bulky torsos and large heads, they show scant concern for realism. It was a symbolic art and as such continued to find favour in the periods that followed. The little figurines, many of them mysterious and disconcerting, sometimes take the form of a curious personage with two heads, which may be an embodiment of the deep-seated dualism of primitive beliefs (Pl. 2).

Compared with these pieces, consisting of lumps of incised clay with appliqué elements, the fine Olmec type hollow ware, which now emerged, marks a considerable advance in modes of expression. Typically Olmec are the seated figures with the lineaments of a fat baby (Pl. 3), a head that is often misshapen, a drooping mouth and slit eyes. The potter displays great mastery of line and volume, the most notable features being economy, sobriety and self-sufficiency. Such pieces are the creation of artists whose sense of plasticity has already reached maturity.

Among these works we might cite the marvellous priest, warrior or ball-game player (?) from Altihuayán (Morelos). He wears a helmet and is dressed in a jaguar's skin, with the powerful claws disposed over his shoulders. The pose is that of a ball-game player—a ritual sport that will be discussed in more detail in a later chapter—while the face, with its curiously scalloped eyes and drooping mouth (a convention whereby the muzzle of a mythical animal is associated with man) is typically Olmec.

Despite its modest size (21 cm), this example of Middle pre-Classic conveys a remarkable impression of tension and concentrated power (Pl. 1).

In similar vein, the astonishing acrobat from Tlatilco (Mexico City), whose features are already less Olmecoid, displays unusually animated qualities, especially in the boldness of his posture (Pl. 6). Lastly, mention should also be made of the superb head of a child (?), again from Tlatilco. Below the slit eyes with their disquieting gaze, the grinning mouth reveals teeth that have probably been filed, a common practice among the Pre-Columbians (Pl. 7).

Apart from these pieces of very fine, light beige clay, Central Mexico has yielded up vessels of black lustred ware with anthropomorphic motifs. The personages depicted reveal a series of characteristics that are even less Olmecoid; the facial scarifications, for example, are evidence of a different cultural stream (Pls. 4, 5).

However, to draw distinctions between styles and cultures from a body of discoveries spanning half a millennium would be much too premature. Nor can we be certain that a day will come when it will be possible to place the various ethnic groups and the phases of their existence with any greater precision. Not only are examples often isolated and finds sometimes fortuitous, but the formal and technical variants are so numerous and the gaps so great as to make it impossible to enter this maze of uncertainty save with the utmost caution.

As suddenly as it would seem to have arrived, the repertoire of forms constituting the Olmecoid style of the high plateaux was to disappear in favour of others whose characteristics correspond to the Classic style of Teotihuacán. And we shall see how, in their turn, these new forms became diffused over a wide area. Between the fifth and sixth centuries A.D. they penetrated as far as the Kaminaljuyú region near Guatemala City, and even to Tikal in the Petén, at the very heart of the Maya world.

It is clear, therefore, that to speak of the Pre-Columbians as a cultural community is no empty phrase. Interchanges and the diffusion of influences and forms occurred irrespective of climate, region or geographical location, and embraced tropical and temperate zones alike. Whenever an art acquired sufficient vitality, it necessarily propagated itself far from its place of origin and made its mark outside the boundaries of a given culture. Were it not for the homogeneous nature of the pre-Columbian world, we should find it harder to grasp this traffic in ideas, divinities and forms.

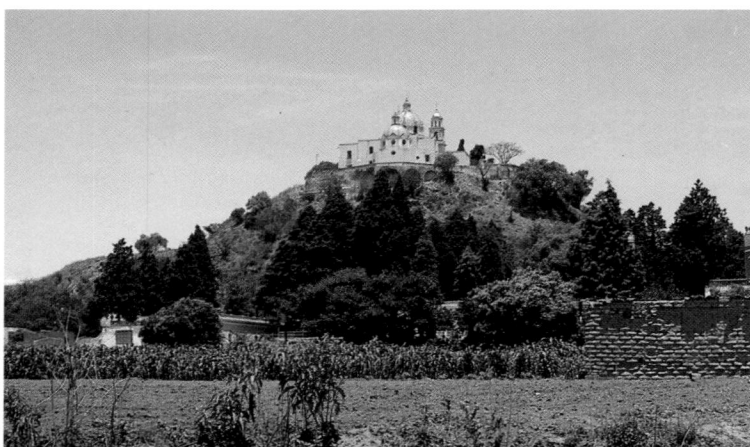

8

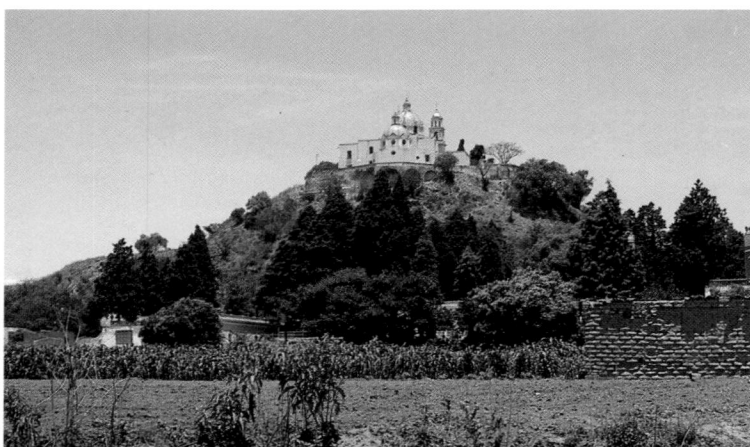

9

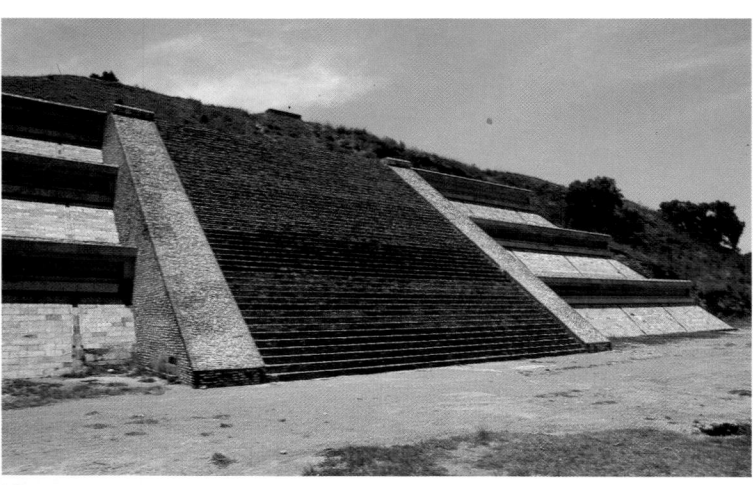

10

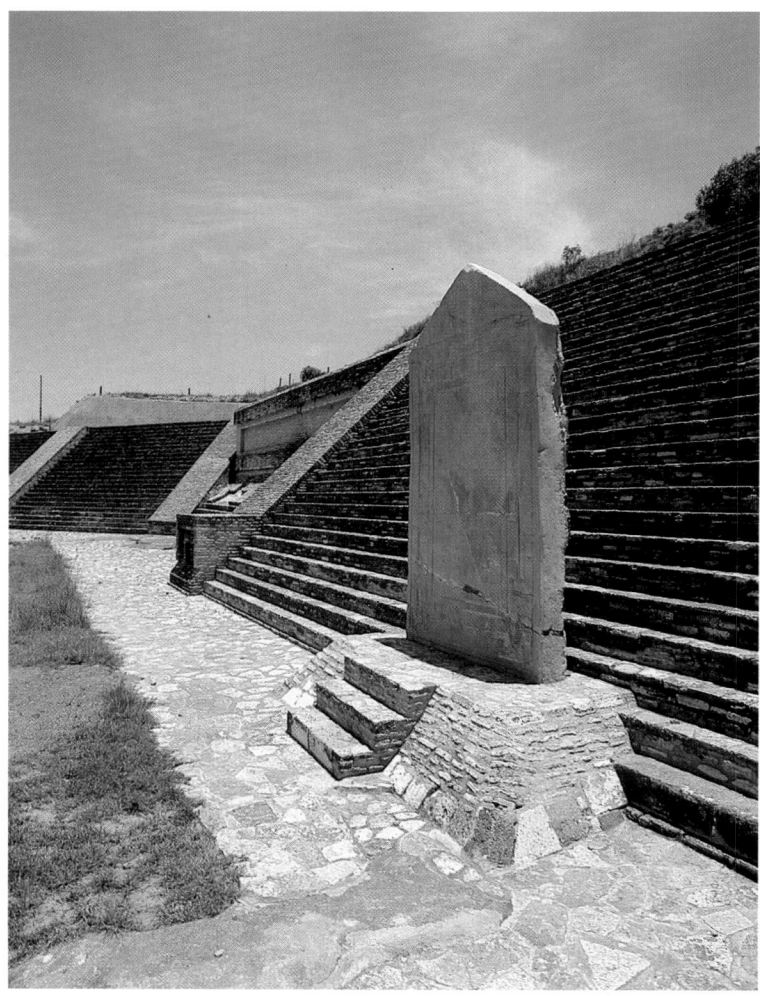

11

II. Teotihuacán and the Classic Heyday

Like the advent of the Neolithic era, the birth of the town marked a revolution in man's mode of existence and a notable step forward along the path of civilization. It is above all by its architecture that the period is characterized, for during this time agglomerations grew up that far surpassed in importance the rural villages of the pre-Classic era. The greater density of population arising from the creation of large urban centres had a profound effect on the people's way of life. They passed progressively from the more or less autarchic existence of the small agricultural community (in which pottery was, perhaps, the sole truly specialized craft) to a far more complex and structured social organization characterized by a variety of callings and the introduction of a true class system.

It was round the ceremonial centres, which covered an ever wider area and which, strictly speaking, constituted the urban nucleus, that the great pre-Columbian cities came into being, marking the start of the Classic period in Central Mexico. The largest was unquestionably Teotihuacán, the 'place of the Gods', built on the high plateaux at an altitude of 2,300 metres, some forty kilometres north of what is now Mexico City. Of these religious metropolises nothing remains save heaps of rubble dominated by partially ruined pyramids. All we perceive is in fact the bare bones of a town, largely confined to religious structures such as temples upon a pyramidal base, esplanades, processional avenues and the like. Indeed, as in many of the cultures of antiquity, the only buildings made of stone were those dedicated to the gods and their servants, the priests. Unlike the palaces of the high dignitaries of the priestly hierarchy, the dwellings of the populace were constructed, as was the primitive village, of adobes, or bricks of dried mud, and were roofed with thatch. Under the circumstances it is hardly surprising that little or nothing remains, since what might be called the flesh that clothed these bare bones of masonry and stone has vanished without trace.

The Olmec Heritage

The importance of Olmec influence in the field of pre-Classic ceramics has already been noted. That influence was also brought to bear on the early architecture of the Classic period. In *Art of the Maya* we drew attention to the fact that the Olmecs of San Lorenzo and La Venta were the creators, in the tenth century B.C., of the ceremonial centre with its

8 Circular pyramid at Cuicuilco, southwest of Mexico City, built in two campaigns in the fifth and fourth centuries B.C. With a diameter of 135 m, it has a wide ramp leading to the upper platform which must have supported a temple built of non-durable materials. Shortly before our era it was partially buried by a lava flow from Mt. Xitli.

9 General view of the pyramid at Cholula (State of Puebla). With sides measuring 325 m and a height of 65 m, it is the largest pyramid in the world. After the Conquest the Spaniards built a Christian church at its summit.

10 A three-storeyed platform ascended by a great stair leading to the Cholula pyramid whose west face it precedes. It is of talus and tablero construction, like the Classic buildings of Teotihuacán.

11 The stairway south of Cholula pyramid is preceded by large monolithic stelae, recently discovered, and dates from the Upper Classic period (between 450 and 650 A.D.).

various component parts, namely the pyramid commanding the structural ensemble, quadrilateral courtyards surrounded by platforms, and the ball-court.

On the high plateaux the early pyramids, begun in the fifth or fourth century B.C., were very similar in size to that of La Venta, i.e. approximately 100,000 cubic metres. Indeed the circular pyramid at Cuicuilco south of Mexico City might be regarded as the first important building in the region. In terms of volume it is comparable to La Venta as was, in its original state, the pyramid at Cholula, which is built on a square plan.

However, it is at Teotihuacán that we find the most grandiose examples of pre-Columbian urban planning in the shape of the vast pyramids of the Moon and of the Sun, whose volume is respectively twice and ten times that of the Olmec pyramid at La Venta. Again, this immense ceremonial centre adopts from the Olmec model its rectilinear perspective and organization, as also the formulas of the quadrilateral courtyard and of the ball-court. Thus the rules governing theocratic urbanism, first elaborated by the early Olmec architects, are here applied to the first monumental architecture to appear on the high plateaux in the Classic period.

It should at once be said that the pre-Columbian pyramid, unlike the Egyptian, is not an edifice in its own right, being nothing more than a massive base supporting a sanctuary. Like the Babylonian ziggurat, the Mexican pyramid was therefore given flights of steps leading to the temple at the top where, high above the abodes of mere mortals in an intermediate zone between heaven and earth, the priests ascended to meet their gods.

While they inherited from the Olmecs the principles of urbanism governing ceremonial centres, as elaborated in the first millennium B.C. at La Venta and at San Lorenzo, the peoples of the high plateaux were nevertheless to evolve an indigenous architecture along original lines. Unlike the Olmecs, who simply piled up vast mounds of earth, there being a scarcity of lithic materials in the swampy plains of the Gulf, the inhabitants of the Meseta central made use of local stone, initially as revetment for the earliest pyramids and, later, in the shape of masonry proper.

The Coming of Masonry

In the sphere of Classic architecture, the most striking advance, by comparison with the Olmecs, was the introduction of masonry in the shape of virtually uncut lava blocks embedded in a rudimentary form of cement, the lime for which was obtained by burning calcareous matter. The use of cement, which before long was to cover the whole exterior of sacred monuments with a kind of rendering similar to stucco and usually polychrome, represents one of the crucial achievements of this period. The new albeit weighty material was to make possible the emergence of a true architecture comprising covered buildings, courtyards surrounded by porticoes, halls and dwelling-places.

But the ever-increasing demand for cement, without which the building of the religious centres would not have been feasible, was to lead to the despoliation of the forests in order to keep the lime-kilns supplied

with fuel. This resulted at the end of the Classic period in what can only be described as an ecological catastrophe, in that it turned the high plateaux into a semi-desert. Countless acres of mature standing timber were denuded to obtain wood for building and to supply sufficient lime to meet the requirements of the building sites where work continued unceasingly on the erection and enlargement of the colossal monuments that were to turn Teotihuacán into the religious capital of the highlands.

The disappearance of so large an area of forest brought about profound climatic changes whose repercussions on the environment throughout the Meseta central are still felt today. The more recent effects of this deforestation have become particularly noticeable during the past four centuries. For progressive desiccation, accelerated by an ill-advised policy of reclamation, has turned Lake Texcoco, once a paradise, into the brackish and fetid puddle we know today.

A further consequence of that over-exploitation—already apparent in the Classic period—was the problem of transport to which it gave rise. Indeed to provide the masonry for edifices covering thousands of square metres, and adorned furthermore with frescoes, the builders of Teotihuacán had to go further and further afield in search of materials. Nor is it difficult to imagine the exertions required to build the awe-inspiring complexes left by that civilization at a time when the absence of wheeled transport meant that the carriage of all heavy materials was dependent on man-power alone.

The Development of Classic Urban Planning

Before we go on to examine the huge theocratic metropolis, Teotihuacán, it would be pertinent to consider those architectural developments that preceded the constructions of the Classic period.

The architecture of the high plateaux had its beginnings at Cuicuilco in the middle of the first millennium B.C. Here, south of Mexico City on the edge of the district known as the Pedregal, may be found the earliest known pyramidal construction. In the third or second century the volcano Xitli erupted, covering the whole region with a stream of lava. Since it also engulfed the lower part of the pyramid, we know that the latter antedates the catastrophe.

It is a circular structure 135 metres in diameter and, in its first phase, comprised only two steps, two more being subsequently added to give it a total height of 20 metres. The summit was reached by a ramp on the west face and by flights of stairs on the east. It was crowned by a rectangular sanctuary built of non-durable materials and roofed with thatch (Pl. 8).

A compact mass of earth and rubble comprising, as we have already said, some 100,000 cubic metres, this truncated cone was faced throughout with rough stones, forming as it were retaining walls to obviate gulley erosion by rain. The uppermost platform was surfaced with adobe, for cement had yet to come into use.

After the eruption of Xitli the religious centre of Cuicuilco was abandoned. At about the same time work was begun by the farming communities round Cholula in Puebla on what was to become over the centuries the largest pyramid in the world, each addition obliterating the last in a series of superimpositions spanning several centuries. In its first

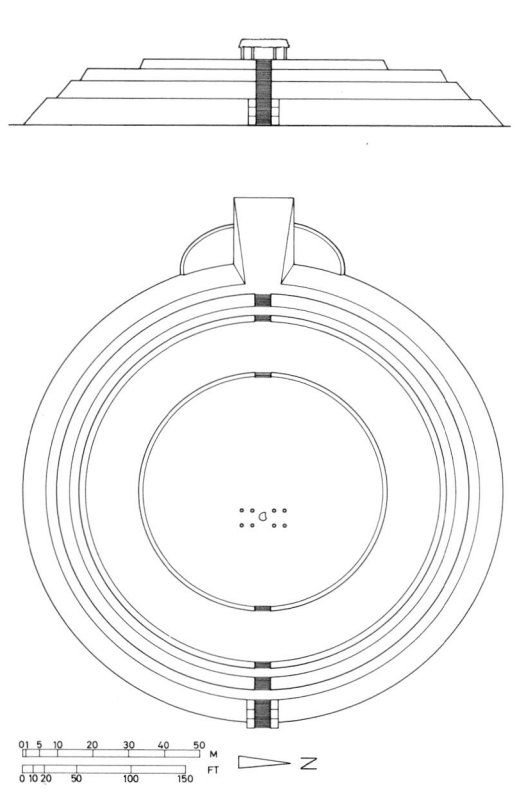

Elevation and plan of the circular pyramid at Cuicuilco, near Mexico City. Its crowning temple was built of non-durable materials.

phase round about 200 B.C. the core of this pyramid was no larger than Cuicuilco, though built on a square rather than a circular plan, each side measuring some 100 metres, while its height was about 20 metres. When completed, however, the mighty edifice covered an area 325 metres square and rose to a height of between 60 and 65 metres. Containing six million tons of materials, it has a volume of more than 2.5 million cubic metres.

Shortly after the Conquest its ruins, used as a quarry by generations of builders, were crowned with a baroque church, replacing the former sanctuary of which no trace remains. So vast are the dimensions of this structure that it might be taken for a natural eminence (Pl. 9).

The pyramid is magnificently situated at an altitude of 2,350 metres, between the volcanoes of Popocatépetl and Ixtacihuatl in the west and the Cerro de Malinche in the east. First investigated in 1917, the site has more recently been the subject of a systematic excavation campaign known as the *Proyecto Cholula* of which the most important results

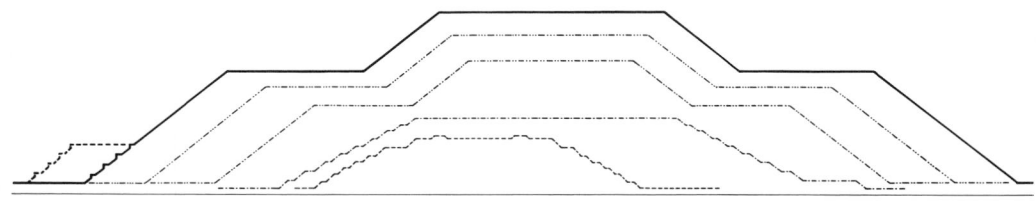

Section and plan of Cholula Pyramid. The section shows five superimpositions, the plan only the first and final phases.

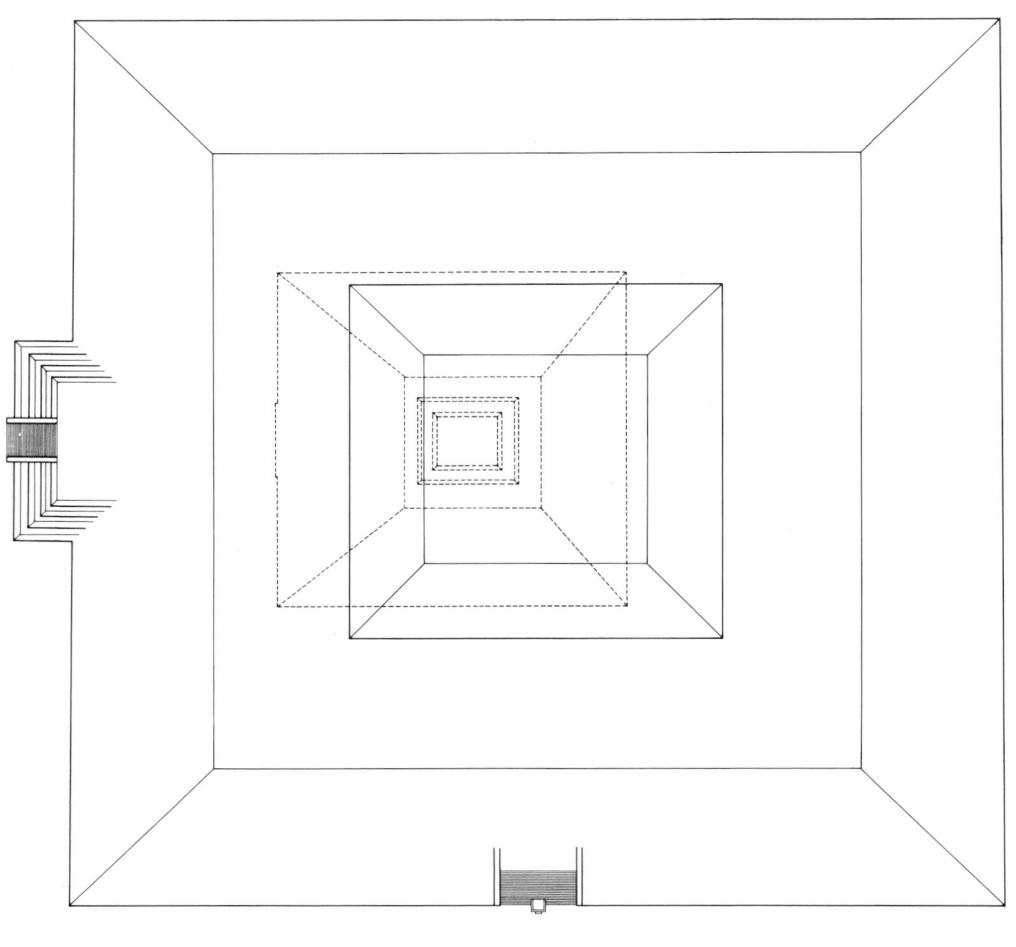

0 15 10 20 50 100 M
0 20 50 100 200 300 FT

12 The great Sun Pyramid, Teotihuacán. With its four superimpositions it attains a height of 65 m, on a base of 225 by 222 m. It was built at the beginning of the Classic period shortly before our era. The west face, shown here, is preceded by a platform. It is ascended by a great stairway which at one time led to a temple.

13 Typical form of construction at Teotihuacán. The platforms consist of a sloping base (talus) and a vertical panel (tablero) in a projecting frame.

14 On axis with the great Avenue of the Dead at Teotihuacán, the Moon Pyramid, with its four-storeyed avant-corps, is silhouetted against the mountain. It is 150 m wide and 42 m high.

15 View of the platforms lining the west side of the Moon Plaza at Teotihuacán. This Classic structure still retains traces of the polychrome stucco which covered all the surfaces of the buildings in the ceremonial complex.

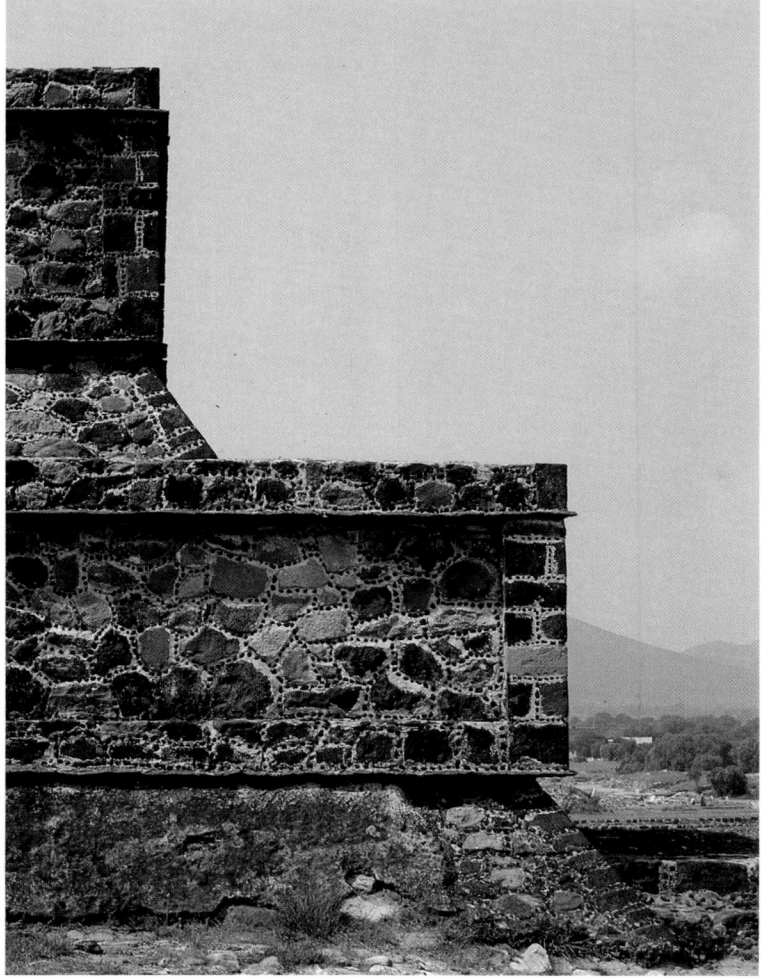

12

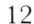

13

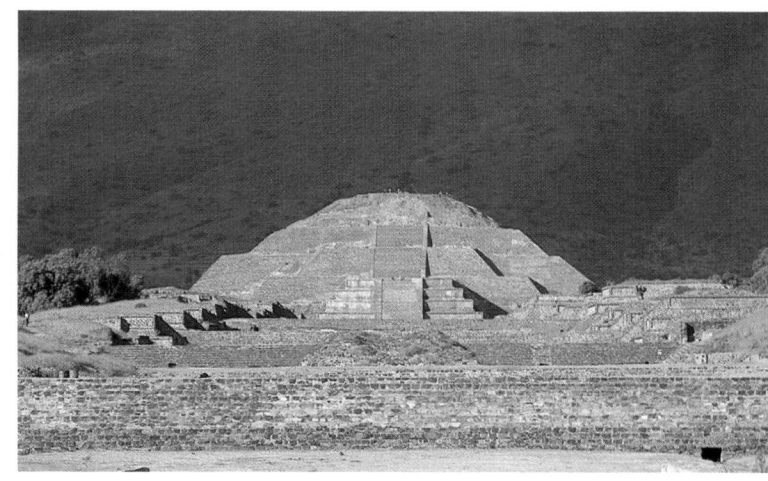

14

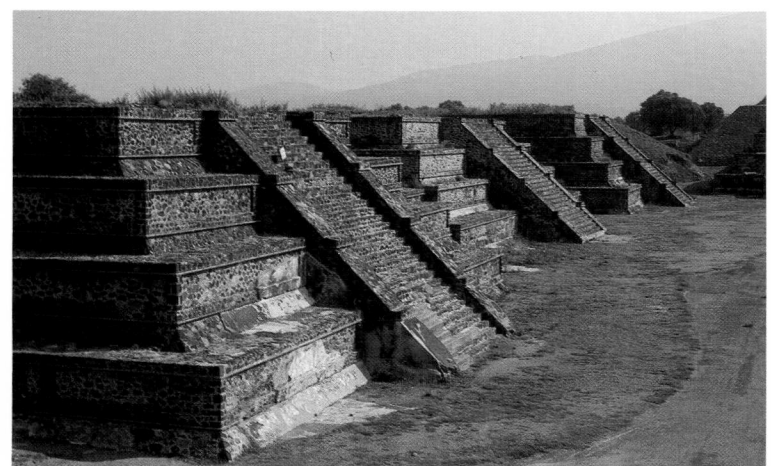

15

were published in 1970 by its co-ordinator, the architectural historian Ignacio Marquina. The restorations made under this scheme have shown that new additions continued to be made to the immense structure right up to the post-Classic (Pls. 10, 11).

In this connection mention should be made of layering, or superimposition, a feature of pre-Columbian architecture found throughout Mesoamerica including the Maya country. Most pre-Columbian pyramids were, in the course of their history, covered by successive layers of material, each concealing its predecessor. Such accretions habitually occur in ritual edifices, which is why certain pyramids, notably Cholula, reveal a series of successive stages, one encased within the next after the manner of a Russian doll. As a result the final or most recent layer of a pyramid is, as a rule, the least well preserved, having been exposed, not only to natural, but also to human depredations. For this reason the archaeologist, seeking to discover the history of a pre-Columbian building, always chooses to drive a deep tunnel into the interior, a technique which enables him to identify the various phases of a monument and uncover decorative elements such as bas-reliefs or frescoes, themselves a valuable source of information on architectural development.

At Cholula, for instance, the above procedure has revealed no less than five or six superimpositions, each of which increased the volume of the structure until in the end it was twenty-five times greater than that of the original core and, as we have seen, comprised six million tons of materials, all of which had to be transported on men's backs.

Teotihuacán, 'Place of the Gods'

On the plain encircled by mountains, some of them in the shape of a truncated cone that clearly betrays their volcanic origin, the two pyramids of Teotihuacán, the Sun and the Moon, emerge from the morning mist as though they were real natural features. Because of their vast proportions and the general inclination of their now relatively featureless façades, they blend with the surrounding countryside in a strange kind of mimicry, the silhouettes of the terraced pyramids being echoed by the outline of the bare hills.

As we approach the ceremonial centre of Teotihuacán, the two colossal edifices seem to draw themselves up, to gain in height and vigour. Wide stairs, their flights ascending the main façade and leading to the now vanished upper sanctuary, come into view, as does the tiered avant-corps projecting from the base. In short, angles and ledges acquire definition and man's handiwork becomes apparent, while the contrast between the sheer volume of the masses and the quality of the conception engenders a sense of awed stupefaction.

Work on these two pyramids must have begun in about the second century B.C. Their names, as also that of Teotihuacán, 'place of the Gods', are hallowed by long tradition, having been imparted to the Conquistadors by Aztecs who knew nothing of their early predecessors. But in view of the typical orientation of the Sun Pyramid (to which we shall revert), there is reason to believe that it was put up in honour of the Sun God who commanded the heavens, just as this grandiose monument commands the ceremonial centre of the high plateaux (Pl. 12).

The dimensions of the edifice plainly express the veneration for the sun felt by an agrarian people whose life was governed by the solar calendar. On an almost square base (225 by 222 metres, i.e. 5 hectares), its four terraces rise to a height of 65 metres, forming a fantastic stairway to the world of the gods. With a total volume of a million cubic metres the building contains 2.5 million tons of material, and its construction probably entailed the labour of some three thousand workmen over a period of no less than thirty years.

Research undertaken inside the structure has not produced any evidence to show that it contains an early core encased in subsequent superimpositions. It was conceived and realized in one operation, shortly before the beginning of our era, but must later have been refurbished on more than one occasion and been given additions such as the four-storeyed avant-corps which precedes it.

The Moon Pyramid, while still imposing, is appreciably smaller. Its base, measuring 150 by 140 metres, covers an area of 2 hectares, and it rises to a height of 42 metres. Thus its volume is approximately 320,000 cubic metres and the weight of the materials almost 700,000 tons (Pl. 14). Plastically the two pyramids display an almost identical formula: the three lower storeys are divided from the fourth by a terrace of which the riser must at one time have been accentuated by what Mexican archaeologists call a tablero, i.e. a vertical panel in a projecting frame. This element, which was not fully reconstituted during the course of restoration, must have emphasized the vigorous appearance of the profile and at the same time have served as a kind of enceinte round the topmost storey of the pyramid, guarding, as it were, the access to the upper sanctuary by which the whole is crowned.

In the Sun Pyramid this elevated temple, of which little now remains, may have consisted of two rooms one behind the other, the sanctuary proper being preceded by a vestibule; in the Moon Pyramid it consisted of three rooms in a row, possibly dedicated to a divine triad.

Archaeological tunnelling has shown that, in order to contain the mass of earth constituting the main bulk of these pyramids, the pre-Columbian builders hit on the device of embedding, in what was relatively unstable material, a number of stone walls at right angles to the external surfaces and designed to secure better cohesion of the whole.

Lastly, we should remember that the entire edifice must have been coated with a layer of polychrome stucco which, while enhancing its forms, lent it an artificial appearance so that it would not have blended with the surrounding hills as it does today.

The Plastic Unity of the Ceremonial Centre

The entire ritual complex of Teotihuacán is dominated by the Pyramids of the Moon and of the Sun which stand more than two kilometres apart. They form part of a theocratic urban plan which also comprises a hundred or more platforms, some on the periphery and others lining the Avenue of the Dead whose rectilinear course governs the layout of the city. We shall revert to the planning of this grandiose concourse, but first we must examine its component parts.

Anyone who visits these ruins of superhuman dimensions is immediately struck by the ubiquity of a single structural system, forming as it

Plan of cult complex at Teotihuacán
1 Enclosure wall of citadel
2 Quetzalcóatl Temple
3 Avenue of the Dead
4 'Subterraneo' Group
5 Viking Group
6 Pyramid of the Sun
7 Plaza of the Columns
8 Quetzalpápalotl Palace
9 Moon Plaza
10 Pyramid of the Moon

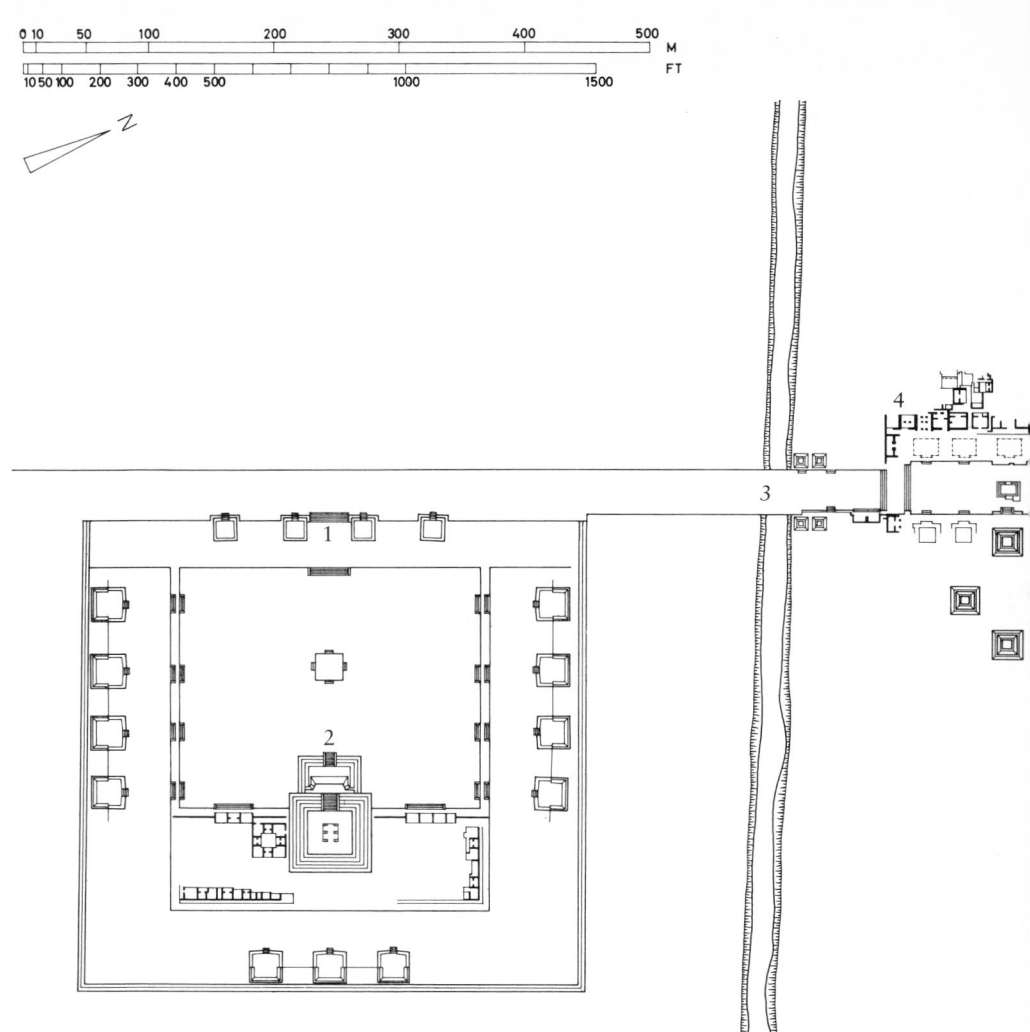

were the *leitmotiv* of Teotihuacán's architecture, namely the repeated use of the tablero, to which allusion has already been made. All the edifices lining the great vista of the Avenue of the Dead are similar in construction, consisting of superimposed tiers served by flights of stairs with flanking wall strings.

However, these tiers do not consist simply of terraces and risers. What we have here is a complex plastic element made up of a base, its sides sloping at an angle of between 45° and 60°, surmounted by a projecting tablero composed of a panel within a salient frame. The vertical profile of the tier is defined by these austere mouldings whose shadows emphasize the articulation of the masses (Pl. 13).

This constant recourse to the tablero is significant in that it betrays a lively sense of plasticity on the part of the creators of the Classic architecture of the high plateaux. For the only materials available to them for the construction of their platforms were relatively unstable. On a core of earth they built a retaining wall. Originally, as may be seen from the pyramids, the face of a building was usually inclined at the angle of repose of the materials employed, namely 45°. But the architects soon came to see that their monuments, however large and imposing they might be, tended to merge with the surrounding landscape, since in these latitudes the light falls vertically, thus flattening the pyramidal forms.

In so far as their means allowed they sought to remedy this shortcoming by building, with the aid of cement, stepped tiers intersected by vertical faces. But the friable nature of this primitive type of cement pre-

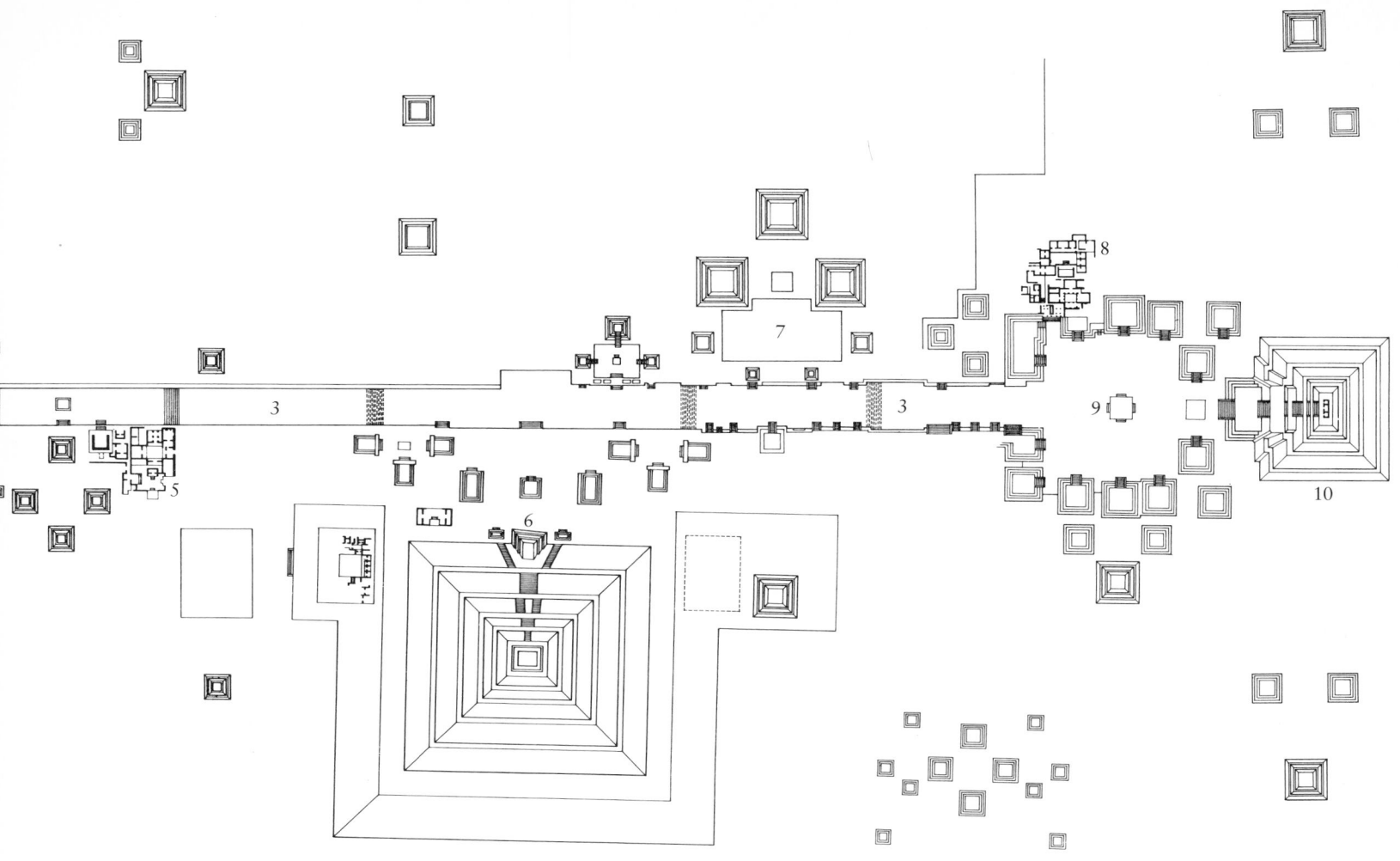

cluded the building of very high walls, which in rainy periods might have failed to retain the mass of earth behind them. To solve this problem of statics the builders had recourse to a formula which consisted in subdividing the vertical elements and interposing inclined surfaces.

In practice, what this involved was the construction, at each level of these tiered buildings, of a battered base, representing roughly one third of the height of the tier; on that base, cantilevered stone slabs were used to support the tablero with its projecting frame, of which the function was primarily visual. Thus, although the composition is always conceived in accordance with the overall inclination corresponding to the angle of repose, each face of the stepped platforms is divided into strongly profiled tiers. The effect on plasticity is all the more remarkable for being endlessly repeated, not only in the structures of one, two, three or four storeys, but also along the whole length of the Avenue of the Dead. At the same time, as we have already seen, it gives added emphasis to the crowning riser of each pyramid.

Thus the omnipresence of the tablero motif endows the ritual complex of Teotihuacán with a stylistic unity and vigour that are almost obsessive.

This characteristic of the Classic architecture of the 'place of the Gods' was to be disseminated over an astonishingly wide area. It first found its way to the ritual centre of Cholula where, at the height of the Classic period, the avant-corps of the great pyramid displays a talus-tablero form in combination with decorative geometrical motifs. In the fifth and sixth centuries A.D. it again recurs, as does Teotihuacán pot-

tery, in Kaminaljuyú, near what is now Guatemala City. This town, 1,100 kilometres further south-east as the crow flies, or 1,500 overland, served as a refuge to Teotihuacános driven from their capital by an influx of barbarian nomads whose bands were ravaging the centres of the sedentary civilizations.

Similar elements are also found in some of the buildings in Tikal, then the Maya capital in the heart of the Petén. In short, the art of the high plateaux had extended its influence to the frontiers of the Meso-american world.

After the final destruction of Teotihuacán in the seventh century as a result of another invasion from the north, a talus-tablero type of motif reappeared early in the following century in the late Classic centre of Teotenango near Toluca. Here, however, it assumed a simplified form, consisting merely of a talus surmounted by a projecting panel, but without a surrounding frame.

The Great Complexes

The architectonic vocabulary of the Teotihuacános, therefore, finds expression in a succession of vertical planes whose function is to interrupt the slope of the structure; varying in scale, they range from the risers of the stairs to the steps of the great pyramids and include the tableros which define the tiers of the multi-storeyed platforms. All these elements are combined in architectural complexes whose compact masses, with their long horizontal lines, convey an impression of exceptional vigour thanks to the panels which catch the light and help to articulate the volumes of the building.

At Teotihuacán these formulae culminate in two great assemblies, namely the Moon Plaza and the Citadel. Combining groups of platforms and flights of stairs in a strictly rectilinear composition, they form a unified whole on a grandiose scale.

The Moon Plaza, situated in front of the Pyramid of the Moon at the northern end of the Avenue of the Dead, is an ensemble of platforms on four levels. It enables us to trace the growth of these vast places of worship which came into being at the foot of the pyramids around an open space, the scene, no doubt, of the great ritual ceremonies peculiar to the people of Teotihuacán. Archaeological investigations have, in fact, enabled us to identify the successive stages leading up to the realization of this complex, with its fifteen flights of stairs surrounding the plaza. In the first phase, four lateral platforms were symmetrically disposed to face each other, to the right and left, in front of the main façade of the Moon Pyramid, while four more flights of stairs ascended the platforms, enclosing the space on the south side at its junction with the Avenue of the Dead. Thus the plaza obeys the principle of centrality.

In the second phase, the composition received its finishing touches— on the one hand, a four-storeyed avant-corps preceding the pyramid and, on the other, a series of three platforms on either side interposed between the earlier ones, as if the intention had been to create, in visual terms, the complete enclosure of the space defined by the plaza (Pl. 15). In the centre of the complex is an altar with four axial stairways.

At this point we might inquire into the function of the various platforms surrounding the open space at the foot of the pyramid. Now, it

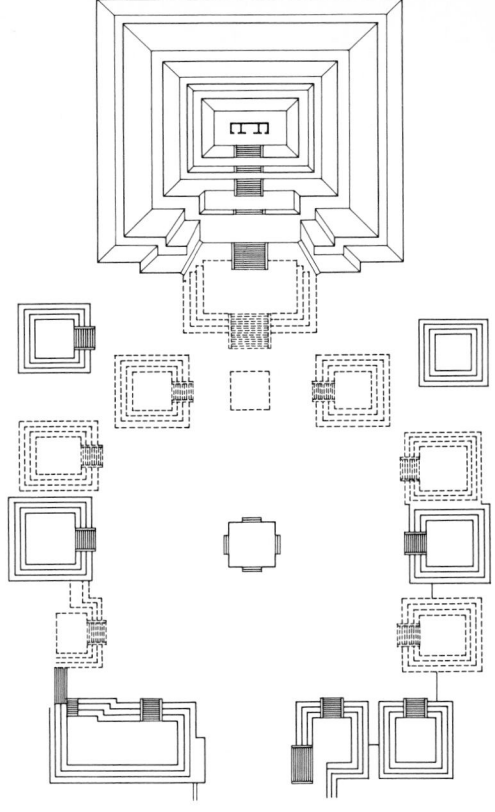

Plan of the Moon Plaza at Teotihuacán. The dotted lines indicate buildings that date from the second campaign of construction.

will be remembered that the great pyramids, being crowned by a temple, were important ritual centres; the various platforms, therefore, may be regarded as subsidiary temples since each is provided with a stairway giving access to the top where religious ceremonies must have been performed. This arrangement is reminiscent—if on a quite different scale—of that obtaining in the Christian cathedral, with its main altar in the choir, at the focal point of the building, and its side chapels. Here, then, we may discern a hierarchical system of worship with a main temple, the preserve of the high priest, and subsidiary temples.

Though empiricism is the keynote of the development out of which this complex was born, there can be no denying the remarkable architectural quality displayed by its final phase. Though, perhaps, not altogether successful, the formula was nevertheless the product of a comprehensive concept of urban planning, while the articulation of open volumes testifies to a remarkable sense of plasticity. Here the plaza represents what might be called the 'negative' complement to the massive pyramidal structure, an effect indeed which seems to have been consciously intended since the space occupied by the plaza accords exactly with the dimensions of the base on which the pyramid rises. Thus a deliberate complementarity, an absolute duality, is obtained thanks to the adjustments made during the second phase of the building campaign.

The conclusion drawn from these architectural findings may be applied no less successfully to Teotihuacán's other great complex, the Citadel—

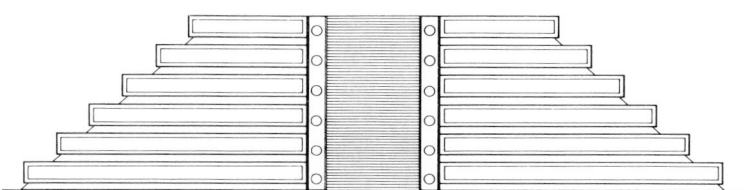 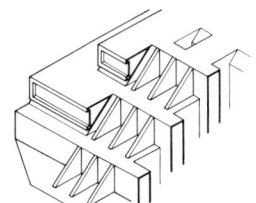

Elevation, plan and diagram of assembly of the Pyramid of the Temple of Quetzalcóatl at Teotihuacán.

16 Detail of a three-storeyed platform flanking the Citadel at Teotihuacán. Wide flights of stairs give access to the top where the ceremonies were enacted.

17 Vista of stairs flanking the inner plaza of the Citadel at Teotihuacán. The characteristics of this art of the early Classic period (before 100 A.D.) are rigorous urban planning and an ineluctable system.

18 The platforms and great stair give access to the Citadel at Teotihuacán. This vast complex covers an area of 400 m square, or about 16 ha, 5 of which are occupied by the inner plaza alone.

 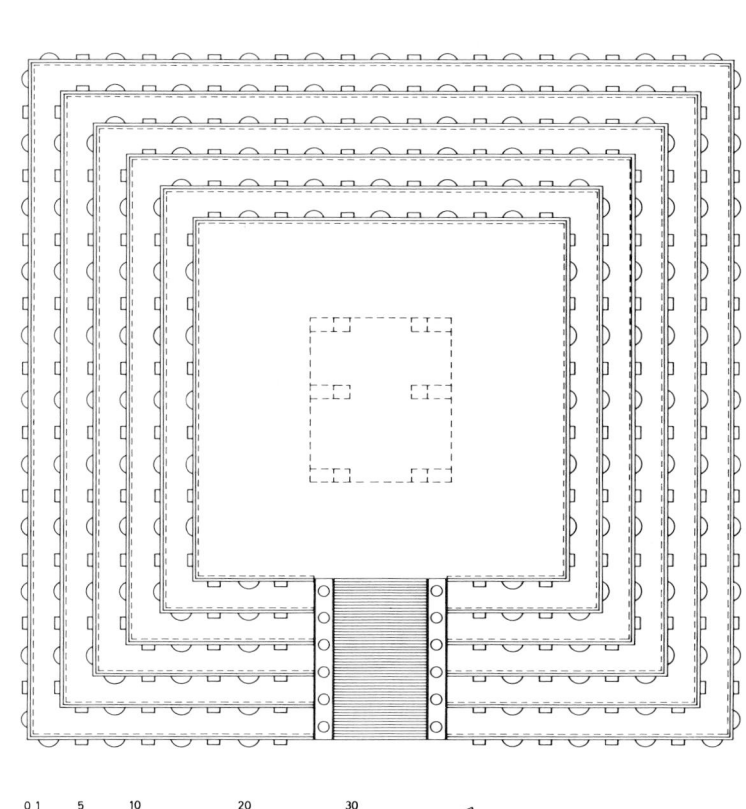

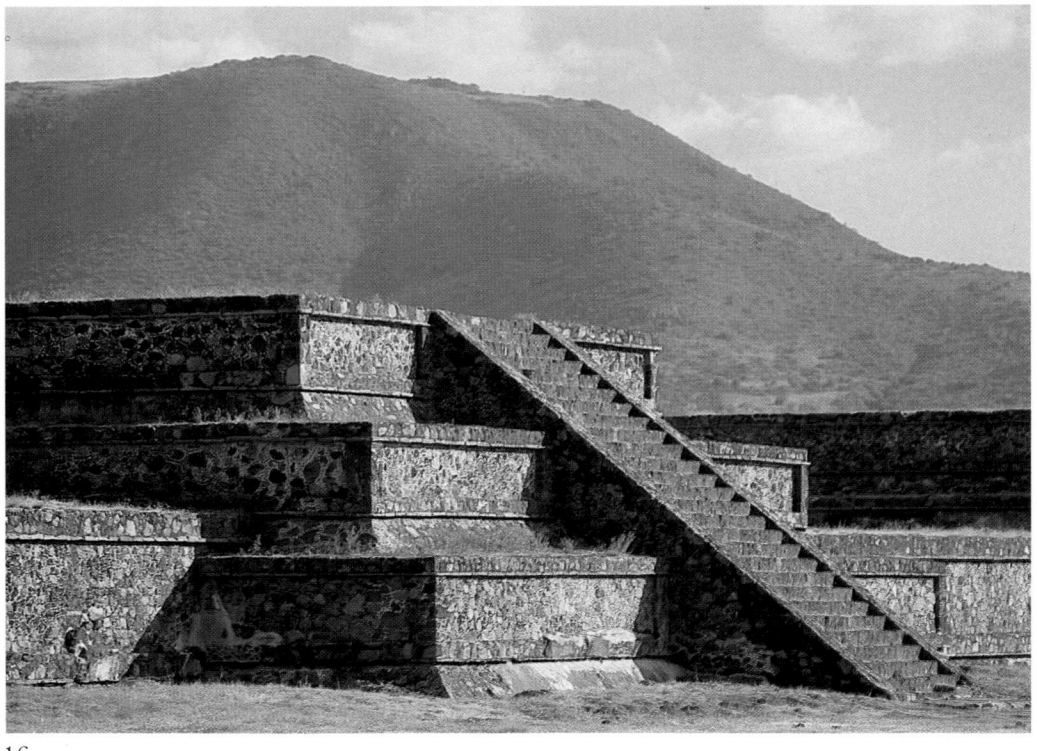

16

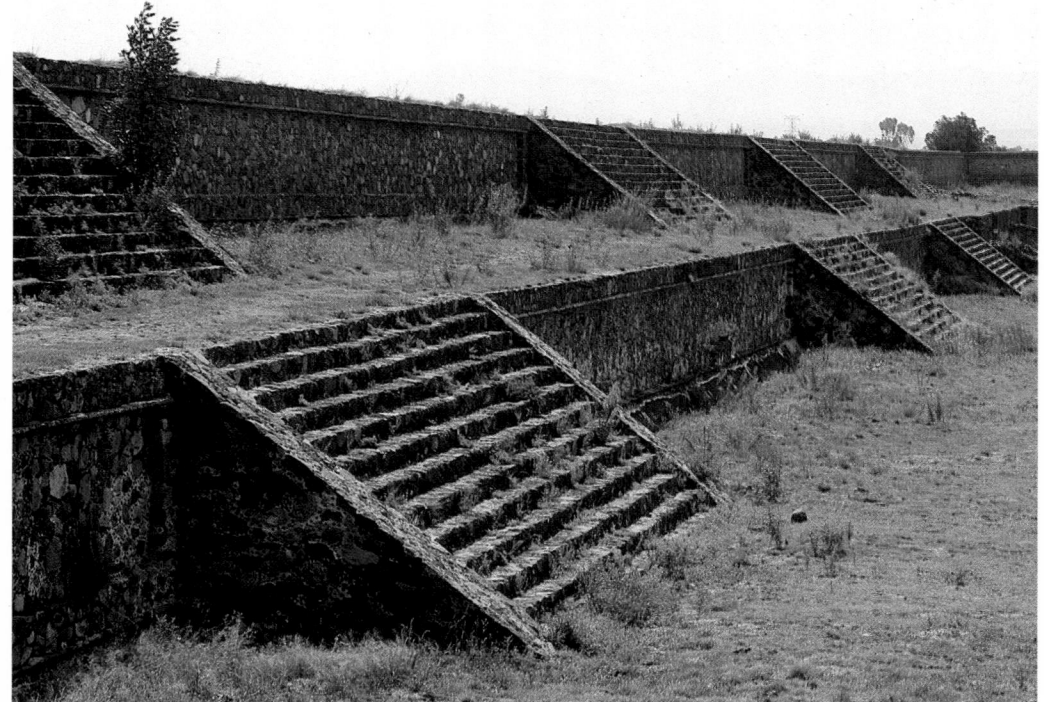

17

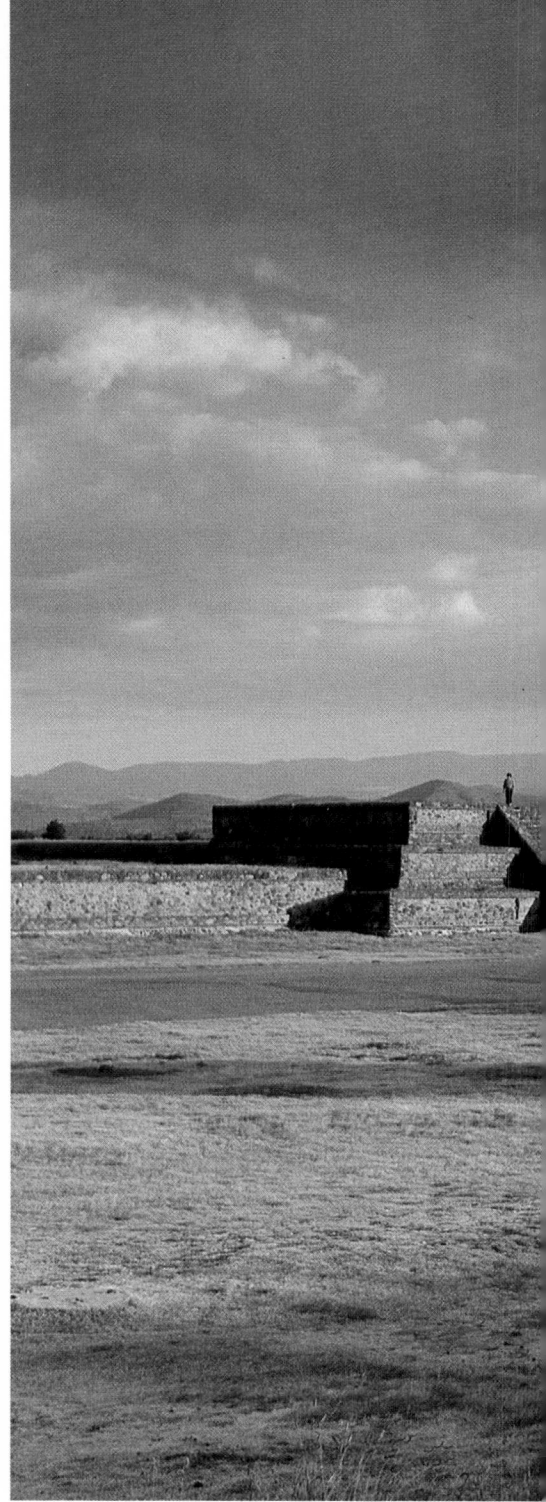

18

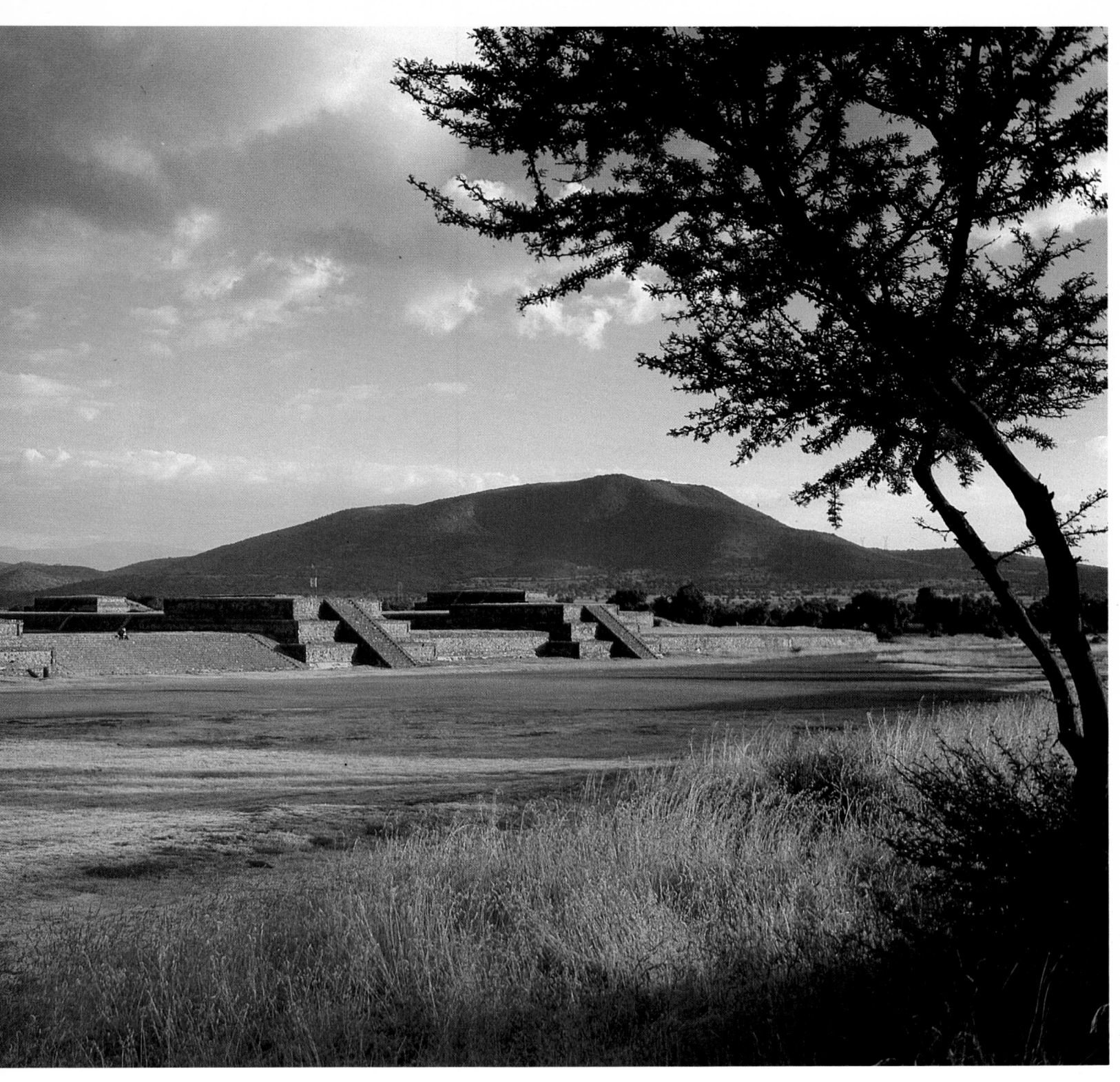

a name, we need hardly add, without any warlike or defensive connotations, but deriving solely from the impression made on early visitors from the West.

Like the Pyramid of the Sun, the Citadel lies to the east of the Avenue of the Dead which bounds and gives access to it. The two buildings of majestic proportions are some 800 metres apart, but both occupy the same amount of ground, and would certainly seem to accord with and complement each other. Thus the base of the pyramid, like the depressed central plaza of the Citadel, covers an area of approximately 5 hectares, a correlation that can hardly be fortuitous. Once again we are confronted by the complementarity between positive and negative elements.

In the case of the Citadel the principle elaborated in the Moon Plaza is exploited to the full to achieve a coherent whole. For whereas the original solution—the juxtaposition of discrete elements between which spaces are left to provide oblique vistas—had been reached tentatively and by slow degrees, the arrangement adopted by the architect of the Citadel was more rigorously co-ordinated. What he built was virtually a quadrilateral *enceinte* with a terreplein surmounted by linked platforms, so forming a homogeneous whole. There are fifteen of these platforms, four on the west face ascended by broad flights of stairs, four on the south and north sides and three on the east. Like crenellations, they punctuate the horizon, conveying the impression of a powerful theocratic fortress (Pls. 16, 18).

This precinct, with its fifteen platforms ascended by flights of stairs, forms a complex that is at once grandiose and austere. Here the motif of the tablero is repeated with a regularity and insistence that is almost inhuman, so rigorous is it, and so cold the symmetry. This rectilinear system is as implacable as a mathematical formula and no less ineluctable (Pl. 17).

At the heart of the complex, but set back from the cross-axis and dominating the platform with its pyramidal mass, is the Temple of Quetzalcóatl—the Feathered Serpent or god of agriculture—erected in the course of two distinct campaigns.

The building put up during the first phase was a six-storeyed pyramid on a square plan measuring 65 by 65 metres. A wide axial stair led to the sanctuary at the top, consisting of two rooms, a vestibule and inner shrine, like that crowning the Pyramid of the Sun (Pl. 19).

The monumental stair was flanked by ramps each adorned with twelve stone heads of the Feathered Serpent, carved in the round and set one above the other. The six stages of the pyramid are faced with tableros or panels superbly embellished with reliefs in a polychrome mosaic of stone and stucco and representing in high relief the effigies, now of the Feathered Serpent, now of Tlaloc, the rain god. On the rear plane of the composition are the meanders of the former, in combination with sea-shells symbolizing water.

Subsequently, in the age of the Toltecs of Tula, the Feathered Serpent came to be identified with the god Quetzalcóatl, the name given to the temple dedicated to him in the Citadel. His image, in the form of a dragon's head with bared fangs, emerges from a collar of flames, while that of Tlaloc consists of a stylized mask with rings for eyes and of discs in relief which punctuate the whole surface in a vigorous geometrical rhythm (Pls. 20, 21).

19 The temple known as Quetzalcóatl at the heart of the Citadel in Teotihuacán, with its great stairs lined with Feathered Serpent heads and stages adorned with masks of Tlaloc, god of rain. It was built before 100 A.D.

20 Detail of the stylized mask of the rain god, Tlaloc, on the Temple of Quetzalcóatl at Teotihuacán. The geometric schematization of this deity, who corresponds to the Maya god, Chac, is expressive of the severity of Classic sculpture.

21 Detail of Feathered Serpent heads, Temple of Quetzalcóatl. The mask with its huge fangs emerges from a ruff suggesting flames or rays. The sculptures were protected by a superimposition which entirely concealed them until their retrieval by archaeologists.

19

20

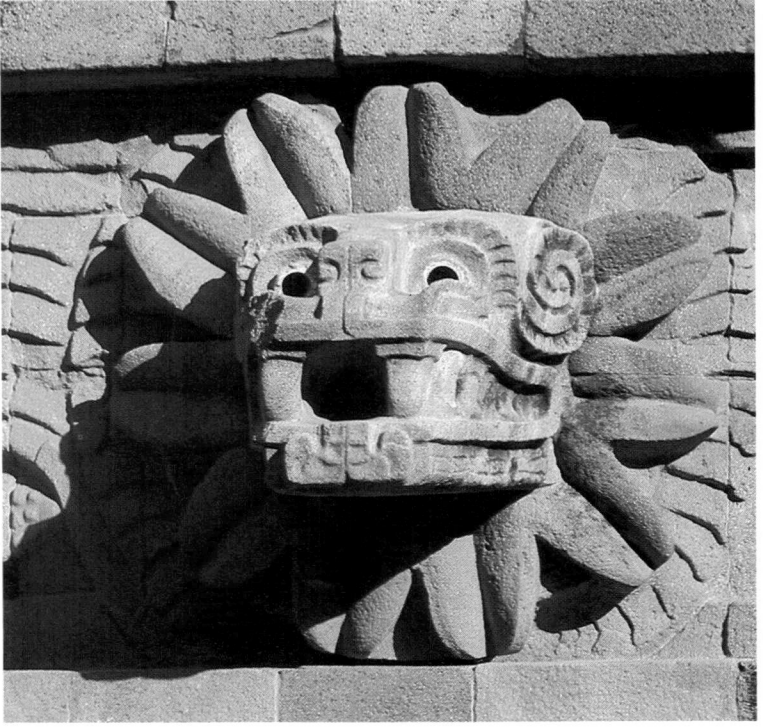

21

Counting the afore-mentioned heads lining the ramp, the total number of sacred effigies adorning the pyramid amounts to 366, a symbolic figure corresponding to the number of days in the solar year, allowing for the additional day eliminated by our Leap Year. What we have here, then, is obviously a form of symbolism based on the solar calendar. While on the subject of numerical symbols, it should be noted that the small, single-storeyed platform forming the central altar or temple of the Citadel comprises four axial stairs each of thirteen steps, making a total of fifty-two. Now, the figure 52 corresponded to a fifty-two-year cycle which was to the Pre-Columbians what the century is to us. Again, thirteen was the number of twenty-day months that went to make up the sacred year.

During the second phase of construction the west face of the magnificent pyramid supporting the Temple of Quetzalcóatl was given a four-storeyed avant-corps. As so often in the case of superimpositions, this overlaid and thus also preserved an architectural mosaic of great merit.

It should be added that archaeologists have also uncovered a number of domestic buildings on either side of the sanctuary. These were the palaces inhabited by the priests who served the temple.

The Houses of High Dignitaries

The palaces were built of stone unlike the huts of the rank and file. Architecturally they are markedly different from the platforms and pyramids discussed above. The solid mound here gives way to internal volumes in the exact sense. Hence an examination of these remains yields much invaluable information which helps us to understand not only the art of the builder but also the way of life of high dignitaries in Teotihuacán. Here we may see the development of forms around a courtyard—

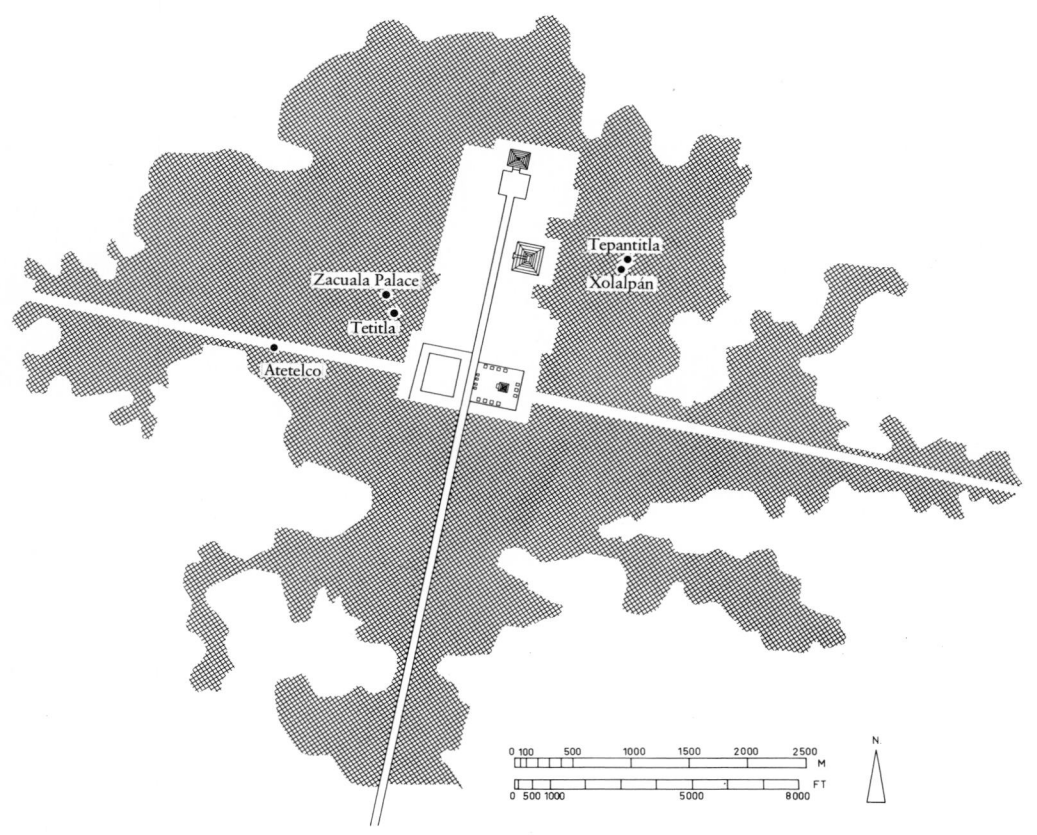

Plan of the Teotihuacán agglomeration at the time of its apogee, showing the position of the principal palaces mentioned.

Plan and section of Quetzalpápalotl
Palace at Teotihuacán.
1 Hypostyle vestibule
2 Courtyard flanked by galleries
3 Living quarters
4 A platform in the Moon Plaza

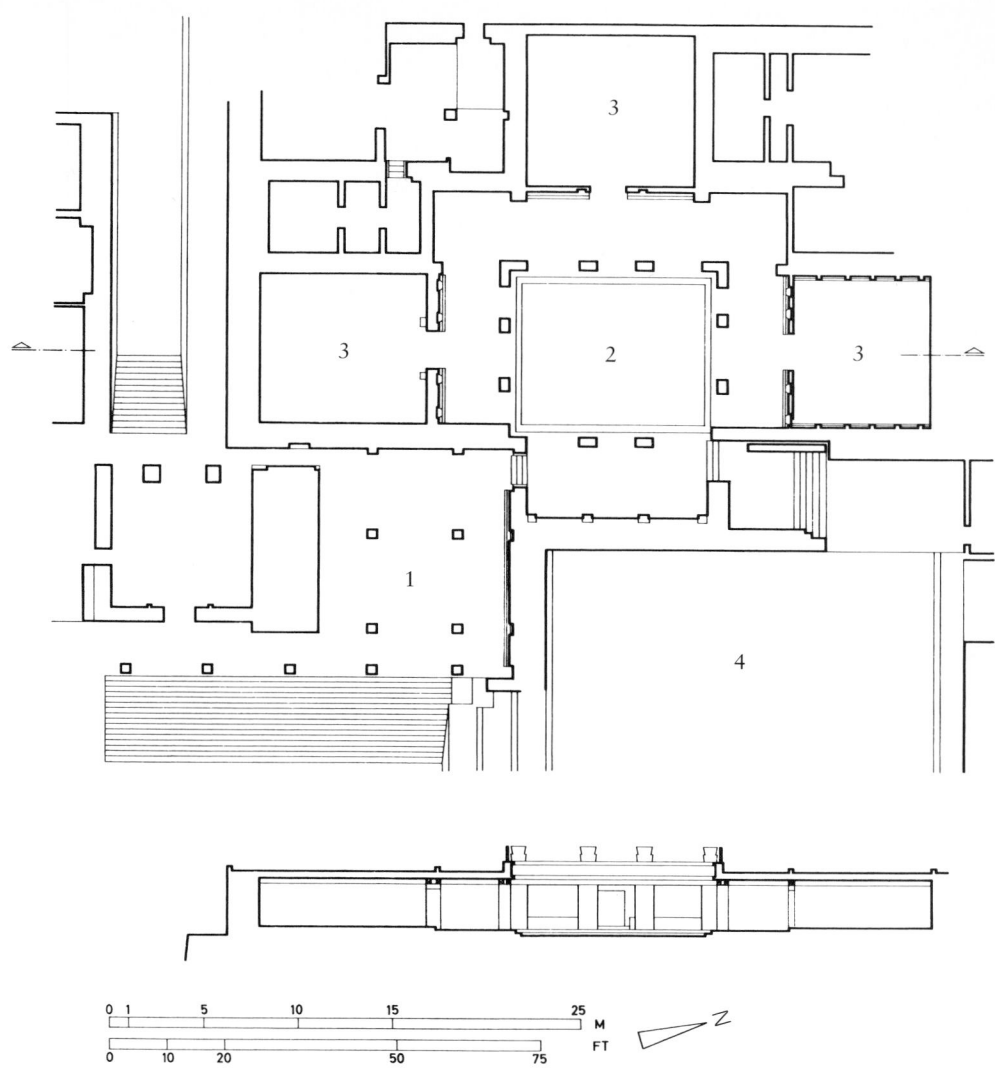

the portico, the living quarters, the public rooms and even the hypo-
styles in which the men of the Classic era spent their lives fifteen centu-
ries ago. Such, then, was the background to the existence of those who
held spiritual and temporal sway over a theocratic and agrarian empire.

First it should be stressed that Teotihuacán was a huge capital whose
suburbs extended far beyond the confines of the ceremonial centre. The
latter is 2.5 kilometres long and 600 metres wide, while the dwelling
houses are scattered about an area of over twenty square kilometres.
Comprised within that agglomeration are various palace complexes
such as those at Tetitla, Tepántitla, Atetelco and Xolapan. The most
important, however, is the Quetzalpápalotl complex for, unlike the oth-
ers which have merely been excavated and possess at most the lower
part of their walls, this palace has been reconstructed with remarkable
skill by Jorge R. Acosta. Its appearance, now that its piers and roofs
have been restored, enables us to imagine what life was like in these
residences occupied by high dignitaries (Pls. 22, 23).

The reconstruction of Quetzalpápalotl Palace formed part of the
important archaeological campaign of 1962–4, directed by Professor
Ignacio Bernal in the area of the Moon Plaza. The complex is situated
to the west of the latter and is exceptional in that it embodies the main
principles of secular architecture as applied in Teotihuacán during the
Classic era.

At the front of the building a wide stairway leads to an open hypo-
style, from the right of which access is gained to the quadrangle of the

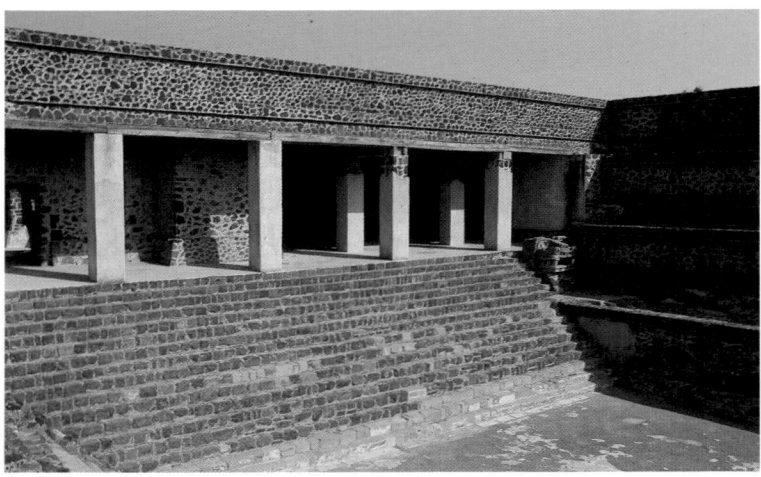

22

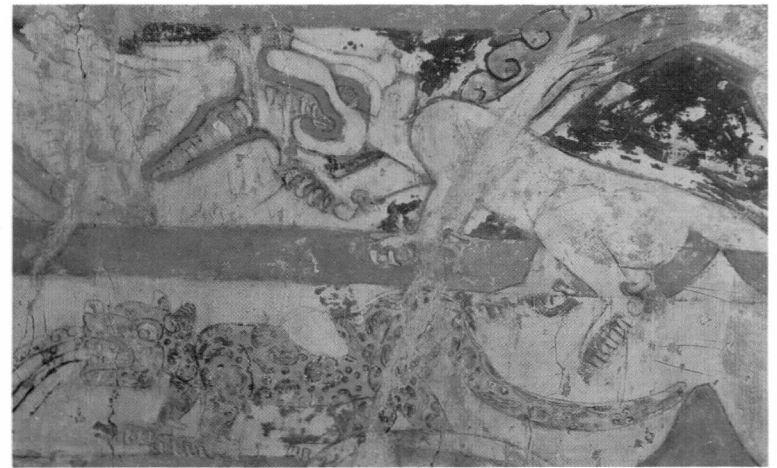

23

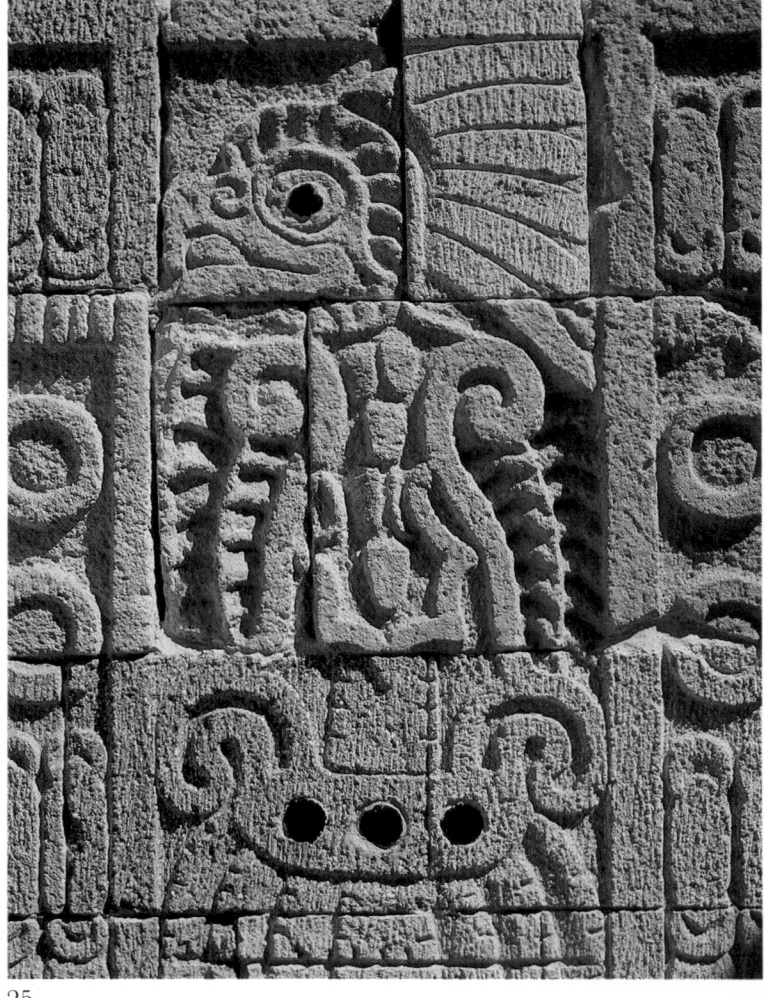

24

25

Stela known as La Ventilla: a goal-post used in the ball-game at Teotihuacán.

palace proper comprising a fine central courtyard surrounded by porticoes with square stone piers. These are covered with bas-reliefs showing the effigy of the quetzal bird—the eponym of the complex—either in profile or full-face with a pectoral in the form of a butterfly (Pl.25). Behind these piers runs a continuous covered gallery which gives access to three relatively dark rooms lit only by the wide entrance bays. Situated respectively on the west, south and north sides of the quadrangle, the rooms present a cruciform layout typical of pre-Columbian spatial organization, for it recurs not only in the Viking Group, but in the main courtyard at Tetitla and in the palace at Zacuala, to mention only local examples. On either side of the doors opening out of the gallery are benches decorated with frescoes on stucco, as are some of the interiors. In addition, the panels surmounting the porticoes are also painted in polychrome while above these again, silhouetted against the sky, are ornamental crenellations symbolizing the cycle of the planet Venus as the Morning Star.

Spatially, then, the house is centripetally disposed around the courtyard, its covered galleries affording protection from the elements. Life here would have been shut off from the outside world had not the broad portico fronting the hypostyle been open to the Moon Plaza.

The roofs of all these buildings were flat, consisting of beams embedded in cement with a waterproof rendering of stucco and, save where thatch was used, are typical of palace architecture throughout pre-Columbian Mexico.

The Avenue of the Dead and the Ball-Courts

As has already been seen, the ceremonial complex of Teotihuacán is defined by the straight causeway, 2 kilometres long, which traverses it from south to north and on to which are grafted at right angles the various components of the urban system. Now, the Avenue of the Dead consists of various sections terminated by flights of steps and forming as it were plazas which interrupt the vista. Some of these plazas, flanked on all four sides by panels or stairs, were undoubtedly ball-courts. Elsewhere we have mentioned that it was the Olmecs of La Venta and San Lorenzo who invented this ritual 'sport', played with a large rubber ball made from the latex obtained in the virgin forests of the lowlands. However, Teotihuacán does not possess a ball-court that is a recognizable and independent architectural entity, as found at the two large Olmec sites or the ritual centres in the Maya country. Nor do we find here the typical parallel slopes between which the contests took place. Yet some form of ball-game is known to have been played in Teotihuacán.

The archaeological evidence is of two kinds—firstly a fresco at Tepántitla which shows two seven-man teams confronting each other with curved bats and, secondly, a goal-post, recovered intact, which resembles those depicted in the fresco. This goal-post takes the form of a stela over 2 metres high. Known as La Ventilla, it is a remarkable sculpture consisting of superimposed stone elements—a disc, a sphere, a cone and a cylinder—fastened together by mortice joints. Now, fragments of similar posts have been uncovered in the Avenue of the Dead. Hence it may be surmised that some sections of this processional route were devoted to the game, in particular a portion south-west of the Pyramid of the

22 A remarkable reconstruction of palace architecture at Teotihuacán. Quetzalpápalotl Palace, with square piers lining an interior court. This is surrounded by a gallery giving access to chambers whose only light comes from the entrance doorways. The building dates from between 100 and 200 A.D.

23 From the Moon Plaza a wide stair leads to an open-fronted hypostyle giving access to Quetzalpápalotl Palace. The virtuosity of Teotihuacán's architectural vocabulary is apparent in these dwellings intended for high dignitaries.

24 Detail of fresco discovered near the Moon Plaza at Teotihuacán. Depicted here are several jaguars, with outsize fangs and claws, treated in an expressionist style.

25 Detail of a quetzal bird adorning the piers of Quetzalpápalotl Palace. An interesting feature is the use of obsidian elements, notably for the eye. Vertical hachuring denotes restoration work.

26

27

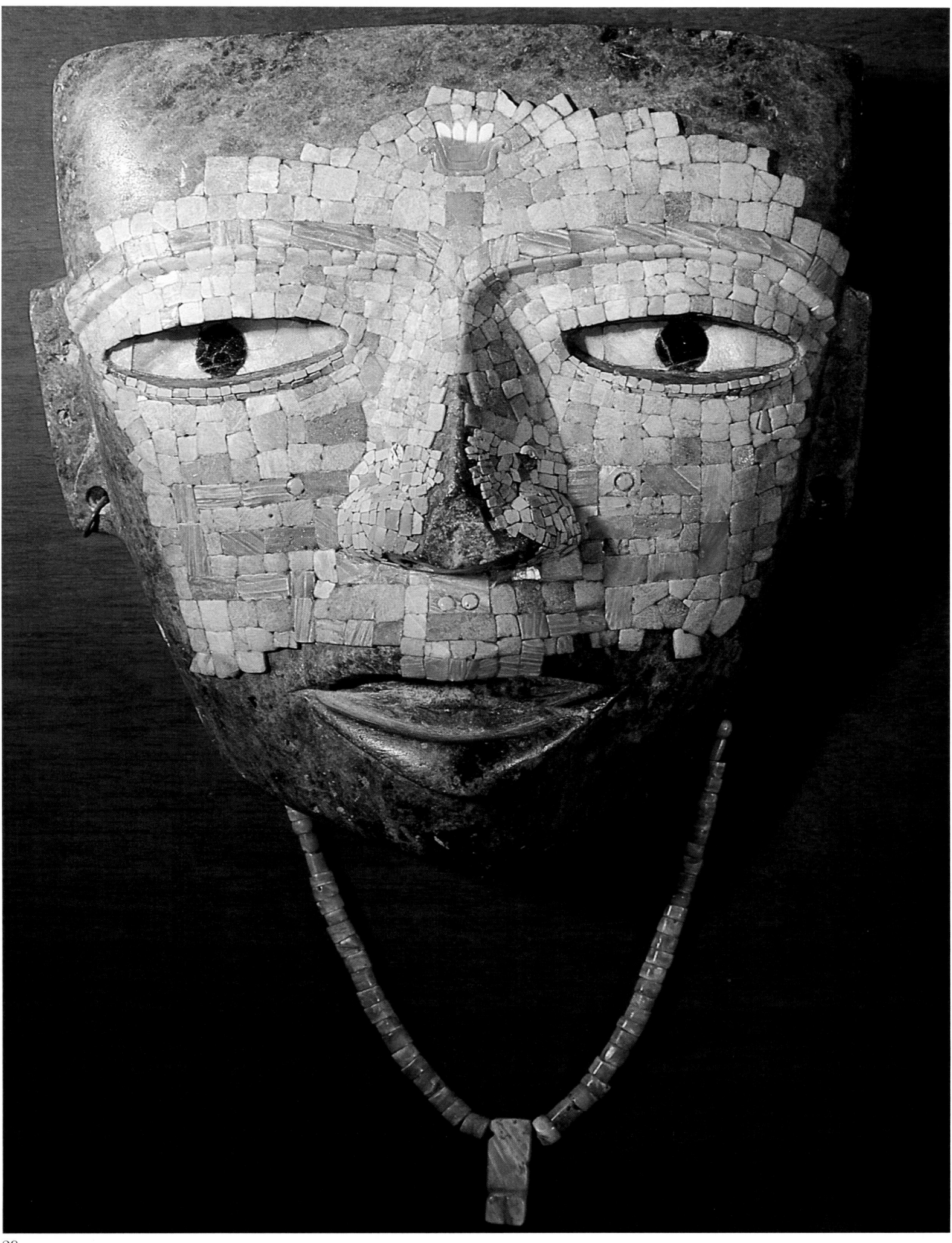

Sun. Measuring 40 metres by nearly 100 metres, this could readily have lent itself to the purpose, for it is comparable in size to the ball-courts at La Venta, or even to that built by the Maya–Toltecs in the eleventh century at Chichén Itzá.

There can be small doubt, therefore, that ball-courts existed at Teotihuacán. As will presently be seen, the ball-game was an essential element in any pre-Columbian city where it assumed a variety of forms, many of which were symbolically associated with the course of the sun.

The Steady Progress of Urban Planning

The Avenue of the Dead, which runs northward for 2 kilometres and ends at the foot of the Moon Pyramid, conforms to an orientation that deviates no more than 14° from the meridian. This axial arrangement governs the strictly orthogonal organization of the monuments in the ceremonial centre, the one, barely perceptible, exception being the Sun Pyramid. Here there is an axial deviation of 3° WNW and ESE, making a total of 17° when added to the above-mentioned variation of 14°, since it was intended that the main façade should directly face the sun on the days when it reaches its zenith. On the latitude of Teotihuacán, namely 19° 21′ N, or 4° 06′ south of the Tropic of Cancer, this happens twice a year, before and after the summer solstice.

However, the Avenue of the Dead is an axis in the symmetrical sense only when it debouches into the Moon Plaza. Until that point, it is, rather, a vector along which the main groups are distributed. What is most striking about this rectilinear lay-out is that, far from being based on a cut-and-dried formula, on restricted urban growth, on a finite plan, it is a dynamic system permitting of indefinite expansion on cross-axes whose ramifications extend ever further in a manner reminiscent of organic forms. This is particularly noticeable in the disposition of the peripheral platforms.

In this highly original lay-out we may therefore discern rules which might appear to contradict each other. The overall plan is not dependent on symmetrical organization—which at the very least would demand that the Sun Pyramid and the Citadel should be placed opposite each other on either side of the thoroughfare—yet symmetry is discernible everywhere in the internal arrangement of each individual structure within the ensemble. We would cite as examples the Moon Plaza, the Citadel and other complexes of lesser importance such as the Group of Columns. By observing the principle of rectilinearity and restricting the principle of symmetry to the constituent elements as elaborated by the architect and planner of Teotihuacán, it was possible, over the course of centuries, to enlarge the sacred city indefinitely, without its bursting its bounds. It was a form of urban planning whose fundamental principles also embraced the future.

The formula is a profoundly original one, adapted as it is to an open perspective which introduces the time-factor into planning. This spatio-temporal outlook is all the more surprising in that it emanated from a late Neolithic people and is virtually without parallel in the Old World. The cities both of Antiquity and of the Middle Ages were usually enclosed within the confines of a defensive wall or restricted by a short-term programme which did not admit of subsequent accretions.

26 Small polychrome terracotta mask from Teotihuacán. With its large ear discs and stylized butterfly emblem, it represents Xochipilli, the spring and flower god. This piece, 17 cm across, belongs to the Classic Teotihuacán III period. National Museum of Anthropology, Mexico City.

27 Mica mask from Cholula, in the Classic style of Teotihuacán, with features of great purity. The eyes are delicately outlined, the mouth wide and well defined and the nose unaggressive, while the stylized ears have been pierced. This piece is 23 cm wide. National Museum of Anthropology, Mexico City.

28 One of the finest masks of the Teotihuacán Classic period. Made of serpentine, it is enhanced with a mosaic of turquoise, mother of pearl and coral. The pupils of the eyes are of obsidian. Above the mouth is the Xochipilli butterfly motif (cf. Pl. 26). This fine piece, 24 cm high without the pendant, is said to have been discovered in a tomb in the State of Guerrero. National Museum of Anthropology, Mexico City.

Such was by no means the case at Teotihuacán where the rectilinear layout extends over the plain like a grid. But it is not a mere network, for it also possesses a dynamic quality, as conducive to growth as are the twigs of a branch or the veins of a leaf. This means that new focal points are constantly being generated to form what we might call satellite cities.

Thus the architect allowed future generations a measure of choice; they could add to their city when and where they liked, provided they adhered to the rules already laid down. This formula was a happy compromise between liberty and despotism and marked a new departure of a particularly bold kind. Moreover, pre-Columbian urban planning can help us to understand the mentality then prevalent and provides us with one of the most interesting examples of social psychology to be found in the world of art. That is why we deemed it pertinent to enlarge on these aspects of the 'place of the Gods'.

The Flowering of Classic Forms

Like its architects and town planners, Teotihuacán's sculptors elaborated a style easily recognizable, as is evident more notably in the treatment of the human face.

The works most typical of Teotihuacán are undoubtedly the stone masks, examples of which, however, had already been produced by the Olmecs. These masks were intended to cover the faces of the dead before cremation in order that their image might be perpetuated. The masks are free of the distortion and schematization often displayed by Olmec art which, however, they resemble in certain respects, for the Gulf people are known to have influenced the plastic development of pre-Classic art on the high plateaux, notably in the field of ceramics. And in the Classic sculptures of Teotihuacán we find the same predilection for hard, lovingly polished stone, the same concise vocabulary, the same consummate craftsmanship. The features of the funerary masks are strictly idealized and quite expressionless. The eyes, horizontal slits,

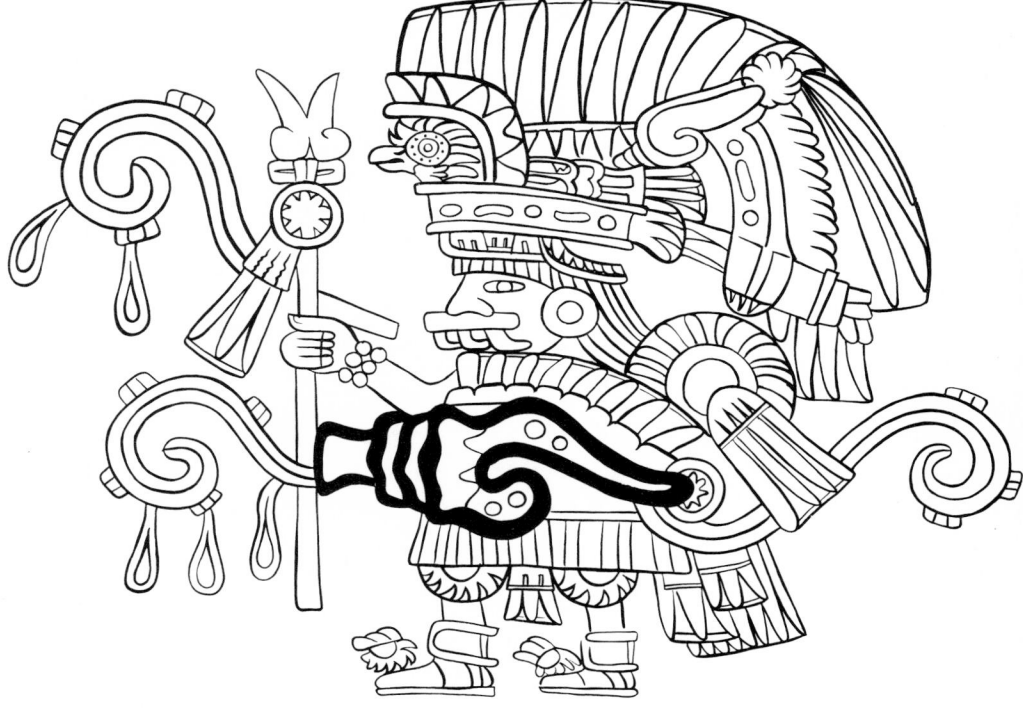

Drawing of a wall-painting of Teotihuacán from Atetelco: Quetzalcóatl, as god of the wind, is shown wearing his emblem, a section of a shell (after Laurette Séjourné).

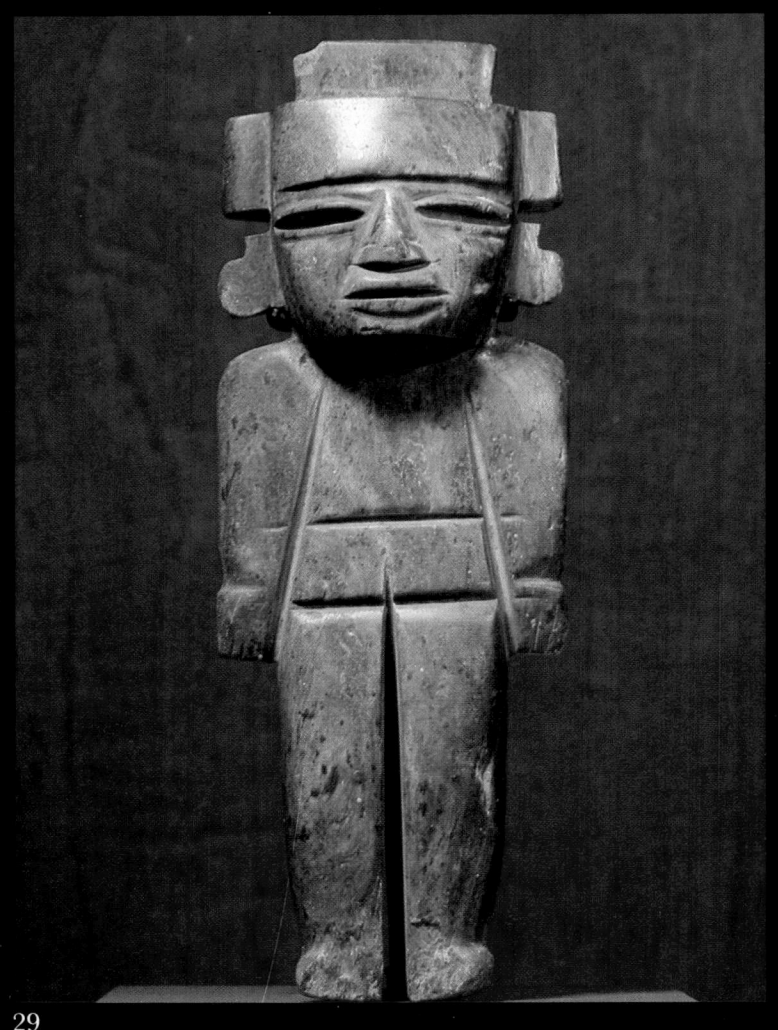

29

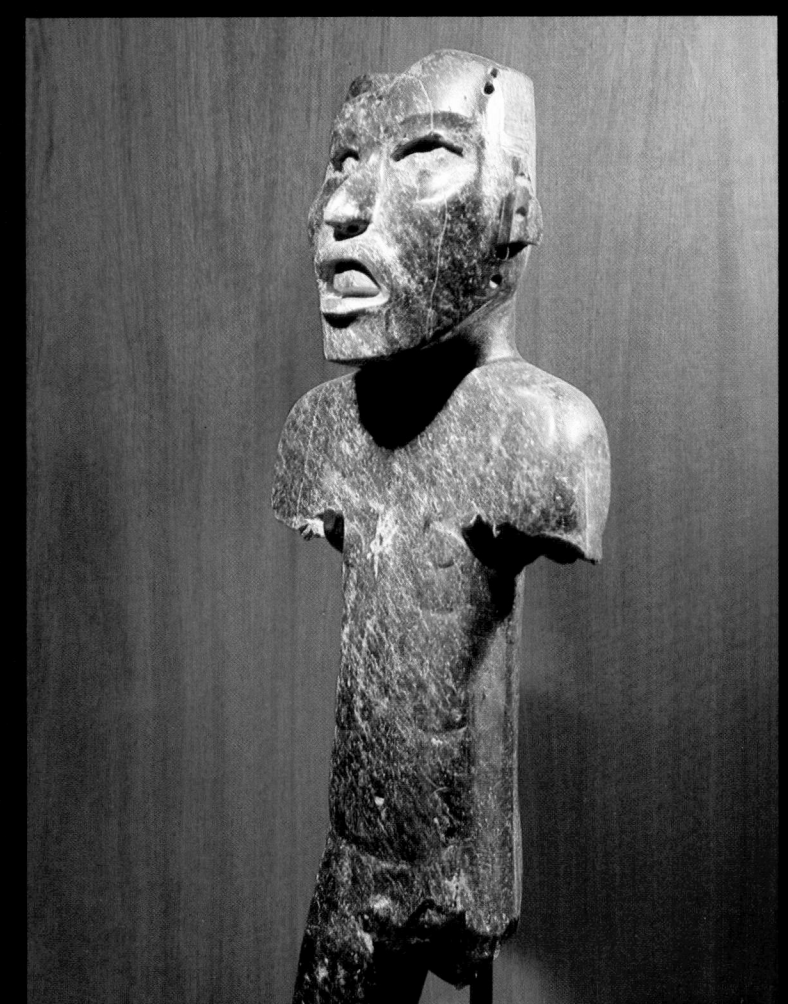

30

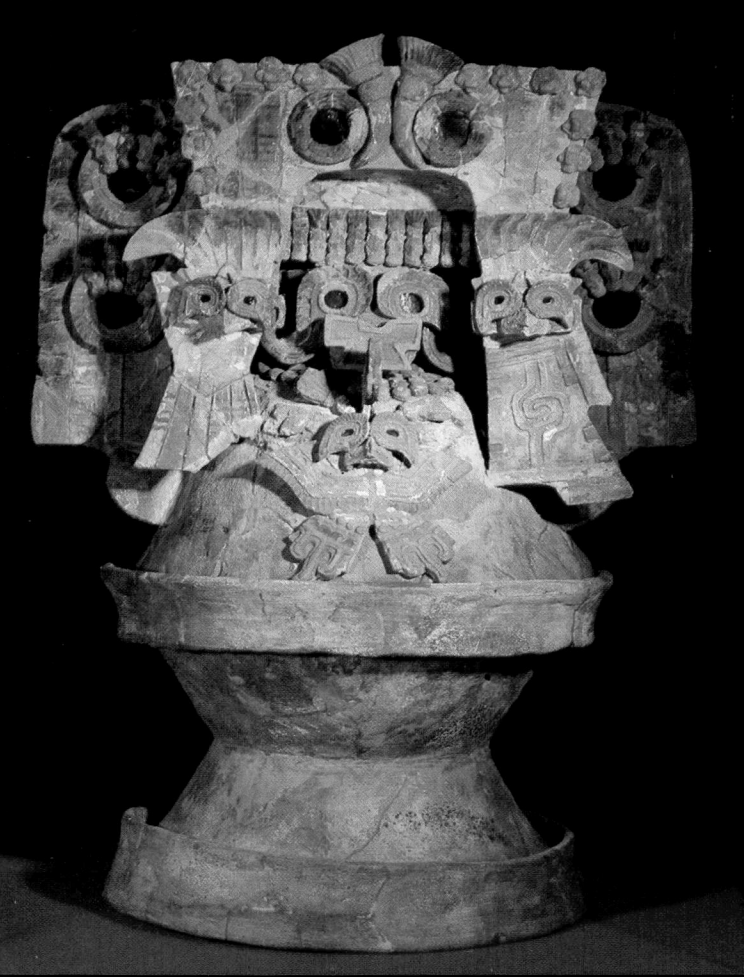

31

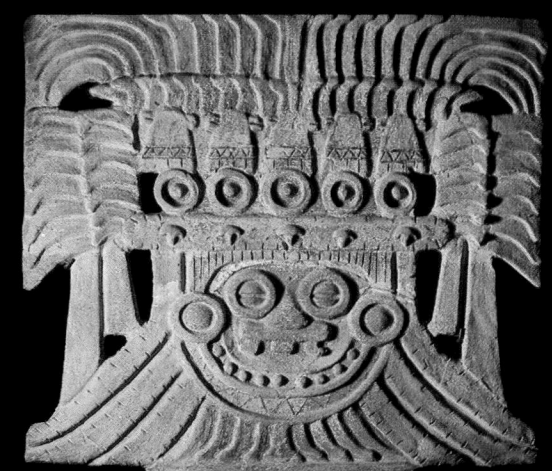

32

33

look out from beneath understated brow ridges. The nose is delicate, straight and not very prominent. The well-defined mouth does not droop at the corners as does that of the jaguar worshipped by the Olmecs. Ears are small and stylized. This is truly a Classic art—economical, sober, and shunning, not only the exaggerations of an expressionism verging on caricature, but also the niceties of an insipid naturalism. Nobility, serenity, timelessness and impassivity, such are its aims. It is an aristocratic art in which forms are often simplified and purified, betraying the structural rigour of a canon governed by laws (Pls. 26–8).

In the monumental sculpture devoted to the gods these tendencies led to abstract schematization so that its forms assumed a geometrical structure, as, for instance, in the images of Tlaloc in the Temple of Quetzalcóatl. The abstract nature of the representational modes resulted in what can only be called graphic symbols that are replete with significance for those who beheld them. In this sense it was the expression of a sacerdotal body, the reflection of a caste of learned clerics concerned with elaborating the concepts of a pantheon in which the forces of the universe are personified.

It is in the frescoes adorning the palaces that the art of Teotihuacán displays to the full its graphic sense and its powers of expression. Unfortunately few of the paintings that have been uncovered are in a perfect state of preservation. Nevertheless, they reveal a profound feeling for simplicity of line, and a predilection for flat tints and clearly defined silhouettes. Yet it is an art so encumbered with mythical beings and symbolic forms that it has become a kind of holy writ. Its numerous components are often baffling in their complexity. The various personages of the Classic pantheon, with their strange head-dresses, their opulent clothing, and their emblematic accessories, seem to convey a message which only a long period of initiation would enable us to read—as is also the case with some Egyptian deities in whom human and zoomorphic features are combined. Indeed a whole world of meaning, allusion and connotation, now largely lost, must once have rendered these mythical representations comprehensible (Pl. 24).

In the field of ceramics (to whose Classic manifestations we shall devote less space than to the earliest period when pottery is our only source of artistic information), we may discern the same Classicism as in sculpture. The profile of the pieces is for the most part very sober, while their decoration consists simply in key-fret or geometrical motifs and stylized figures (Pl. 33). Particularly characteristic of Teotihuacán are the tripod vases, cylindrical in shape and often provided with a lid; these lent themselves to all-round decoration, whether painted in rich polychrome or whether in the form of incised or moulded bas-relief. They may represent priests, deities or mythical animals, and would seem to have been used for ritual purposes.

Also worthy of note are the 'set pieces', as the incense-burners might be described. Above a base in the shape of an inverted vase is a brazier in which copal is burnt and which is in its turn surmounted by a construction made up of polychrome terracotta elements. This very fragile piece represents the richly decorated door of a temple inside which we may see the effigy of a god. Its rôle was that of a household altar, a type found throughout the whole period of Teotihuacán's civilization. It owes its baroque appearance to the crowding together of sacred elements so as to include as many beneficent and tutelary powers as possible (Pl. 31).

29 Jadeite statuette from Teotihuacán. This Classic piece, 17.5 cm high, displays rectilinear incisions which recall the style of certain works from Guerrero. National Museum of Anthropology, Mexico City.

30 Anthropomorphic diorite statue of the Classic period, in which the Teotihuacán style seems to comprise Olmec reminiscences, notably in the downturned mouth and protuberant lips. This piece, 56 cm high, must originally have possessed a head-dress and ear-rings. National Museum of Anthropology, Mexico City.

31 Polychrome terracotta incense-burner from La Ventilla, near Teotihuacán. This large piece, a domestic altar producing incense from copal, is an effigy of the quetzal bird. The central portion represents a symbolic temple in which the god Xochipilli is discernible. Height 75 cm. National Museum of Anthropology, Mexico City.

32 Decorative terracotta crenellation which must once have crowned the roof of a building in Teotihuacán. It portrays an effigy of the rain god, Tlaloc, wearing a head-dress of quetzal plumes and is approx. 50 cm high. National Museum of Anthropology, Mexico City.

33 Ceramic vessel from Teotihuacán. With its key-fret decoration, this very sober piece bears witness to the economy of forms and ornamentation in the early Classic era. Diameter 17 cm. National Museum of Anthropology, Mexico City.

The Chronology of Teotihuacán

Teotihuacán's great civilization, whose influence spread well beyond the confines of the high plateaux—extending, as we have previously mentioned, as far as the Petén lowlands in the heart of the Maya country—was the melting-pot of pre-Columbian art in Mexico. It was also the progenitor both of the repertory of forms out of which the arts of later periods were to develop, and of the pantheon of the Mexican religions.

Nevertheless we know very little about it, despite fruitful archaeological excavations which have resulted in the discovery of countless documents and many imposing buildings. In fact, we do not know to what the diffusion of objects from Teotihuacán must be attributed—whether to an expansionist policy, to military expeditions, to commercial exchanges or, in the case of religious symbols, to priestly proselytizing.

Neither do we know what was the type of socio-political organization of the city or of the state it presupposes; for life in a metropolis such as this would not have been possible unless the latter had been surrounded by extensive possessions and probably also by tributaries. Again, we must assume the existence of a caste of high dignitaries in which all temporal and spiritual powers were vested.

The only inference to be drawn from the complete absence of fortifications and the very rare occurrence of warlike elements in the images that have come down to us, is the stability of a world sufficiently secure and enduring for a civilization such as this to flourish.

For the history of Teotihuacán spans more than a millennium. While archaeology has revealed its most prominent milestones, there is nevertheless a marked lack of consensus between different schools of thought. Thus, specialists assign dates to periods which are often difficult to reconcile one with the other, or as between one author and another. We have here sought to produce a synthesis based on the most recent archaeological works, radiocarbon (C14) datings and the connections between the various Classic civilizations of Mesoamerica. At the same time we are perfectly aware that this synthesis may yet have to be amended within the major phases which it has been possible to date. The evolution of the 'place of the Gods' may be set out schematically as follows:

Phase I. The Upper pre-Classic era, about 500 B.C., marks the stylistic transition from the pottery of Tlatilco–Copilco to the early products of Teotihuacán. What had been a settlement in the middle of the fertile plain, surrounded by hills and volcanic cones, soon grew into an agglomeration with a sizeable population. By the third century Teotihuacán can safely be said to have become a city in the true sense of the term.

Phase IA. In about 200 B.C. work began on the building of the Sun Pyramid in its original form, ritual complexes being subsequently added. The size of the edifice suggests that Teotihuacán was becoming a place of pilgrimage and a focal point for the inhabitants of the high plateaux.

Phase II. Teotihuacán's Classic era began properly speaking in 150 B.C. and it was then that the city's grandiose expansion began. The Avenue of the Dead, whose northern end terminates at the Moon Pyramid, dates from this period, as does the tablero motif which was to dominate the architecture of the entire site. Work also began on the building of the Citadel.

Phase II A. Beginning in about 50 B.C., this stage marks the flowering of religious architecture as exemplified by the building of the Temple of Quetzalcóatl whose sumptuous decoration testifies to the mastery of Teotihuacán's artists.

Phase III. In about 100 A.D. the great Classic capital reached its apogee, boasting a population of a hundred thousand and, with its suburbs, covering a total area of some 30 square kilometres. Innumerable secondary sanctuaries were built within its confines, as well as opulent palaces for high dignitaries.

Phase III A. While the period was still one of high culture and refined development, it would seem to have been preceded, perhaps in 200 A.D., by a state of emergency resulting from an unsuccessful assault upon the capital by nomadic peoples from the north. In about 250 work was completed on the sumptuous Palace of Quetzalpápalotl. This glorious phase was brought to an abrupt end by a catastrophe which struck the ceremonial centre in about 400 or 420, when the city was sacked by nomadic bands who, before withdrawing, burnt down the temples, profaned the sanctuaries and reduced the palaces to ashes. Part of the surviving population then set out towards the south-west and, after a journey of 1,500 kilometres, reached Kaminaljuyú, near what is now Guatemala City, to found, as it were, a second Teotihuacán.

Phase IV. After the catastrophe the city was partially rebuilt by those who had remained among its ruins, and Teotihuacán again experienced a measure of prosperity. It was, however, finally abandoned in about 650 A.D. after an onslaught by a fresh wave of invaders to which other towns on the high plateaux also succumbed. This new disaster proved fatal to the Classic civilizations as a whole. The entire country entered a period of transition, possibly of several decades, that was characterized by population movements and a complete reshuffling of the cards following the dissolution of centralized government in favour of a kind of 'feudal system'. On the high plateaux a number of new cultures came into being, as is borne out by the emergence of a variety of what were generally more or less localized styles. This in turn suggests that the former 'empire' of Teotihuacán had been partitioned amongst provincial rulers.

Such, in brief outline, is the history of the most advanced civilization of Central Mexico which, like a beacon, sheds its light over the whole Classic era in the pre-Columbian world.

III. From Xochicalco to the Toltecs

Teotihuacán was a vast city standing in the plains. Because it was not encircled by walls, it could expand as far as its development required. But it was also an open city, vulnerable to surprise attack, and the barbarian assault upon the great religious capital marked, not only the end of an era, but the shattering of the proud belief in the power of a metropolis apparently immune to all danger. Henceforward the inhabitants would have to reckon with the possibility of another such visitation, for the north was an inexhaustible reservoir of migrant populations.

After the collapse of the 'place of the Gods', culture was confined to fortified towns built on hill tops—veritable eyries strong enough to withstand the raids of the nomads who thenceforward were to prowl round the settlements, posing a constant threat to farmers and town-dwellers whose food stocks and wealth they coveted.

In certain respects the situation was similar to that obtaining in the Old World at the time of the fall of the Roman Empire. At about this period, Classical Rome and Classic Teotihuacán, the two leading cities—one of the Mediterranean world, the other of pre-Columbian civilization in the northern hemisphere—were first shaken and then destroyed by the onslaughts of peoples from the steppes. Even in China events were taking a similar turn, with the capture of Lo-yang by the Huns, and the ensuing irruption of Turco-Mongol hordes into the Celestial Empire.

Indeed these parallels are illuminating in that they reveal not only an identical pattern of barbarian invasion throughout all the regions of high civilization, but also a degree of synchronicity. Lo-yang fell in 311, Rome in 410 and Teotihuacán in 420. These three events were followed by a period of instability lasting two or three centuries.

This sudden incursion by nomadic peoples would seem to have been due to profound changes in their traditional environment, probably following periods of drought, not only in the steppes, but in other parts of the world. Impelled by such occurrences, whose far-reaching implications may currently be observed in the Sahel, the affected tribes sought to save themselves from extinction by raiding the food stores of sedentary communities.

Whatever the case, the legacy of Teotihuacán owes its survival—and transformation—to cities built on escarpments and therefore easily defensible. The names of these strongholds are Xochicalco (Morelos), Cacaxtla (Tlaxcala) and Teotenango (near Toluca in the State of Mexico). All three dominated rich plains where farmers tilled the land but could take refuge in the acropolis at the first sign of danger.

Like the castles and monasteries of medieval Europe, these cities fostered artistic endeavour and the pursuit of learning. They also witnessed the transformation of religion and the pantheon under the impulse of new currents—the emergence, in fact, of a new type of civilization as a result of demographic redistribution and reciprocal contacts and influences that embraced all the pre-Columbian peoples of Mexico. For the great upheaval caused by the invasions did at least possess the merit of tightening the links between the old civilized nations. It was almost as if the latter were seeking to pool their patrimony so that as much of it as possible might be preserved. Here again we see how richly significant is the notion of a legacy shared in common by the Pre-Columbians. In adversity these peoples, while not altogether abjuring war, discovered bonds that helped to unite them.

Although traditions and cultural currents intermingled, there is no denying that this multiform heritage also went through an inward-looking, particularist phase, since during this transitional period none of the cultures, however brilliant, succeeded in gaining the upper hand. Mexico now experienced a kind of Middle Ages, with fragmentation of power, lack of social organization and a decline in political centralization. Not until the accession of the Toltecs of Tula did a measure of unity return to the Mexican world, but that was not until the ninth century. Thus the cohesion of the peoples of the Altiplano was not restored until two centuries after the final collapse of Teotihuacán—or four centuries after the initial blow had been struck.

The period that intervened between the destruction of Teotihuacán and the rise of Tula is sometimes called 'Epiclassic'. It was a period of rich and varied artistic achievement, though not necessarily grandiose in scale, and is characterized by a remarkable feeling for quality.

The Acropolis of Xochicalco

This archaeological site, some forty kilometres south of Cuernavaca, dominates a plain which lies at an altitude of 1,500 metres and hence is lower than the Altiplano proper. In Náhuatl, the language of the Aztecs, the name Xochicalco means 'house of flowers'. It is an acropolis standing 130 metres above the surrounding plain and measuring 1,200 metres from north to south and 700 metres from east to west.

Its plan is of a type wholly different from that of Teotihuacán but which, as will be seen, bears certain similitaries to the great Classic capital. It is a ritual centre enclosed within walls and protected by ditches and glacis. From its elevated position it kept watch over the plain and thus provided a safe refuge for the latter's inhabitants at the first sign of danger. The city exploits to the full the highly irregular contours, broken by deep, precipitous gullies, of the eminence on which it stands. A comprehensive system of terraces and retaining walls was employed to transform this rugged terrain and impress upon it the largely orthogonal design which governs the disposition of the ensemble. This arduous task was tantamount to sculpting the mountainside in order to humanize its forms, and it is hard to imagine how these men, who possessed neither wheeled vehicles nor explosives, could thus mould the landscape solely with the aid of rudimentary tools.

The composition, which is wholly asymmetrical, is arranged about a north-south axis. That asymmetry is not dictated solely by the geographic configuration of the site; rather it is deliberately emphasized by the disposition of the buildings. Indeed, on the esplanade or Upper Plaza, measuring some 150 by 100 metres, the buildings might easily have been arranged in a strictly symmetrical manner but instead each is so disposed as to relate freely to the others as if in a grid.

It should be noted that the entire northern part of the city lies on an axis that deviates some 3° from that of the southern part, the latter being directly orientated upon the cardinal points. This slight variation, which corresponds to the axial deviation of the Sun Pyramid relative to the Avenue of the Dead at Teotihuacán, is discernible in the two groups of ceremonial buildings of which the Lower Plaza forms the pivot; to the north of it lies the Upper Plaza and the Pyramid of the Feathered Serpent, while the paved causeway begins on its south side. The above variation would seem to suggest that in this, as in certain other respects, Xochicalco was the heir of Teotihuacán.

The Temple of Quetzalcóatl or Pyramid of the Feathered Serpent at Xochicalco is a structure of modest proportions, measuring 21 by 18.6 metres. It consists of a platform with a high talus surmounted by a panel somewhat narrower than the tableros at Teotihuacán. However the basic principle is the same save that here we find an edifice wholly revetted with large blocks incorporating superb, deeply cut reliefs. On each face the theme is the same, namely two feathered serpents whose undulations cover the entire surface of the talus. Their tails join at the centre of the composition while their heads, which occupy the corners, return to face their bodies in a movement of great elegance. Protruding from the open mouths is a menacing forked tongue. Numerical signs and the figures of priests sitting cross-legged occupy the spaces between the coils. The priests, with their head-dresses of trailing quetzal feathers, are frontally posed, the head alone being in profile in accordance with a visual convention often found in Maya art. The numerical signs are hieroglyphs deriving both from the Mayas and from the Monte Albán culture (Pls. 34, 35, 37).

An axial stairway ascends the west face of the platform and leads to a temple of which nothing remains save the lower part of the sloping walls. Beyond its triple entrance there was once an inner sanctum with a timber roof carried on four no longer extant pillars. This square internal space, with a floor area of some 120 square metres, prefigures the Toltec structures at Tula.

The edifice may possibly have commemorated both the renewal of a calendrical cycle and the co-ordination of the Altiplano method of computation with those of Monte Albán, the Mayas, and even, perhaps, El Tajín in Veracruz.

To the south of the Pyramid of the Feathered Serpent, the archaeologist Cesar Saenz has discovered the substructure of the Temple of the Stelae. Here we no longer have an architecture revetted with large sculptured slabs, but a less elaborate form of construction built of cut stone blocks, as are all the other buildings of the city. The edifice is preceded over the whole of its width by a grand stair. It owes its name to three extremely fine sculptured stelae, covered with inscriptions of the utmost interest. The slabs were found in a ditch where they had been placed after being carefully cut in two so as not to damage the hieroglyphic signs (Pl. 38).

34 Pyramid of the Feathered Serpent, or Temple of Quetzalcóatl at Xochicalco (Morelos), characterized by splendid bas-reliefs carved on large slabs. The principle of the talus-tablero is borrowed from Teotihuacán but here the proportions are different. The building probably belongs to the seventh or eighth century A.D.

35 A wide axial stair leads to the Temple of Quetzalcóatl at Xochicalco. The lower part of its battered walls has survived. The internal area of this structure, of which the roof was once supported by four piers, is 120 sq. m.

36 View of Structure D at Xochicalco, showing a platform surmounted by a cella comprising a vestibule with a triple entrance and an inner sanctum with only one door. The whole is built of large undressed stones.

37 Detail of decoration, Pyramid of the Feathered Serpent, Xochicalco. Maya influence is discernible in this priest, with his opulent head-dress of quetzal feathers, sitting cross-legged amidst the serpent's coils.

34

35

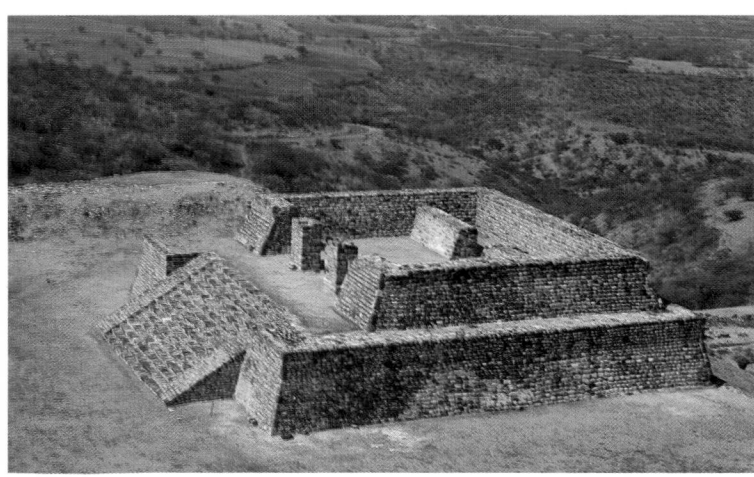

36

37

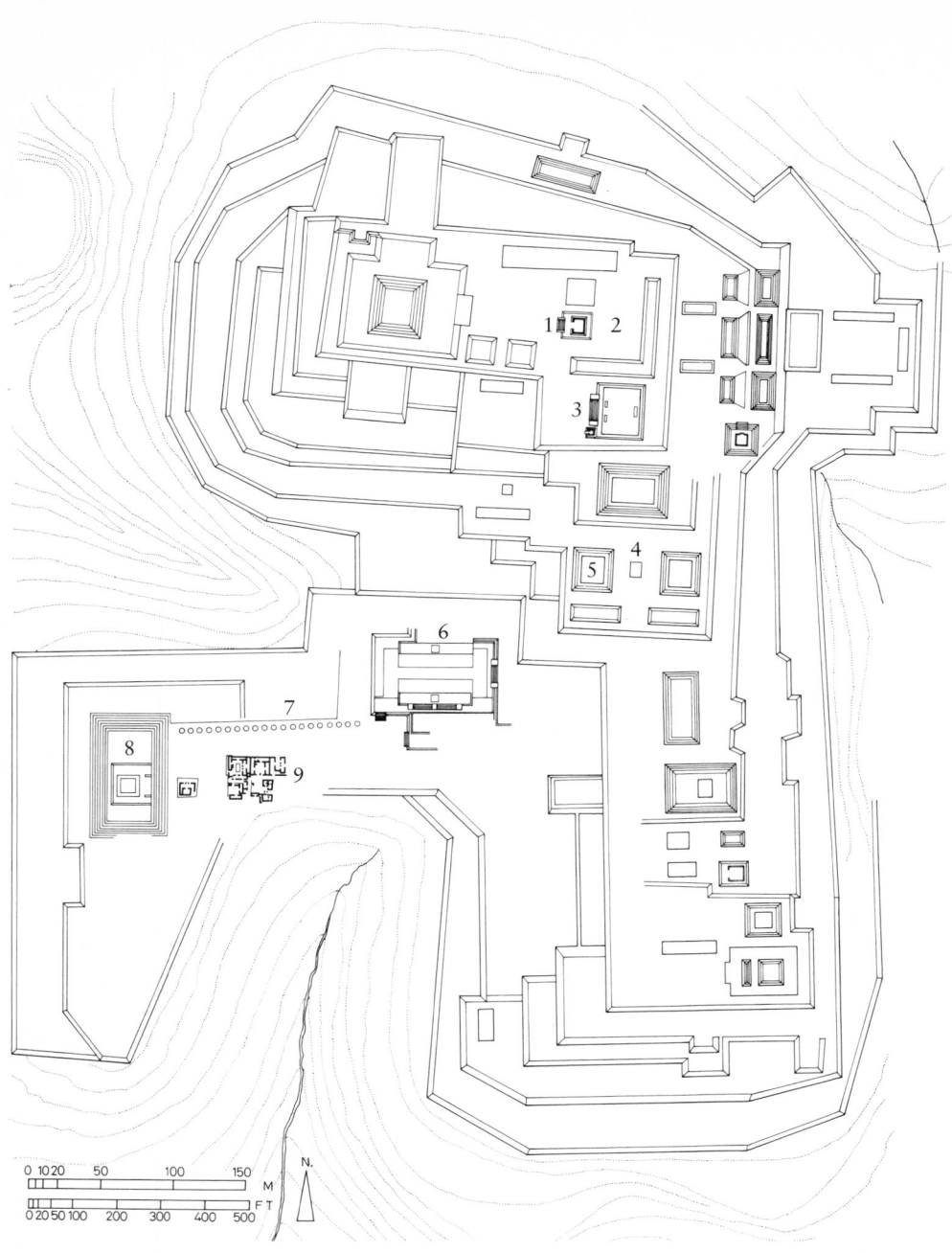

Plan of the Acropolis at Xochicalco.
1 Feathered Serpent Pyramid
2 Upper Plaza
3 Temple of the Stelae
4 Lower Plaza
5 Structure D
6 Great ball-court
7 Avenue of the Altars
8 Malinche Pyramid
9 Palace Quarter

As a form the stela—a tall and usually decorated monolith—originated in the Maya country, notably Copán and Quiriguá where the finest examples are to be found. They are commemorative monuments which, in many cases, reflect chronological and astronomical preoccupations. The theme of each of the three stelae at Xochicalco reveals a common function. The inscription on the first of these parallelipipedal blocks, one and a half metres high, concerns the cycle of the apparent revolution of the planet Venus, estimated by the Pre-Columbians at 584 days. The planet is shown, now as the Evening Star descending towards the world of the dead, now as the Morning Star, personified in the Toltec god Tlahuizcalpantecuhtli, as it emerges from the jaws of the primordial monster (of Olmec origin) which represents the underworld. At the centre of the second stela is the image of Tlaloc, god of rain and fertility, while the third shows Quetzalcóatl being sacrificed at Teotihuacán in order to create the fifth sun of the new era. These stelae, therefore, are the expression of the religio-cosmological preoccupations of agrarian civilizations. Indeed, like the inscriptions on the Pyramid of the Feathered Serpent, they combine the numerical signs of Monte Albán with the form of numeration used on the Altiplano and later adopted by the Aztecs.

The science underlying this concern with astronomy evinced by the inscriptions on the stelae was not, however, solely an import, for the city possesses underground chambers or grottoes from which the priests would appear to have observed the stars. Thus their knowledge was founded on original studies and was not confined to the skilled compilation of borrowed material.

The most elaborate element in terms of urban planning, and of the organization of masses in particular, is the complex of the Lower Plaza, forming a pivot between the northern zone (with its Upper Plaza) and the southern zone which is on axis with the paved causeway. The Lower Plaza is the result of an ingenious arrangement. At the back of the terrace stands the pyramid which is the key to the whole composition. It dominates the lower esplanade and comprises a wide axial stairway. An altar on a square plan, known as the Stela of the Glyphs, occupies the centre of the plaza, between two subsidiary sanctuaries facing each other on an east-west axis. These are Structures C and D, each standing on a platform and having a triple entrance leading to a vestibule from which a single doorway gives access to the inner sanctum. As in the case of the Pyramid of the Feathered Serpent, these sanctuaries are now roofless, all that remains of them being the lower part of the sloping walls surrounding the temple (Pl. 36).

This symmetrical and centralized organization, with the three flights of stairs flanking the altar, constitutes an advanced form of urban planning, as does the skilful exploitation of levelling and terracing. Indeed the Pre-Columbians were often past masters in the handling of space and evidently possessed a strong feeling for plasticity.

A little beneath and to the west of the Lower Plaza is the ball-court. It lies on a shoulder between the Plaza and the Cerro de Malinche with its crowning pyramid—the two zones being linked by a paved causeway lined with some twenty stone monoliths known as 'altars'. The court is 69 metres long and is laid out on a depressed H plan typical of those in the Maya country. In this respect it resembles the courts at Copán or Uxmal, and also Monte Albán. Its gently sloping sides are flanked by vertical walls in each of which a beautiful monolithic ring is fastened, halfway between the two ends of the court. These two rings are the goals through which the rubber ball had to pass in the Xochicalco version of the game which differed from that played at Teotihuacán.

Here we have another very clear instance of the influence of Maya art and architecture, further evidence of which was provided by the discovery in Xochicalco of a superb sculptured macaw (quacamaya) stylized almost to the point of abstraction and astonishingly modern in appearance (Pl. 39). Now, similar sculptured macaws are also found at Copán where they mark the boundaries of the ball-court.

Also discernible, however, is the influence of Veracruz, for in Xochicalco a fine stone yoke has been found, similar to those produced by the Tajín culture. These sculptures are closely linked with the ball-game, one of whose accessories they appear to symbolize.

At the foot of the Pyramid of La Malinche not far from the ball-court are the remains of a palace. This consisted of a labyrinth of rooms laid out on a chess-board pattern on a steepish slope to the south of the complex, no doubt with a view to making the most of the sun and of the winds which, according to season, swept up through the town and to improving the conditions of the people who lived in them.

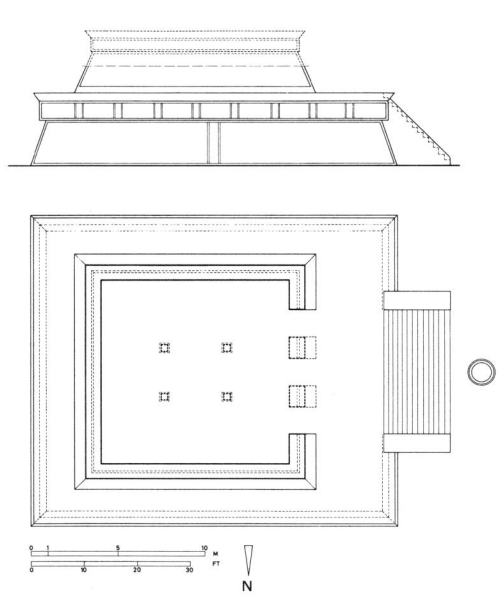

Side elevation and plan of the Feathered Serpent Pyramid at Xochicalco. The dotted lines in the elevation indicate the parts of the original sanctuary that have been restored.

38

39

40

41

Thus in every sphere, be it urban planning, architecture, sculpture, stelae, inscriptions, or the ball-court so typical of the pre-Columbian peoples, we find evidence of close contacts between Xochicalco and its neighbours, both near and far—Teotihuacán (whose heritage lived on), Monte Albán, the Maya region and the Gulf. Neither a highland nor a lowland city, it was predestined to become as it were an entrepôt of ideas, knowledge and techniques and to give expression to what we can only call cultural syncretism. But whereas twenty years ago Xochicalco was believed to be the only city to have played that particular rôle, we now know that, in the turbulent period following the invasions, other places were also instrumental in preserving traditions and engendering new trends. One such was Cacaxtla.

The Cacaxtla Paintings

The discovery of paintings at Cacaxtla near Cholula in 1975 was quite fortuitous. The terraced site on a hill some 40 kilometres from Tlaxcala and the same distance from Cholula would seem to have been inhabited as long ago as the second millennium B.C. Most of the early structures date back to the Classic period between 300 B.C. and 100 A.D. With the rise of Cholula, a strong religious metropolis down in the plains, the city entered into a decline, nor did it regain its importance until after the invasions, when places more readily defensible than large open towns became in their turn centres of civilization.

The building of defensive works with glacis and surrounding wall dates back to this time. These fortifications enabled the city to escape constant harassment by raiders, so that a refined form of art could flourish unchecked. The digging of ditches afforded even greater security and marked a renewal of architectural activity, when palaces were built at the top of the esplanade from which the distant white cone of Popacatépetl could be seen beyond the intervening expanse of fertile plain.

This renascence, which occurred in the seventh and eighth centuries, was thus contemporaneous with the rise of Xochicalco. It is attributable to a new people, the Olmec–Xicalanca, who seized Cholula in the course of the same upheavals as those that had led to the fall of Teotihuacán. It should be noted here that these Olmecs should not be confused with the early progenitors of pre-Columbian civilization. Rather, they were tribes of Maya origin and came from the Gulf Coast, as various aspects of the newly discovered frescoes would seem to suggest.

These frescoes consist in the main of two groups. The earliest are found on the sloping substructure of Edifice B at Cacaxtla, a building probably intended to be a palace. They depict an extensive battle scene in which the two opposing tribes are distinguished not only by the colour of their skin, but also by their garb and ornaments. Treated in very animated style, the frescoes eschew neither the pathetic gesture nor the inextricable disorder of a battle at its height. They form a pendant to those discovered in 1946 at Bonampak in the Maya country, 500 kilometres away as the crow flies, which, while more or less contemporary, cannot be said with any precision to be either earlier or later. The Cacaxtla battle scenes demonstrate that art was no longer exclusively the province of religion, for it now assigned a position of importance to sec-

38 Stela 3 from Xochicalco represents the sacrifice of Quetzalcóatl at Teotihuacán in order to create the Fifth Sun and usher in the new era. The god emerges from the jaws of the Feathered Serpent. Height 1.5 m. National Museum of Anthropology, Mexico City.

39 Sculpture from Xochicalco depicting the stylized head of a *quacamaya* or macaw. Discovered amongst the ruins of the ball-court, it is reminiscent of abstract art, and dates from the end of the Classic era, or about the eighth century A.D. Height 55 cm. National Museum of Anthropology, Mexico City.

40 A four-glyph stone from Xochicalco combines the Náhua language (upper register) and Zapotec writing (lower register) to express the same date. The stela is 52 cm high. National Museum of Anthropology, Mexico City.

41 A small relief 9 cm high from the Votive Chamber at Xochicalco. Carved in a soft stone akin to jadeite, it resembles certain Zapotec pieces (cf. Pl. 87). National Museum of Anthropology, Mexico City.

ular dignitaries. Unfortunately this work is not as well preserved as the other group of paintings on Edifice A on this site.

The latter frescoes occupy the two panels on either side of the entrance door, as also the inside surfaces of the jambs, and depict in vivid colour four sumptuously attired figures. The two larger panels are devoted to high dignitaries—either kings, priests or warriors—in poses at once formal and relatively free. One, in a relaxed posture, stands with his left leg crossed nonchalantly over his right. They are painted in a rich polychrome of no less than eight colours. On the left is a standing figure, possibly a magnate, in a frontal pose but with his head turned to the right. He is dressed in the skin of the mythical jaguar whose gaping jaws, armed with fearsome fangs, reveal the wearer's face. In his hand is a huge ceremonial staff of Maya type in the form of a dart-filled quiver from which drops of liquid fall on to a large spotted dragon occupying the bottom and the left-hand side of the panel. The ground of the composition is scattered with numerical signs akin to those found at Xochicalco. The fresco, which is very well preserved, has a frame of aquatic creatures—snails, water snakes, turtles and shell-fish. The right-hand panel (Pl. 42) shows a similar notable, also in a frontal pose but this time facing left. He wears a voluminous feather cloak and, on his head, the effigy of an eagle whose curved beak is wide open to reveal his blackened face. He, too, holds an enormous ceremonial staff from which issue stylized snakes.

Each of the paintings on the inside of the jambs depicts a standing figure turned towards the aperture. The personage on the north is clad in the skin of a spotted jaguar, his face emerging from its muzzle, while from his waist hangs a curved object, possibly an oddly shaped ceremonial axe in polished obsidian similar to, but much larger than, those found by archaeologists. In one hand he holds a large snake, in the other what appears to be a vase from which liquid flows. The south jamb displays a figure richly clad in robes of state who appears to be carrying a waterskin (?), and also a minute image of a man. Numerical signs in the form of dots probably indicate a date associated with the protome of a deer. Both of the sumptuously attired beings wear nose ornaments (Pls. 45, 46).

A strong Maya influence is instantly discernible in these Epiclassic paintings and constitutes their chief characteristic. This applies especially to the physical types of the personages (or rather to their pictorial treatment), as also to the ceremonial rods or staffs they carry. In many respects the frescoes, notably the battle scene, but also the four figures, recall the art of Chiapas. However there is an absence of the numerical signs that might be described as Maya hieroglyphic writing.

The most striking aspects of this art are an accomplished sense of line and the concern accurately to depict—if enlarged for the sake of greater clarity—hierarchic elements such as the symbol of power and details of state apparel. Now the same may be said of the Mayas, as the stelae at Copán go to show. It must be borne in mind that only the arrival of the Olmec–Xicalanca, who imposed their aesthetic views on the people of the Altiplano, can explain the introduction there of Maya forms, a process facilitated by the void left when Teotihuacán met its end. Until then the influence of the 'place of the Gods' had been such as to inhibit importations, in that it exercised a kind of 'cultural intimidation' and tolerated only indigenous forms. The cessation of this tutelage, and the

42 Fresco at Cacaxtla (Tlascala), on the right of the doorway in Edifice A. This very fine painting figures a richly clad high dignitary wearing a bird's mask and holding a large ceremonial staff. He has a bird's claws in lieu of feet and appears to be standing on a large Feathered Serpent. This recently discovered work has been ascribed to the eighth century and betrays strong Maya influence.

43 Flanking the left-hand fresco in Edifice A at Cacaxtla is a figural relief in polychrome stucco in the Maya style.

44 Detail of the Feathered Serpent from the right-hand fresco at Cacaxtla. The superlative quality of the drawing is instantly apparent.

42

43

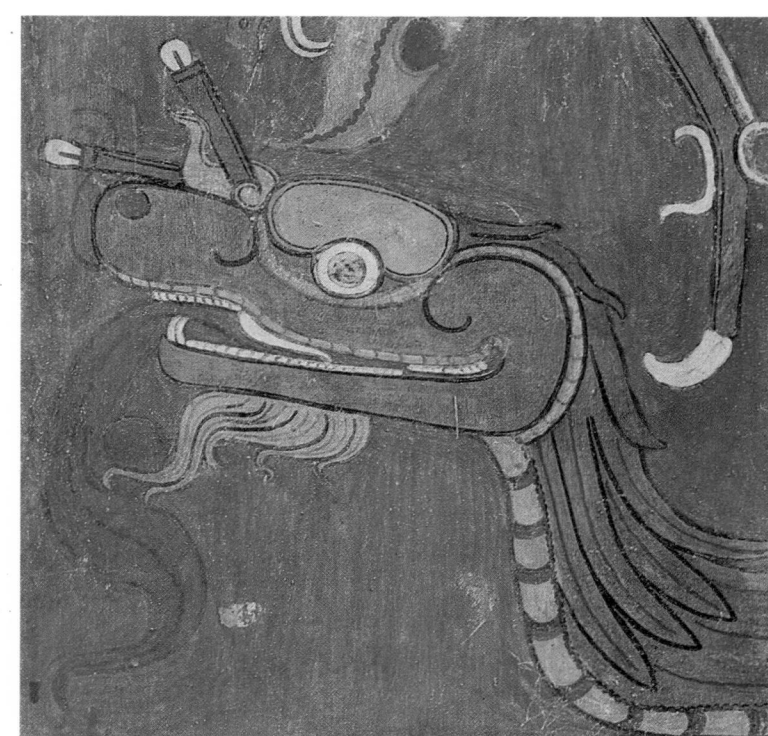

44

population movements consequent upon the great upheaval of the seventh century, enabled trends from other centres, both near and far, to assert themselves. At Cacaxtla, as at Xochicalco, there then came into being a syncretic art which drew for sustenance on the common heritage of the Pre-Columbians.

Yet there can be no denying that the paintings at Cacaxtla have nothing in common with those at Teotihuacán. They indicate the appearance on the high plateaux of a different concept, a form of representation that is both closer to reality and less symbolic. It is an indication of the importance assumed by the human being in the new order then taking shape. It was a universe in which the theocratic and centralized government of the early agrarian empires was on the wane.

Just as the Maya paintings of Bonampak mark the increasing importance attached to historical occasions such as wars, coronations, and triumphal and funerary ceremonies, so the most recently deciphered Maya hieroglyphs testify to a new interest in biographical matters. Now, the same holds good for the Altiplano where the Cacaxtla paintings evince a decline in purely religious forms of expression in favour of 'historiographic' art, or at any rate of a certain degree of secularization. Yet the ritual aspect does not altogether disappear. However realistically their attributes may be depicted, the subjects are shown in company with the great deities, whether Feathered Serpent, Jaguar or Eagle.

It might be asked whether the representation of these two latter beings presages the military orders of the Jaguar and of the Eagle characteristic of Tula, whence they spread to Chichén Itzá, to be adopted at a later date by the Aztecs. To this no definite answer can as yet be given. But of one thing we may be sure—the opulent paintings of Cacaxtla mark a turning-point in pre-Columbian art. Thereafter the primacy of the gods was challenged by the destiny of man.

From this we may see what a wealth of information it has been possible to glean from only one recent discovery, and also how, in the field of Mexican archaeology, the unexpected may at any time demolish apparently unassailable theories. For who would have dared to suggest that Maya-type frescoes would one day be discovered on the Altiplano? Indeed, by no means the least intriguing aspect of pre-Columbian art is the constant revision to which it is subject.

Teotenango, Citadel of the Gods

Like Cacaxtla, Teotenango is one of the more recent acquisitions of Mexican archaeology. Excavation of the site did not begin until 1971 and the work of restoring the monuments that have been cleared has been going on for several years. The project, which as yet has brought to light no more than part of the ceremonial centre, is under the direction of the Mexican archaeologist Ramón Piña-Chan.

Teotenango lies at an altitude of 2,700 metres in the valley of Toluca (State of Mexico). The complex occupies the upper part of an enormous lava flow, shaped like a thick tongue of rock, which has invaded the fertile plain. The precipitous nature of this eminence, the Cerro Tetépetl, provided the people of Teotenango with a natural fortification upon whose heights they erected a huge cluster of buildings and, in particular, an important ritual complex.

45 Detail of figure inside the right jamb of the doorway in Edifice A at Cacaxtla. Standing in a nonchalant pose, this black-faced personage appears to be holding a water-skin. Top left is a date, 'Three Deer', which may also denote a name.

46 Detail from left door jamb in Edifice A at Cacaxtla. The figure is clad in a jaguar's skin with all its appurtenances. Note the claws on his hands and feet.

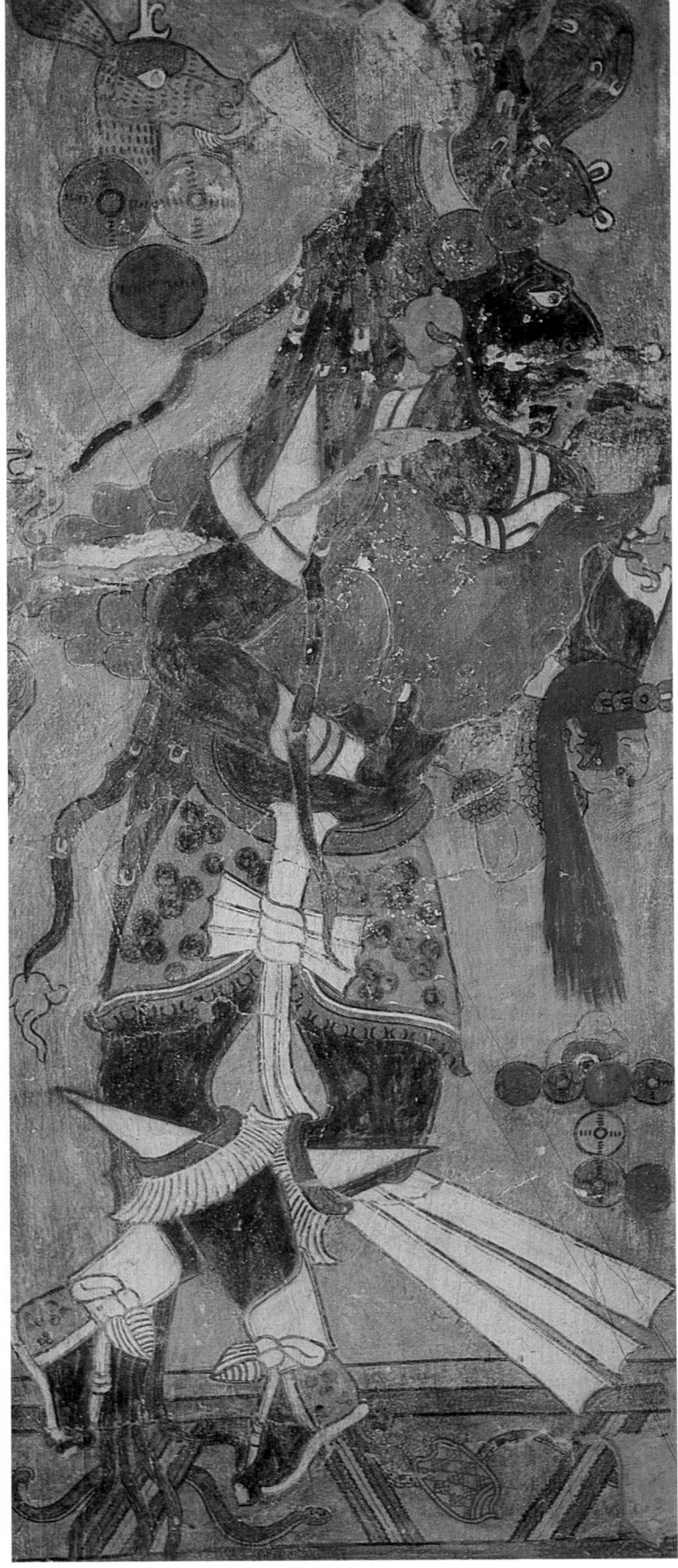

45

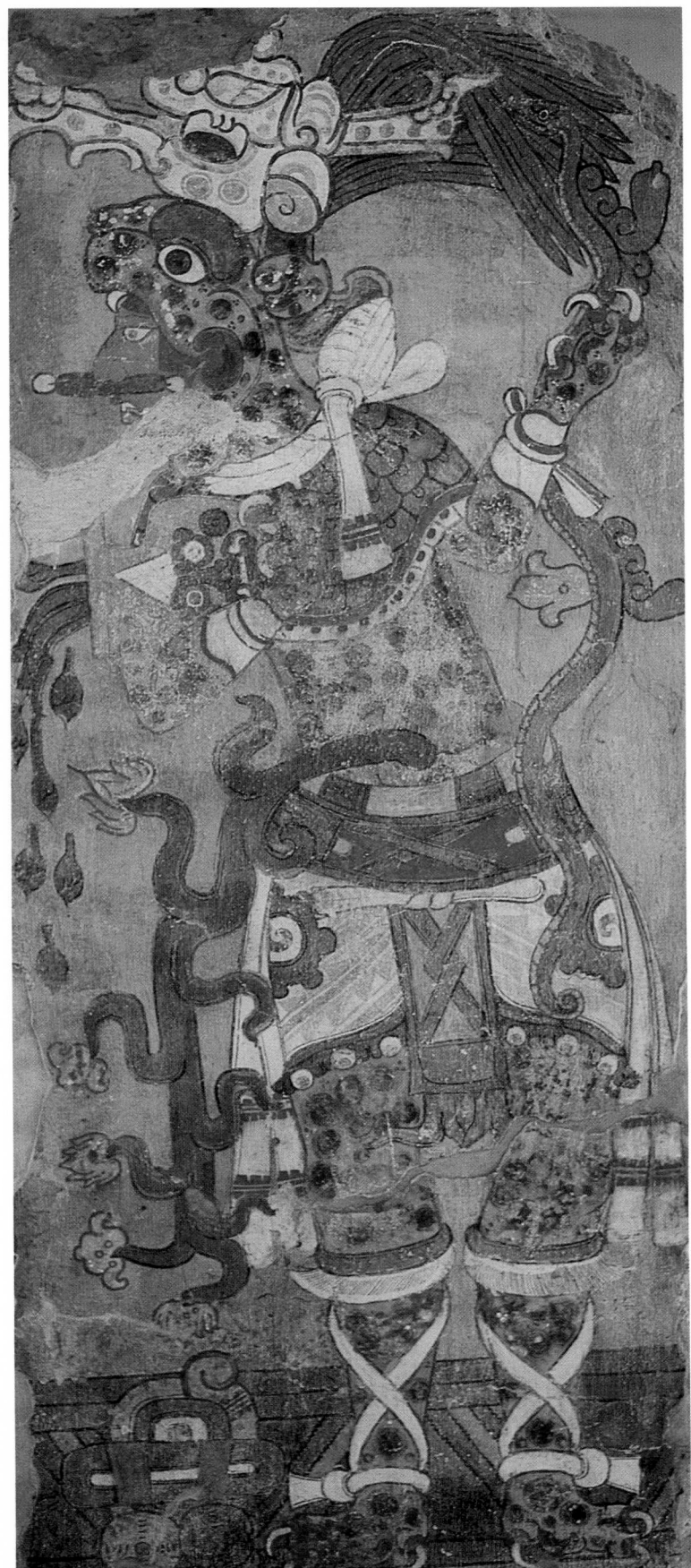

46

In Náhuatl Teotenango means 'place of the Divine Wall', a term defining the ritual function as well as its dominant position from which watch might be kept over the plain. The site forms a natural refuge which was further strengthened by its inhabitants in the seventh century. Only the eastern extremity, whose height varies between 70 and 100 metres, was inhabited. Here the hill has been transformed by means of walls and terraces so imposing that they can be seen from afar by the traveller as he comes up the valley of Toluca.

The people who occupied the region since the seventh century are known as the Matlatzinca. They probably entered the valley in the course of the population movements that took place between the fifth century and the fall of Teotihuacán, initially settling as cultivators in the plain at the foot of the lava flow. In about 750, under the threat of renewed attack, they decided to occupy the heights upon which they founded the city of Teotenango. At first this was no more than a ceremonial centre with sanctuaries that were safe from incursion, but as time went on residential quarters and a civic complex were added to the other groups of ritual buildings.

Recent reconstructions have largely been confined to the northern part of the city. It lies at the top of an escarpment crossed by the modern motor road that ascends the steep incline marking the edge of the lava flow. The visitor, once he reaches this upper plateau—a natural balcony, as it were, overlooking the valley—is confronted by a vast complex of buildings affording tremendous vistas in which pyramids, stepped platforms, flights of stairs, plazas and a ball-court form long tiers of horizontals. These are articulated in accordance with a disposition governed for the most part by the right angle, though the irregularities of the volcanic topography precluded its systematic application (Pls. 47–9).

A close study of the plan shows that the northern part of the esplanade is laid out on an east-west axis (Plaza A, Pyramid 1A and ball-court), while the buildings (Plaza B and Pyramids 1B and 3B) adjoining this group on the south are orientated some 3° further to the south-west. Here we find the same variation as obtains in Teotihuacán between the Sun Pyramid and the Avenue of the Dead, and, at Xochicalco, between the northern and southern groups. Once again, the bi-axial system is seen to be a constant of pre-Columbian religious architecture, no doubt in response to ritual requirements concerning the orientation of certain sanctuaries.

It is the stylistic unity of Teotenango that immediately strikes the eye. As at Teotihuacán, this is achieved by the method of construction applied to the platforms and to the steps. What we have here, however, is not the Classic tablero or framed panel peculiar to the 'place of the Gods', but rather a type of moulding which undoubtedly derives from it and suggests a close affinity between the edifices of Teotenango and those of the Classic metropolis. Indeed, the Teotihuacán model is perpetuated in the formula of the talus at the base of each step. But here the sloping portion takes up two-thirds of the height of the terrace riser of which the tablero, now reduced to a simple, slightly projecting band, occupies only a third, accentuating the edge of the step after the manner of a cornice. In this way the proportions of Teotihuacán are virtually reversed, a procedure that also facilitated the building of the steps. Yet the vigour of the visual impact is undiminished and contrasts with the flights of stairs and the smooth ramps that flank them.

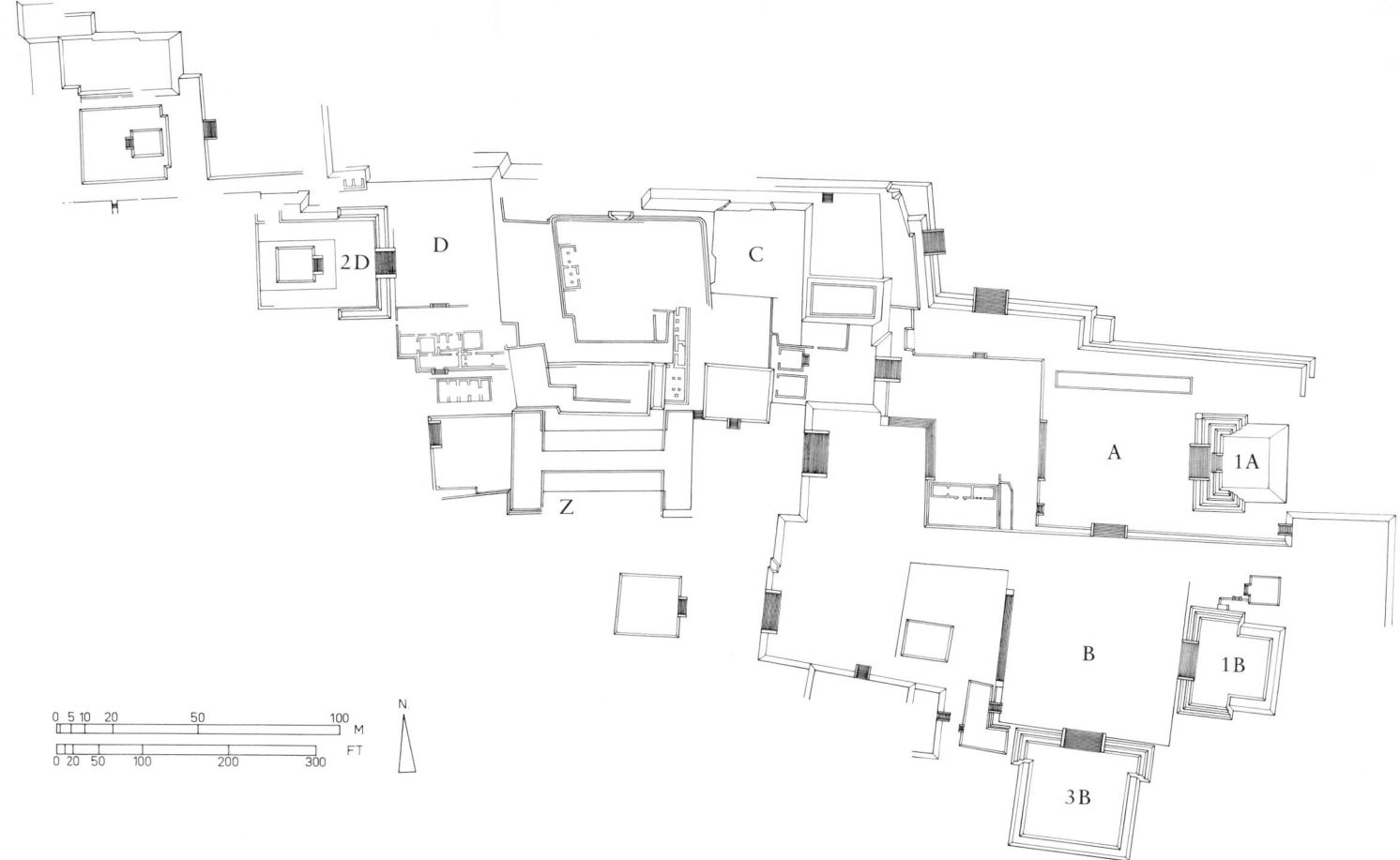

Plan of Teotenango
A: Plaza A
1 A: Pyramid
B: Plaza B
1 B and 3 B: Pyramids
C: Plaza C
D: Plaza D
2 D: Pyramid
Z: Ball-court

Oddly enough, a consideration of Pyramids 1A and 1B reveals that here, too, the principle applied at Teotihuacán is reversed. In the latter, the sanctuaries formed a small, stepped avant-corps tacked on to the vast mass of the pyramid, whereas in Teotenango the avant-corps has swollen to the point of concealing the small pyramid it precedes. This feature, previously no more than an annexe, here becomes the main element of the building.

These three-storeyed pyramids surmounted by a recessed platform stand at the very edge of the rocky plateau and are silhouetted against the sky. The ritual complex of Teotenango rises in stages whose rhythm derives from broad flights of stairs and long retaining walls.

For the most part the tiered structures north-east of the ceremonial centre may be assigned to the period between 750 and 900 A.D. Between the latter date and 1162 a number of additions were made to give this vast assembly of harmoniously disposed platforms and terraces its definitive appearance. It is to this second period that the fine ball-court belongs (Pl. 50). Measuring 65 metres in length, it is situated on the third terrace relative to Plaza A and takes the traditional form of a depressed H. Its gently sloping sides are flanked by walls in which, halfway down the court, two stone rings are affixed to serve as goals. Like the ball-court at Xochicalco, its origins go back to Monte Albán and Copán, with the exception of the rings which were an import from the high plateaux.

In the same locality excavations have revealed the remains of a *temascal* or steam bath, a form of sauna widely favoured by the Pre-Columbians for its hygienic and prophylactic properties. Again, the same period saw the construction, west of the city and astride the lava flow, of an imposing wall which completed the defensive system dominating the valley.

We should add that the masonry throughout consists of lava blocks bound together with a rudimentary form of cement. There must also have been a cladding of stucco, as at Teotihuacán. Both at Teotenango and at Xochicalco, the god Quetzalcóatl was worshipped in the guise of the Morning Star (Venus), as is evident from a carved stela whose decoration consists mainly of the interlaced triangles we have already encountered at Teotihuacán in the crenellations overlooking the court-yard of Quetzalpápalotl Palace. Finally, it is evident from certain glyphs similar to those at Xochicalco that this period, extending from the fall of Teotihuacán to the heyday of the Toltecs, was informed by a common culture.

The Rise of Tula

Situated in the State of Hidalgo on the high plateaux 90 kilometres north of Mexico City, the Toltec capital of Tula is believed to have been founded in 856. Having survived one onslaught in the tenth century, it was put to the flames by barbarians from the north in 1168. Its inhabit-ants were dubbed Toltecs or 'wise ones' by the barbarian tribes who succeeded them on the Altiplano. The Toltecs, like the Aztecs, were Ná-hua-speaking.

From the Tula period onwards we find an amalgam, not always dis-cernible as such, of archaeological data on the one hand and old Indian traditions on the other, the latter—a combination of legend, history and myth—being recorded in the codices (notably the Mixtec and the Aztec) and in the chronicles written at the time of the Conquest by members of the Aztec nobility or recounted by them to Spanish missionaries. Hence this is not so much a historic as a proto-historic phase, for pictographic writings are difficult to decipher with any degree of certainty. Again, not only do the accounts of Tula obtained from the Indians by Cortés and his companions relate to events that had happened some five hundred years previously, but they mingle reality and myth in much the same way as the Five Books of Moses. Hence it is impossible to regard them as anything more than pointers which, though valuable, are really diffi-cult to reconcile either with chronology or with a true historical per-spective.

For the chronicles are often muddled, precise facts being jumbled up with symbolic notions governing both dates and names. Here we find a simplistic dualism, with the gods on the one hand and men on the other. Indeed, these sources tend to confuse rather than enlighten the historian. The information they contain proves, on examination, to be comprehen-sible only when other means of investigation have supplied the key; otherwise they remain an enigma. This is not to say that these writings do not contain a modicum of truth. Some, indeed, are reliable enough—for instance the *Historia Tolteca-Chichimeca*, written by an unknown hand, or again Fernando de Alva's *Relaciones* and *Historia Chichimeca*. Finally, we might cite the *Historia general de las cosas de Nueva España* by the Spanish missionary, Bernardino de Sahagún, the gist of which was dictated to him by Mexicans. But these books must be read as early Christian writings primarily concerned with evangelization and the struggle against heresy. Thus they depict the enemy's gods as diabolical

47 With its high esplanade, Teotenan-go near Tolula dominates the valley below. The structures, while similar to those at Teotihuacán, date from the eighth to the twelfth century. The tem-ples are preceded by three-storeyed plat-forms, and space is so organized as to produce vast, rectilinear perspectives.

48 Lined by retaining walls, the plat-forms at Teotenango rise in terraces on a site that is entirely man-made.

49 The site of Teotenango with its temples and terraces occupies the sur-face of a large lava flow. The uniform architectural style comprises the talus-tablero motif, though here the panels are unframed.

50 The upper part of the ceremonial centre at Teotenango contains a fine ball-court with gently sloping sides flanked by walls. Like other courts in-fluenced by the Mayas and Zapotecs, it is shaped like a depressed H, but the two stone rings affixed on either side are of Toltec origin. It probably dates from the tenth or eleventh century.

51 Detail of late rock carving at Teote-nango showing a date. The writing is that of the Altiplano cultures.

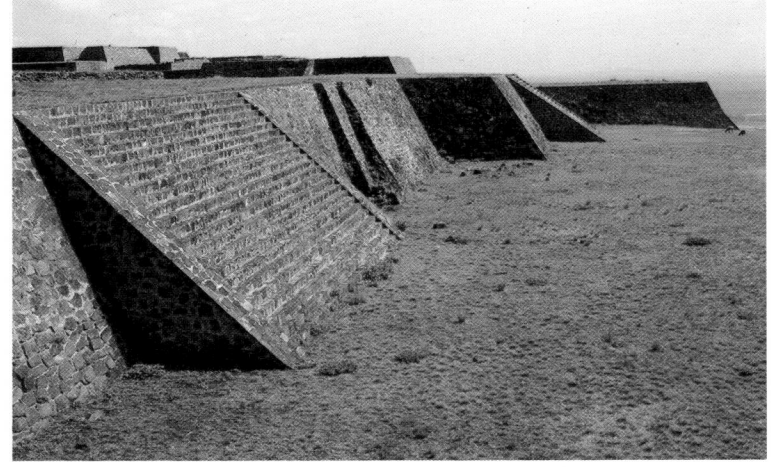

47

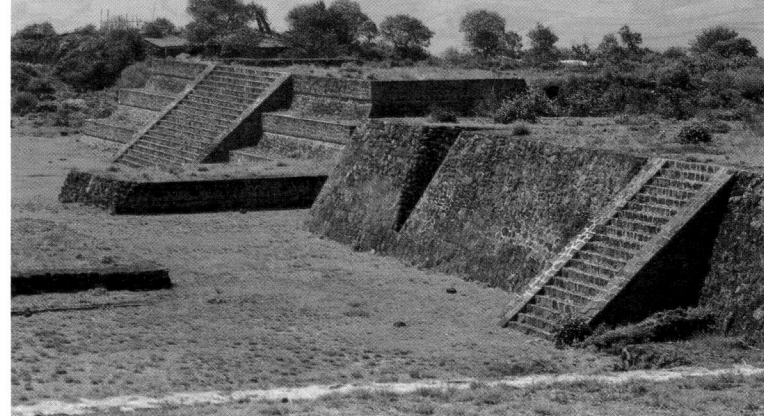

48

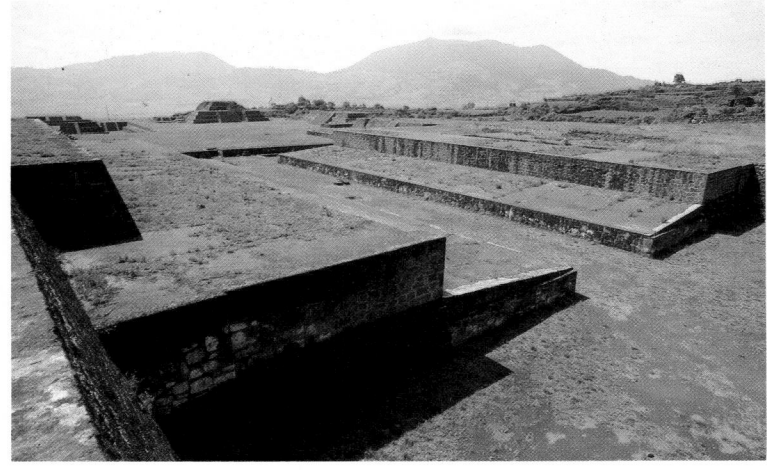

49

50

51

agencies, just as Quetzalcóatl's rival, the god Tezcatlipoca, is decried as a cruel and malignant deity. Throughout history a change of religion or ritual has involved the inversion of divine attributes, whereby today's benevolent god unfailingly becomes the evil god of tomorrow.

The inclusion in the pantheon of Quetzalcóatl (whose name has been wrongly applied by archaeologists to the temple at Teotihuacán Citadel) seems to have coincided with the rise of Xochicalco and introduces an exceedingly complex element into Mesoamerican religion. As god of the planet Venus he assumes the guise of the Morning Star, a symbol of resurrection in all archaic religions. At the same time he still retains some of the attributes of the old agrarian deities. This is apparent from the confusion obtaining between the god and his high priest, the king of Tula, also called Quetzalcóatl (among pre-Columbian Indians it was not unusual for men to be called after divinities). This sovereign, believed to have reigned in the tenth century, was a paragon of virtue and is credited with all the attainments of civilization. The chroniclers report that he stole maize from the kingdom of the dead and gave it to man, which suggests a god of vegetation who causes seed to germinate and whose domain must therefore include agriculture. Besides being the inventor of the calendar and astronomy, as became an agrarian deity, he also discovered writing, medicine and ritual. The amphibology between the god and his representative would seem to have been deliberately fostered; similarly, the antagonism between the devotees of Quetzalcóatl and those of Tezcatlipoca is symptomatic of the profound religious upheavals of this time as compared with the Classic era. The pantheon was changing— the old fertility rites still persisted, but the assumption of a stellar image spiritualized the gods and turned them into the exemplars of an ethic. Religion was becoming a means of salvation.

Thus Quetzalcóatl, a personage half god and half man, was to assume a position of considerable importance in the pre-Columbian world— so important, in fact, that historians (e.g. Laurette Séjourné) and writers (e.g. Lopez Portillo) have seen in him a being as charismatic and civilizing as that represented by the image of Christ in Western societies. To omnipotence he adds the qualities of mercy and humanity but, as the foremost god of the Indian pantheon, he is also the creator of the Fifth Sun, the wind god who sweeps the ancient divinities from the sky and whose spiritual exhalations are the source of life. He is a magus who has the power to transfigure death. All this is over-refined and altogether too redolent of Christian theology. Again the Judaeo–Christian outlook, based on a messianic concept, has patently left its mark on the story of Quetzalcóatl's departure towards the rising sun and the promise of his early return. Reminiscent of the Second Coming, the myth was used by Cortés as a tool with which to subdue the first Indian tribes he encountered, for he realized what capital could be made out of the legend recounted to him by his intermediaries. Today it seems almost impossible to disentangle what is genuinely of pre-Columbian origin from what is implantation, a 'contagion' attributable to the white invader.

To return to our sources, the chroniclers allude, amongst other things, to close and complex relations between Xochicalco and Tula. Mixcóatl—the first pre-Columbian ruler whose name has come down to us—was king of the Toltec tribes and married a princess from Xochicalco, in which city his son, Acatl Topiltzin, was brought up. Subsequently, as king and high priest, the latter was known as Quetzalcóatl.

Plan of ceremonial centre at Tula
1 North ball-court
2–4 Hypostyle halls
5 Pyramid of Tlahuizcalpantecuhtli
6 Hypostyle hall
7 Hypostyle vestibule
8 Central altar
9 Principal pyramid
10 South ball-court

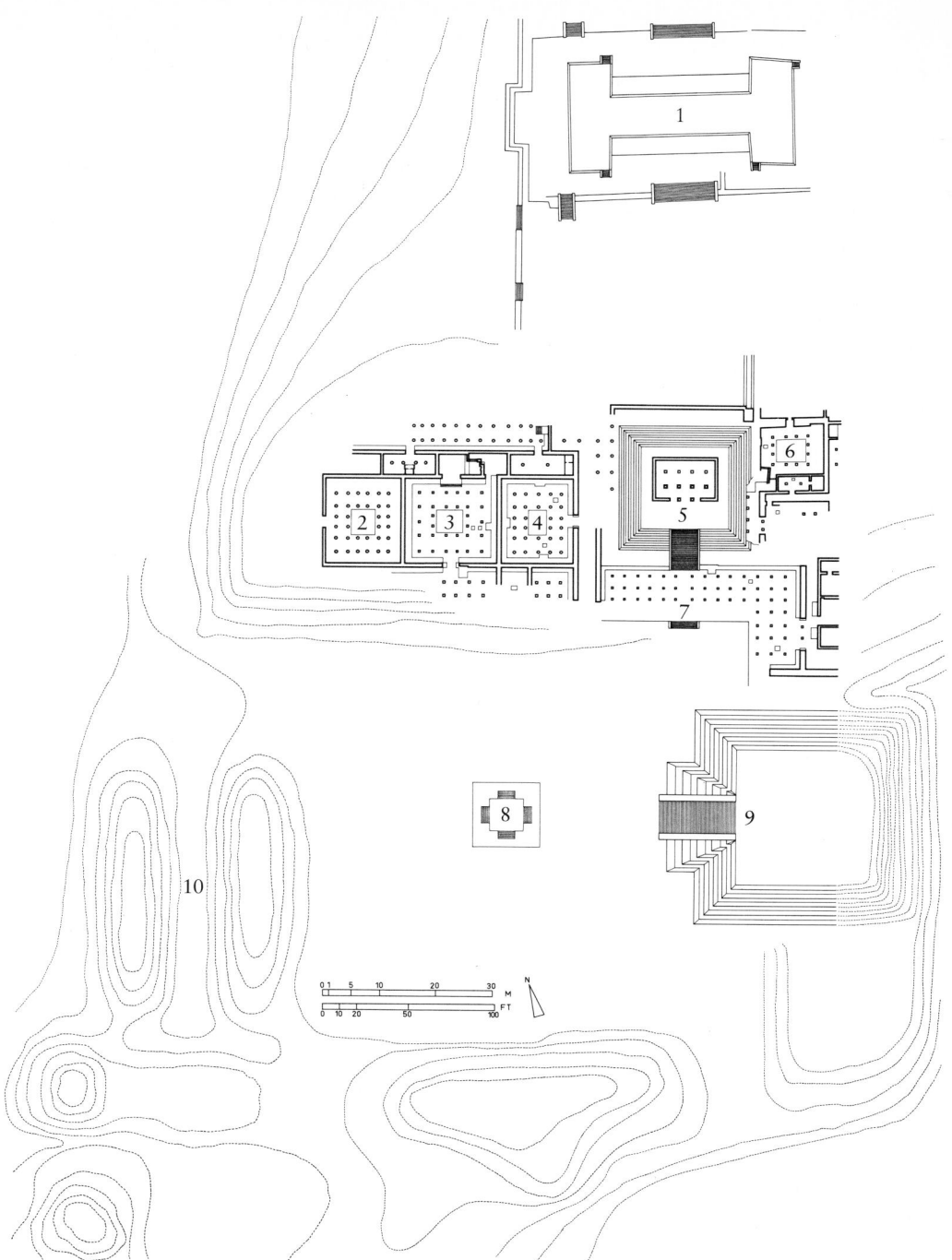

He imported into Tula, a capital allegedly founded by him, the cult of the god whose name he bore. From the same sources we learn, however, that the formidable god Tezcatlipoca was also worshipped there.

Here, then, we have a king who converted his people and the inhabitants of his capital city to the worship of a new god from a more advanced centre of civilization, a god born, perhaps, of the turbulence attendant on the coming of the Fifth Sun in the Mexican cosmic cycle. This event marked the beginning of a new era which comprised both the Toltec and the Aztec periods. From the foregoing we can only infer that the newcomers adopted an older cult, itself the product of drastic religious reforms imposed upon the now mythical 'place of the Gods', for it was doubtless at Teotihuacán that Quetzalcóatl had presided over the sacrifices ushering in the era of the Fifth Sun. We are therefore confronted by a wealth of secondary meanings whose interpretation calls for the utmost caution. Indeed, in our present state of knowledge no such inter-

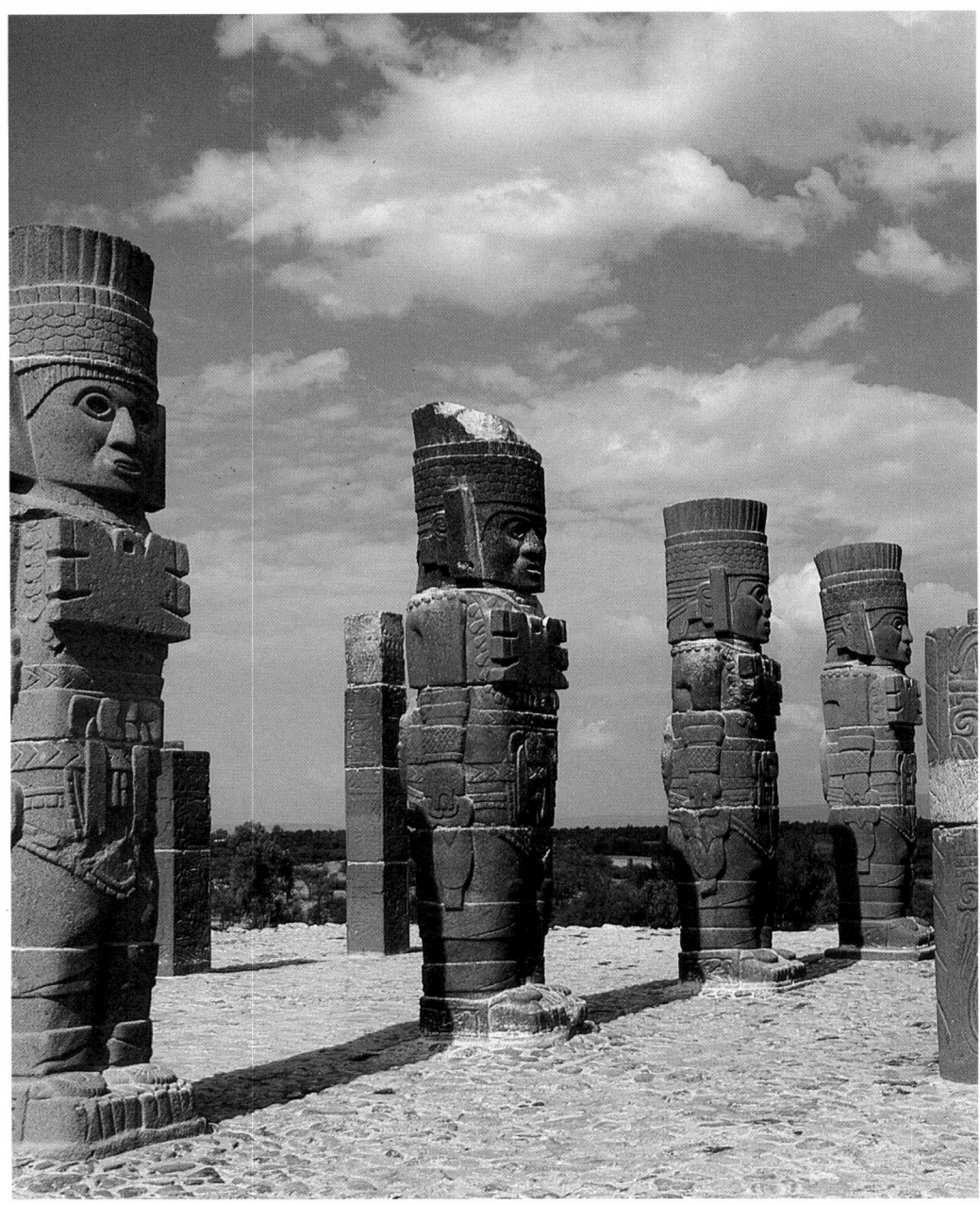

52

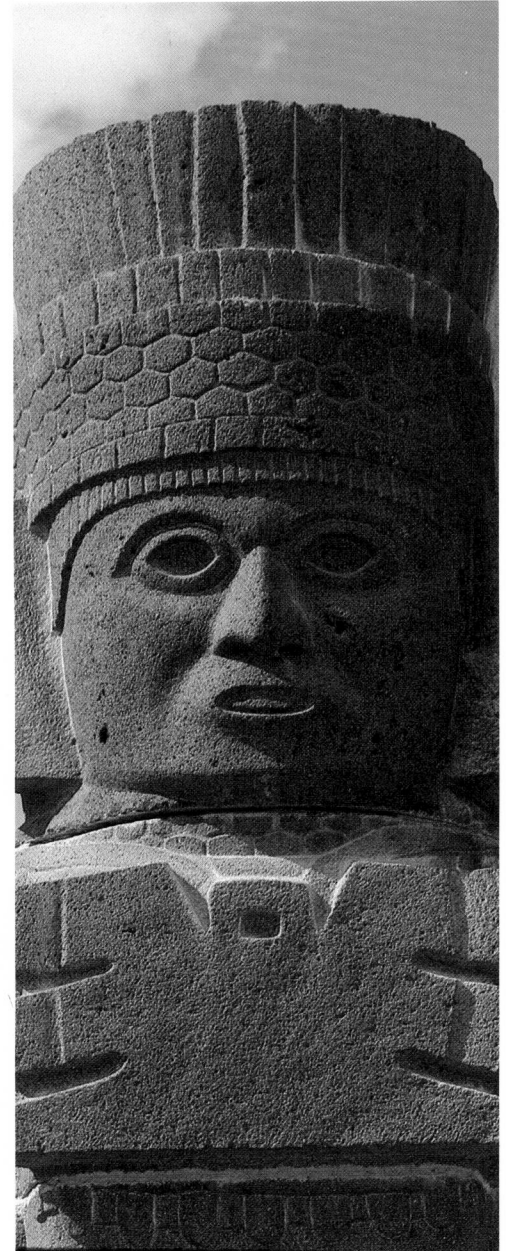

53

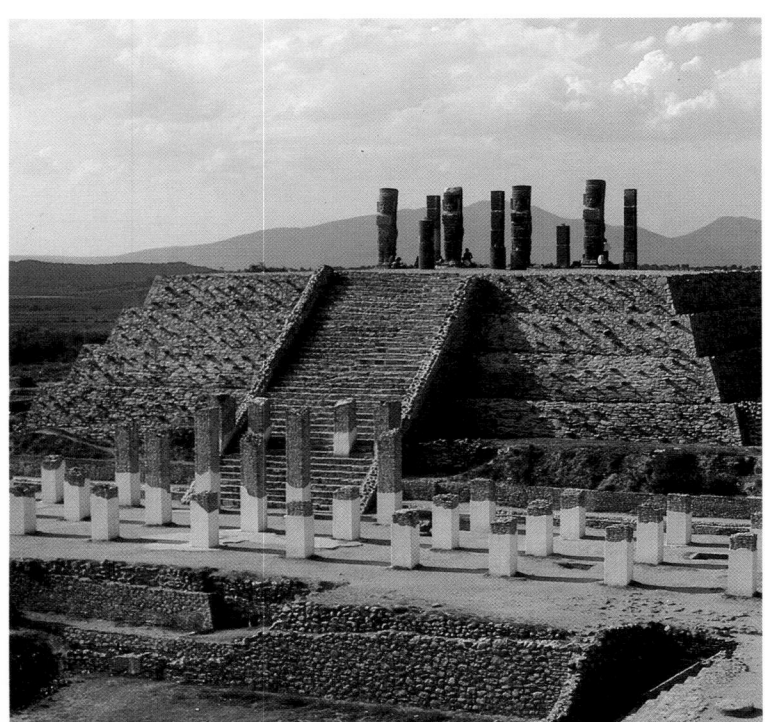

54

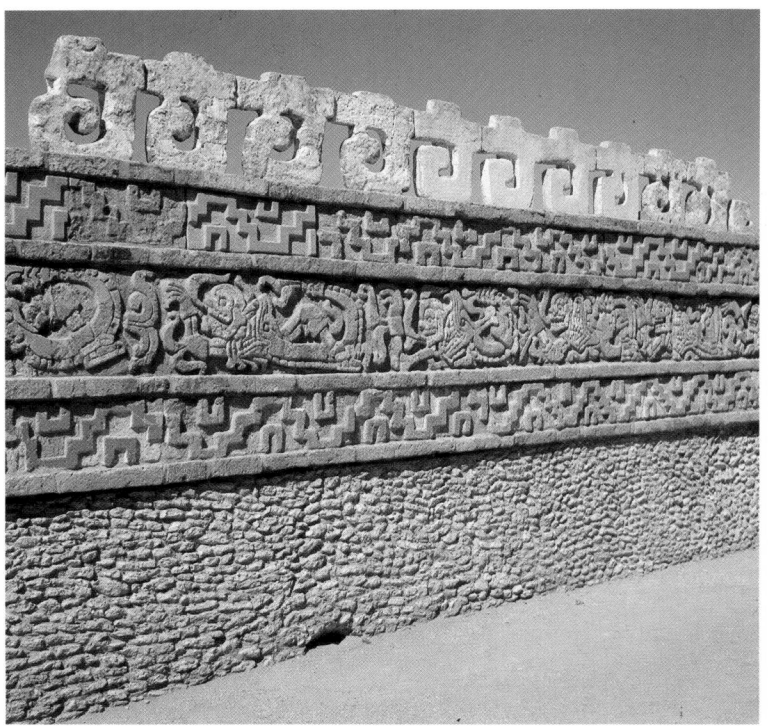

55

52 At the top of the Pyramid of Tla-huizcalpantecuhtli (god of the Morning Star, avatar of Quetzalcóatl) at Tula (State of Hidalgo), stand four great Atlantean figures carved in basalt. These Toltec sculptures consist of four super-imposed elements and are thought to date from the tenth century A.D. They once supported the roof of the temple and are 4.6 m high.

53 Detail of an Atlantean figure at Tula. The hard, impersonal features of this warrior are surmounted by a tall plumed head-dress, while his chest is protected by a pectoral in the form of an emblematic butterfly.

54 General view of the Pyramid of the Morning Star at Tula. A wide axial stair ascends the four terraces and leads to a no longer extant temple. However, the supports, retrieved by archaeologists from the interior of the pyramid in which they were buried, have been restored to their original position. At the foot of the pyramid are the bases of the piers that once formed the great hypostyle.

55 The Coatepantli or serpent wall at Tula is crowned with decorative crenellations in the form of shell sections, emblems of the wind god. In the central register is the Feathered Serpent devouring Quetzalcóatl whose fleshless head has already taken on the appearance of a skull.

56 The Chacmool, a purely Toltec form of sculpture, shows a man lying on his back, and was intended as a receptacle for sacrificial offerings. Roughly carved in basalt, it is 95 cm long. National Museum of Anthropology, Mexico City.

57 Detail of Toltec basalt statue of a woman wearing a traditional triangular shawl known as a *quechquémitl*. This sculpture from Tula dates from the eleventh century, the detail shown here being 60 cm high. National Museum of Anthropology, Mexico City.

58 Small Atlantean figure from Tula, probably an altar support. The basalt sculpture still shows traces of colouring. Works similar to this were produced in Chichén Itzá in the Maya–Toltec period. Height 78 cm. National Museum of Anthropology, Mexico City.

pretation of events in Tula would be likely to find general acceptance. There are too many imponderables and too many lacunae in Toltec archaeology and the history of this people with whose aid the pre-Columbian world was to emerge from its Middle Ages amidst the convulsions created by the final waves of invaders that preceded its unification by the Aztecs.

The first excavations of the ceremonial centre were made over a hundred years ago. In 1940 investigations of a more scientific nature began under the direction of Jorge R. Acosta, and were continued until the early years of the 1960s. But much remains to be elucidated and many edifices, now no more than shapeless mounds, are deserving of excavation and restoration. This is particularly applicable to a ball-court, to the highest pyramid and to a building south of the main plaza.

Nevertheless the remains that have been uncovered are of considerable interest. The most important is the Pyramid of Tlahuizcalpantecuhtli, god of the Morning Star and avatar of Quetzalcóatl, which is preceded by an enormous hypostyle; three assembly halls, in the shape of hypostyles with patios, are situated to the west of the pyramid while a fourth, porticoed building lies to the east. South of this group, in the middle of the main plaza, is a temple with four axial stairs, while to the north lies a ball-court, 65 metres in length, with sloping sides.

The orientation determining the disposition of this group of buildings recalls the axial deviation of 17° found in the Sun Pyramid at Teotihuacán and this would seem to suggest that the main pyramid, to the east of the plaza, was dedicated to the solar cult.

Tula's most spectacular edifice is undoubtedly the pyramid surmounted by the temple of the Morning Star, with its five steps ascended by a wide axial stair and its four great carved Atlantean columns which must at one time have supported the roof of the cella. From a base 38 metres square the building rises to a height of 10 metres, the level of the topmost platform. At one time it was crowned by a sanctuary with a triple doorway defined by two serpent columns, only fragments of which now remain. The four Atlantean columns, on the other hand, which are complemented by four piers, stand in what was once a vast hypostyle measuring 17 by 12 metres and occupying an area of some 200 square metres (Pls. 52–4).

The Atlantean columns were discovered in the dismantled state in which they had been concealed inside the pyramid and have been reassembled by archaeologists in their original positions. It would seem that they had been subjected to ritual burial after the systematic destruction of Tula's ceremonial centre during the decline of the Toltecs in the twelfth century. The dismantling and reassembly of these tall basalt sculptures, 4.5 metres high, was facilitated by the fact that each of the anthropomorphic supports was composed of four drums fixed together by mortice joints carved in the block.

Thanks to layering, some parts of the decoration on the steps of the pyramid's east face have survived intact and reveal a method of construction remotely descended from Teotihuacán. Above the talus, the alternation of salient and recessed panels gives rhythm to what might correspond to the Classic tablero. Displayed on them in profile are eagles and vultures devouring hearts in alternation with large, frontally presented motifs showing the Feathered Serpent's gaping jaws between which appears a human face. These panels are surmounted by a wide frieze of jaguars and pumas in procession. The decoration in low relief

56

57

58

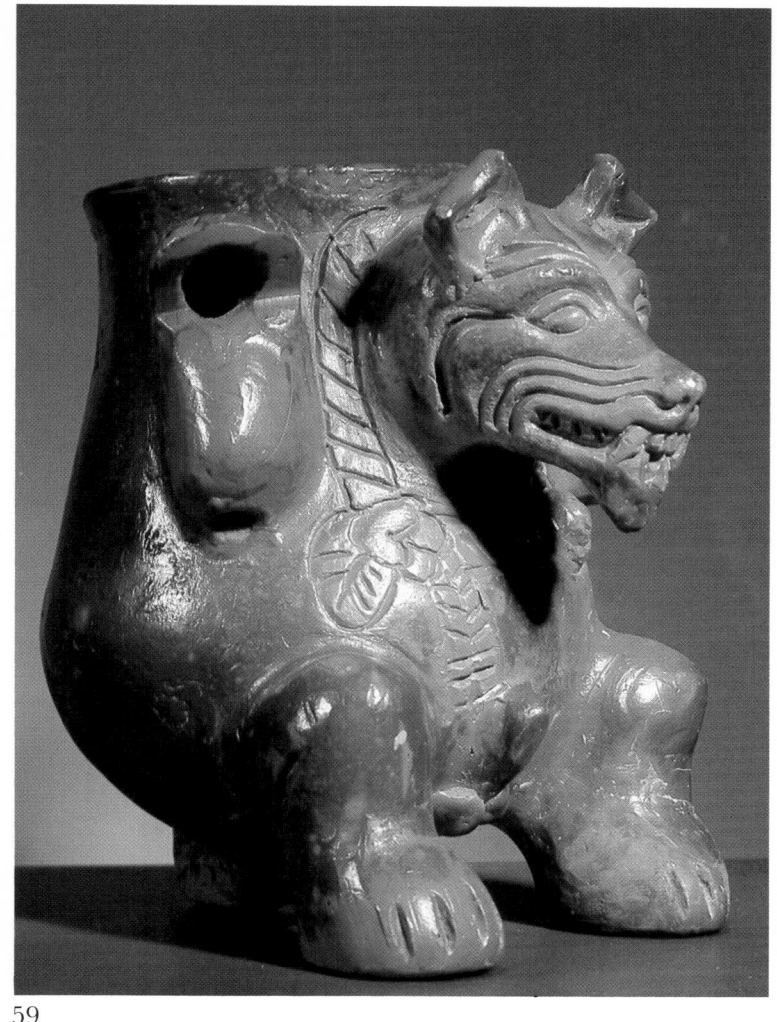

59

60

61

62

on stone slabs covered with polychrome stucco must have girdled the building at all five levels.

The cella itself is the first comparatively spacious structure of the kind, being almost double the size of that at Xochicalco, which seems to indicate that large numbers of worshippers participated in the ceremonies, an assumption further supported by the presence of the huge L-shaped hypostyle forming a vestibule in front of the south pyramid. Only the bases remain of the fifty-six piers which must have carried a roof of horizontal wooden members embedded in stuccoed cement. This open-fronted hypostyle, whose floor area of some 800 square metres is suggestive of large congregations, was a new phenomenon in ritual buildings and resulted from drastic changes in the Toltec social structure. These changes went hand in hand with the rise of the military orders in whose temple the great religio-military feasts were now celebrated. Both the Atlantean columns and the bas-relief figures on the piers of the inner sanctum represent Toltec warriors.

We should add that the architecture of Tula, with its more generous treatment of internal space, was to find an echo in the superb Temple of the Warriors at Chichén Itzá in Yucatán, about 1,200 kilometres further east, whither part of the Toltec population had migrated in the late tenth century. In this building the principle of the hypostyle is also adopted, but now developed to exploit the possibilities afforded by the vaulted concrete roof—a Maya innovation we have already discussed in our book on Maya art.

Hence it would seem that the tumults of the Mexican Middle Ages had worked to the advantage of the military, whose representatives were to become the rulers of the country. The priests of the theocratic states lost their primacy and a species of feudalism now held sway with a consequent demand for places of assembly suited to the conduct of political business.

It was in response to this particular need that buildings of a completely new type were erected west of the Pyramid of Tlahuizcalpantecuhtli. These are the three hypostyles built round a central patio; the two at either end of the ensemble possess thirty-two and twenty-eight masonry columns respectively, while the central hall which, with an area of 700 square metres, is also the largest, has thirty piers. In each case the supports are disposed in two concentric rectangles and must have carried a flat timber roof, as in the Teotihuacán palaces. The courtyard, which serves as a light-well, occupies an area of 64 square metres. As regards the function of these halls, there can be little doubt that they were used for the ceremonial assemblies of the Toltec religio-military orders governing the state.

Thus in Tula the open volumes of Classic architecture gave way to enclosed volumes, in response to new programmes resulting from social structures brought into being by the rise of the war-lords and of a warrior-rather than peasant-based hierarchy. From now on, the military presided over the great feasts, making them the occasion for proclaiming their might, and it was they who ruled the country through councils amongst which was apportioned the erstwhile monolithic power of the old agrarian empires.

Here, in the simultaneous emergence of an eschatological god (Quetzalcóatl) and of the politico-military power of the Toltecs, we may detect the germ of the crisis which was to come to a head at the end of the

59 Toltec plumbate (*plomiza*) ware. Eighteen cm high, the pot is decorated in bold relief with the effigy of a coyote. It is a brilliant example of the use of slip typical of Tula ceramics in the eleventh and twelfth centuries. National Museum of Anthropology, Mexico City.

60 A Toltec plumbate pot in the effigy of Tlaloc which probably came from Teotihuacán. Distinguishing attributes of the rain god, clad in a feathered garment, are the protuberant eye-teeth and the rings round the eyes. Height 21 cm. National Museum of Anthropology, Mexico City.

61 Toltec stone bas-relief of a dancing jaguar symbolizing the underworld, the spotted skin being associated with the starry sky. Height 1.26 m. National Museum of Anthropology, Mexico City.

62 Commemorative bas-relief of Toltec origin, depicting Quetzalcóatl whose face looks out from between the jaws of the Feathered Serpent. This very fine sculpture, 61 cm high, bears witness to the mastery of the Tulan artists after 1000 A.D. National Museum of Anthropology, Mexico City.

63 This plumbate pot in the Toltec style is encrusted all over with a fine mother of pearl mosaic and is no more than 14 cm high. It shows the apparently bearded face of Quetzalcóatl emerging from the jaws of the Feathered Serpent. National Museum of Anthropology, Mexico City.

tenth century when, if the chroniclers are to be believed, King Quetzal-cóatl was compelled to leave his capital. It would seen that, in a fresh onslaught by nomads from the north, the votaries of Tezcatlipoca, the god of war, scored a decisive victory over the reformer, Quetzalcóatl. However, this did not mean that the god of the Morning Star was no longer an object of veneration, even though the subsequent military ascendancy of the Aztecs would appear to have effected his perpetual banishment.

In the field of the plastic arts, already alluded to in our discussion of certain architectonic sculptures, the Toltec period brought radical changes. For instance the Atlantean columns, with their rigid, symmetrical posture and inscrutable faces, are executed with consummate mastery. The head-dress of eagle's feathers above a band encircling the forehead, the large butterfly pectoral, the stiff 'at attention' attitude with hands pressed close to the sides and grasping a dart-thrower and darts, the short apron knotted at the waist, the high-laced sandals—all this, carved in fine black basalt and repeated on one column after another, endows the volumes with masses of the utmost geometricality and plainly symbolizes the brutal power and arrogance of the pre-Columbian warlords.

This schematization is also discernible in sculpture of purely Toltec origin, namely the ritual statues dubbed Chacmools by nineteenth-century explorers. The Chacmool is a figure reclining on its back, with drawn up legs and raised head and whose hands or stomach serve as receptacles for votive offerings. Invariably massive, often rigid and austere—such is the plastic art of Tula (Pls. 56–8).

The magnificent sculptured plaque commemorating the Feathered Serpent whose open jaws reveal the human face of Quetzalcóatl, the god of resurrection, displays a greater sense of refinement. Delicate modelling and serene composition characterize this bas-relief (Pl. 62) and recur in the beautiful glazed pottery (Pls. 59, 60). The most remarkable of these pieces is in fact an astonishing effigy of the Feathered Serpent, barely 14 centimetres high, encrusted with a mother-of-pearl mosaic of the utmost delicacy. The feathers are represented by means of small close-set elements, while Quetzalcóatl's face, bearded and open-mouthed, is executed with singular felicity, having regard to the small size of the piece and the technique used to clothe the pottery (Pl. 63).

Thus, alongside sculptures of a military nature with their suggestion of brute force there existed an art of less robust character, devoted to the symbols of the Morning Star. In Toltec art, therefore, the same opposition is found as has already been noted in the case of Tezcatlipoca and Quetzalcóatl. It is a circumstance symptomatic of the dichotomy of a nation, a dichotomy which was to have tragic consequences—the first, at the end of the tenth century, when the exiled king departed to found Chichén Itzá, the second in 1168, when the Toltec warriors were vanquished by barbarians of similar stock. The chroniclers call them Chichimecs which is simply a generic name for the nomadic peoples of the north. Indeed, it is plain that the internal struggles of the kings of Tula accelerated the fall of a power which had, none the less, succeeded in dominating the greater part of pre-Columbian Mexico, thus presaging the Aztec empire.

IV. The Ritual Esplanade of Monte Albán

The subject of our first three chapters has been the art of pre-Columbian Mexico in the Altiplano region, from its origins to the fall of Tula in the twelfth century. We have analysed the pre-Classic period in which pottery betrays an Olmec influence, the Classic period which saw the apotheosis of Teotihuacán and, finally, the Epiclassic, or Mexican medieval period of Xochicalco, Cacaxtla and Teotenango.

We shall now resume our chronological survey, this time in a different part of the country, namely the valleys of Oaxaca in the sub-tropical zone some 350 kilometres south-east of Mexico City. The inhabited valleys of this mountainous district lie at an altitude of 1,500 metres, or nearly one thousand metres lower than the high plateaux. They are dominated by massifs, the highest of which is Cerro Yucuyacula, rising to about 3,400 metres. Two peoples, in particular—the Mixtecs and the Zapotecs (preceded by the pre-Zapotecs)—settled in this region, reaching their apogee at different periods. The first appearance of the Zapotecs who, along with their language, have survived to the present day, would seem to date back to the dawn of the Classic era. It was they who were responsible for the spectacular structures at Monte Albán. The Mixtecs, on the other hand, having first settled in the northern part of Oaxaca, gradually encroached on the Zapotecs as the latter declined in the ninth century, and reached their zenith between the eleventh and thirteenth centuries.

Hence this chapter will be devoted to the Zapotecs and to their predecessors and will largely revolve round the ceremonial esplanade at Monte Albán, while the achievements of the Mixtecs will be dealt with in the next, covering the period up to the Aztec conquest in the fifteenth century.

As we have already noted, there were numerous points of contact between the different cultures—interchanges and reciprocal influences which confirm the notion of a common legacy, a notion that must never be lost from view in any study of the Pre-Columbians. Hence it would have been perfectly legitimate to begin by considering the pre-Classic cultures as a whole, before turning to the various Classic civilizations and, finally, to the post-Classic period. However, we thought it preferable to take each region in turn—the high plateaux, the sub-tropical zone, the Gulf Coast, the North and the West—and to present separately the changes that determined the evolution of forms, proceeding, as it were, from cause to effect. In this way we hoped to discover what it is that constitutes the 'personality' of each culture, considered as a living entity which is born, develops, reaches full maturity, declines and dies.

64

65

Such an approach inevitably involves a certain amount of repetition. But it has the advantage of clarity as compared with the indiscriminate juxtaposition of societies whose alien character and apparent inaccessibility might deter the reader. In the case of Oaxaca, therefore, we shall follow the development of the arts, starting with the pre-Classic period whose mysterious beginnings coincide with the emergence of the first signs of an aesthetic sensibility.

A Man-Made Acropolis

Situated at the junction of three valleys, the lofty eminence of Monte Albán rises some 400 metres above the surrounding plain to form an astonishing gallery commanding the vast landscape of Oaxaca. Generations of architects, masons and labourers carved the upper esplanade out of the hog's back which runs north-south and measures 750 by 250 metres. The whole of this area of twenty hectares or thereabouts was levelled, moulded and adapted by the hand of man to produce an immense urban complex. Here, at the summit of Monte Albán, there is not a patch of level ground, not a slope or a crest that has not been artificially created. This gigantic, rigorously planned ceremonial centre comprising terraces, pyramids, platforms, palaces, courts and tombs, took over a thousand years to acquire the appearance we are able to reconstitute today on the basis of the surviving ruins. At the time Monte Albán must have resembled an ant-heap as vast multitudes of workers swarmed over the mountain they laboured to transform (Pls. 64, 65).

The men responsible for this grandiose open-volume composition in which some twenty complexes are clustered around an immense plaza measuring 300 by 150 metres, literally sculpted the landscape, shifting tens of thousands of tons of material after they had tackled the rugged slopes as though they were so many sand heaps.

We shall presently consider the elements that go to make up this astonishing city in which priests and high dignitaries lived midway between earth and sky, between the farmers of the plain and the gods to whom they dedicated this awe-inspiring oblation, this vast stairway ascending to the celestial world.

In earliest antiquity—i.e. in the Formative and pre-Classic periods— men chose this site of infinite vistas and made of it a temple of religious thought, almost a mystical acropolis, and a meeting-place in which the omnipotent shamans and the initiates might converse with the higher powers. That is why Monte Albán is the cultural hub of Mexico's sub-tropical zone. It was the starting-point for the adventure of a people which succeeded in attaining a level of civilization virtually unequalled in the New World. For on this gigantic 'mound' 2,000 metres above sea-level the Mexicans created a pendant to the vast 'bowl' in the plain of Teotihuacán. Here they forged an art that was at once coherent, rigorous and powerful and which marks one of the most significant moments of the pre-Columbian message.

The Riddle of the Danzantes

Monte Albán would seem to have been inhabited as far back as 900 or 1000 B.C. At some time during the pre-Classic period, between 500 and

64 Aerial view of the esplanade at Monte Albán. At the top of the photograph are the two complexes known as System M (left) and System IV (right) with, between them, the Danzantes Palace. In the middle are the three temples of the central complex, to the left of which is the Observatory or Mound J. In the foreground, the ball-court.

65 General view of the esplanade at Monte Albán from the northern quadrangle. In the middle of the picture are the drums of masonry columns which once formed part of the triple triumphal arch, a masterpiece of Zapotec architecture. Back right are the two complexes System M and System IV, flanking the Danzantes Palace. Back left, the great south platform.

150 B.C., there emerged one of the most mystifying art forms of the New World in the shape of large, upright slabs carved with representations of strange personages called Danzantes by the archaeologists who discovered them. The name derives from the wild, disconcerting gestures, the curious poses and the supple, animated forms typical of these figures which, when recumbent, are known as 'swimmers'. Each of these slabs—in effect orthostats—displays only one figure carved in low relief. Set in a row they may serve as cladding for the entire base of a building, a notable instance being the palace west of the esplanade and known as Los Danzantes. Other reliefs appear to represent symbols of towns, and occur mainly in the vicinity of Mound J, also known as the Observatory, on the central axis of the esplanade (Pls. 66–8).

The interpretation of these pre-Classic works adorning the walls of several buildings on the site has given rise to much speculation. Historians, however eminent, and archaeologists, however competent, are apt to become lost in conjecture when faced with this archaic, powerful and incontestably original art form.

Some authorities have discerned in these figures, not only dancers and swimmers, but also shamans in a state of trance and personages castrated to produce ecstasy, while others believe the works to be of Olmec origin, thus endorsing the thesis that Olmec tribes were present in Monte Albán in the pre-Classic era. They are at pains to find parallels between the motifs on certain stelae and the altars at La Venta or San Lorenzo on the one hand and, on the other, the incised decoration of the Monte Albán slabs which, however, have nothing in common with the sense of plasticity evinced by Olmec sculptors. In the first examples, the treatment evokes a third dimension thanks to an exceedingly subtle champlevé technique, whereas the slabs lining the pre-Classic structures in the Zapotec capital confine themselves to a schematic, linear representation devoid of any real plastic character (Pl. 69).

Nevertheless, allusions to Olmec sources have become increasingly frequent over the past fifty years. Yet in the treatment of the Danzantes we find neither the confident sense of volume peculiar to the aristocratic and ordered art of the Olmecs, nor the latter's symbolic repertory comprising the baby faces and the sacred jaguar's drooping mouth. Unlike Olmec art whose firm lines imply the existence of muscles beneath the skin and of the body's architecture, the Danzantes are characterized by flaccid if compact lines that envelop and yet are free. The faces, always in profile, display an extraordinary variety of physical types, from the hook-nosed and bearded to the round-headed, heavy-featured, thick-lipped type once described as 'negroid' and sometimes likened to the colossal heads of Olmec origin.

In short, a comparison between these carved slabs and Olmec bas-reliefs tends rather to underline the differences in treatment and reveals at most a very distant affinity, a debased echo, as it were, of Olmec art. At Monte Albán, as on the Altiplano, nothing of purely Olmec origin is found save for ceramics—evidence of the existence of intercourse and commercial exchanges between the Gulf and Oaxaca, for the Olmecs must necessarily have had recourse to that region's mineral resources if they were to obtain the hard stone they needed. Another interesting parallel arises out of the discovery at Monte Albán of the same numerical notation as on the famous Stela C at Tres Zapotes. This takes the form of dots and bars, one dot signifying one unit and a bar five units,

66 One of the finest of the sculpted slabs known as Danzantes. It depicts a squatting figure with closed eyes. In front of the mouth is a hieroglyphic sign, possibly denoting a name. These pre-Classic carvings from Monte Albán date back to the pre-Zapotec period between the fifth and second centuries B.C.

67 The sculptor of this Danzante at Monte Albán has made the most of the natural colouring of the rock. As in the preceding example, the figure has a large, round head and is wearing ear discs. Here, however, the hieroglyphic sign is to the right of, and above, the figure.

68 A Danzante at Monte Albán, this time bearded and with aquiline features but without an accompanying glyph.

66

67

68

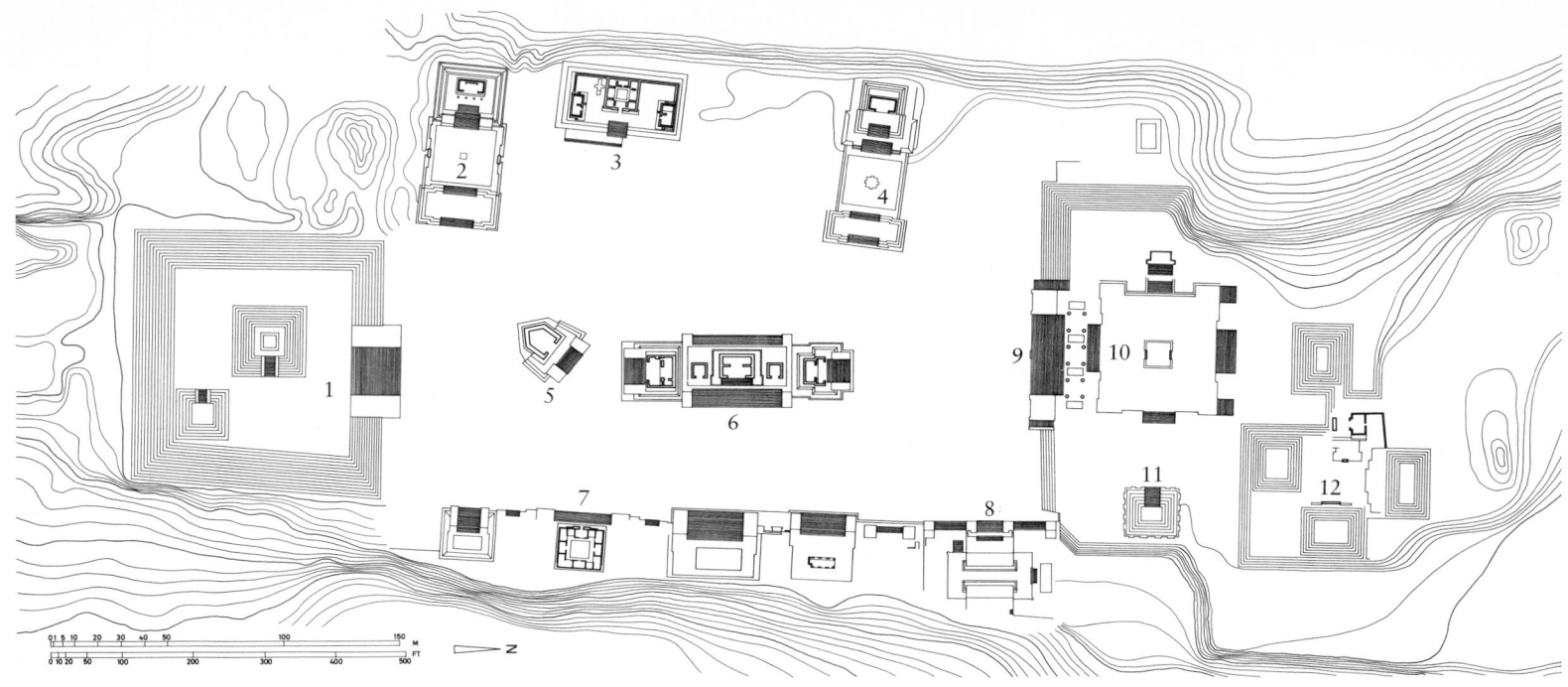

a pre-Classic system later adopted both by the people of Xochicalco and by the Mayas.

On the other hand we should stress the stylistic homogeneity of the 320 large carved slabs at Monte Albán. This applies not only to the figural Danzantes series but also to what we shall call the 'town' series. Colossal in scale—as often in civilizations that are 'primitive' in the sense that they go back to the origins of art—these early aesthetic manifestations attain from the first a very specific and unified form of expression, for there is nothing experimental about them. The figures are governed by a common convention which aims at a given mode of representation.

Recently, John F. Scott, in a thesis written in 1971 and published in 1978, advances an original hypothesis, namely that the Danzantes were in fact sacrificial victims. In our view this interpretation should be accorded the closest attention by specialists, since it is based on a sound reading of the carvings. As indeed may be seen, the eyes of the figures are closed, their mouths sometimes open and their limbs apparently dislocated. The intention may have been to commemorate a sacrifice to the gods, to record permanently in stone what was a momentary act, or to recall the execution of a vanquished enemy, just as the 'towns' may have denoted victories scored by Monte Albán over its neighbours. While their true function still remains in doubt, the fact of their being representations of dead men, possibly sacrificial victims, casts a certain amount of light on these enigmatic works. For if that is the case, the figures would be those of enemy kings or chiefs sacrificed to the gods of the sacred city. However, the stelae might also have been intended to extol the might of the Oaxacan capital, a form of expression often found in Pharaonic Egypt and elsewhere. The few hieroglyphic signs that appear on the slabs might confirm this interpretation by revealing the name of the king, the people or the town. But these writings—in most cases restricted to one, two or three signs—have so far resisted all attempts to decipher them.

It is none the less surprising to note the existence, as far back as the Monte Albán I period (350–100 B.C.), of hieroglyphic writing, albeit of

Plan of the Esplanade at Monte Albán
1 South platform
2 System M
3 Danzantes Palace
4 System IV
5 Mound J
6 Central group
7 Palace
8 Ball-court
9 Stair and portico
10 North quadrangle
11 Edifice A
12 North complex

a rudimentary kind, with signs for numbers and with names apparently denoted by pictographs.

Before we leave the pre-Classic art of Oaxaca, mention should be made of the reliefs found in 1966–7 at Dainzú, an archaeological site near Yagul and some forty kilometres from Monte Albán. It was here that Ignacio Bernal uncovered a series of revetment slabs displaying incised figures in a style akin to that of the Danzantes. They are not, however, representations of corpses with closed eyes, but rather of personages whom Bernal has identified as ball-game players.

On thirty-three out of the forty-one slabs discovered, the figures are shown in dynamic poses, often squatting and sometimes bouncing a large ball. Bernal assigns the carvings to the beginning of Monte Albán II (i.e. between 150 B.C. and 100 A.D., a period marking the transition from pre-Classic to Classic) which puts them somewhat later than the Danzantes. Hence, if his supposition is correct, it is evident that the ball-game, which originated in the Olmec country, reached the Oaxaca region very early on. The fact that two of the Dainzú figures wear an effigy mask of the jaguar god provides an interesting parallel with Olmec civilization, in which the existence of masked players is attested by more than one sculpture.

No sooner, then, do we look for Olmec sources in one direction (the Danzantes) than they promptly crop up in another. Indeed the references both to the ball-game and to the jaguar's mask are far more convincing than the all too rare analogies with Olmec art displayed by the carved slabs at Monte Albán. And by no means the least puzzling aspect of the latter's influence is that it first made itself felt when Olmec civilization was already on the wane and that it affected Monte Albán II rather than the Formative art of Monte Albán I.

The Pre-Classic Architecture of Monte Albán

But to return to the orthostats at Monte Albán. What is particularly striking about this series of large carved stones encasing the platforms of certain pre-Classic structures is their enormous size—yet another example of their affinity to Olmec art. They must, one imagines, have been dressed, transported to the site and erected by the hundreds of captives who made up the victor's labour force. Thus, Monte Albán's own contribution would have been confined to the work of its sculptors, members of a people whom we describe as pre-Zapotec for want of more accurate information.

There can, however, be no doubt—and accounts of the excavations made half a century ago by Alfonso Caso, father of Mexican archaeology, seem to bear this out—that the carved slabs served from the outset as revetments for the platforms. In other words they were not first designed as stelae and then re-used as retaining elements for a Classic structure. If the Danzante and Town slabs are in fact in their original position, we can only infer that their authors were also architects of outstanding ability, for in that case they must have been responsible for a series of major monuments going back as far as the pre-Classic period.

These structures have been subjected to so many alterations and superimpositions, however, that, in the present state of the excavations, no precise idea can be gained of Monte Albán's early architecture. We can

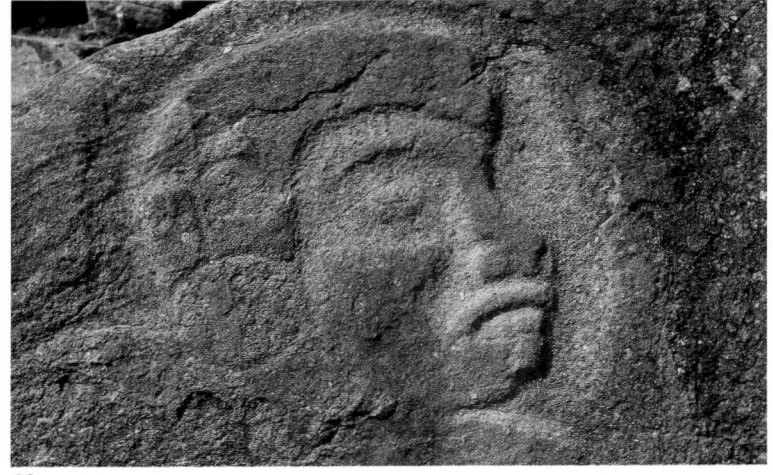

69

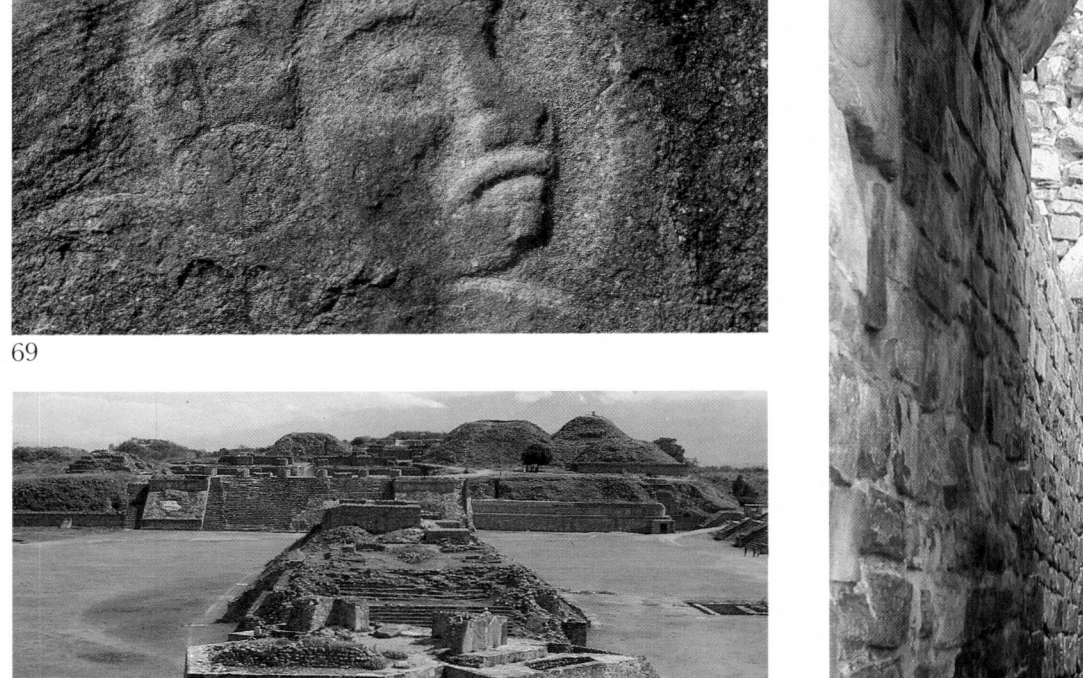

70

71

72

only say that at one time the carved slabs lined large platforms presumably supporting superstructures of which, for the most part, little or nothing remains. And it has now been established that the majority of the early buildings bordered by these slabs face some 7° or 8° south of east, an axial arrangement that applies particularly to the group comprising the Danzantes Palace, the temple known as System IV which flanks it to the south, and System M which echoes the latter to the north (Pl. 75).

The orientation of these three buildings occupying the whole area west of the esplanade varies slightly from that of the other complexes. Together with Mound J, a structure likewise lined with orthostats but differently orientated, the group may have formed the original nucleus of the ceremonial complex.

Of the three buildings in this group which, as we have seen, presents a contrast to the precise north-south orientation typical of the Classic period, two are worthy of analysis by reason of their highly original disposition. Possessing all the characteristics of a place of worship, these two similar structures, System IV and System M, typify the sanctuaries of Monte Albán and differ considerably from those of Teotihuacán. Both consist of three components: a) a square western pyramid surmounted by a now ruined, east-facing temple which is served by flights of axial stairs; b) a square plaza with a central altar in front and to the east of the pyramid; c) a platform, its east and west faces ascended by stairs, which precedes the plaza.

These three architectural components, namely the platform, the plaza and the pyramid surmounted by a sanctuary, together form a unified complex of 75 by 35 metres lying on the cross-axis and facing some 7° or 8° south of east. Now, these temples on the upper part of the Monte Albán esplanade may have served as a kind of geomantic station such as was often erected by the Pre-Columbians. An observer standing halfway up the stair on the east face of the pyramid and looking eastwards across the plaza might easily select a datum point, say a post or a stela, at the centre of the entrance platform. This point would then provide him with an accurate line of sight to the horizon. By taking an astronomical observation of this kind, he could determine where the sun would rise on any particular date. At Monte Albán, on latitude 18°N, the sun rises on an axis of 8° south of east on 21 December, i.e. the day of the winter solstice, the most southerly point reached by the sun in its celestial course. This may be found by applying the classic astronomical formula: $\cos H = \tan \delta \times \tan \psi$ (where δ is the declination of the sun and ψ the latitude, from which we get an azimuth of 82° relative to south or 8° relative to east). As a result of this investigation we have to rectify a statement in our book, *Ancient Mexico* (1967), in which the equinox was assumed to be the determining factor.

From the foregoing it follows that the earliest edifices at Monte Albán were built as places for the celebration of feasts marking the renewal of the solar year, the lengthening of the days, the beginning of the vital cycle and the rebirth of life. We might add that, in the two groups known as System IV and System M, there occurs another constant which has already been noted at Teotihuacán, namely the correlation between pyramid and court, between positive and negative. But here this complementary arrangement of hollow and solid is even more successful. Indeed the architects of Monte Albán may be seen to have achieved an organic whole thanks to the composition of the Systems whereby the

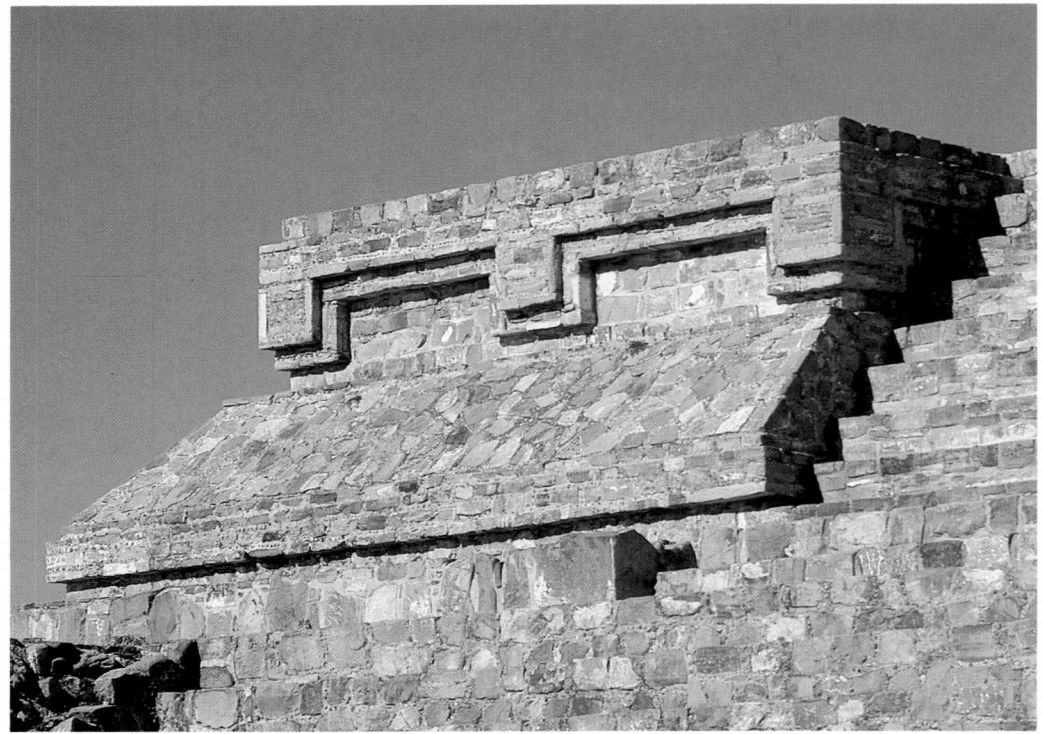

73

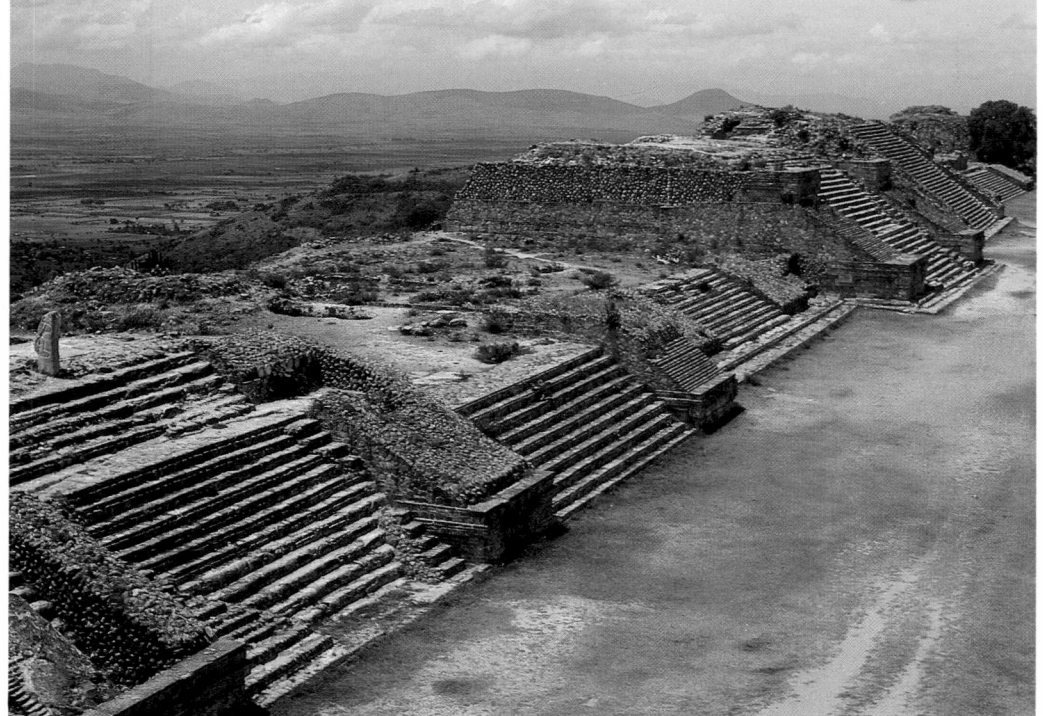

74

75

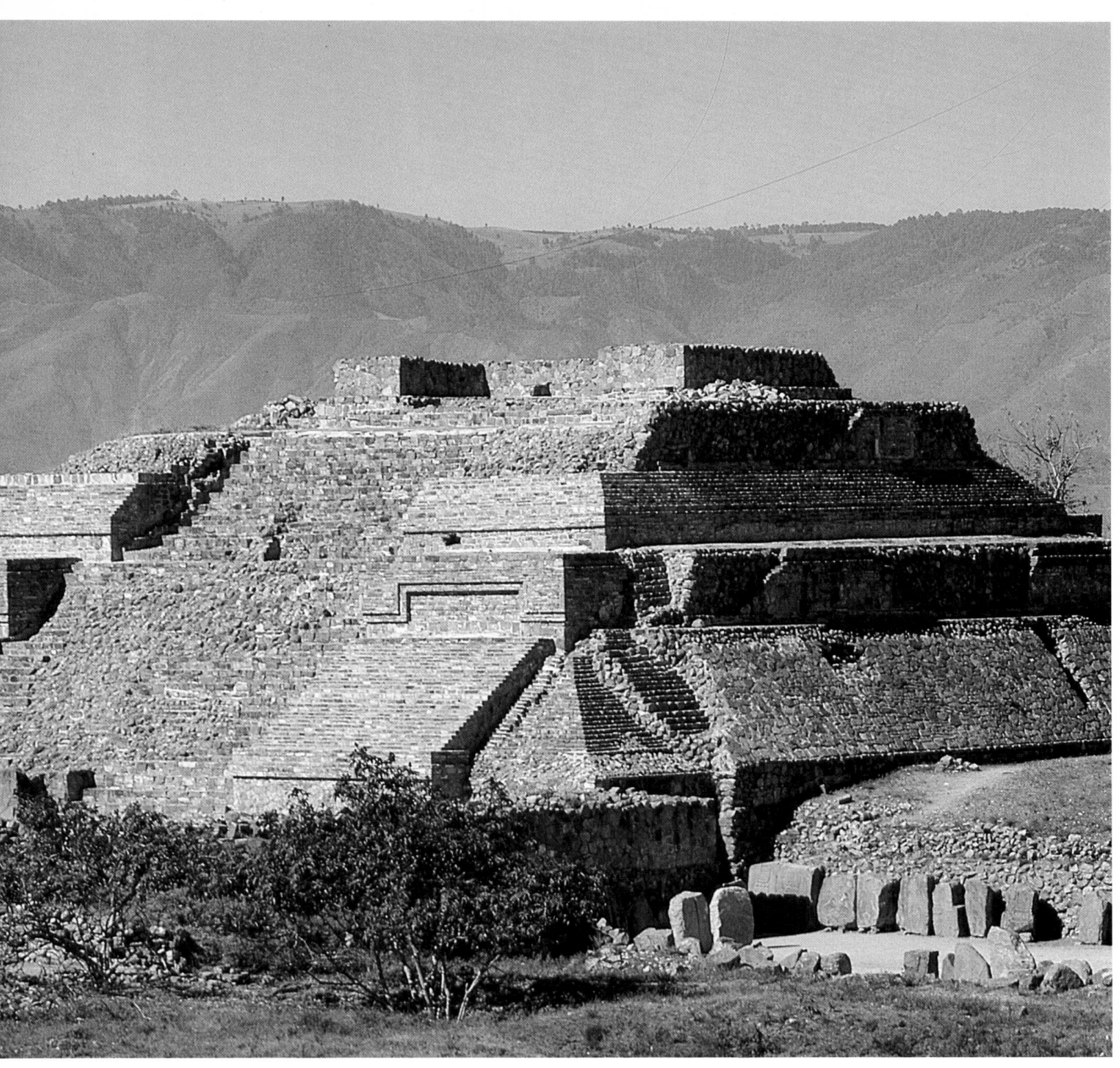

central court corresponds exactly to the pyramid in a wall-girt ensemble of remarkable coherence. Such then, was the scene of the great ceremonies which must have been enacted at three different levels—on the entrance platform, down in the court and in the cella which crowns the pyramid and dominates the entire complex.

The Buildings of the Classic Period

After this campaign of construction, Monte Albán appears to have undergone some profound changes, possibly as a result of the arrival in about 150 B.C. of a new people, and with it the introduction of authentically Zapotec elements. At all events, with the dawn of the Classic period, the use at Monte Albán of large revetment slabs ceased, as did the representations of Danzantes and towns.

Before we consider the buildings of that period, we should, perhaps, say a few more words about Mound J, also known as the Observatory. It is disposed quite differently from the other buildings on the site. On plan it resembles the prow of a ship, which would seem to suggest some sort of sighting-line. Yet it is difficult to say what might correspond to its axis, running as it does some 38° west of south. We should also note that some of the revetment slabs, unlike those lining the Danzantes Palace, appear to have been re-used. Moreover, what we now see probably bears little resemblance to the original structure which was altered during Monte Albán II (Pls. 70, 71).

An unusual feature of the Observatory is an old passageway which traverses it and is covered by stone slabs that meet in a point. The line of the passageway runs 17° east of the esplanade's north-south axis, i.e. at right angles to the axis of the Sun Pyramid at Teotihuacán. Accordingly, there is no connection between the 17° here and the angle marking the zenith setting of the sun. It is hard to see what observations might be made from this curious structure. On examination we find that the view to the north is obstructed by a wall and to the south by a pyramid. We may therefore inquire whether this opening, which runs diagonally across the building, fulfils any sort of astronomical function and whether Mound J was in effect an observatory.

The Zapotecs freely refashioned the buildings they found at Monte Albán but, for their new edifices, adopted an orientation that was more strictly aligned with the meridian, as is evident in the complexes at the centre of the esplanade and those to the north, east and south of it. Only the east face of the latter group of pyramids fails to conform, as we have already said.

Thereafter the esplanade as a whole was bounded by edifices, some twenty complexes being ranged round the vast space occupied by the ceremonial centre. All the peripheral buildings face inwards, turning their backs on the surrounding precipices. A central spine runs through the plaza from north to south, and comprises three elements—a sanctuary at either end and, in between, a block of three east-facing temples, the chief of which, with its higher base, dominates the ensemble.

To the east, the esplanade is flanked by big flights of stairs leading to sanctuaries and palaces and forming an imposing vista (Pl. 74). At the northern end of these six buildings is a ball-court in the customary form of a flattened H and with steeply sloping sides. There is no sign of rings

76 Dating from Monte Albán II, between 150 B.C. and 100 A.D., this magnificent ceramic sculpture is one of the masterpieces of Zapotec art. The cross-legged figure wears a head-dress bearing a hieroglyphic sign and the number 13 (two bars, each indicating 5 and three dots indicating units); on his breast is the same number, surmounted by another hieroglyph. The protuberant, drooping lips are reminiscent of the Olmec style. Height 32 cm. Oaxaca Museum.

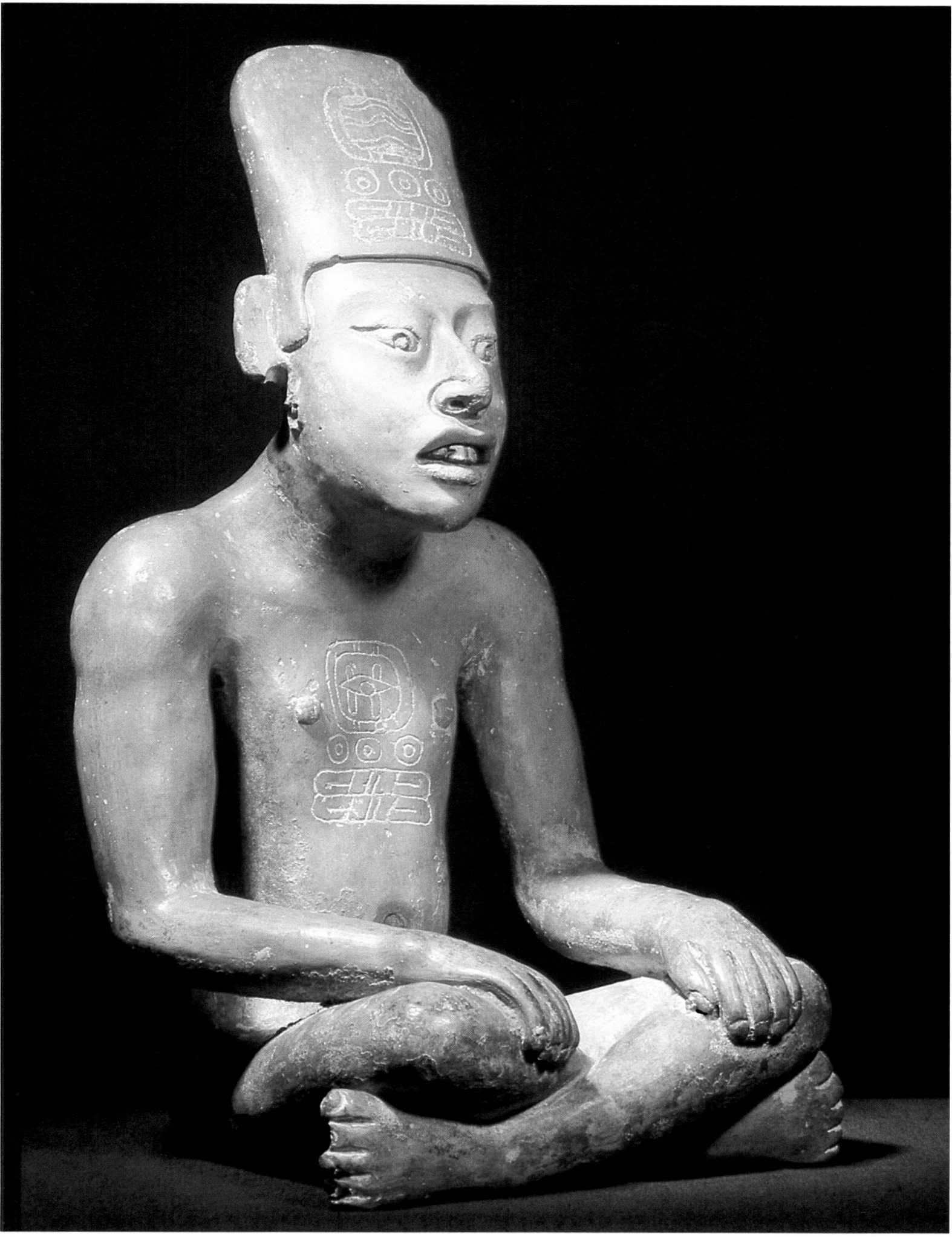

such as are found at Xochicalco and Chichén Itzá. In its present form this structure dates back to Monte Albán III (Pl. 72).

If it be remembered that the northern and southern extremities of the esplanade are occupied by lofty pyramidal platforms, themselves the base of several (as yet unrestored) pyramids, the grandiose appearance presented by the Zapotec capital may readily be imagined. Nowhere is there a surface that has not been fashioned by the hand of man. Here nothing has remained in its natural state. Rather, the whole environment has been tamed, geometrized and sculpted, to become at last a mighty anthem to the gods. And even though the site may not attain the gigantic proportions of Teotihuacán, its commanding position endows it with a sovereign majesty.

Though we do not propose to enter any further into the town-planning aspect of the major complexes at Monte Albán, it would seem pertinent to analyse the city's architectonic components. For the plastic vocabulary adopted by the Zapotecs for the mouldings adorning their buildings was of a new kind. A comparison with the tablero system at Teotihuacán reveals that the Monte Albán designs are based on the inclined plane which plays a far more important rôle than does the simple talus of the 'place of the Gods'. Here, however, the slopes are defined by the verticals of the terrace risers which form a dentilled frieze (as it were inverted crenellations) and thus lend vigour to the profiles. As at Teotihuacán, these pronounced, cornice-like mouldings are used to accentuate the plastic effect of the pyramids which would otherwise be diminished by the overhead light of the tropics (Pl. 73).

Another highly original departure was the use of cylindrical masonry columns as opposed to the square piers at Teotihuacán. Astonishing results were achieved by setting them close together, as in the temple entrance of System M, or by deploying them in porticoes, a notable example of the latter being the six pairs of immense shafts, 2 metres in diameter, which surmount the 50-metre-wide stairway ascending the northern platform. This diaphanous structure once formed a three-bayed triumphal arch at the entrance to the quadrangle, and undoubtedly represents a most innovative contribution to the pre-Columbian view of architecture.

Thus the Zapotecs displayed considerable plastic sensibility and, in their sacred architecture, achieved a subtle mastery in their handling of volume and space. But their palaces appear to be less sophisticated than those at Teotihuacán, being confined to square buildings with a central court. However, the influence of less distant neighbours, the Mayas, is discernible in the stelae, some of these large standing monoliths being covered with hieroglyphic signs—notably dates—but virtually devoid of ornamental carving.

Finally, mention should be made of the fine Zapotec tombs of which there are close on 200 at Monte Albán. These hypogea, often built beneath a funerary temple, may be roofed with large slabs, either trabeated or in the form of a pointed vault. However, we shall revert to these structures which prove that the Zapotecs practised burial rather than the cremation of the dead customary in Teotihuacán. For these tombs, which were later to be re-used under Mixtec rule, have provided Mexican archaeology with some spectacular finds.

Before completing this survey of Zapotec architecture at Monte Albán, it should be recalled that the ceremonial centre was not the work of a

single intelligence but resulted rather from innumerable refurbishings, accretions and superimpositions spanning almost a thousand years. It was not till after Monte Albán II (150 B.C. to 100 A.D.), which had ushered in the Classic era, that the city experienced its heyday in the period of Monte Albán III (150–400 A.D.). This was followed by Monte Albán IIIA which lasted until the eighth century, long after the collapse of Teotihuacán. There followed a decadent phase known as Monte Albán IV which marks the decline of the Zapotecs and the rise of the Mixtecs.

Zapotec Urns

If we except the Mayas, the Zapotecs were, perhaps, the most prolific Mesoamerican potters of the Classic period. They produced quantities of lavishly decorated pieces intended, not for use, but for purely ritual purposes, which have come down to us in their thousands. As a rule the finest examples of Zapotec terracottas were placed in tombs (Pl. 76).

These pieces, found in the burial chambers of Monte Albán and the Oaxaca region, have been dubbed 'funerary urns'. In fact they are hollow clay sculptures with appliqué elements which, around the figure of a divine personage, often include a wealth of identifying attributes. The Zapotecs would place these pieces in funerary crypts, often above the door of a chamber in which the dead were laid. They accompanied the deceased into the other world, protecting him and acting as a viaticum, but they never served as repositories for human remains. In that sense, they are strictly speaking not funerary urns, despite their functional links with the cult of the dead. In these pieces the god is shown sitting cross-legged and adorned with accessories that distinguish him from the many other deities in the Zapotec pantheon. Unobtrusive at the outset, these distinctive elements proliferated in the course of time until they played a predominant rôle—so much so, indeed, that the face, now a mere stereotype, was produced with the help of a mould. In the Classic era the quality of these pieces was outstanding (Pls. 78–83).

The expressive power of the urns which, as befits a deity, are almost always symmetrical and static, brilliantly exemplifies the talent of the Zapotec sculptors. For the treatment of the faces, whose modelling is akin to that of the Teotihuacán masks but in this case opulently embellished, is for the most part structurally very pure. The eyes are precisely defined, the outline of the lips almost overstated, the cheeks delicately modelled and the nose fine and straight. This is truly Classic art. The head-dresses and sumptuous ornaments that go with them are rendered with meticulous care.

This pottery, whose function was symbolic, often attains a rare degree of plastic perfection which is not apparent, however, unless one looks beyond the baffling wealth of detail and analyses the features as such. From it we learn how intense was the aesthetic sensibility of the Zapotecs, even though in the course of time the ritual aspect tended to overlay the artistic quality.

Nevertheless, the fact remains that the artists of Oaxaca continued for almost a millennium to fashion these strange sculptures in the image of the innumerable gods that peopled their universe and were supposed to watch over them. The most important of these Zapotec deities, members of a pantheon reconstituted for us by ceramics, were Cocijó, god of

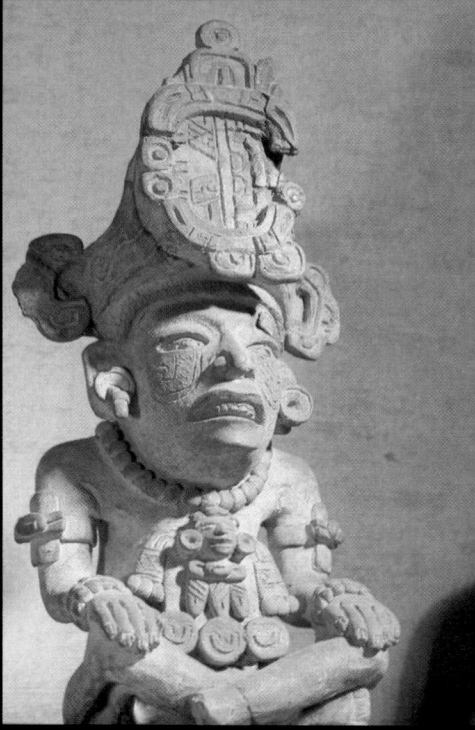

78

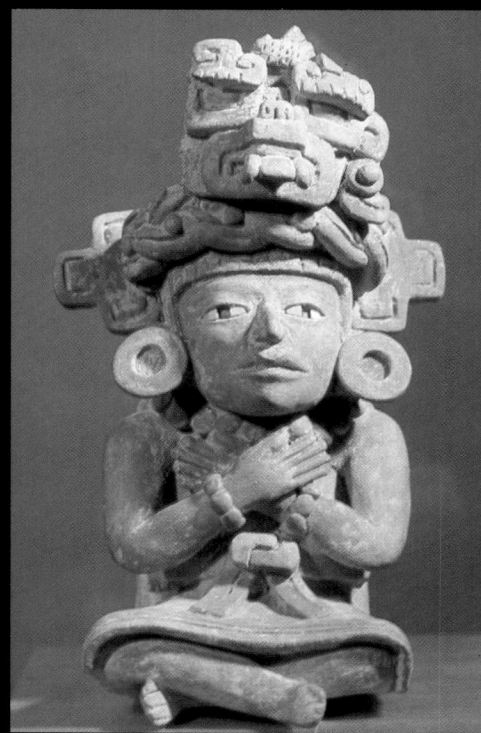

79

77

77 Stela known as the Bazán Stela from Monte Albán, representing a figure wearing a sacred jaguar's mask and a complex head-dress with a plumed crest. It dates from Monte Albán III, or between 150 and 400 A.D. and comprises a number of glyphs around the god of turquoise. Height 43 cm. National Museum of Anthropology, Mexico City.

78 A small Zapotec urn of the same period showing a richly adorned deity, wearing a head-dress at the centre of which is a glyph. Height 32 cm. National Museum of Anthropology, Mexico City.

79 The goddess Thirteen Serpent from Tomb 109 at Monte Albán belongs to Monte Albán IIIA, between the fifth and eighth centuries. The eyes are enhanced with mother of pearl and the ears adorned with large discs. Height 25 cm. National Museum of Anthropology, Mexico City.

80 Detail of large funerary urn from Monte Albán figuring the god of rain and thunderbolts, Cocijó, the equivalent of Tlaloc at Teotihuacán. The detail shown is about 50 cm wide. National Museum of Anthropology, Mexico City.

81 Large polychrome funerary urn from Tomb 77 at Monte Albán. The human face of the god is surmounted by the mask of a mythical animal (bird or snake). It is a work of great sculptural quality and dates back to Monte Albán III, some time between 150 and 400 A.D. The detail is about 50 cm high, out of a total height of 82 cm. National Museum of Anthropology, Mexico City.

82 Zoomorphic urn depicting the god One Jaguar. This Zapotec terracotta from the Cerro de la Campaña in Oaxaca is 42 cm high. National Museum of Anthropology, Mexico City.

rain, Huehuetéotl, god of fire, Murciélago, the bat god, lord of the night and the dead, the young maize god, the jaguar god, the goddess Thirteen Serpent, Quetzalcóatl, the Feathered Serpent and wind god, and Xipé Totec, god of spring and vegetation. Eventually all these deities, personifying the forces of nature, were to intermingle, borrow one another's emblems and acquire a plurality of powers, to the extent even of losing their own identity in one vast syncretic system.

The proliferation of these funerary urns, dug up on the numerous archaeological sites in the State of Oaxaca (no less than 200 cities are recorded in that region), has meant that the art of the Zapotec potters was one of the first in the New World to attract the attention of fakers. Certain copies date back to the middle of the nineteenth century, when they found their way on to the souvenir market through the agency of Maximilian's troops. With the building of the first railroad in 1880 the number of genuine finds increased. According to Frank H. Boos, however, public interest in this mysterious art had already been aroused as early as 1842, in consequence of an exhibition held in Seville.

The Working of Hard Stone

The use of metal was unknown to the Zapotecs as to the other Classic civilizations of Mexico. Yet they were highly skilled in the working of hard or semi-precious stones, such as onyx, jade, jadeite and other lithic materials which abounded in the mountainous district in which they lived. Indeed, it was in order to secure a supply of high-quality stones that the Olmecs had entered into close relations with this part of Oaxaca in the pre-Classic era.

The Monte Albán craftsmen, whose techniques were inherited from the Olmecs, gave proof of their skill in a large number of original works, notably the finely carved stela known as the Bazán, which shows the jaguar god in an upright position and wearing a head-dress richly ornamented with featherwork. This famous sculpture, belonging to the Monte Albán III period, also displays a great variety of glyphs constituting an as yet undeciphered pictographic writing (Pl. 77).

Like the Mayas, the Zapotecs would appear to have had a veritable passion for jade—the *chalchihuitl* or water symbol of the Aztecs—a stone they reserved for their finest pieces which they probably invested with magical properties. Here we might cite the mask in which close-set elements form an image of the bat god, Murciélago, lord of the dead. This work, of the Monte Albán II period, presages the Maya funerary masks, such as that in the crypt of the Temple of the Inscriptions at Palenque. It bears witness to a very vivid sense of the geometricity of forms. Pieces of shell have been used to enhance the eyes and give them a hypnotic effect (Pl. 84).

Tomb Paintings

Our knowledge of the pictorial art of the Zapotecs is confined to the frescoes with which some of the tombs at Monte Albán are decorated. For no trace remains of the polychrome paintings on stucco that must have adorned the other buildings here. In Tombs 104 and 105, on the

80

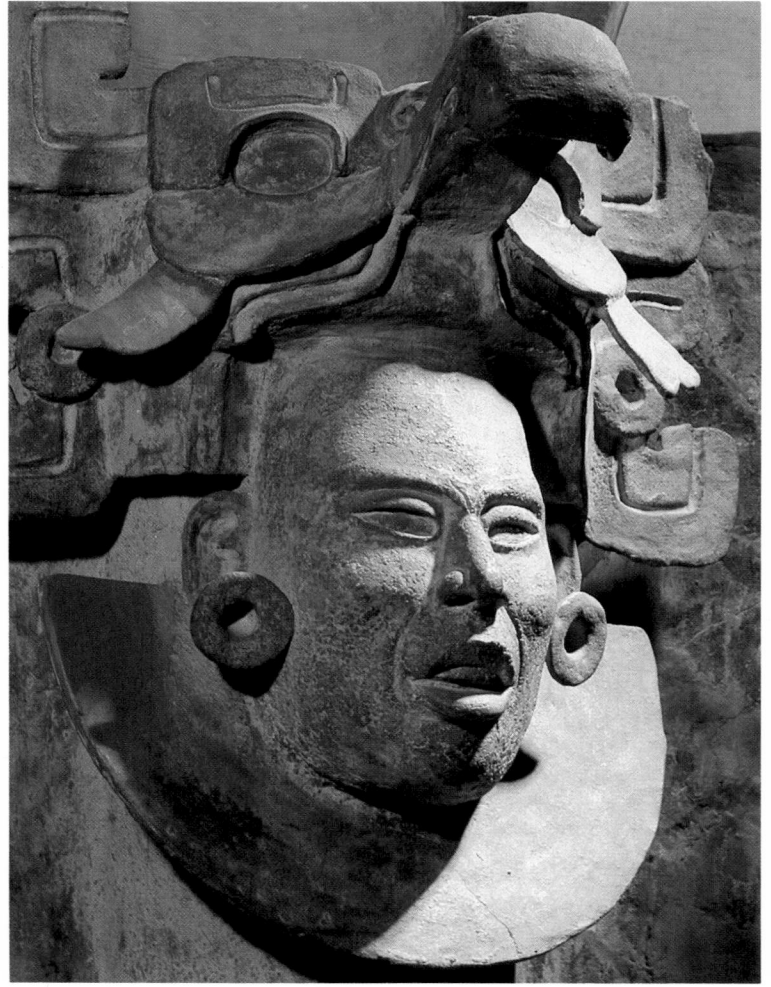

81

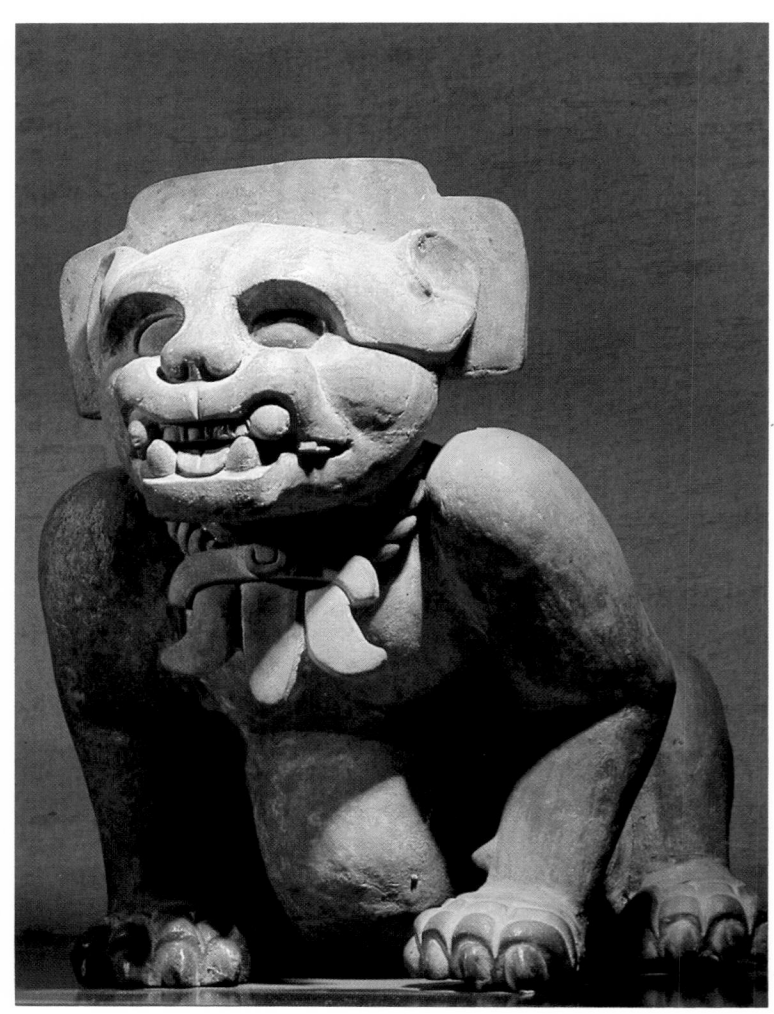

82

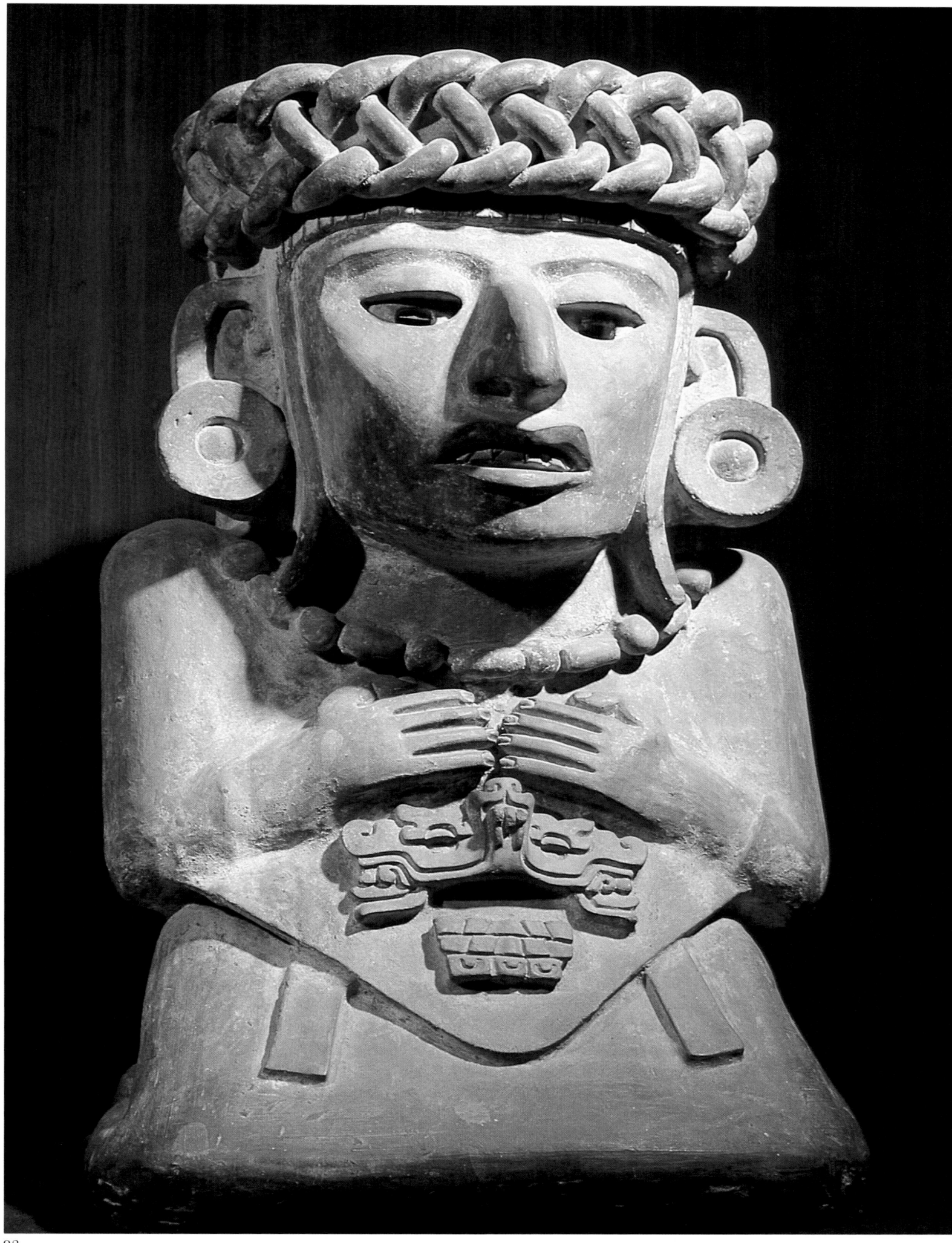

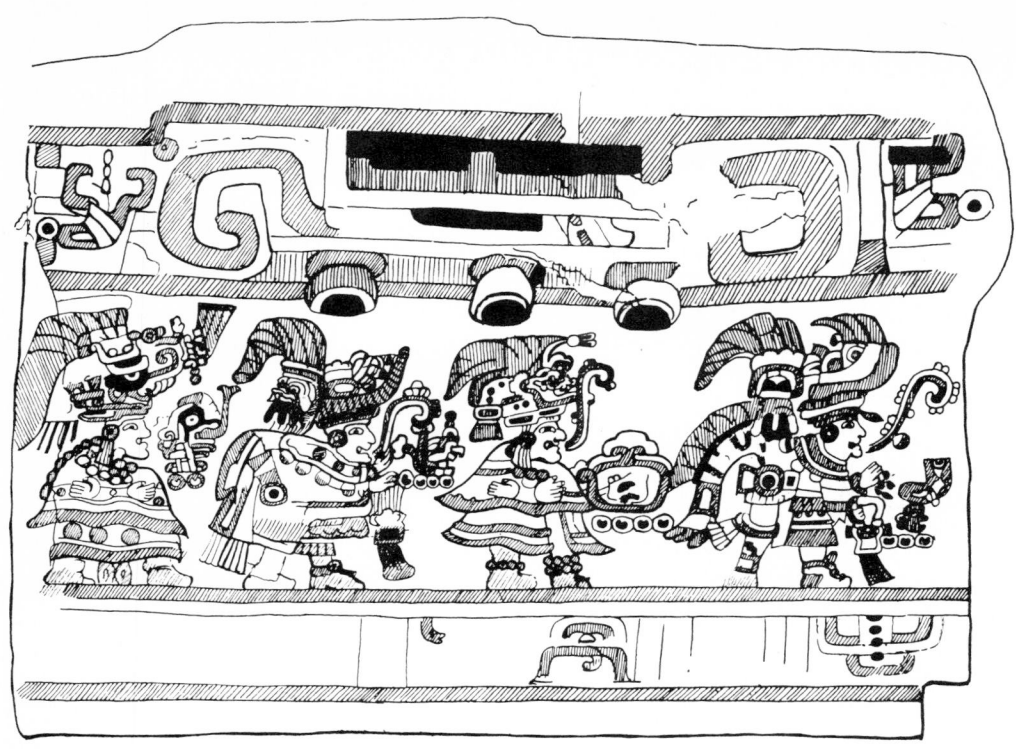

other hand, we still find wall-paintings and scenes featuring the gods. The latter, shown in profile and surrounded by graphic signs and symbols, testify to a remarkable stylistic unity. The pigments, red ochre, yellow, blue-grey and black, are applied to a monochrome pinkish beige ground.

Tomb 105 is cruciform and covered with paintings. Here we find eighteen gods and goddesses of the underworld, nine to either side, who process towards the doorway as if to confront the visitor and thus protect the deceased. Speech scrolls issue from their mouths to indicate that they are singing or uttering incantations.

As in the case of the urns, which also depict deities, the figures are stocky, the main emphasis being placed on the head with its tall plumed head-dress and on the costume accessories. The male garments are read-

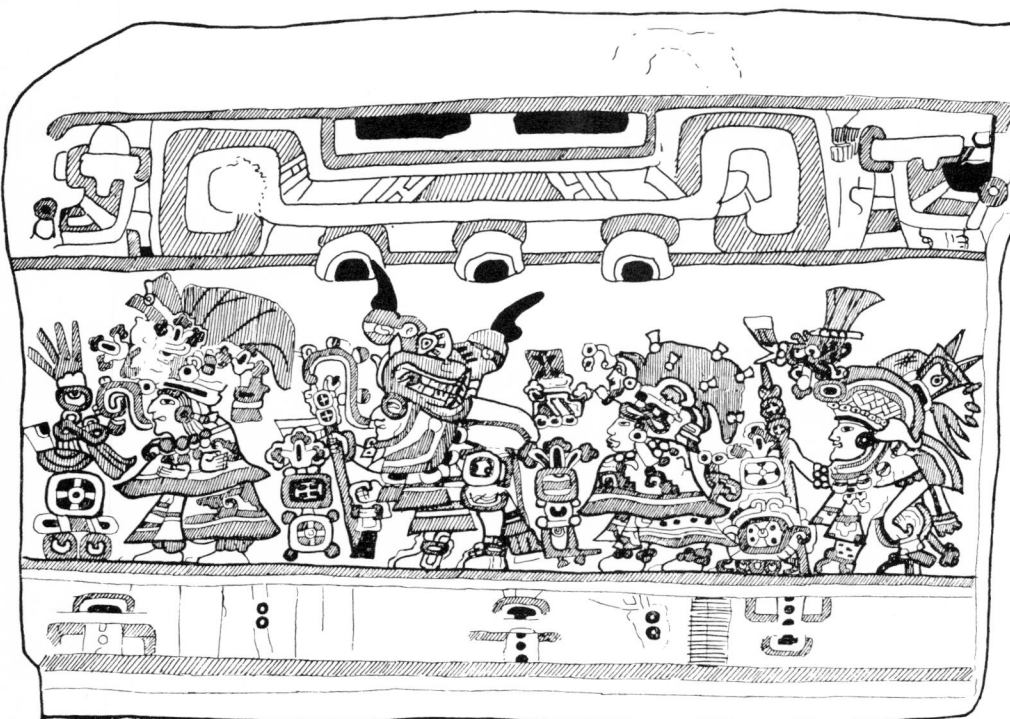

84

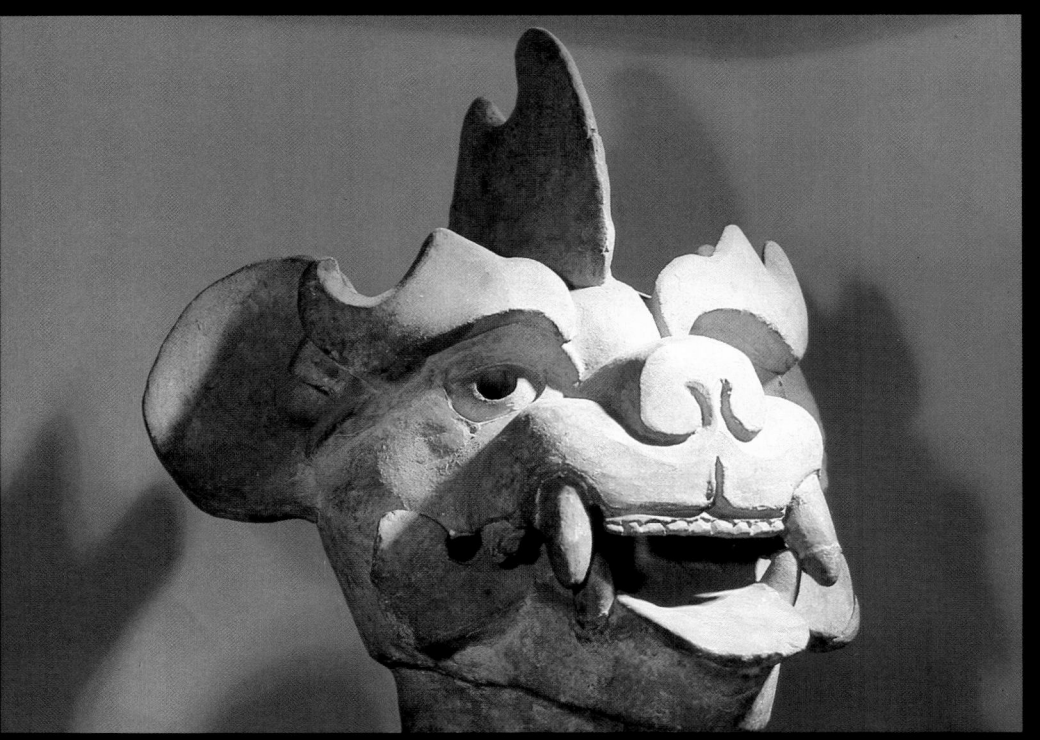

85

86

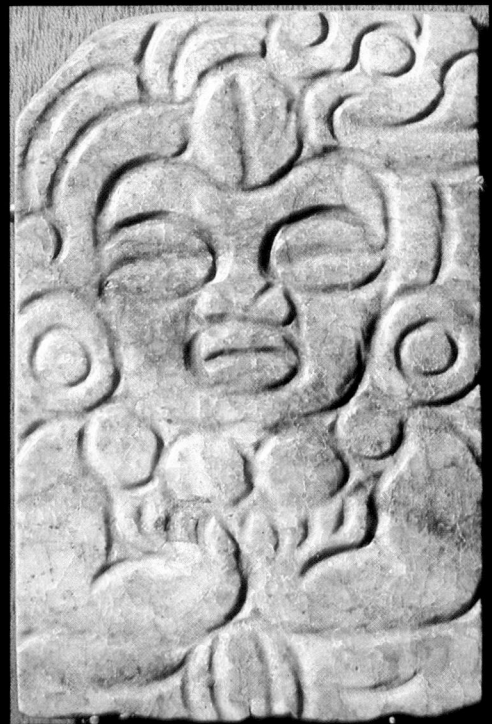

87

ily distinguishable from the female ones and consist of a kilt and a short coat or cape, probably embroidered in accordance with a tradition that still survives in the region today.

A profusion of detail provides us with information about the attributes of each of the deities. As in the sculptures, costume takes precedence over the subject's features, and there is no attempt at individualization. However, each figure is supplied with a name in hieroglyphic signs which corresponds to a date. For the date is at one and the same time the name of the god and the day of his feast, a convention that remained in force in the pre-Columbian world until the time of the Conquest.

Along the top of the wall runs a frieze adorned with large angular hooks representing the mask of the sky monster with eyes and huge fangs. From this it is plainly evident that the scene illustrated in these frescoes belongs to the Monte Albán III period.

A Theocratic View

All the works we have discussed above belong, not only to the Classic tradition of the Teotihuacán frescoes, but also and more especially to a form of aesthetics foreshadowing the schematism of the Mixtec codices in which the same conventions were used to depict the gods.

Thus Zapotec art derives from a view that was wholly theocratic. The civilization that gave birth to these works, imbued as they are with an intensely religious symbolism, was hierarchical in the extreme, as was the civilization of Teotihuacán. The architecture, painting and pottery of the Classic period were all subservient to the demands of ritual. The priests belonged to the upper social stratum and it was they who controlled the entire life of the community. The priestly caste, held to be omniscient and all-powerful, supplied the people of Monte Albán with a *raison d'être* in the shape of a religion, the greatest part of whose myths and forms of worship are unfortunately lost to us, even though we may sometimes succeed in identifying the major deities of the Zapotec pantheon.

But we are faced with a paradox surprising in so hieratic an art, namely the difference, in plastic terms, between the luxuriance of ritual pottery and tomb paintings on the one hand and, on the other, the austerity of the vast, grandiose architectural masses with their horizontal lines and long, denuded vistas. The Pre-Columbians of the Classic period were for ever seeking to strike an aesthetic balance between the almost ascetic starkness of the architectural volumes and the proliferation of richly detailed representations. And it is, perhaps, this apparent ambivalence that is the most baffling characteristic of the great arts of Mesoamerica.

V. The Mixtecs: Writing and Metallurgy

This chapter, devoted to the Mixtecs, brings us to a period characterized by considerable intellectual and technological advances. The Mixtecs first appeared on the scene some time in the eighth century, but it was not until after 1000 A.D. that they really came into their own. Their civilization saw the emergence both of gold-work—consisting mainly of personal ornaments—and of writing. The latter, based on pictograms and ideograms, is found in splendid manuscripts known as codices which came into being between 1200 and the Spanish Conquest.

Thus, rudimentary though this form of writing may be, it nevertheless introduces the Mixtec region into history some three centuries before the arrival of the Conquistadors. The system of pictographic and ideographic notation elaborated by the Mixtec chroniclers continued to be employed in the Aztec empire.

This period, which saw the emergence of post-Classic art and the rise of a new people, the Mixtecs, is marked by changes even more far-reaching than those wrought by the arrival on the high plateaux of the Toltecs of Tula. Indeed, there is ample evidence of mutual contacts and reciprocal influences between the two peoples during the period of their co-existence.

Mixtec Origins and Expansion

The Mixtecs—which, in Aztec, means 'people of the cloud country'—originated in the north-west of the State of Oaxaca and the south of the State of Puebla, the home of the Náhua peoples. During the period of their demographic growth the Mixtecs occupied three regions: at the centre, the mountainous Mixteca Alta, in the north, the plains of the Mixteca Baja adjoining the districts of Cholula and Puebla and, in the south, the Mixteca Costa on the shores of the Pacific.

Tilantongo, the first known capital of the Mixtecs, lies north-west of Monte Albán in the Mixteca Alta and is believed to have been founded in 692 A.D. It was from here that the Mixtec warriors set out to dominate a large part of the sub-tropical zone between the high plateaux and the lands of the Mayas.

For several centuries the Mixtecs and the Zapotecs contended for the control of the Oaxaca region. When, in the eighth century, the slow decline of Monte Albán began, the former gradually gained the upper hand. But they were always to preserve a profound feeling of veneration

88

89

for their predecessors. For them, then, Monte Albán played the same rôle as did Teotihuacán for the people of the Altiplano—that of mythical city and religious centre.

The first Mixtec victories were won at the expense of the Zapotecs in the east and of the Náhua peoples of the Cholula region in the north. From the eleventh century onwards a cultural entity comprising Oaxaca and the area round Cholula and Tlaxcala is known to have existed under the aegis of the Mixtecs. Hence the term Mixteca-Puebla which is frequently applied to its art and especially to its pottery. It was then that the Mixtecs assimilated the dualist modes of thought and the cult of the planet Venus, the Morning Star, which had characterized the Toltecs of Tula. Zapotec borrowings, on the other hand, are scarcely in evidence. For the Mixtecs drew their inspiration from the politico-religious movement then at its height on the Altiplano, a movement attuned to the spirit of post-Classicism. By so doing they abandoned the now outdated Classic traditions elaborated by Monte Albán, though they continued to venerate the former sacred city and to use it as burial-place for their illustrious dead.

Thus contact with Cholula led to the emergence of a mixed culture of great promise which was to find fulfilment in the Aztec empire. Yet several centuries were to go by before Mixtec power and Mixtec thought were to become properly established, and they did not assert themselves in the arts until after the eleventh century. But by then this long period of maturation had given rise to techniques and an aesthetic outlook of a completely new kind, and the break with the Classic past was complete.

Yagul and its Courtyard Buildings

The Mixtec penetration of the Zapotec region began with the occupation of fortified cities built on acropolises that commanded the surrounding countryside. Among them, Yagul provides a good example of a centre where the new architecture was taking root without supplanting the forms of Monte Albán.

The city is situated in the valley of Tlacolula some 30 kilometres from Oaxaca, and stands on an eminence that could be defended without difficulty. The site, of Zapotec origin, came into being several centuries before our era. But it was not until Monte Albán IV, under the influence of the Mixtecs (or rather the mixtecized Cuicatecs) that it reached its apogee and was given a large palace quarter with six courtyards. The city, which rises by stages, consists of pyramids and a fine ball-court some forty metres long, and similar in plan and size to that of Monte Albán. In the shape of a flattened H, it is therefore of purely Classic type and indicates that, despite cultural changes, the sacred 'sport' continued to be a *leitmotiv* of pre-Columbian civilizations, even though there might be a gap of several centuries between structures displaying the same characteristics (Pls. 88, 89).

Whereas the early pyramids at Yagul date back to about 900 A.D., the palaces are no earlier than Monte Albán V, in other words they may be assigned to the thirteenth century, if not to the beginning of the fourteenth. As we have already said, the palace quarter is the most important part of the city. Dominating the platforms and pyramids that make up the ceremonial centre, it flaunts itself in their midst as if to demonstrate

88 The Palace quarter at Yagul, between Oaxaca and Mitla. The Mixtec courtyard architecture is thirteenth century. The city dominates the rich plain of Tlacolula.

89 The fine ball-court at Yagul on a typical depressed H plan, which was restored in the early 1960s. Its kinship to the court at Monte Albán provides proof of a continuity extending from the time of the Zapotecs to the Mixtec period. The hills above the city were fortified by exploiting the existing cliffs which were reinforced with walls.

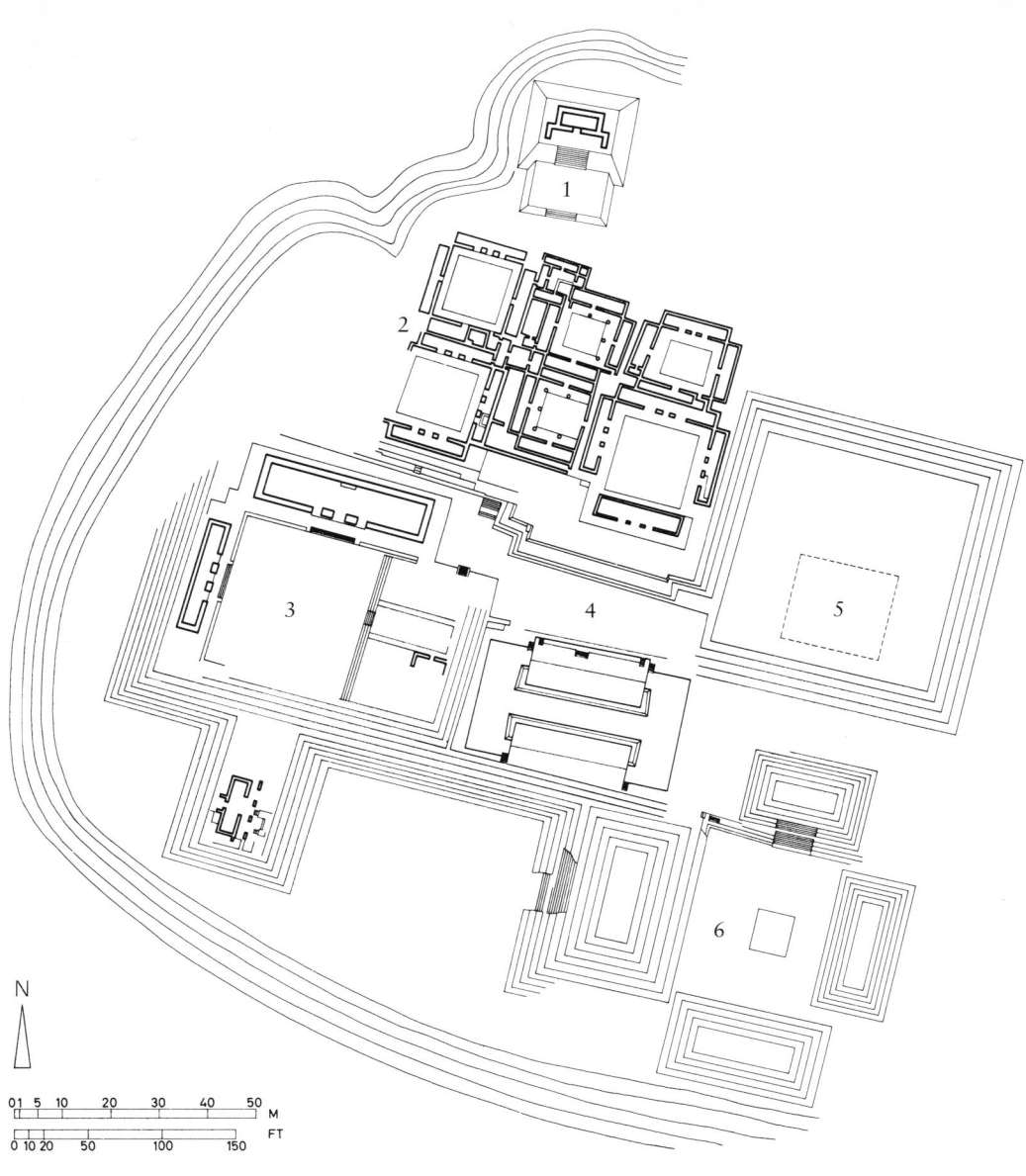

Plan of Yagul
1 North pyramid
2 Palace quarter
3 West courtyard
4 Ball-court
5 East courtyard platform
6 South courtyard

that henceforth the masters will be the Caciques (the Cacicazgo of the chroniclers) and not the priestly caste. The military aspect is emphasized by the fortress overlooking the town, a veritable eyrie which still retains traces of its defensive works.

The palaces of Yagul constitute a link in the development which begins with the small housing units at Monte Albán and their modest square courtyards and ends with the imposing quadrangles at Mitla. Here we find a lay-out of square courtyards presaging the groups of white palaces built at Mitla before the Aztec conquest.

There are two temple zones, of which the northern comprises only one pyramid, while the southern has four such structures, facing inwards around a plaza at whose centre there once stood a square altar. Between those zones is the palace quarter in which the living space consists of long halls disposed round a series of quadrangles. In an arrangement such as this, the buildings may join at the corners which are thus closed, or may be discrete, with open corners. The latter solution, a feature of the Nunnery at Uxmal in the Maya country, was sparingly applied at Yagul, where it occurs only once, on the south side of the quadrangle in the south-eastern part of the complex. At Mitla, on the other hand, full use is made of this system.

One of the major innovations of this period, however, as compared with the Classic art of Monte Albán, was the importance accorded by

the Mixtecs to palace architecture, in consequence, no doubt, of the profound social changes they themselves had brought about. For instance, as we have already seen in the case of the Toltecs at Tula, their high dignitaries were accustomed to convene frequent assemblies. Thus, the west quadrangle at Yagul is flanked in the north by an imposing 35-metre-long palace standing on a platform with an axial stair that leads by way of a triple entrance to what is evidently a council chamber.

In the quarter comprising the six quadrangles, most of the long halls possess a triple entrance of this kind. Some of the palaces, however, are preceded by porticoes on masonry columns, on the same principle as the entrance to Quetzalpápalotl Palace at Teotihuacán, but on a much larger scale. The roofs were probably flat and made of timber covered with stucco.

The Mitla Palaces

The city of Mitla in the valley of Tlacolula was probably a Mixtec capital (as were the towns of Tilantongo, Teozacoalco, Coixtlahuaca, Tutútepec and Comáltepec). Nothing now remains of the agglomeration at the confluence of two streams and the Rio Mitla save for five groups of more or less well-preserved buildings, the most spectacular of which is the Group of the Columns (Pls. 90–2).

Mitla is not a fortified city, but a city of the plains, built at the foot of the hills without apparent regard for defensive considerations, from which we may conclude that the power of the Mixtecs went unchallenged in that region. Thus the history of the town must have coincided with the second half of Monte Albán V (about 1300 to 1450).

The five cardinally orientated groups are disposed round square quadrangles. Two of them consist of platforms and pyramids of which the remains are in a poor state of preservation. The other three are made

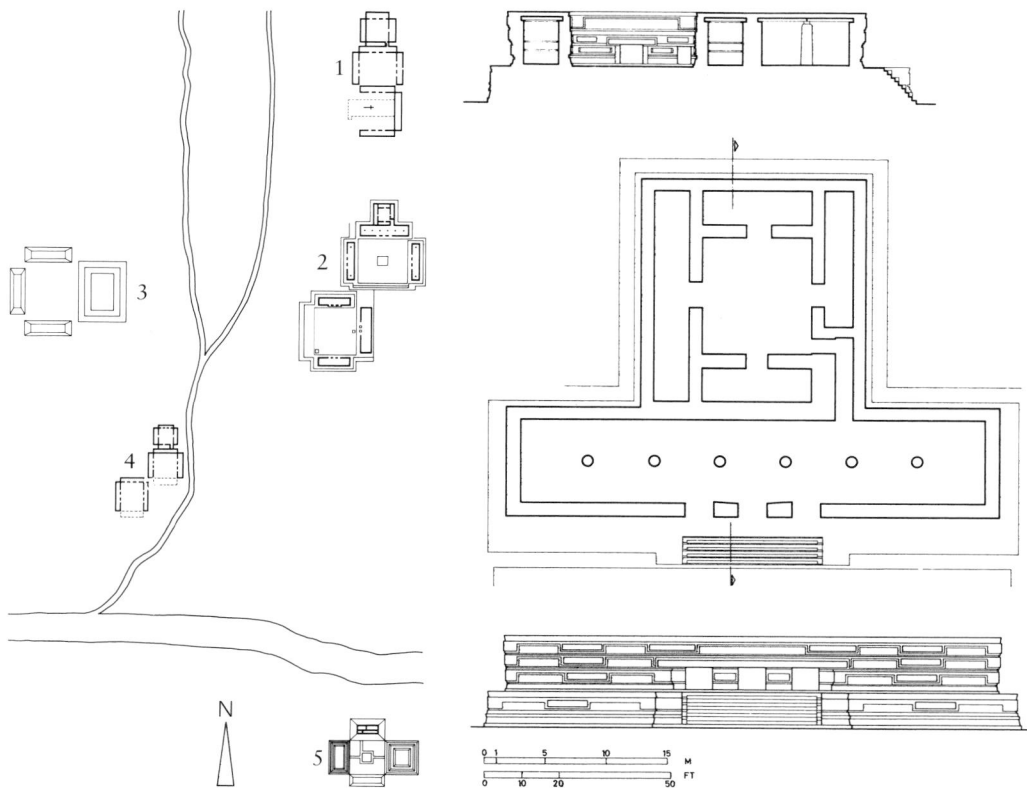

Plan showing the Mitla palaces; on the right, section, plan and elevation of the Palace of the Columns.
1 Church Court
2 Group of the Columns
3 Western Group
4 Arroyo Group
5 Southern Group

up exclusively of long ranges—the palaces—which in each case line two quadrangles and a courtyard. All these quadrangles are strictly rectilinear in plan. In the Church and Arroyo Groups the palaces meet at the corners which are therefore closed. In the Group of the Columns, on the other hand, which is the best preserved and architecturally the most remarkable, the corners are open so that the palaces retain their identity.

The disposition of this latter plan repays analysis. It displays two quadrangles, of which the more southerly is echeloned to the west. Since each quadrangle consists of three buildings, one of its sides remains open. All the palaces possess similar façades with a triple entrance at the centre. However, the organization of the building from which the group derives its name, the Palace of the Columns, on the north side of the west quadrangle, is somewhat more complex. Its front opening, like that of all the others, is a triple doorway, while a wide flight of axial stairs ascends the platform which serves as a podium to the building, and gives access to the hall. Having crossed the threshold, the observer finds himself in a vast space seven metres wide by forty metres long and running the full length of the edifice. The hall is subdivided by a row of columns, enormous tufa monoliths, some 4.5 metres high and disposed along the longitudinal axis, which must have supported a flat timber roof.

The hall, of perhaps 200 square metres, is large enough to serve as a council chamber and leads, by way of a small door in its north wall and a 7-metre corridor with a left-hand bend, to a courtyard surrounded by four more halls. This group of buildings, measuring some 20 metres square, projects from the north face of the palace, thus describing an inverted T. The courtyard, 10 metres square, is wholly enclosed but not covered and, as we have said, is flanked by long halls each having only one door. The only exit is through the corridor leading into the Hall of the Columns.

Thus it will be seen that, within the restraints of an austere and rigorous plan, itself governed by an axial arrangement whose symmetry is impaired only by the corridor, the formula is not without complexity. A coherent and harmonious system, inscribed in the gentle north-south slope of the site, is produced by the spatial interplay of the great hall, the enclosed courtyard and, lastly, the quadrangle of 1,600 square metres which is open to the south and preceded by another more westerly quadrangle.

A noteworthy feature of this architecture is the quality of its execution. The buildings are entirely faced with fine, impeccably cut blocks of white tufa consisting of a projecting framework enclosing panels with geometrical stone mosaics of great rhythmical subtlety. Before discussing this decoration, however, we must stress the originality of the elevation of this columnar building. It is supported by a platform 3 metres high whose faces are almost vertical. A single stair, 10 metres wide, in the centre of the south front leads to a narrow terrace that surrounds the building. The latter is something entirely new in pre-Columbian architecture, for the walls, approximately 4.5 metres high, have been given a pronounced negative batter. The result of the corbelling of the panels one above the other is to produce an overhang. Thus there is a difference of some 30 centimetres between the most recessed part (above the plinth) and the most salient part (at the cornice). It is a rare display of technical virtuosity. Instead of the talus, the inclined plane and the step, we have walls rising upwards and outwards to project into space, as if

to underline the boldness of a solution whose function is primarily aesthetic. For in the overhead light of the tropics it accentuates the shadows and the vigour of a composition made up of horizontals.

We should add that these beautifully dressed tufa blocks serve to retain an in-filling of rubble, earth and cement which demanded walls almost 1.5 metres thick.

With its horizontal lines and the vigorous profile of its walls rising above the steep-sided platform below, this palace proclaims a new vocabulary—well-defined volumes, blind façades everywhere save for the triple opening at the front, and strictly rectilinear cornice—which gives these white buildings a distinctly modern flavour, enhanced by a mosaic ornamentation of extreme delicacy and astonishing craftsmanship.

Not the least fascinating aspect of Mixtec architecture is the decoration of the Mitla palaces. In one sense it may be seen as a continuation of the decorative principles of Zapotec architecture at Monte Albán. Indeed, the system of cornice mouldings in the shape of a band furnished with dentils (like inverted crenellations) recurs at the corners of the platforms and of the palace. While aesthetic considerations played some part in the use of this motif, which accentuates the angles and confirms the volumes it defines, it was not without symbolic connotations. In appearance it is akin to the symbol of the heavens, a typical feature of which is the square hook at either end already seen in the Zapotec tomb paintings at Monte Albán, where it represents the celestial and tutelary monster. Whatever the reason, the Mixtecs ensured the perpetuation of a tradition by employing a moulding that was characteristic of Monte Albán's architecture.

However, they would seem to have introduced a new style with the mosaic relief motifs filling the three tiers of corbelled panels on the palace façades. The twenty or so projecting frames on the façade of the Palace of the Columns display a great variety of motifs—meanders, key fret, lozenges, quincunxes, etc.—whose diversity is as remarkable as is their graphic unity. These ornaments make up a veritable jigsaw puzzle of parallelepipedal stone elements cut with infinite care and accurately assembled, seemingly without the help of cement. In fact, an evolutionary process may be discerned in this decorative technique of which mosaic is simply the culmination, for there is every likelihood that at the outset the motifs were merely carved on monolithic blocks. Examples of such work may still be seen on the lintels above the entrance, where the original technique has been retained for structural reasons, mosaics being of insufficient strength to span an opening.

A brief calculation will show that each decorative panel contains some 800 to one thousand components. Thus, if we consider only the magnificent stone mosaics adorning the faces of the Palace of the Columns, including the courtyard with its living quarters, we may estimate that they required a total of 130,000 pieces. We might add that the entire decoration, executed in material of superb quality, was rendered with stucco and painted in polychrome. Traces of colour still remain, suggesting the original existence of blue or red grounds.

Now these motifs, which make play with the symbolic themes of the key fret (associated throughout pre-Columbian America with the motion of the sun) and of the meander evoking the Feathered Serpent, establish a link between the ornamentation of the palaces and a traditional mythological legacy. Their highly geometrical treatment would seem to

90 The great Palace of the Columns at Mitla, probably fourteenth century, was given a magnificent façade some 40 m long, completely covered with fine geometrical mosaics in tufa combining meander, key-fret and lozenge patterns. It is a masterpiece of Mixtec architecture. The base on which it rests was partially restored at the end of the last century.

91 Detail of a decorative motif from a panel on the Palace of the Columns at Mitla. The interplay of meander and key-fret patterns creates an impression of vigorous movement.

92 Decoration of the inner court at the Palace of the Columns, Mitla. The panels adorned with geometrical motifs are interrupted by mouldings in the shape of inverted merlons which, at Monte Albán, served to accentuate the angles of the buildings and are therefore a Zapotec reminiscence.

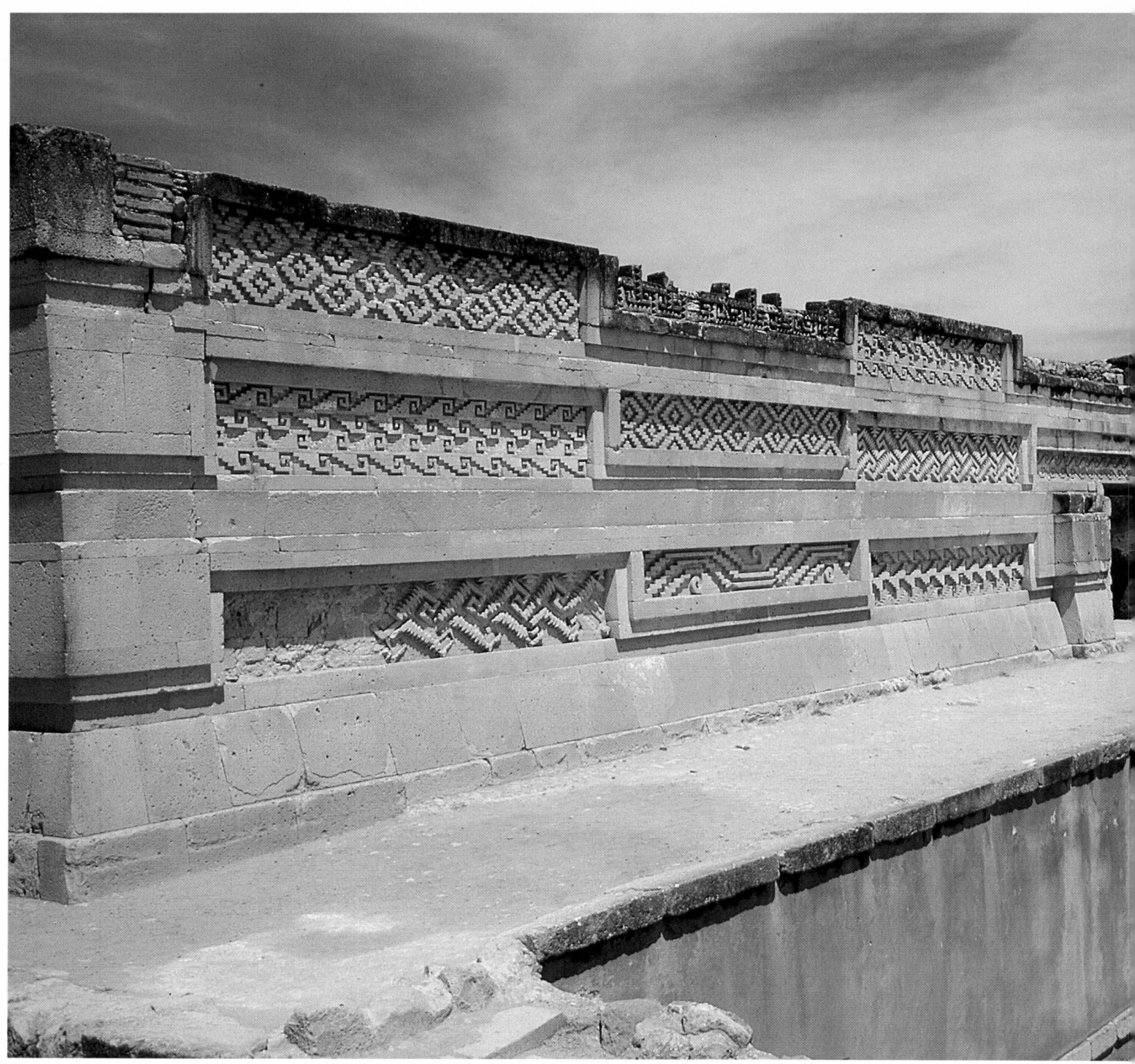

90

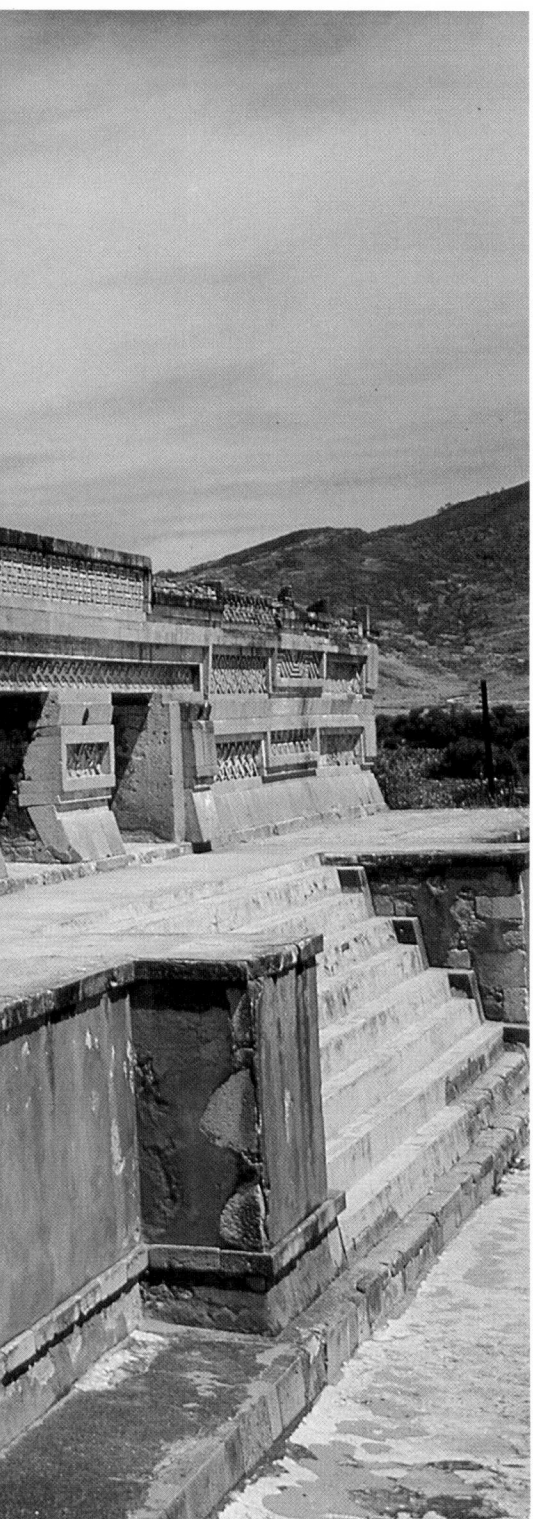

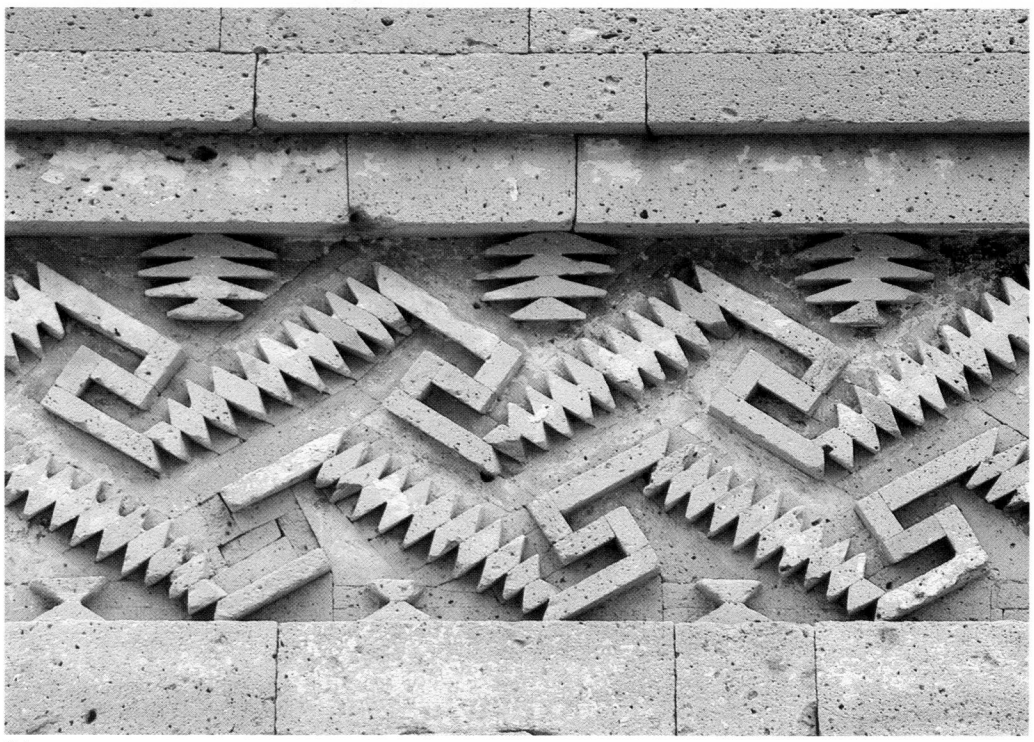

91

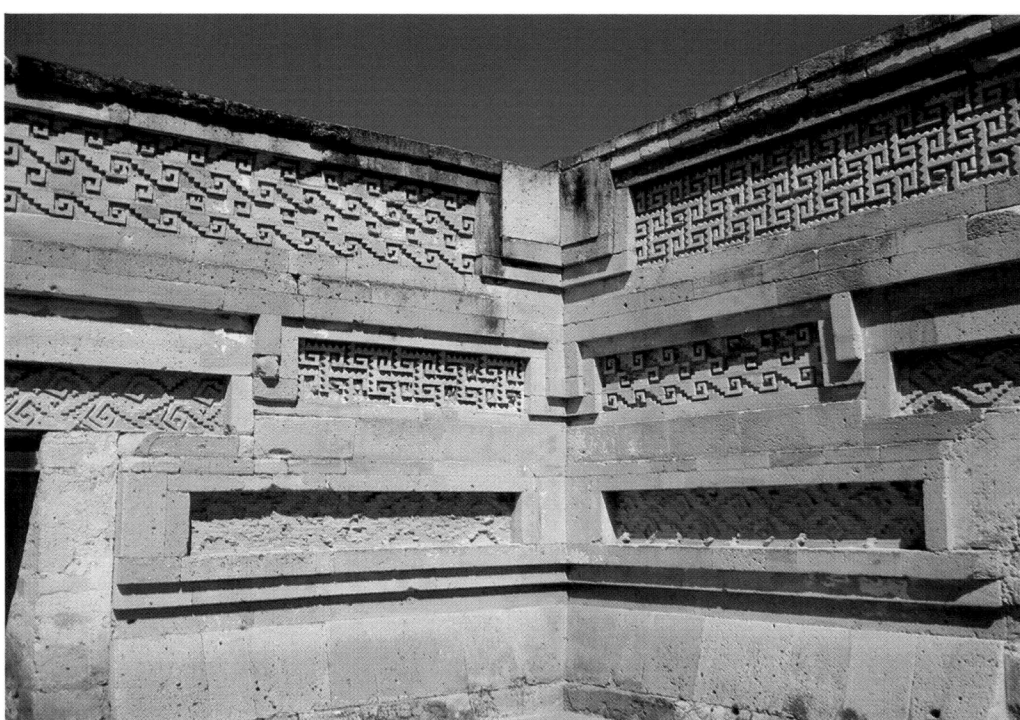

92

derive from the patterns used in weaving, a field in which the notable advances made by the Oaxacans helped to enrich the crafts elsewhere in pre-Columbian Mexico. Unfortunately our only witnesses consist of representations in Zapotec frescoes and Mixtec codices, since few, if any, textiles have survived intact. There can be no doubt, however, that at this period embroidery and weaving played a major rôle not only in personal adornment but also as providers of status symbols.

To conclude our discussion of Mixtec palace architecture, we should mention the tombs that have been discovered beneath certain buildings at Yagul and Mitla. At Mitla these cruciform chambers—their walls decorated with geometrical motifs and their roofs supported by monolithic columns—are located beneath the palaces, for instance beneath the building north of the second quadrangle of the Columns Group. Some are tantamount to hypogea and, as repositories of the remains of several of the Mixtec monarchs, must have contained much treasure. They have, however, suffered from the attentions of looters, first the Conquistadors and, more latterly, an ever-growing number of clandestine excavators lured by the high prices paid for collectors' items.

A Fortified Town on the Confines of the Mixtec Country

Before we examine the contents of such Mixtec tombs as have eluded violators, both past and present, we shall make a rapid excursion further north to a site that has been discovered in the Mixteca–Puebla region. Here American archaeologists, notably Shirley Gorenstein, have investigated a fortified city, Tepexi el Viejo, on the dividing line between the two zones, which has revealed a remarkable array of defensive works. The dominant position occupied by this Mixtec citadel on the threshold of the Cholula country was akin to that of Cacaxtla. To render impregnable the eminence on which it stood called for the construction of walls, glacis and ditches, an operation that began in about 1300 and continued until the arrival of the Aztecs.

The existence of such a late yet heavily fortified centre demonstrates that at no time did the Mixtecs hold undisputed sway over the northern territories. Despite their close links with Cholula, of which the magnificent Mixtec–Puebla pottery provides visible evidence, disaster never ceased to threaten from the north and, indeed, eventually overwhelmed the Mixtecs when they fell to the forces of Tenochtitlán.

Thus Tepexi el Viejo was, by necessity, the architectural antithesis of the open city as represented by Mitla. Situated in a hilly region on the Mixtec border, this garrison town had none of the natural defences such as the mountain chains which protected Mitla from attack. The difference between the two contemporary sites plainly reveals the disparity between the metropolitan regions of the Mixteca Alta and the front-line area of the Mixteca Baja.

Tomb 7 at Monte Albán

The discovery at Monte Albán on 9 January 1932 of Tomb 7 was a major occasion in the history of pre-Columbian archaeology. It was made by

93 The magnificent gold pectoral found in Tomb 7 at Monte Albán. It is one of the finest pieces of Mixtec gold-work. In our photograph the piece, representing the god of death, has been enlarged to almost twice its actual size of 12 cm. On the left side of the chest is the profile of the wind god, Ehécatl, surrounded by dots which stand for calendrical units; on the right is the glyph signifying 'house', flanked by eleven units. The piece was made by the lost-wax method, while the opulent head-dress seems to have consisted mainly of filigree work which probably became distorted in the soldering process. Oaxaca Museum.

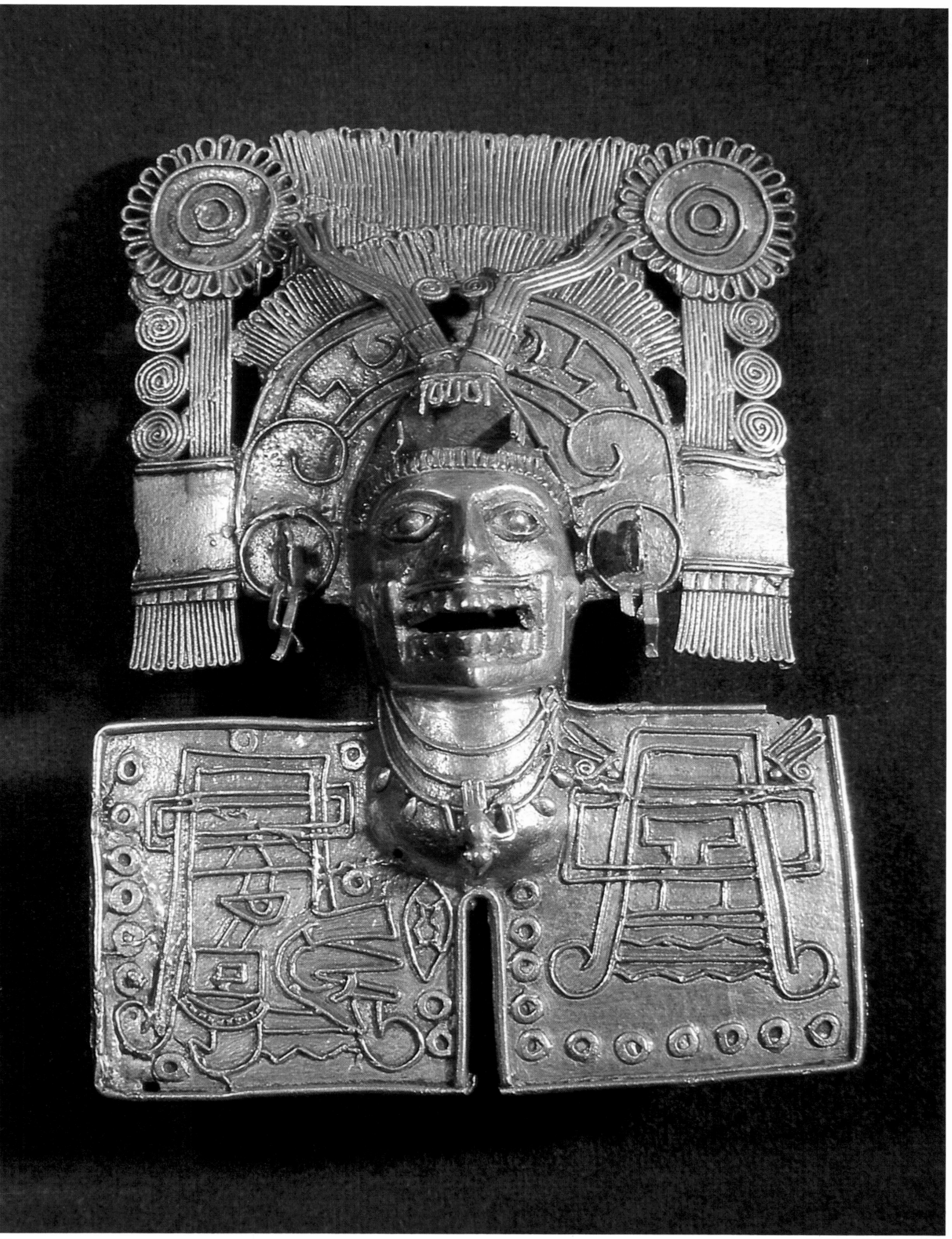

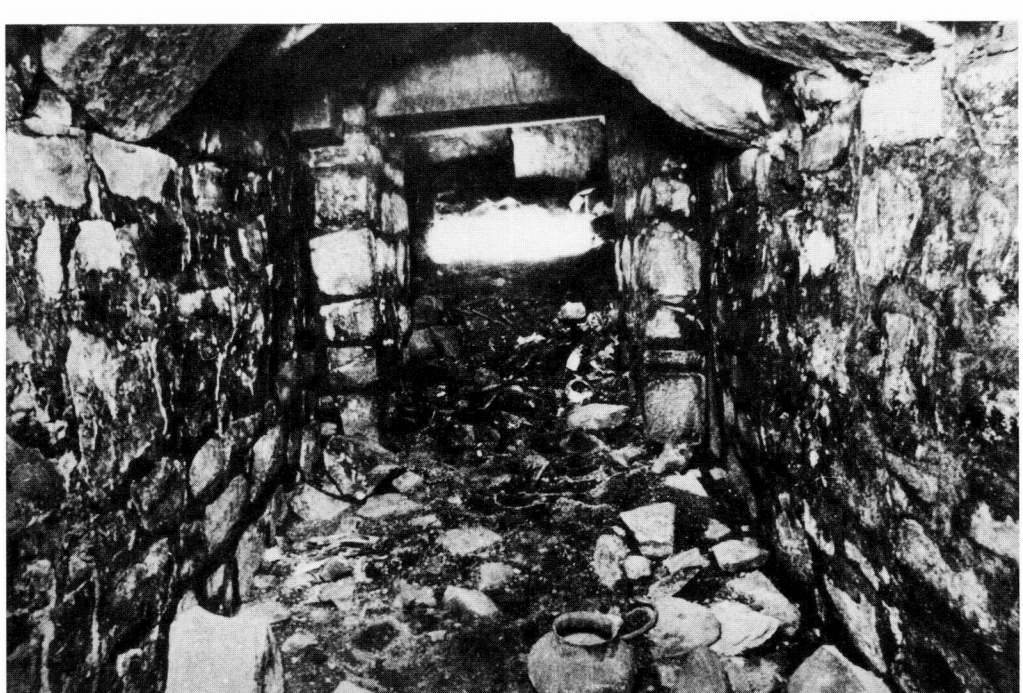

the great Alfonso Caso who has contributed so much to the study of his country's past. Moreover, it is almost the only scientific find of Mixtec treasure, if we except the tomb at Zaachila investigated in 1962 by Roberto Gallegos, a discovery similar to that at Monte Albán, if of a more modest kind.

Tomb 7 also compares in importance with the crypt of the Pyramid of the Inscriptions at Palenque, the Maya capital, brought to light by Alberto Ruz, a quarter of a century after Caso's discovery. The finds made by these two gifted archaeologists were events of signal importance in the field of Mexican excavation and, if we allow for the difference in scale, bear comparison with Carter's remarkable discovery of Tutankhamun's tomb in 1922.

Tomb 7 was found to contain nine bodies, including one of a woman, and some 500 artifacts in gold, turquoise, shell, bone, rock crystal, pottery, etc. It is a hypogeum of the Classic Zapotec type dating from Monte Albán III B, and built of stone with a covering of large slabs. The walls were rendered in stucco and decorated with Zapotec hieroglyphs. However, Alfonso Caso soon ascertained that the contents must belong to the Monte Albán V period and were therefore not of Zapotec but rather of Mixtec origin. The treasure, which dates from about 1400 A.D., points to the subsequent re-use of the tomb for a second interment.

Evidently the Mixtecs regarded the ancient city, now abandoned and fallen into decay, as a holy spot and wished to place the remains of their high dignitaries under what they supposed to be its protective aura. For they revered Monte Albán somewhat after the fashion of medieval monarchs in Europe who laid claim to the imperial purple and sought to restore the *imperium romanum*.

It was, however, the discovery of gold-work of the highest quality in Tomb 7 which aroused the most interest, not only because of its artistic and intrinsic merits but also because it marked the appearance of metallurgical techniques in Mexico. Between the two wars the question of their origin was studied by that eminent scholar, Paul Rivet, director of the Musée de l'Homme, whose conclusions, published in 1946, are still largely valid and provide a lucid exposition of the subject.

The Mixtecs and Metallurgy

In Mexico, the art of metalwork is chiefly associated with the Mixtecs, and Mixtec craftsmen were the first to apply the goldsmith's techniques which enabled them to produce the beautiful pieces found in Tomb 7. But here the question arises as to how they arrived at these techniques. The earliest manifestations of the autochthonous use of metal consist of small copper axes which served as currency and date back to the eleventh century. Gold-work, on the other hand, does not occur until later, some time in the fourteenth or fifteenth century. Yet there is nothing tentative or experimental about these pieces. Rather they suggest the existence of a veritable arsenal of fully evolved techniques.

In his book *La Métallurgie en Amérique précolombienne*, Paul Rivet has sought to discover how this came about. His first contention is that, on the American continent, metallurgy arose independently, in other words, it was neither a European nor an Asian import. It came into being empirically in several different places and at different times as the result of the local availability of metal in the form of gold nuggets which initially were beaten and, later on, melted.

Rivet goes on to maintain that there is a close similarity between the metallurgy of the Peruvian coast and that of the Mixtecs of Mexico. He supports this contention by pointing out that, at the time of the Conquest, the use of metal was still very restricted in Mexico as opposed to South America, where it was widely known from Colombia and Ecuador to southern Peru. From this he concludes that Mexican metallurgy is neither autochthonous nor of early date. Its diffusion was confined almost solely to the Mixtec region which, as will be remembered, comprises a province on the Pacific littoral—the Mixteca Costa. The art of metal-working only began to flourish under Aztec rule, shortly before the arrival of the Conquistadors.

One of the factors common to both Peru and Mexico is the range of metals known to have been used there, among them gold, silver, copper, tin and lead, as well as a number of alloys such as copper and tin (bronze) and gold and copper. But even more conclusive is the fact that identical techniques were used by the craftsmen of the two regions, despite the great distance—almost 2,500 kilometres—that separated them. Among these processes were beating, casting (including lost wax), staining, soldering, brazing, gold and silver plating on copper, repoussé work and laminating.

The evident absence of an experimental period in Mexico and the employment of identical techniques by Peruvian and Mixtec metal-workers have led Rivet to conclude that the latter came under the influence of the former. That influence must have been exerted through the medium of Peruvian merchants who took passage on balsa rafts such as the one encountered on its northbound voyage by Pizarro and his companions. Inca traders covered great distances on these craft, a type introduced by their predecessors, the Chimus, who, as early as the ninth or tenth century, would seem to have maintained uninterrupted relations with Central America and, in particular, with the Isthmus of Panama. The vessels might have carried either gold objects or the goldsmiths themselves who would thus have been able to transmit the accumulated skills of an ancient tradition, for Peruvian gold-work goes back to the Nazca era somewhere about 500 A.D.

94 For this piece, representing Xipé, god of spring, from Coixtlahuaca, the same techniques were used as for the pectoral in Plate 93. This entailed two operations, filigree work and cire-perdue. The joining of the two parts called for a temperature so high as almost to reach melting-point, which can only have damaged the filigree. Height 10 cm. National Museum of Anthropology, Mexico City.

95 Another portrait of Xipé Totec, a deity analogous to Xochipilli. A piece of Mixtec gold-work no more than 6 cm high from Tomb 7 at Monte Albán. In front of the mouth is a symbolic butterfly in the shape of a nose ring. Oaxaca Museum.

96 Mixtec ear-ring consisting of a death's head and drops in the form of small bells which are hollow and hinged. This delicate object is 7.5 cm high. National Museum of Anthropology, Mexico City.

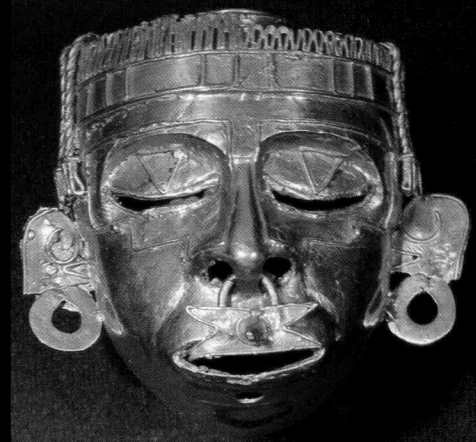

95

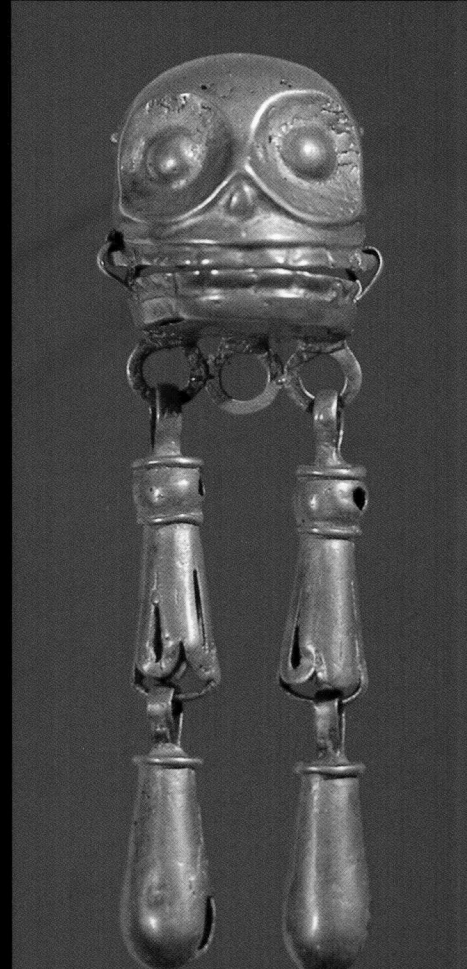

96

94

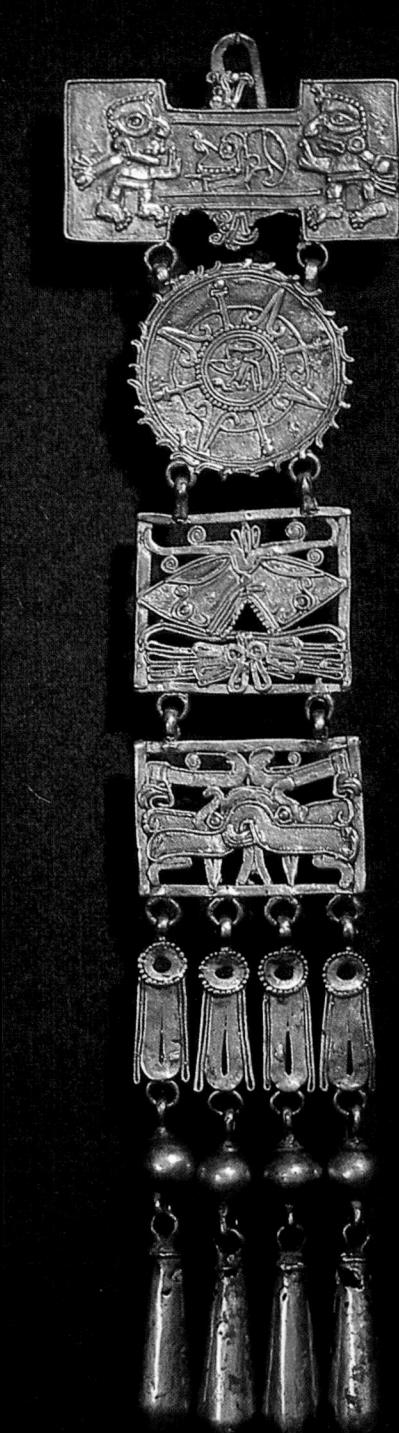

97 98

It would seem, therefore, that Peruvian metallurgical techniques could only have reached Mexico by sea. For had they travelled overland, via Colombia, an even earlier centre of the craft, other techniques would have been conveyed simultaneously and have left their mark on the work of Mixtec craftsmen. This transmission of skills must have begun at the time of the Chimus, a civilization that existed between 1100 and 1400 A.D.

Rivet cites similarities, not only of technique, but also of artifacts. For instance, the treasure from Tomb 7 at Monte Albán includes a crown consisting of a gold band surmounted by a gold plume, identical to the pieces produced by the Chimus.

It was therefore during Monte Albán V that gold-work began to flourish in Mexico, subsequent to a relatively short-lived phase during Monte Albán IV when a few copper articles were produced. At all events metal was always to serve as an ornamental and decorative medium, tools being almost exclusively made of stone, as they continued to be until the fall of Tenochtitlán early in the sixteenth century. Hence the discovery of metal did not constitute as radical a technological revolution in America as had the discovery in the Ancient World of bronze and, above all, of iron which was never known to the Pre-Columbians, if we except the rare occasions on which they made use of siderite.

Gold Ornaments

The quality of Mixtec gold-work is instantly apparent in the pieces uncovered at Monte Albán, Zaachila and other contemporary sites. It is an art that has recourse to complex methods and testifies to a high degree of maturity. Thus, an examination of the fine gold pectoral from Tomb 7 figuring the god of death reveals that various techniques are combined in this piece which, though only 12 centimetres high, exhibits a quality of monumental grandeur. Most of it, the three-dimensional head and the plaque representing the shoulders, has been produced by the time-honoured lost-wax method, while the head-dress, at once rich and diaphanous, consists of concentric circles, spirals and fans of stylized feathers possibly executed in filigree. The same techniques are found in a pectoral from Coixtlahuaca, depicting Xipé, god of spring, whose plumed head-dress resembles that in the preceding piece (Pls. 93, 94).

A stylistic unity links these two works with the beautiful pendant 22 cm long from Tomb 7, which is made up of various hinged elements arranged in seven superimposed stages. At the top is the plan of a ball-court in which two players confront each other; between them is a skull signifying, perhaps, that one of the protagonists is to be sacrificed. Next comes a circular plaque with rays representing the sun, followed by two open-work rectangular plaques, one figuring a butterfly together with a sacrificial knife (symbol of the moon), the other a toad (symbol of the earth). Finally come the drops, the lowest stage of which consists of small bells. Here the technical virtuosity of the Mixtecs is even more in evidence for, besides the methods already mentioned in connection with the pectoral ornaments, this piece possesses hollow bells and beads, as do the beautiful gold necklaces whose elements, now spherical now ovoid, are of astounding regularity (Pls. 97, 98).

97 A large Mixtec gold pendant 22 cm long from Tomb 7 at Monte Albán. This piece is rich in iconography. At the top is a ball-court on a depressed H plan in which two players confront one another over a skull, symbolizing the outcome of the game, namely the sacrifice of one of the antagonists. Next comes the emblem of the sun with which the ball-game is connected. Beneath this are two rectangular open-work plaques, the first depicting the moon in the shape of a butterfly surmounting a sacrificial knife, the second a toad or earth symbol. Finally come drops in the form of small bells. Oaxaca Museum.

98 A fine gold necklace consisting of several strings of hollow beads, either spherical or ovoid, and of bells from Tomb 7 at Monte Albán. Like most of the gold-work found in Oaxaca, this Mixtec piece probably dates from about 1400 A.D. Oaxaca Museum.

99 One of the most fascinating pieces discovered in Tomb 7 at Monte Albán is this human skull, entirely encrusted with fine turquoise mosaic. The eyes consist of shell circles, pierced at the centre to represent pupils. The custom of preserving and decorating the skull of an important personage still persisted in the Aztec period. Oaxaca Museum.

100 A turquoise necklace of some thirty strings, forming part of the treasure from Tomb 7 at Monte Albán. Oaxaca Museum.

101 A pretty necklace in which gold and turquoise are happily combined to produce a polychrome effect, proof of the inventiveness of the Mixtec goldsmiths. Oaxaca Museum.

99

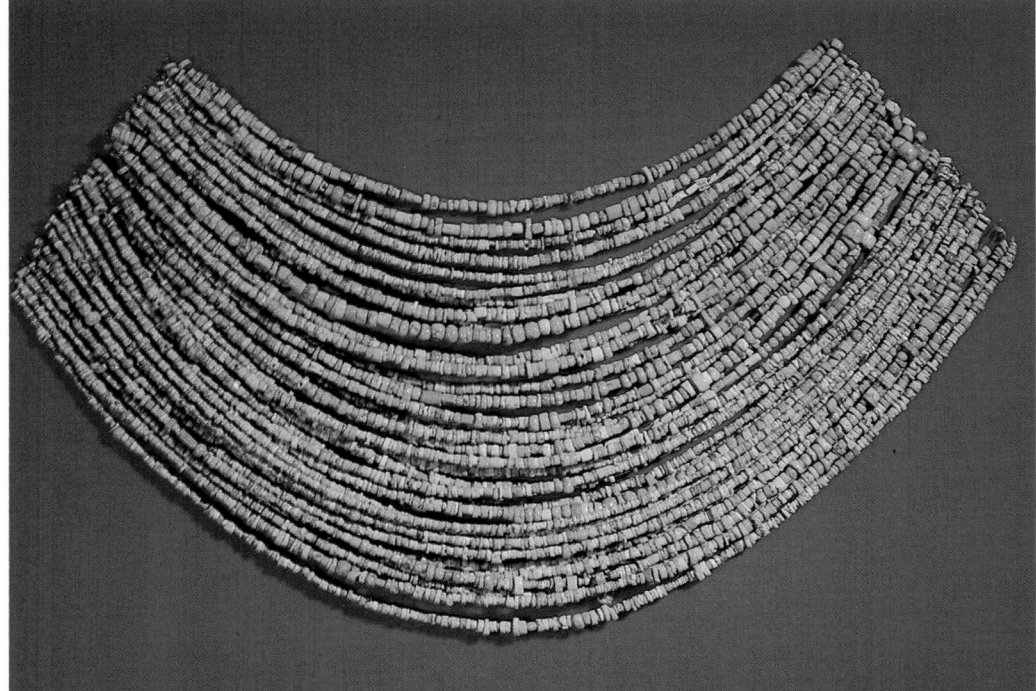

100

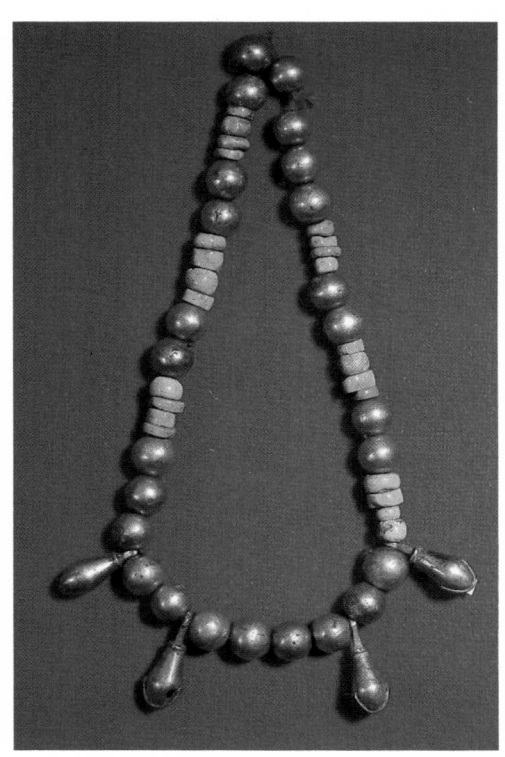

101

The Use of Turquoise and Rock Crystal

Just as the Olmecs and Mayas set great store by jade, so the Mixtecs attached considerable importance to turquoise, possibly because of its blue-green colour which they associated with sky and water. Thus the Monte Albán treasure contains some remarkable examples of this lapidary art, among them an astonishing human skull entirely covered in fine turquoise mosaic with, in the eye-sockets, discs of shell pierced at the centre to represent pupils. It seems probable that turquoise, found in association with human masks from the Teotihuacán period onwards, was a symbol of life. There are also beautiful necklaces, one consisting of some thirty strings of small turquoise beads, while others combine this material with gold, amber and shell elements to produce a delicate polychrome effect (Pls. 99–102).

The exceptional virtuosity of the Mixtec craftsmen is apparent above all in their use of rock crystal and obsidian, in which they fashioned large cylindrical ear discs of a regularity and delicacy that is truly astonishing. These objects, with their exceedingly thin flanges, were produced by a seemingly miraculous process in which string and abrasive sand did duty for a lathe. These light translucent pieces, worked in a material of great fragility, have to be seen if one is fully to appreciate the hazards attendant on an operation thus crowned with success (Pl. 103).

Bone Carving

Here we have another most interesting sphere of Mixtec craftsmanship, of which Tomb 7 has yielded numerous examples, namely bone carving. The bone reliefs reveal a rich iconography depicted in delicate miniature. Their motifs complement those we shall presently examine in connection with the codices. Replete with information yet often difficult to interpret, they are peopled by small figures with huge heads, as also by a veritable bestiary of birds, fish and other creatures. Here the Mixtec craftsmen give proof of a skill comparable to that of the ivory carvers of the Old World. On surfaces perhaps 2 or 3 centimetres wide and 15 centimetres long, they manage to depict closely-packed scenes in which numerous creatures jostle one another within an unyielding frame symptomatic of a profound *horror vacui*. (Pls. 104, 105).

Mixteca-Puebla Ceramics

In all those spheres of art too often called minor, the Mixtecs have shown themselves to be remarkable craftsmen, not least in pottery. After the beginning of the twelfth century, however, its centre of development was no longer situated in Mixtec metropolitan territory but further north, in the ancient city of Cholula, at the heart of the Puebla country. This was the birthplace of the magnificent polychrome pottery known as Mixteca-Puebla whose decoration subscribed to the same conventions as we find in the famous historico-mythical codices. The close co-operation between the two cultures and their merger in the Mixteca-Puebla civilization, the products of which were diffused over a vast area, presage the process of integration that was to take place in the Aztec

102 Two examples of Mixtec shell work from Tomb 7 at Monte Albán. Oaxaca Museum.

103 Amongst the most remarkable Mixtec pieces found in Tomb 7 at Monte Albán is this pair of ear discs in rock crystal of astonishing delicacy and perfection of form. Oaxaca Museum.

104–5 A number of fine bone carvings was found in Tomb 7 at Monte Albán, some depicting fabulous beasts and others human figures in scenes that are probably of a narrative nature, such as occur in the Mixtec codices. The two examples shown here are as little as 2 and 3 cm wide. Oaxaca Museum.

102

103

104

105

period during which Mixtec production continued as before, albeit in the service of new overlords.

The pottery of Cholula, with its brilliant colours, attained a degree of perfection only surpassed in the Mesoamerican world by the Classic works of the Mayas. Both the formal elegance of the tripod vases and the fully round motifs adorning some of the vessels bear witness to a consummate mastery and to a feeling for plasticity that is at once generous and restrained (Pls. 106–8).

Among the decorative themes—whether modelled or painted—we may, as in gold-work, often discern motifs associated with death. By now this had begun to occupy an important place in the iconographic repertory and was to become a constant which, in Aztec art, would assume overwhelming proportions, for death exerted a kind of fascination in the pre-Columbian world. This tendency—counterbalanced, it is true, by the cult of the Morning Star as a resurrectional symbol connected with Quetzalcóatl—had been reinforced by the arrival of the Toltecs. It was perpetuated and enriched by the Mixtecs with a wealth of skulls, skeletons and tibias. But it was at Tenochtitlán that these motifs would acquire their full gravity and grandiosity, pervading the vision of the Pre-Columbians like a divine intoxication (Pls. 109–11).

Mixtec sculptors virtually confined themselves to terracotta though it was not the field in which they were most at ease. Certain works, however, display great force of expression, in particular the portrait of a one-eyed man with vertical scarifications. This might be one of those personages revered as demi-gods, as was the madman whose skeleton was found occupying the place of honour in Tomb 7 at Monte Albán and who, because of his madness (caused by a cerebral tumour), was believed to be an incarnation of Xolotl, monster god and avatar of Quetzalcóatl in the land of the dead (Pl. 112).

Also worthy of note are the figurines known as *xantiles* which adorned the lids of sacrificial incense-burners. Mixtec stone sculpture, whether in the form of bas-reliefs or small stelae, is not only reminiscent of the codices but also presages the sculptures of the Aztec period, for it would seem probable that the wide-ranging skills of the Mixtecs resulted in their being forcibly employed by Mexican sovereigns in the workshops of Tenochtitlán (Pls. 113, 114).

The Mixtec Codices

As we have previously pointed out, the codices represent one of the major contributions made by the Mixtec civilization to the pre-Columbian world. They consist of manuscripts written mainly in pictographs and ideographs. We shall now examine the nature of these works, which are known as codices despite the fact that the pages are not bound into books, as were the ancient and medieval manuscripts to which the name properly applies. They are, in fact, long deerskin strips pleated like an accordion. The codex Zouche-Nuttall, for example, is no less than 11.22 metres long and is divided into forty-two panels (front and reverse, making a total of eighty-four), each measuring 25.5 by 18.8 centimetres. In these codices, the narrative—whether in pictographic or ideographic form—may progress from left to right of the strip (Colombino and Becker I) or from right to left (Zouche-Nuttall). The page is

Page from the Codex Zouche-Nuttall (Mixtec), in the British Museum.

Page from the Codex Fejérváry-Mayer (Mixtec), in the library of the Liverpool Free Public Museum.

106 A Mixtec–Puebla pottery goblet, with polychrome decoration, from the Mixtec tomb at Zaachila. This piece bears witness to the virtuosity of the post-Classic potters. On its rim is perched a stylized humming-bird whose blue colouring was not applied before firing, but consists of finely ground turquoise. Height 7 cm. National Museum of Anthropology, Mexico City.

107 Mixtec pottery jug with polychrome decoration from Tomb 36 at Inguiteria, Coixtlahuaca, dating from the post-Classic period known as Monte Albán V, i.e. after 1400. Height 25 cm. Oaxaca Museum.

108 Polychrome tripod bowl with feet in the shape of eagles, from Tomb 1 at San Pablo Huitzo, Barrio del Rosario. Diameter 17 cm. A typical piece of Mixteca-Puebla ware. Oaxaca Museum.

divided into several bands of which the sequence is boustrophedonic; the lines run either between the pleats or between vertical bars that mark a break and direct the reader to an upper or lower band. Having completed the front, or first half, of the manuscript, he then turns it over and reads the back.

Eight Mixtec codices have survived—or nine, if we include the fragments of a once complete manuscript. All these originated in the period between the thirteenth century and the years immediately after the Conquest. The most important manuscripts are thought to have appeared in the following order: the Colombino and Becker I in the thirteenth century, the Zouche-Nuttall in 1330, the Vindobonensis (reverse) in 1357, the Bodley in 1520 and, finally, the Selden, no later than 1560, i.e. some forty years after the fall of Tenochtitlán. Of these nine, one is in Mexico City, two are at Oxford, three at Vienna, two in London and one in Liverpool.

Mixtec writing is both pictographic—when the meaning corresponds to the object depicted, and ideographic—when based on a more abstract association of ideas. Thus, in the former a drawing of the sun may signify 'the sun', while in the latter if may signify 'heat'. The ideograph is used to represent concepts such as towns, rivers and lakes, or again the year, the day and, perhaps, the month. However, such writing may also assume the form of phonograms or phonetic signs which help to express notions unrelated to the image in question. Thus Alfonso Caso, whose 'translations' have revealed the meaning of the Mixtec codices, suggests that certain signs might have a phonetic value and indicate proper names. At this point we should recall that Mixtec writing was preceded by other systems of a similar but less sophisticated kind. For instance

106

107

108

109

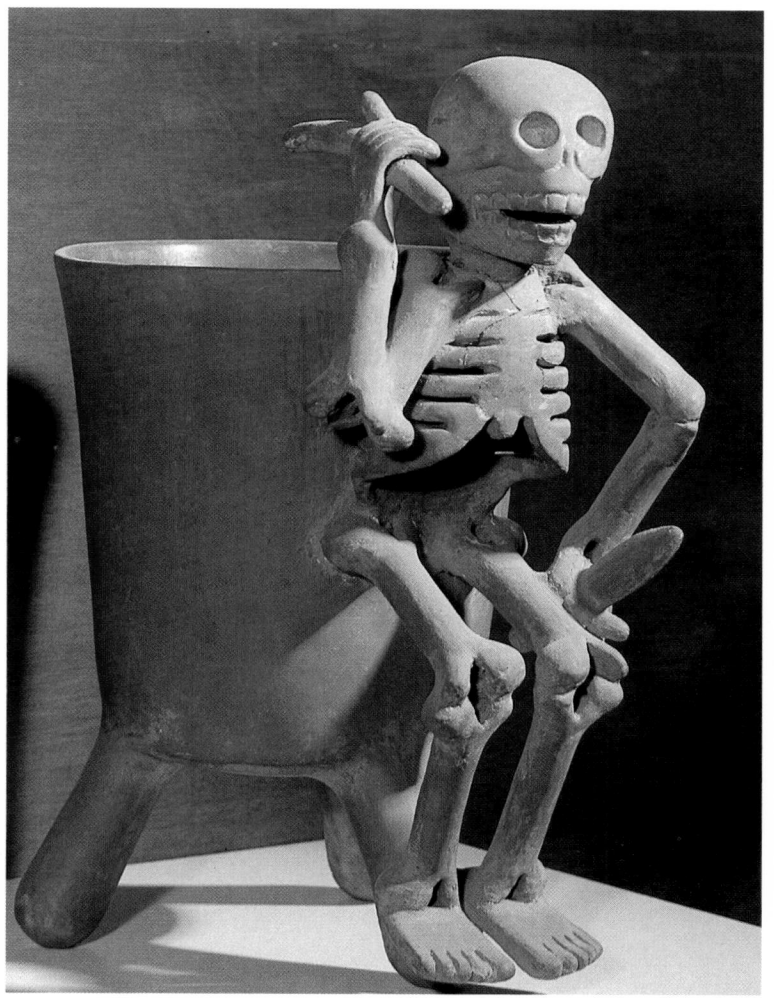

110

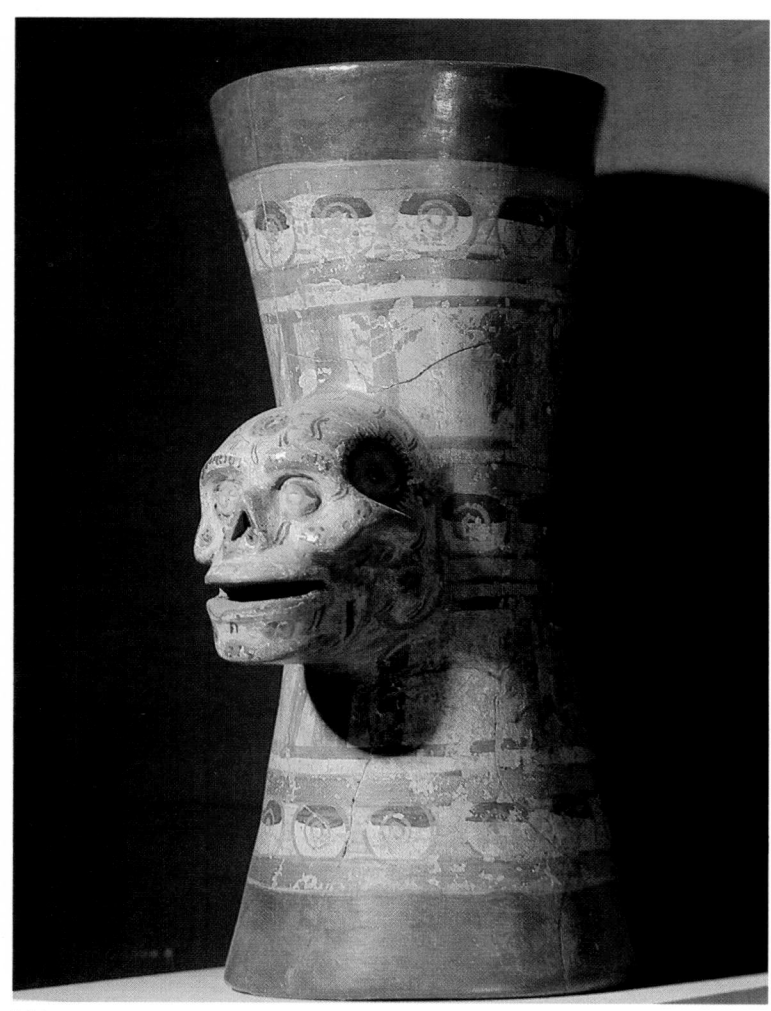

111

there are stone inscriptions which presuppose very early but no longer extant codices. These inscriptions date back as far as the first millennium B.C., being found not only in the Olmec country, but also at Monte Albán in the form of glyphs on the Danzantes slabs.

The contents of the surviving Mixtec codices are mainly of a genealogical and theogonic nature, for the founders of the nation were regarded as deified beings. We are told the name and surname of the sovereign, the date of his birth and the nature of his kingdom; we also learn the names of his father, of his siblings, and of their respective spouses and children. In many cases the manuscript concludes with a list of these people's exploits and gives their date of death.

Some of the manuscripts are also historical in character and concern the lives of a number of kings, while others contain accounts of population movements and military victories. The back of the Vienna Codex is thought to relate to ritual matters, festivals and myths.

The dates given in these texts are based on an exact computation which enables us to place the events they describe. Again, several codices may recount the same story but in somewhat different terms, which gives added historical weight to these works, written over a period of three centuries and employing a system of writing which continued in force sixty years after the Conquest. Dates and numbers are expressed by means of dots (without the bars of Olmec and Maya origin). Their computation is based on a calendar used throughout Mexico and comprising two methods of calculation: on the one hand the so-called ritual year of 260 days, made up of thirteen twenty-day cycles, on the other the solar year of 365 days comprising eighteen twenty-day months and five supplementary days. The first day of the ritual system and that of the solar calendar coincided only once every fifty-two years, a cycle which, to the Pre-Columbians of Mexico, represented more or less what a century does to us.

From these codices, then, we may discover, amongst other things, who reigned in Tilantongo or Teozacoalco in the tenth and eleventh centuries, and what sacrifices were offered to which deities. Again we may follow military campaigns leading to new conquests or learn about dress, weapons, funerary rites and marriage customs.

The following is an example of what we may find in Alfonso Caso's translations of the Mixtec manuscripts. Jacques Soustelle has provided an admirable summary of one of the historical passages, versions of which occur in several of these works 'recounting the eventful and glorious life of a national hero whose calendrical name is Eight Deer. He is said to have lived from 1011 to 1063, i.e. fifty-two years or a 'century'— the Mixtec historiographers have made somewhat free with their dates. His father was called Five Alligator and his mother Nine Eagle. From the age of eight he took part in warlike exploits. Later on we see him at his devotions, playing the ball-game and, needless to say, making war. Between the ages of twenty-one and thirty he conquered twenty-six towns or villages. His growing renown won him the right to wear a turquoise nose ring which, during a solemn ceremony, was put in place by a priest after his septum had been pierced with a bone point. There follows a series of scenes in which he is shown in conference with dignitaries, negotiating and concluding agreements, and attending sacrifices. At the age of forty he took a young bride, Thirteen Serpent, who bore him a son, Six House. Finally, on his fifty-second birthday, he died on

109 Small Mixtec piece of pottery in the form of a death's head, 12 cm high. The obsession with death recurs constantly in the late art of the pre-Columbian peoples. National Museum of Anthropology, Mexico City.

110 Mixtec tripod vessel decorated with a full-round skeleton representing the death god, Mictlantecuhtli. This post-Classic work, 32 cm high, clearly demonstrates the skill of the Mixtec-Puebla potters. National Museum of Anthropology, Mexico City.

111 Mixtec polychrome vessel decorated with a death's head in relief. As in the preceding piece, the sobriety of form contrasts with the baroque nature of the decoration. Height 33 cm. National Museum of Anthropology, Mexico City.

112 Mixtec pottery head of a one-eyed man with deep vertical scarifications and wearing a diadem and large ear discs. This is a post-Classic piece, probably fifteenth century. Width 17 cm. Oaxaca Museum.

113 A type of figurine known as xantiles, forming the lid of a Mixtec incense-burner for incinerating copal, of post-Classic date. The face appears to be emerging from a stylized serpent's mask. Height 37 cm. National Museum of Anthropology, Mexico City.

114 Mixtec stela known as the Stone of Tlaxiaco, in the form of a vessel containing a rabbit surmounted by the number 4. National Museum of Anthropology, Mexico City.

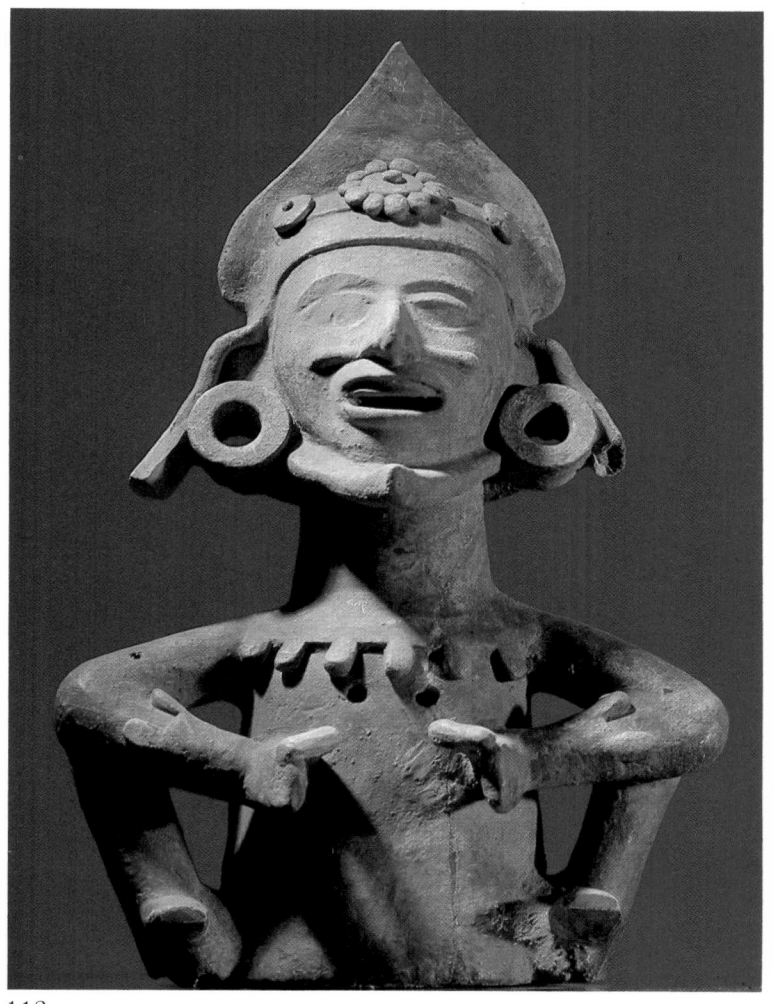

112

113

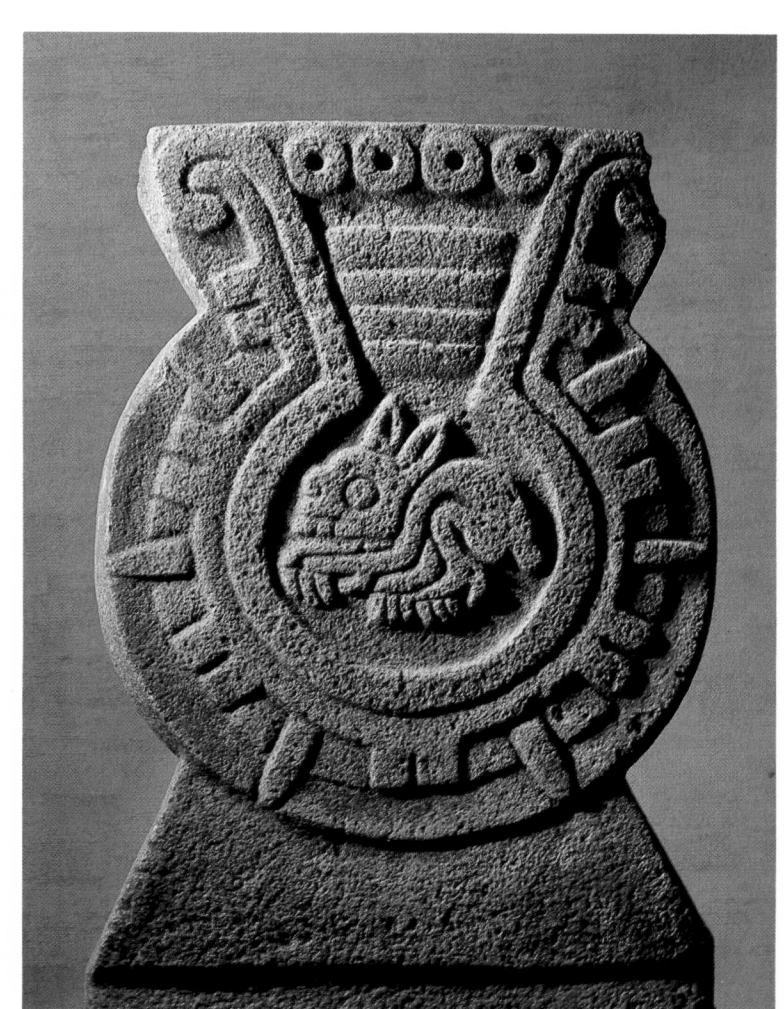

114

the sacrificial stone, a scene recorded in minute detail by the scribe who depicts Eight Deer stretched out on the stone at the moment when the priest plunges his flint knife into his breast.'

Graphic Representation

The aesthetic system informing the Mixtec codices is founded on a form of conceptual representation in which the treatment of the objects and figures makes them look like cut-outs mounted on an empty ground. They are placed side by side, but never in such a way as to overlap or impinge on one another. The artist depicts things as he knows them to be and not as he sees them. In other words what he represents is a concept rather than material reality. Hence his perception assumes a form that need bear no relation to a reality governed by the laws of optics.

In almost all cases the figures, irrespective of the gestures they are making, are depicted in profile, with large heads and stunted bodies, as in the Zapotec tomb paintings at Monte Albán. Buildings may be shown in plan (ball-courts, for instance), in elevation (pyramids and temples) and even in section (interior of sanctuaries), while parts of certain structures appear in horizontal projection to signify their destruction.

Gesture is varied: people are engaged in animated conversation, in combat, in ball-game playing; they administer justice, sacrifice a prisoner, kindle a fire, offer up copal to the gods, or again, catch fish, canoe, burn the dead or slit the throat of a sacrificial animal.

The palette is restricted to red and yellow ochre, brown, mauve, a greenish tint and, for the ground, a pale beige, while skin is rendered in white lime. In addition black is used, like the leads in a painted window, to delineate all coloured surfaces, producing what is in effect a 'coloured drawing', done in flat tints with neither shadows nor modelling to indicate volume.

In general the composition reveals a feeling for the balance of coloured masses on a light ground which makes play with the very even distribution of the painted surfaces and those that are left empty. Some of the bigger scenes, literally swarming with figures, may even extend over two panels. The elements which give rhythm to the composition and vary its density are extremely diverse. Alongside the isolated figure, the architectural mass provides a forceful point of reference.

Even if we postulate the existence of earlier manuscripts, none of which have survived, it still remains that the Mixtec codices represent a remarkable body of documents which have introduced the pre-Columbian world into the realm of history. Their ideographic writing, however, would seem to presuppose an oral tradition essential to a proper understanding of facts and an accurate interpretation of events. For what we have here is a skeletal outline, a mnemonic system which, though elaborate, would not seem to be an adequate vehicle for truly abstract notions by means of which lofty spiritual speculations might be expressed. We are still a very long way from the possibilities inherent in the spelling-book and the primer.

VI. The Gulf Peoples and El Tajín

115 Head of a large terracotta from Central Veracruz, in the style known as Remojadas and dating from the Middle pre-Classic period (between 1300 and 800 B.C.). This very stylized figure has been given a diadem-type head-dress. Typical techniques used in this primitive Gulf Coast art are appliqué work, incising, and the use of bitumen on mouth, ear-rings, eyes and necklace. Jalapa Museum.

116 Anthropomorphic vessel in the Remojadas style dating from the Middle pre-Classic period. The grotesque, if not frightening, face is enhanced with bitumen. Jalapa Museum.

117 A Remojadas terracotta of which the forms are highly schematized, representing an alarming personage sitting cross-legged. The pattern painted in bitumen on the face recalls the motif already noted in the case of the mask of Xochipilli or Xipé Totec, god of spring (Pl. 28). Jalapa Museum.

In this chapter we touch on a region which is artistically one of the richest in the whole of the pre-Columbian world, but at the same time also the most mysterious because of the vast lacunae which still bedevil the scientific investigation of its history. A study of the Gulf region will entail our considering yet again the development of art from the pre-Classic era onwards, beginning with a survey of the tropical lowlands on the eastern fringe of Mexico bounded in the south by the Olmec country and, in the north, by the lands of the Huastecs. It is an original and fecund area which has never received its due owing to the absence of adequately substantiated data. As a result we are faced with considerable difficulties when we seek to understand the legacy of the Totonacs, or 'people of the hot lands', as they were generally referred to by the Aztecs.

At the time of the Aztecs and of the Spanish Conquest this country, fringed by a formidable barrier of sand bars, lagoons, and densely wooded hills, was in fact inhabited by the Totonacs. But whether it was they who built the astonishing Classic ceremonial centre of El Tajín, with its many pyramids, platforms and ball-courts, is a question which still remains unanswered. Thus a great deal of uncertainty continues to surround the identity of those who lived in this region, more especially during the pre-Classic and Classic periods.

The reason for the above-mentioned lack of precise information in this particular area of pre-Columbian culture is twofold. In the first place, archaeological excavation has been virtually restricted to one site, namely El Tajín and, in the second, the work done there since 1935, largely under the direction of José Garcia Payón, has not been adequately publicized, nor has it cast sufficient light on the vexed questions of population and chronology. This failure to resolve what are fundamental problems has hampered our approach to a world of exceptional artistic sensibility which found expression more notably in pottery, bas-reliefs and stone sculpture of great worth. So interesting, indeed, are these all too often neglected works that we have chosen to illustrate them in particular detail.

With the help of the inadequate data at present available, we shall therefore attempt to determine what contribution was made by this wonderfully gifted people and thus, perhaps, gain a better understanding of their sometimes unexampled forms of expression which, by reason of their astonishing humanity, constitute a remarkable chapter in pre-Columbian art.

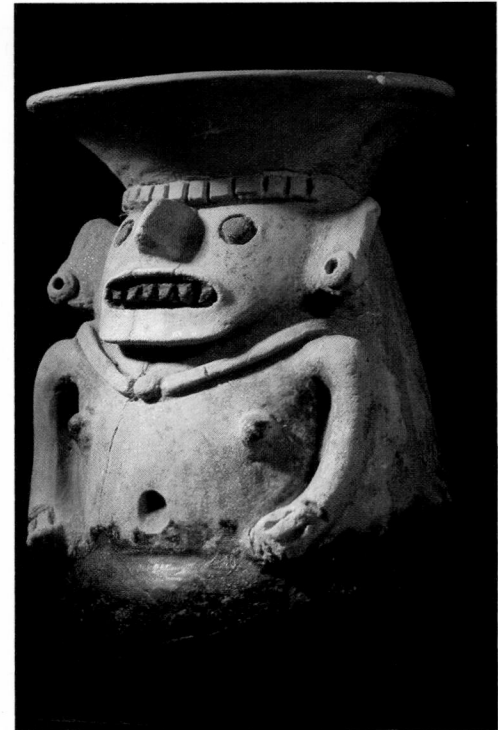

116

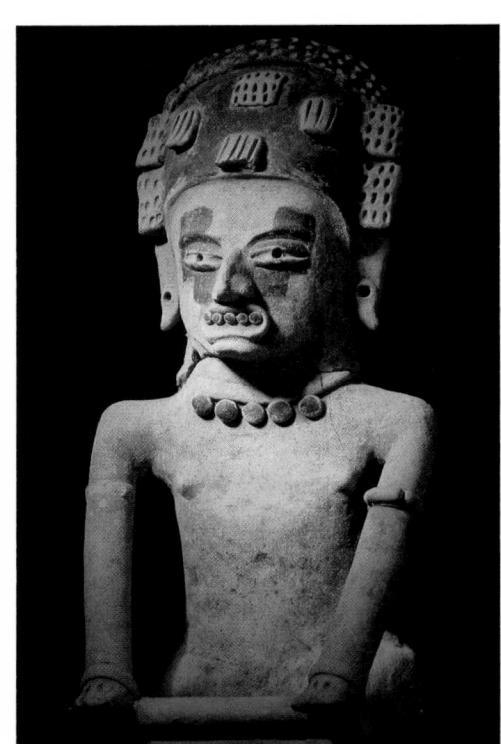

117

115

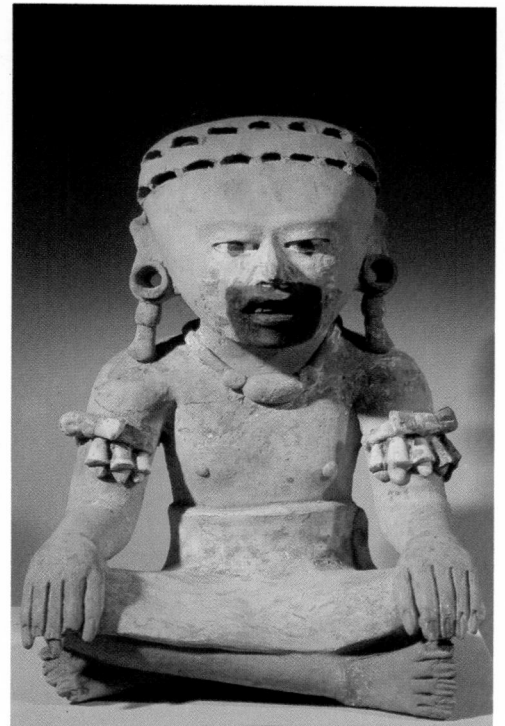

118

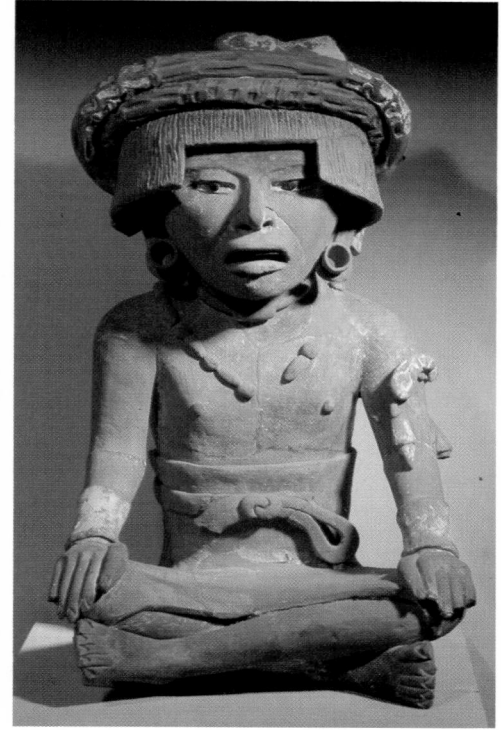

119

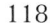

120

Population and Background

We should begin with a note on the geographical location of a region which played so important a part in Mexican art. It lies south of the Tropic of Cancer, between the 21st and 17th parallels, with a coastline some 300 kilometres long running north-west and south-east between the present towns of Tuxpan and Alvarado in Central Veracruz. The climate is very hot and humid, so that the entire hilly coastal zone is covered with dense jungle. Between these hills and the borders of the State of Puebla where, at 2,325 metres, the Elabra Pass forms a natural link between the coast and the high plateaux, are rich lands situated on the increasingly precipitous slopes of the Sierra Madre Oriental.

Thus the climate is varied, ranging from humid sub-tropical to temperate, the latter producing a zone of vast coniferous forests. And yet it was the jungle that gave birth to the region's most important ceremonial centre, El Tajín, a city that is located no more than 40 kilometres from the coast.

Who, then, were the earliest inhabitants of a district which bears more than a passing resemblance to the adjoining Olmec country? We cannot say, any more than we can say who created Teotihuacán and the great Classic art of the high plateaux, or who carved the Danzantes at Monte Albán. As a rule the names of pre-Columbian peoples can be assigned with certainty only to the later cultures—those of the Aztecs, Toltecs, Mixtecs and Huastecs, which appeared between the ninth century and the Conquest. Regarding the Totonacs, opinions have tended to diverge during the past two or three decades. Some authorities are happy to apply the name to the creators of the Classic art of El Tajín, while others stress the lack of data and, on the strength of sundry annals, refuse to regard the Totonacs as the founders of that capital. In their view, that people did not appear until after the great upheaval which put an end to the Classic era, and therefore ushered in the Epiclassic and, in particular, the post-Classic eras. While sound from the ethnological point of view, this cautious approach also presupposes the disappearance, dispersal or extinction of these populations on a scale far more massive than the facts of history would seem to warrant.

Here a comparison might prove instructive. Let us picture what happened in the West at the time of the great invasions of Goths, Franks and Lombards. Europe was not drained of her indigenous populations, for we know that the barbarian invaders numbered at best 200,000. By the same token, the newcomers did not in any sense represent a majority in the regions they invaded, which nevertheless soon acquired the names of the peoples who had conquered them—for instance, Gaul became known as France, northern Italy as Lombardy and Spain as the Visigothic kingdom.

In the pre-Columbian world a very similar process must have taken place. But since the names of some of the Classic peoples are unknown to us, we can either describe them in terms of their capital cities (e.g. the now current Teotihuacános), or speak of the people they preceded (i.e. the Pre-Zapotecs of Monte Albán and the Pre-Totonacs of El Tajín). The latter description has the advantage of stressing a certain formal continuity in the arts. That continuity is, as will presently become apparent, a somewhat disturbing fact of civilization which may even controvert the theories of the paleo-ethnographers. For while the arrival of a

new people was often accompanied by the birth of a new style, the same cannot be said of El Tajín and the Totonacs. No break is discernible here; rather, as will be seen, it was the coming of the Toltecs that marked a 'renascence'.

Remojadas Terracottas

As far back as the pre-Classic era, about 800 B.C., the pottery of the Central Veracruz region was of notably high quality. The figurines and carved terracottas, often enhanced with bitumen—the country is rich in oil deposits—have a style of their own, as distinct from that of the Olmecs as it is from the products of the high plateaux or of Oaxaca. Known as Remojadas ware, after the name of the part of Veracruz in which they were found, the pre-Classic pieces may be numbered in thousands. From the simplest pre-Classic beginnings in the first millennium B.C., they gradually developed an unmistakably Classic style which reached its apogee during the first millennium A.D. and was to remain at a consistently high level until the Toltec renascence. In the early stages the objects were relatively small, but were to reach imposing proportions in the Upper Classic period in which statues of women who had died in childbirth might measure anything up to 1.40 metres.

The faces that adorn pre-Classic terracotta vessels or hollow figurines are often terrifying and might almost be described as caricatures or grotesques. The forms are strongly expressive. Teeth and eyes are given considerable prominence, as are the details of head-dresses and certain articles of adornment such as necklaces and bracelets. In the earlier pieces, arms and legs are cylindrical and stiff, fingers and toes being indicated simply by parallel incisions (Pls. 115–17).

In jugs and vases this simplification often produces forms of great purity, as may be seen in the vessel with a spout in the form of a fledgeling's head. Other pieces betray a mysterious kinship with the early products of the Peruvian Mochicas, for instance the jug in the shape of a kneeling man holding a stick which does duty as a spout (Pls. 121, 122).

The small solid figurines depicting persons from all walks of life testify to a very immediate sense of line and posture. The woman sitting cross-legged, for instance, or the warrior with his shield and plumed 'helmet' are endowed with extraordinary power. Often judicious touches of bitumen strike a vigorous and unexpected note (Pls. 118–20).

In pre-Classic and, later, in Lower Classic ceramics there are themes which constantly recur, notably that of a woman sitting cross-legged. They enable us to trace the development of forms from the sober simplicity characterizing the early manifestations of Remojadas terracotta to the remarkable delicacy of modelling exhibited by elaborate statuettes which must undoubtedly be regarded as portraits.

The art of the figurine in Central Veracruz has peopled the past with a host of highly instructive personages; here we may study forms of ornament, dress, weapons and emblematic elements. Whatever their social position, we see these people as they were in their daily lives—a far cry from the hieratic figures of Monte Albán and Teotihuacán. The impression we gain is one of artists concerned with humans rather than with gods, although the latter sometimes occur.

Classic Sculpture

There is a form of terracotta statuary, usually moulded, which would seem to be based on a curious stereotype whose presumably symbolic significance eludes us. These are the female 'laughing heads', numerous examples of which have been found. However, the expression is not simply one of gaiety, as all too many commentators would have us believe. What we have here is a depersonalized representation. The faces are wide, flat and triangular with a fixed smile that might pass for laughter were it not for the fact that, in certain cases, the protruding tongue beneath pointed teeth suggests some form of ecstatic intoxication, possibly resulting from the consumption of hallucinogens of the kind taken by the Tarahumaras (Pl. 125).

In similar vein are the poignant statues of mothers who have died in childbirth, their faces a mask of sorrow, eyes closed, lips parted and drooping. This theme inspired large terracotta sculptures, forerunners, perhaps, of the Aztec goddess Coatlicue, symbol of fertility and fecundity. Discernible in these young women, their faces distressingly transfigured, are beings who, having transcended their humanity, have already assumed the eternal features of the gods and are surrounded by chthonic forces in the shape of serpents intertwined upon their breasts (Pl. 127).

Thus we enter the realm of Classic art, in which the Veracruz terracottas strike a note of admirable humanity. Some of the larger figures, for instance, display the intensity and acuity, as also the gentleness, of fully mature works. The features are precisely drawn, the faces, with their expressive mouths, are delicate and sharp. The lightness and sensuousness of the forms contrast with a certain rusticity that characterizes pre-Columbian sculptures. Here we find ourselves in the domain of virtuosity, of clear-cut planes, lucid volumes and confident expression.

The Classic sculptors of Veracruz succeeded in investing terracotta—a material that was often soft and unstable—with a stylistic purity found nowhere else save amongst their Maya neighbours. For this statuary is as confident and as perfect as the products of Palenque or the Petén. In this connection we might cite the two bearers of offerings with their ceremonial 'ark'—presented as a symbol of the mystery of their faith. These figures, their pure, incisive faces still endowed with a profound nobility, are graceful, elegant and poised (Pls. 131, 132).

We also find moving 'portraits' of men and women shown as they really are, without any frills, which evoke the quality of some of the figures of Pharaonic Egypt: authority and authenticity—such is their message (Pls. 129, 130). Again, these large terracottas are sometimes reminiscent of the art of the early Chinese dynasties, their hallmark being a clear, economical idiom, notably in the treatment of faces. Despite the stylization of the features, a certain tremor is discernible under the hard light in which the shadows describe lines of almost startling clarity. This mastery, this search for crystalline forms—despite a material which would not naturally lend itself to such treatment—raise these sculptures to the level of great art.

We should not be deceived by the poverty of the medium. The hand of the artist is always there, unmistakably in evidence, to affirm the compelling power of the message, the haughty aspect of the faces, the forceful gaze. For the genius of these sculptors lay in their ability to concentrate attention on the face, a quality also found in the great Maya

121 Middle pre-Classic anthropomorphic pot in the Remojadas style, with a spout in the form of a rod or sceptre. This piece recalls certain Peruvian works. Height 27 cm. National Museum of Anthropology, Mexico City.

122 Small Remojadas vessel with a lateral spout and a mouth in the form of a fledgling's head. The economy of form is truly admirable and presupposes a high degree of virtuosity. This Middle pre-Classic piece is 15 cm high. Jalapa Museum.

123 Terracotta from Central Veracruz. Bitumen is used to remarkable effect in this figure of a warrior, his face emerging from a tall crested helmet; he is also equipped with a large pectoral and square shield. This piece, 16 cm high, may belong to the Lower Classic period (first to fifth century A.D). Jalapa Museum.

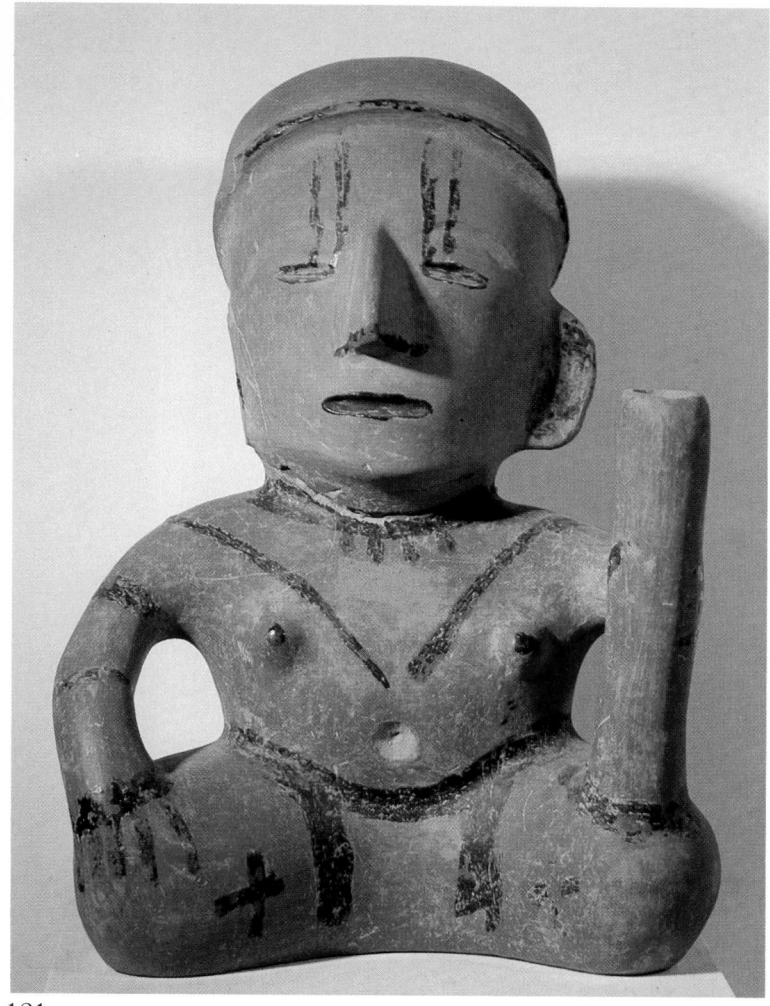

121

122

123

stelae at Copán. Indeed, however complex the garb and rich the adornment, it is the expression, seeming to radiate from within, that immediately catches the eye of anyone seeking to understand the millennary lesson inherent in these works. The interior life finds expression in terracotta. Here we may sense a wave of fellow-feeling all too seldom encountered in the arts of pre-Columbian Mexico.

The Intrusion of Death

The transition from Classic to post-Classic marks an abrupt change of style, for the arrival of Toltecs from Tula introduced the sombre image of omnipresent death into the terracottas of Veracruz (Pls. 133, 134), an obsession already noted in the Mixtecs of the same period, but here strengthened by the tendency to glorify the horror of bloody sacrifice and to exalt the ineluctable fate of the skeleton and of decomposing flesh in the cycle of life and death. Such is certainly the theme of a sculpture depicting a priest clad in the skin of a sacrificial victim whose heart has been torn from his body. To the flayed man's features, to his still warm and palpitating remains, he imparts for the last time the gestures of life as he enacts the mystery of a ritual which enthralled the later Pre-Columbians as much as it would disgust the far from squeamish Conquistadors. For the object of this terrifying exercise was to ensure the rebirth of the sun in a ghastly form of 'communion' with the most pitiable insignia of death. And by a paradox which cannot have eluded the protagonists in this bloody masquerade, the face of the victim concealing that of his executioner assumes a childish air, as if already mimicking the rebirth heralded by death on the altar-stone at the summit of the pyramid (Pl. 135).

However, post-Classic Veracruz can also boast some remarkable ceramics. For the Cerro Montoso potters of the fourteenth and fifteenth centuries give proof of enormous talent. Their works even bear comparison with the best Maya pottery, while the cups and bowls they fashioned betray the hand of the master in the delicacy of their material and the elegance of their forms. The embellishment, always exceedingly economical, testifies to a sureness of touch and to a decorative sense of the highest order (Pls. 136, 137).

Though not, perhaps, as restrained, the potters of the Isla de Sacrificios show a greater plastic awareness. A plumbate ritual pot from the twelfth or thirteenth century features a beautifully expressive effigy of Tlaloc, while anthropomorphic pots from the same source perpetuate certain Remojadas forms related to Peruvian art (Pls. 138, 139).

El Tajín, Jungle Capital

The construction of this great Classic city in Central Veracruz was begun in the first century B.C. by a people said to be related to the Huastecs—i.e. remotely descended from the Mayas—and to have arrived on the Gulf Coast a few centuries earlier.

In Totonac the word *tajín* means lightning, thunderbolt or tornado. The god they revered was Hurakán, lord of the hurricane. The city reached its heyday between 400 and 800 A.D. when it occupied a total

124 This large terracotta incense-burner is supported by a figure of the fire god Huehuetéotl in the guise of a bearded old man. The remarkable Classic piece from Central Veracruz testifies to the profound influence exercised by the art of Teotihuacán between the fifth and seventh century A.D. Height 84 cm. National Museum of Anthropology, Mexico City.

area of some 10 square kilometres. In the thirteenth century, having been put to the flames by invaders, it was abandoned and fell into oblivion. The jungle rapidly took over, covering the ruins with a dense mat of vegetation. The Conquistadors knew nothing of its existence, and it was not until 1785 that Spanish administrators discovered the famous Pyramid of the Niches which was then the only one whose shape was recognizable under the encumbering tree-trunks and lianas.

During the nineteenth century a number of explorers visited the site, but it was not until 1934 that archaeological work was started there. The first task was to clear away the luxuriant vegetation which had engulfed the pyramids and platforms. An aerial view reveals a small valley entirely carpeted with some hundred green hillocks, among them the Pyramid of the Niches, the only one with a revetment of stone and slabs.

The work of retrieval, investigation and restoration was begun in 1938 under the direction of José Garcia Payón, its first object being the Pyramid of the Niches. Indeed there was no time to be lost. The revetment had been breached, enabling the torrential tropical rains to percolate into the interior, thus undermining the edifice and threatening it with total destruction. The task Payón had set himself was a formidable one, yet within a few decades he had restored Tajín to its status of a great pre-Columbian metropolis.

The ceremonial centre covers an area of 80 hectares, flanked by two streams which meet south of the city. It comprises some seventy buildings, such as pyramids, platforms, ball-courts and terraces, as well as other substructures still covered by the surrounding jungle. The disencumbered part of the site consists of two zones, the Lower Town with no fewer than eight ball-courts and the Upper Town known as Tajín Chico (Little Tajín), which dominates the plain with its terraces crowned by a huge pyramid carved out of a natural eminence.

Plan of the ritual ensemble, El Tajín
1 Southern Plaza
2 Ball-court with bas-reliefs
3 Pyramids 5 and 2
4 Pyramid of the Niches
5 Structure 3
6 Plaza in Tajín Chico
7 Building C
8 Building B
9 Building A
10 Building of the Colonnettes
11 Pyramid crowning the acropolis
A to H Eight ball-courts

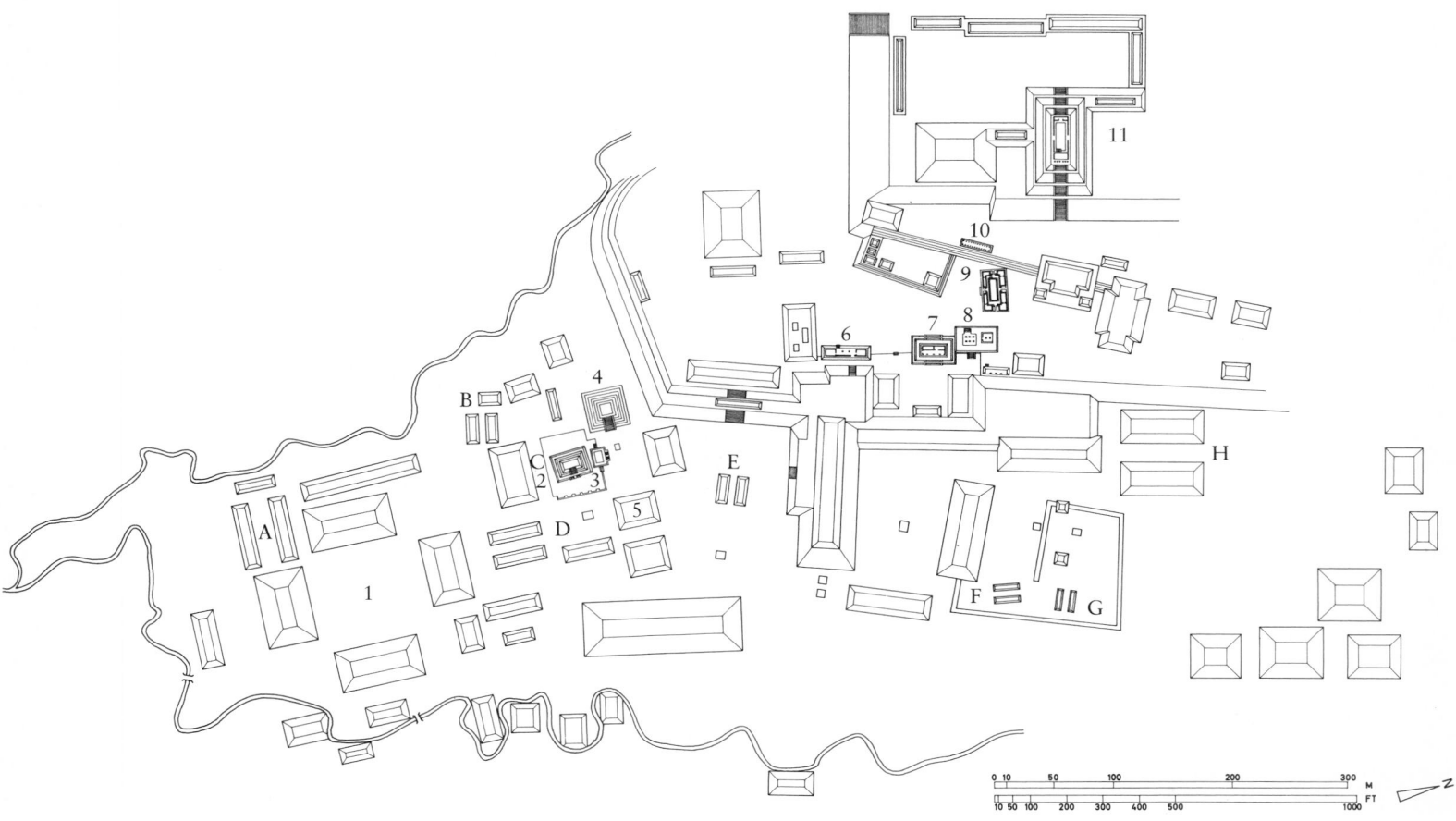

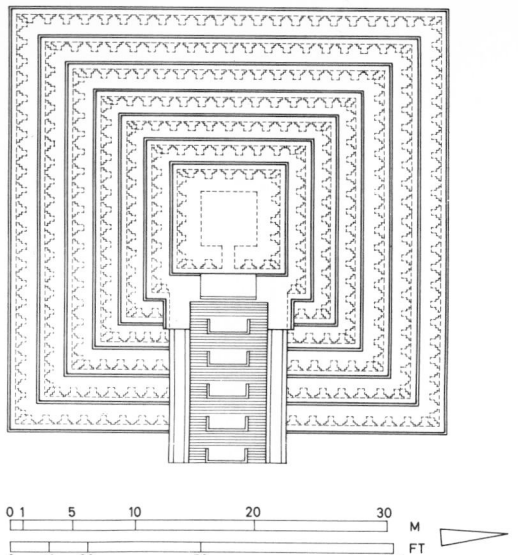

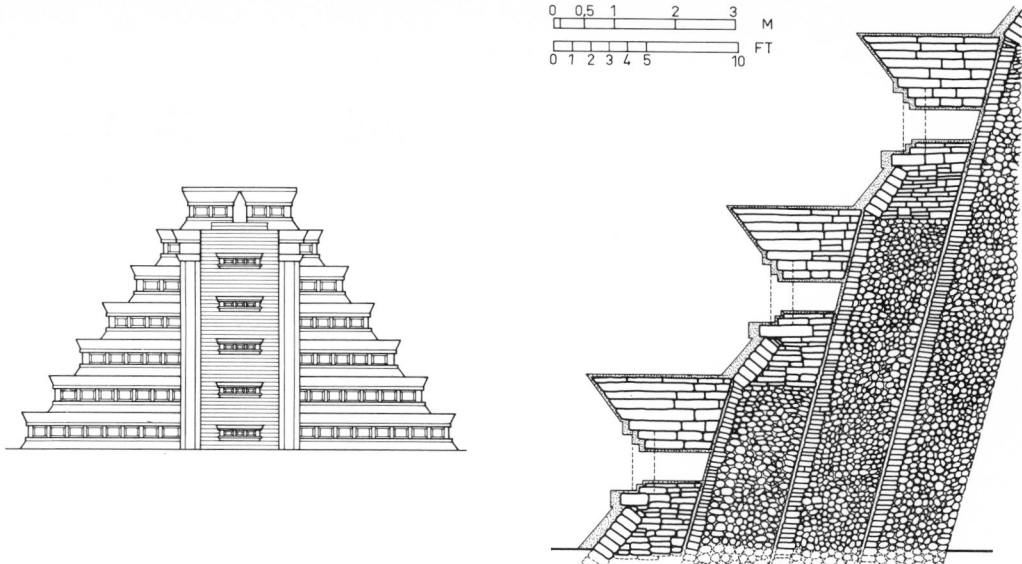

Plan, elevation and diagram of assembly, Pyramid of the Niches, Tajín.

125 This Laughing Head, with the mocking tongue and pointed incisors, originates from the Tierra Blanca, Central Veracruz, and belongs to the Classic period. Width 22 cm. Jalapa Museum.

126 Female figurine enhanced with bitumen and red pigment. It dates from the Classic period. Height 15 cm. Jalapa Museum.

127 Head of a dead woman from the Tierra Blanca. This moving face of a woman who has died in childbirth belongs to the Classic period. A reverence for these unfortunate women was transmitted to the Aztecs by the Gulf peoples. Height 22 cm. Jalapa Museum.

128 Jaguar from Nopiloa, possibly a toy. On the Gulf Coast several wheeled objects have been recovered, yet the wheel was allegedly unknown to the pre-Columbians. Length 18 cm. Jalapa Museum.

As we enter the main plaza we see a series of buildings surrounding a large square altar—pyramids, platforms and temples, almost all of which display the characteristic motif of the square niche. Set in frieze-like ranges, these deeply shadowed recesses accentuate the stages of the various terrace risers crowned by overhanging cornices (Pl. 140).

As one would expect from its name, this principle is taken to its logical conclusion in the Pyramid of the Niches, which is 25 metres high and built on a square plan measuring 35 metres each way. Its six stages were formerly surmounted by a temple which, since its walls were also adorned with niches, might be accounted a seventh stage. The main axial stairway, flanked by ramps, each adorned with thirteen terraced meanders, ascends the east face. The centre of the flight is interrupted at five points by 'landings' in the shape of projecting elements supported by groups of three niches (Pl. 143).

If we consider the structure of this very elegant pyramid, we find that each stage consists of a talus inclined at an angle of about 45° with, above it, a frieze of niches. These are inscribed in a projecting band which recalls the principle of the framed tablero at Teotihuacán. But here, in place of the slightly recessed panel, deep, square niches have been introduced for the sake of greater plasticity and rigidity. In addition, a wide, projecting cornice enhances the vigorous profile of this moulding.

An examination of the main stairway shows that it projects from the façade of the pyramid and that the band of niches continues, albeit invisibly, beneath it. Thus the number of niches, including those which can be assumed to exist under the main stairway, amounts to 365. For each terrace riser possesses three fewer niches than the one below, i.e. twelve fewer if all four faces of the pyramid be taken into account. On each face they number successively 22, 19, 16, 13, 10, 7 and 4, or a total of 88, 76, 64, 52, 40, 28 and 16 per stage, making a grand total of 365, if we include the entrance to the cella.

What we have here is undoubtedly an instance of a symbolism based on the number of days in the solar year. If we further consider that the two sets of thirteen terraced meanders flanking the stairway represent the number of twenty-day months in the Mexican religious year, we have to concede that, in building the Pyramid of the Niches, the Tajín architects gave concrete form to a conceptual system based on the calen-

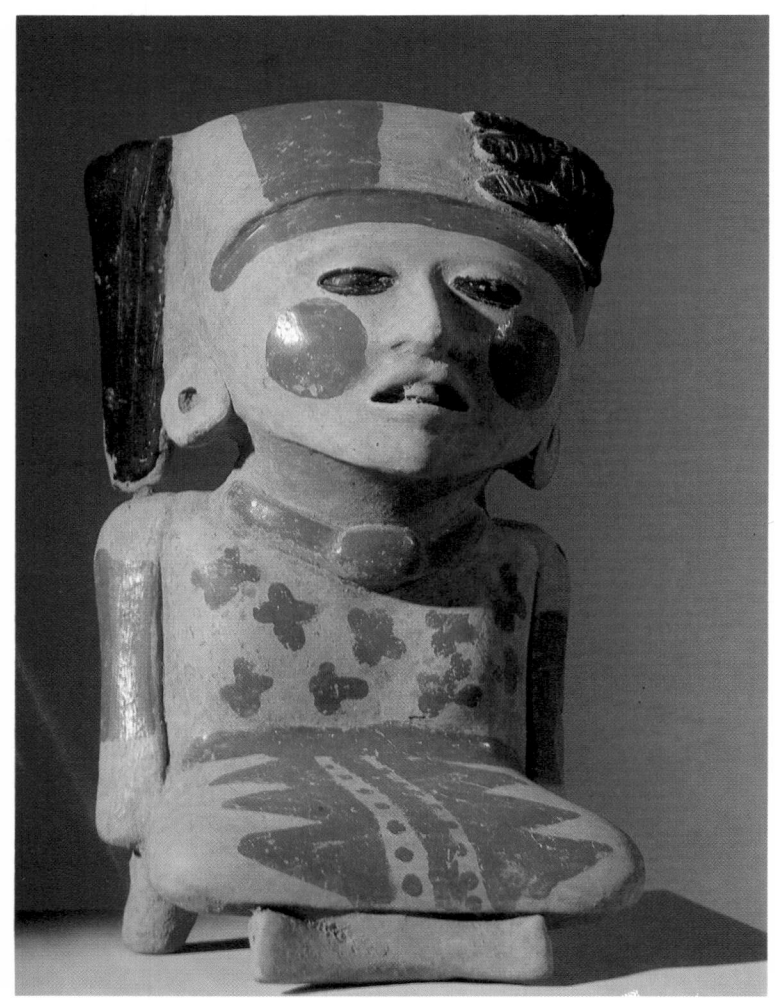

125

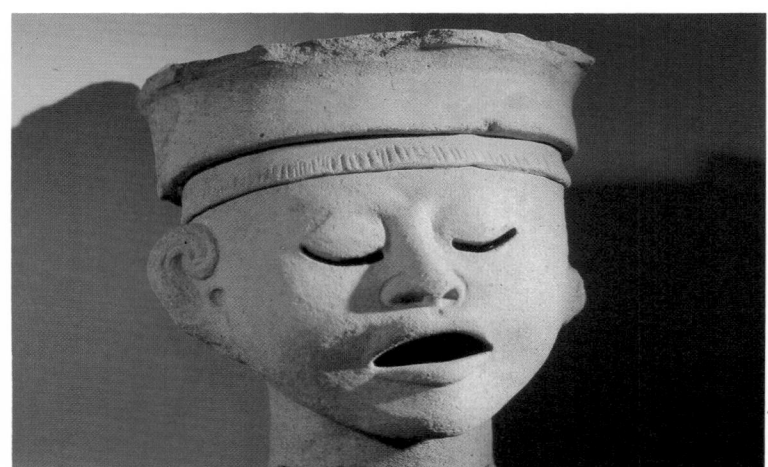

126

127

128

129

130

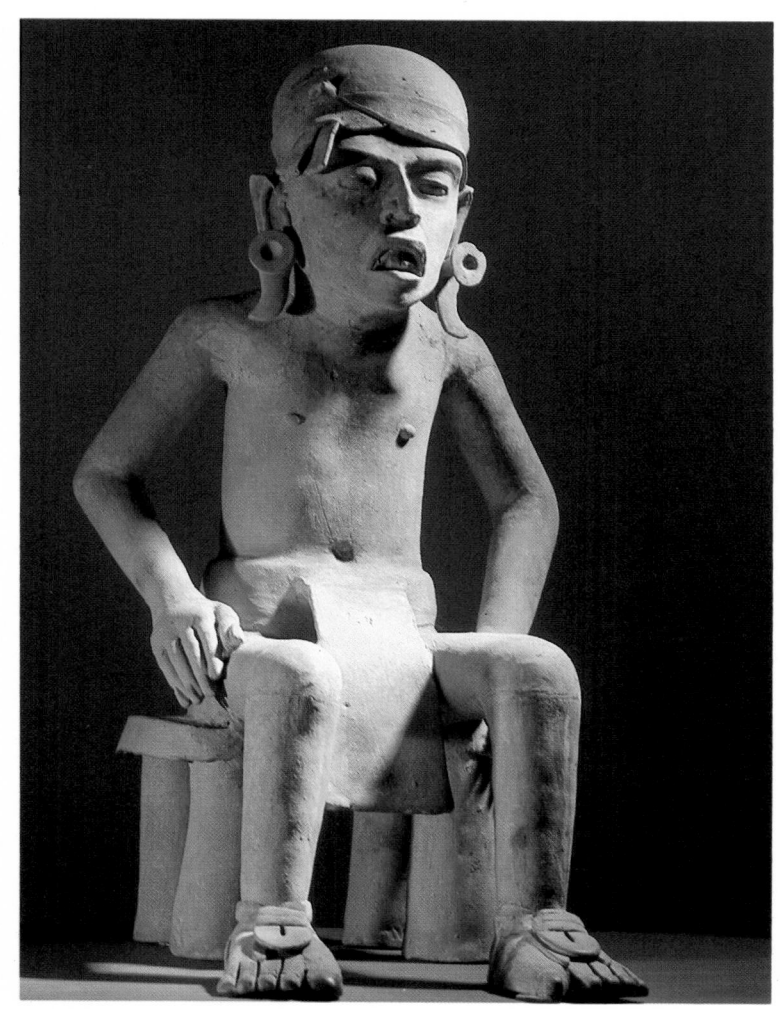

131

132

dar. Here we should add that these niches appear to be governed by no consideration other than that of plastic effect, nor did they ever contain statues, as was supposed quite erroneously by those who first discovered them.

The work of retrieval has shown that the pyramid we see now is in fact a superimposition concealing an earlier structure devoid of niches. It would seem that some three centuries separated the two campaigns. In the first phase the pyramid resembled Structure 3, whose masonry stages have a fairly pronounced batter. Immediately to the left of the latter is Structure 23 in which the architect adopted a form that anticipates the niche, namely a series of projecting supports which subdivide the terrace risers into panels, crowned at each stage by a light cornice. As in the Pyramid of the Niches, the stairway of Structure 23 is interrupted by landings resting on three niches (Pl. 142). Thus we are able to follow an architectonic development that was to attain full maturity in the Pyramid of the Niches, with its vigorous plastic forms and its coherent and harmonious decorative organization.

Several of the other edifices in the Upper Town, Tajín Chico, are conceived along similar lines. One example is Building C, a wide platform of three storeys of which the first two possess ranges of niches which are not simple recesses but are adorned with elegant meander reliefs. Below each terrace riser is a talus whose pitch does not exceed 35° (Pl. 141).

This part of the town also comprises a somewhat curious edifice, Building A, with a complex upper structure in which a small truncated pyramid is combined with a narrow peripheral passage. Access to the latter is by a stair which passes under a false arch similar to the corbelled vault section of the Mayas.

Thus Tajín architecture combines the Teotihuacán tablero principle, if in greatly modified and enriched form, with the techniques of the Maya builders, inventors of the concrete vault. The first of these characteristics is an undoubted indication of the close links subsisting in the Classic period between El Tajín and the great metropolis of the high plateaux, while the second betrays the distant Maya origins from which the inhabitants of the site would seem to have sprung. For they were related to the Huastecs, a Mayoid offshoot who had settled north of the Gulf, cut off from their kindred in Chiapas and Yucatán.

If we examine the relatively free manner in which the buildings of the Lower Town and Tajín Chico are disposed, a distinct pattern emerges. In fact most of the buildings in the Lower Town are orientated almost exactly on the cardinal points. This applies, not only to the south plaza flanked by four large pyramidal structures, but also to the Pyramid of the Niches and the peripheral buildings (notably Structures 3 and 23). The better part of Tajín Chico on the other hand, and in particular Buildings A, B and C, as also the great pyramid crowning the acropolis, is governed by an orientation that deviates some 17° from the east-west axis. This variation, which is similar to that of the Sun Pyramid at Teotihuacán and, later, of the great pyramid at Tula, corresponds to the direction of the setting sun on the days when it reaches its zenith.

The discrepancy between the orientation of the two zones would seem to reflect not only different ritual requirements but also separate campaigns of construction. Indeed, this is confirmed by the site's later architecture to which we shall return after considering one of Tajín's most remarkable structures, the ball-court.

129 Male terracotta portrait-head from Ignacio de la Llave, Veracruz. This fine Upper pre-Classic piece testifies to the immense talent of the Gulf Coast potters and sculptors. Height 34 cm. Jalapa Museum.

130 Another portrait-head from Ignacio de la Llave in Central Veracruz. Representing a young woman with movingly sensitive features, it exemplifies the economy and sobriety of Classic sculpture. Height 19 cm. Jalapa Museum.

131 Large terracotta of a seated figure from Central Veracruz. Dating from the Upper Classic period (sixth to ninth century A.D.), this piece is endowed with remarkable force of expression, not only by the intensity of the features but also by the natural and concentrated attitude of the figure as a whole. Height 62 cm. Jalapa Museum.

132 Large terracotta from Veracruz depicting two figures, probably bearers of votive offerings. The acuity, sculptural force and sobriety of this Upper Classic work are the hallmarks of a great art. The poses of these two exactly similar personages are astonishingly life-like and they carry their burden as though it were a sacred ark. Height 58 cm. Jalapa Museum.

133 Prince of the World of the Dead and Lord of the Ninth Lower Heaven, such are the titles of this skeleton with a tall tiara-like head-dress. A Classic terracotta belonging to the period between the sixth and ninth century from Los Cierros (Tierra Blanca). Height 35 cm. Jalapa Museum.

134 The geometrical forms of the apparel worn by this curious Upper Classic figure of Mictlantecuhtli (death) from Central Veracruz, are difficult to interpret. Height 26 cm. National Museum of Anthropology, Mexico City.

135 Head of terracotta figure from Central Veracruz, clad in the skin of a newly flayed sacrificial victim. Beneath the distended features of the dead man we may discern the face of the wearer who had to spend several days clad in this grisly integument. This detail of an Upper Classic work is some 30 cm high. National Museum of Anthropology, Mexico City.

133

134

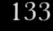

135

A Ritual Sport: The Ball-Game

As we have seen, the Lower Town possessed no fewer than eight ball-courts, from which we may conclude that this ritual form of sport was exceedingly popular among the Pre-Columbians of the Gulf region (it was, indeed, of local—i.e. Olmec—origin).

Called *tlachtli* by the Aztecs, the game was a source of amazement to the Conquistadors. Some time previously Christopher Columbus had brought back from his second voyage a rubber ball which created a considerable stir, for rubber and latex were as yet unknown in the Old World and no one had ever seen anything bounce so high. It was not long before the invaders, followed by ethnographers, began to study the forms assumed by the game. Thus in 1529, a mere seven years after the capture of Tenochtitlán, Christopher Weiditz made some drawings of a party of young Indians brought to Seville at Cortés's instigation to demonstrate the sport, eye-witness descriptions of which are also provided by chroniclers such as Motolinía, Bartolomeo de Las Casas and Sahagún. From the drawings as well as the authors we learn that the ball was struck with the hips only, and no other part of the body.

While played almost everywhere in the New World, from California to Peru, the game was at its most concentrated in Mexico and Central America. The courts, the rules and the number of players varied considerably, as did the dimensions of the solid rubber ball which ranged from the size of a tennis ball to that of a large football and could weigh 3 kilograms or more. In Mexico the latex for its manufacture was obtained from the castilloa and the guayula and in South America mainly from the hevea, which is still the chief source of natural rubber. According to the chroniclers, the tribute paid to the Aztec emperor Moctezuma included some 16,000 balls a year.

The ball-game is still played today in certain remote parts of Mexico, notably in the State of Sinaloa 1,500 kilometres north-west of the capital, where teams in action have been photographed by Ted Leyenaar. Their attitudes and gestures are the same as those seen in the drawings made by Weiditz at the time of the Renaissance.

In *Art of the Maya* we considered the ball-game, with special reference to the forms it adopted among the Olmecs, the Mayas and the Maya–Toltecs, at La Venta, Copán, Uxmal and Chichén Itzá. In the present work it has already been discussed in connection with Teotihuacán (La Ventilla stela and the Tepantitla frescoes), as also with Xochicalco, Tula, Monte Albán, Dainzú and Yagul. But the richest source of information on this ritual sport is undoubtedly El Tajín, where the largest number of ball-courts has been found.

We have so far been able to establish the existence of a number of different types of court:

1) At Teotihuacán it must have consisted simply of a section of the Avenue of the Dead flanked by platforms and stairs. Stone goal-posts stood at either end of the court and a bat was used, as in baseball.

2) At Monte Albán, Yagul and Dainzú the courts are shaped like a flattened H (as in the Maya country), with sloping sides in the shape of benches which in turn are flanked by walls.

3) At Xochicalco and Tula they are also H-shaped but halfway down either side of the court are upright stone rings of the same kind as those at Chichén Itzá, themselves a legacy of the Toltecs.

4) At Tajín we find yet another principle. The court no longer takes the form of the flattened H, but is merely a long space flanked by straight vertical walls. The latter vary in height, from 80 metres in the case of the northern court (length 26 metres) to 1.8 metres in that of the southern court (length 60 metres).

About the game itself various facts are known—namely that bats were employed at Teotihuacán, that in the Classic period the Mayas had no accessories other than items of protective clothing such as the thick padded belt worn round the hips to fend off the large, heavy ball, and, finally, that the ball used by the Toltecs and Maya–Toltecs was very much smaller since it had to pass through the 'goal' rings affixed to the top of the lateral walls. However we do not know what rules governed the matches played at Tajín, although post-Classic bas-reliefs there have provided some highly valuable information on the ritual implications of the game. For instance, they throw light upon the function—long veiled in mystery—of certain accessories whose forms we find reproduced in emblematic sculpture, notably the famous yokes, *hachas,* and *palmas.* Thus the yoke would appear to be a stone version of the open ring, probably made of wood, which was worn round the waist, serving both to deflect the ball and to protect the liver and spleen. For it should be remembered that the ball might weigh several kilograms and could travel very fast, so that padding was required such as is worn by the baseball players of today. But this protective clothing must have been made of rigid material, since the ball evidently glanced off it. In addition, an elegant object known as a *palma* was inserted under the belt behind the yoke and was probably intended to stop the ball or keep it in play. The bas-reliefs of the south ball-court at Tajín show how it was worn, as does the Aparício stela (Pls. 144, 153).

The function of the *hacha* still remains obscure, though it may derive from the sabot-shaped objects, used by players as a support, which may be seen in Olmec sculptures and in the bas-reliefs of the ball-court at Chichén Itzá. We shall presently return to these pieces, since they constitute the most perfect examples of the stone sculpture produced in Tajín and, indeed, in Veracruz generally.

On one point, however, the Tajín bas-reliefs (as also the Mixtec codices) leave us in no doubt. For they make it quite clear that, on the occasion of great ceremonies, the game might be attended by the death of one of the contestants during a ritual sacrifice in which his heart was torn out, a scene depicted in the north-east bas-relief in the largest ball-court. And this brings us back to the religious function of the game. The purpose of human sacrifice was to restore the powers of the gods, particularly that of the sun so that, having disappeared into the nocturnal underworld, it might be able to resume its diurnal cycle. The Pre-Columbians had always associated the ball-game with the movement of the sun, but this frenzied recourse to bloodthirsty sacrifices, so shocking to the Conquistadors, would appear to have been peculiar to the Toltec and Aztec periods when the game came to resemble a kind of lottery in which the stake was the life of the sacrificial victim. But who, we may ask, was sacrificed? In *Art of the Maya* we oversimplified the case when we spoke of the dispatch at Chichén Itzá of the captain of the losing team (after his heart had been torn out, he was decapitated and his head exhibited on the *tzompantli* or skull-rack). In fact, the matter is by no means so straightforward, for we should not necessarily assume that it

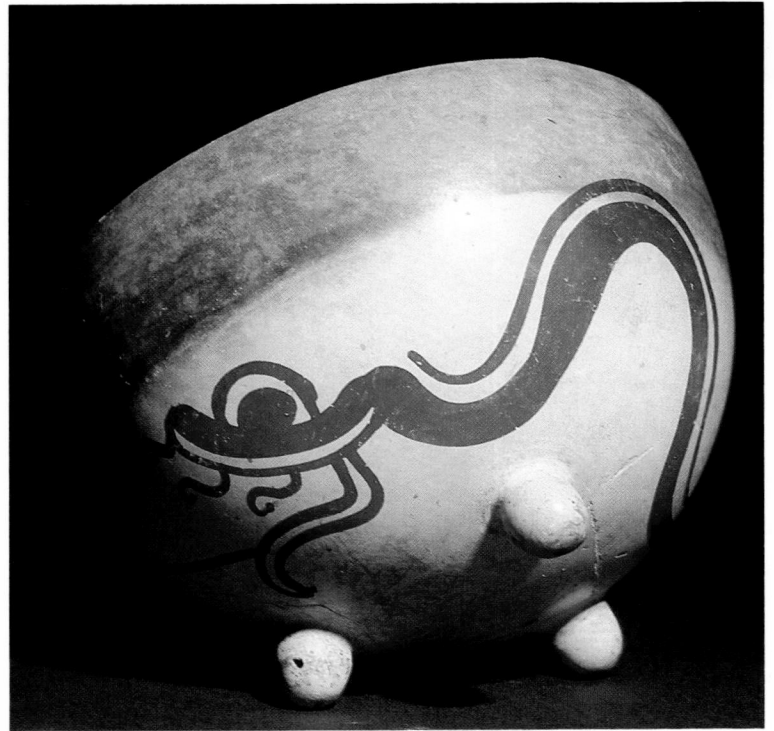

136

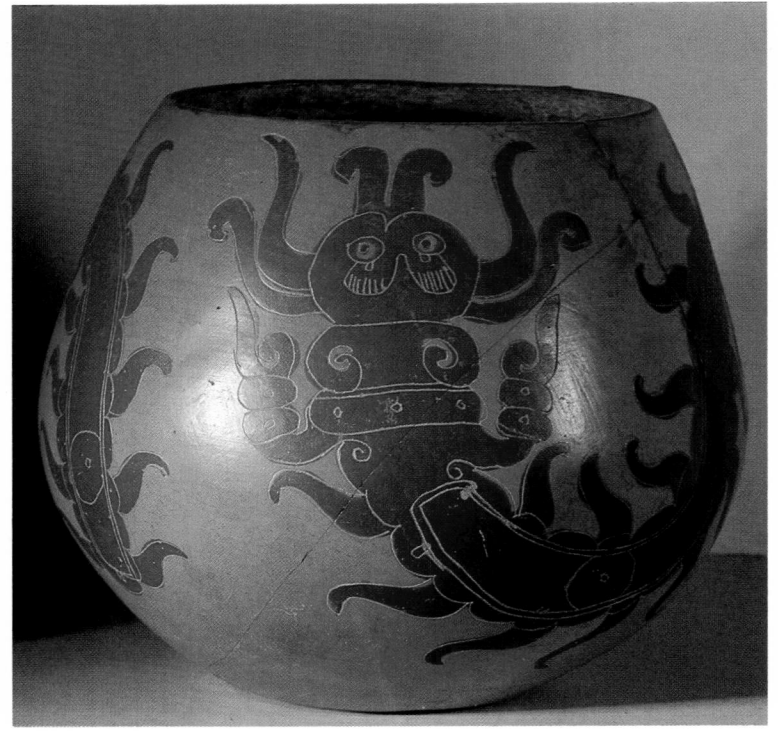

137

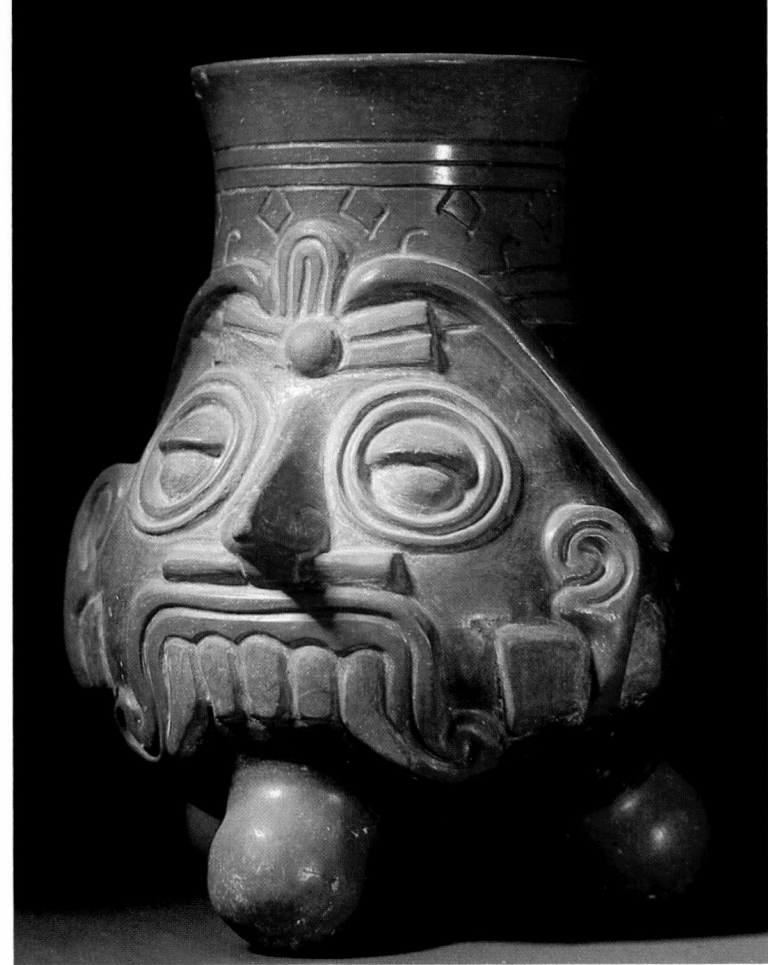

138

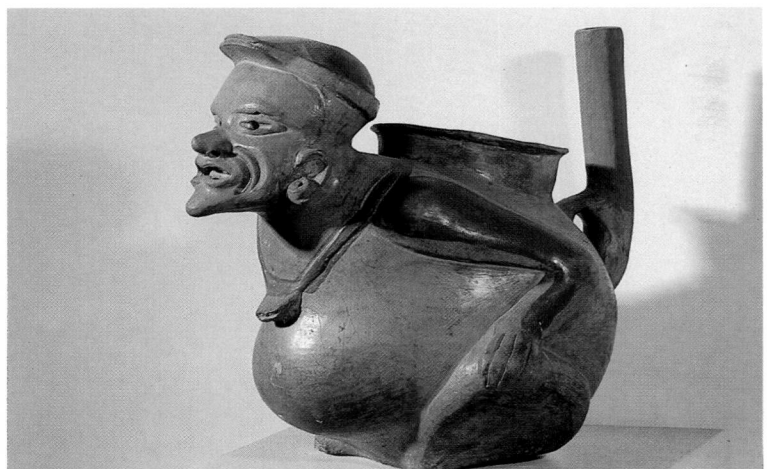

139

136 The perfection of Veracruz workmanship is discernible in this tripod bowl elegantly adorned with a snake motif. It is a Totonac post-Classic (fourteenth or fifteenth century) work from Cerro Montoso, 18 cm in diameter. Jalapa Museum.

137 Like the preceding work, this bowl with a millipede motif comes from Otates in the Cerro Montoso region and is a perfect example of the Veracruz pottery of the post-Classic period. Height 15.5 cm. National Museum of Anthropology, Mexico City.

138 Plumbate ritual vessel from the Isla de Sacrifícios, Veracruz, depicting the god Tlaloc and probably dating from the early post-Classic period (eleventh to twelfth century). Height 17 cm. Jalapa Museum.

139 Anthropomorphic vessel with spout from Central Veracruz and displaying close affinities with Peruvian pottery. Dating from the post-Classic period, it is 22 cm high. National Museum of Anthropology, Mexico City.

140 The plaza at the centre of the ceremonial complex at El Tajín in Veracruz. To the left, behind a square altar, is Structure 5, a pyramid with a frieze of niches crowned with a wide cornice. At the centre of the stair is a polygonal stela. Further to the right is the famous Pyramid of the Niches with its great stairway, while beyond it again stands Structure 3, resembling the Pyramid of the Niches in its first phase and thought to date from the fourth or fifth century. The photograph was taken from Structure 15.

141 Building C in the lower part of Tajín Chico has three platforms lined with niches, the latter being adorned with key-fret motifs in relief.

142 The heart of Tajín's ceremonial centre. In the foreground, at the centre of the plaza, is the altar with, behind it, from left to right, Structures 3, 23 and 15. These demonstrate the development of the niche motif which was to typify the Classic architecture of Veracruz.

was the loser who was offered up to the gods. To do so would be to take too modern a view and leave out of account the very unusual mentality of the profoundly mystical peoples—literally haunted by their deities—who inhabited the pre-Columbian world and, in particular, Mexico.

There are several reasons for supposing that it was the winner who 'deserved' to die. In the first place, he would be admitted to the world of the gods and, with this in view, would do his utmost to win the contest and, with it, the right to ascend the sacrificial stone. Again, the Indian peoples are known to have been imbued with a spirit of self-immolation which is still apparent today in the self-mortification of the pilgrims to the shrine of Our Lady of Guadeloupe, or of those who aspire to play the rôle of Christ at Passiontide feasts, a rôle that is not altogether symbolic, for their hands are literally nailed to the Cross.

This death-orientated outlook, which led to the horrifying Aztec practice of mass sacrifice, is exemplified in the story of the national hero, Eight Deer, recounted by the Mixtec chroniclers. As we have already mentioned, Soustelle suggests that, in making the chief die on the sacrificial stone at the age of fifty-two (i.e. a pre-Columbian 'centenarian'), the historians had made somewhat free with the facts. Might we not rather suppose that this same chief, knowing he had reached the end of a cycle, voluntarily submitted to having his heart torn out? That would be more in keeping with the almost godlike aura of heroism surrounding a man sanctified by the early chroniclers.

A glance at our own history suffices to show the lengths to which the exaltation of the faithful may lead them. In early Christian times many believers, in the grip of a similar mystical frenzy, sought martyrdom in the arenas of Rome, thereby ensuring their admission to paradise. In short, the suggestion that it was the winner who was sacrificed at the end of the ball-game, far from being implausible, accords rather better with the concept of a ritual sport.

The Bas-reliefs in the Great Ball-Court

In its third and final phase, which postdated the settlement in Tajín of Toltecs migrating to Chichén Itzá in the tenth century, the great ball-court south of the Pyramid of the Niches and Structure 5 was adorned with fine bas-reliefs which admirably illustrate the ritual function of the ball-game. In style they are very pure and homogeneous, while the quality of the carving is extremely high. Consisting of six large panels, they occupy the centre and ends of the north and south walls, 1.8 metres high and 60 metres long, which flank the ball-court. We shall attempt to describe these bas-reliefs in the light of the excellent drawings made by Michael E. Kampen in 1965–6 and published in 1972 by the University of Florida.

We shall begin with the two large central motifs on the south wall (A) and on the north wall (B), although they are, perhaps, the most difficult to interpret. In many respects the former, measuring 1.80 by 3 metres overall, is a replica of the latter and both are devoted to the pulque ceremony. This mildly alcoholic drink, made from the fermented sap of the maguey plant, a type of cactus, was productive of 'divine intoxication'.

At the centre of the lower part of the south panel is a figure wearing a fish mask—the spirit of pulque—who is immersed up to the waist in

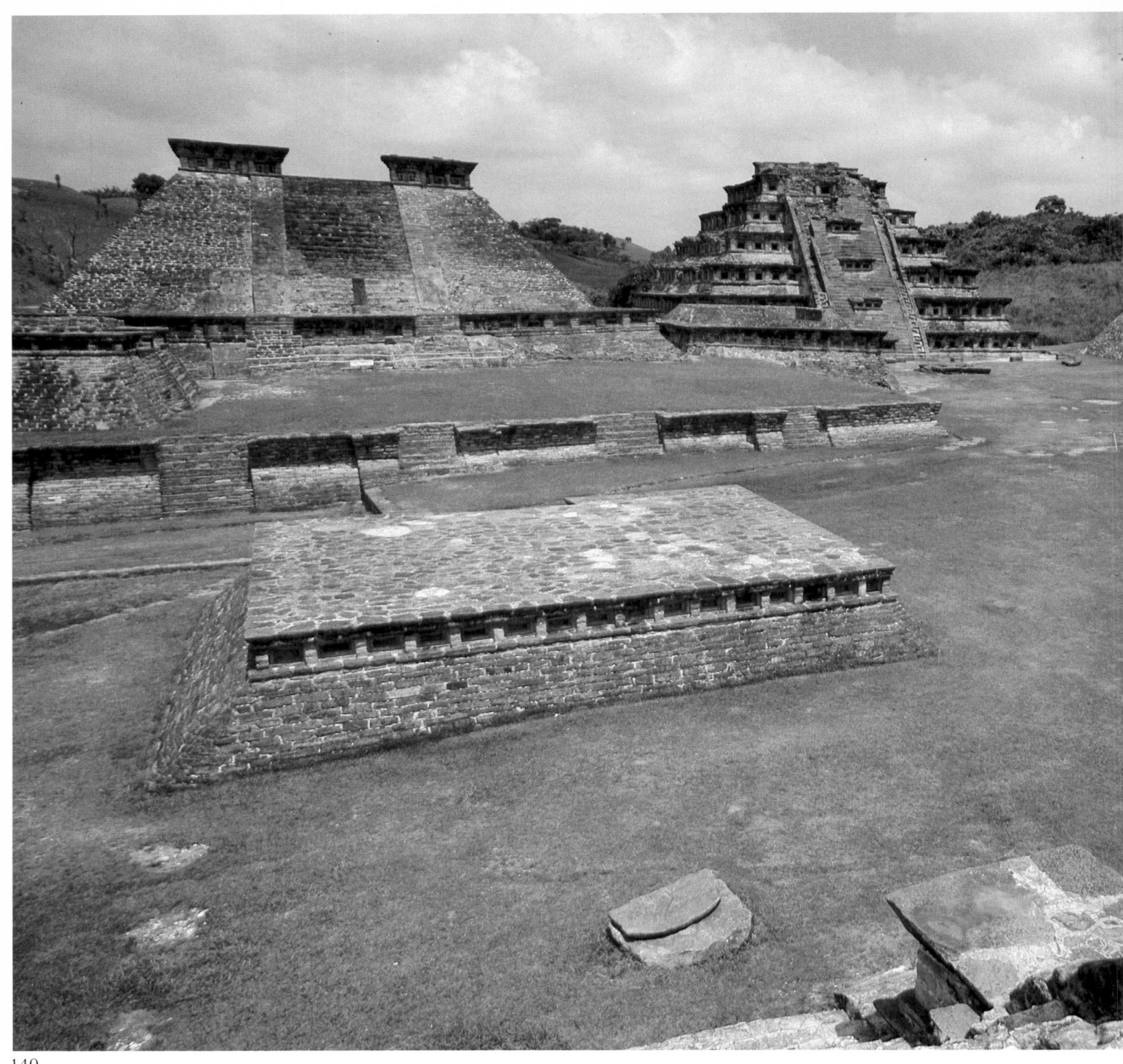

140

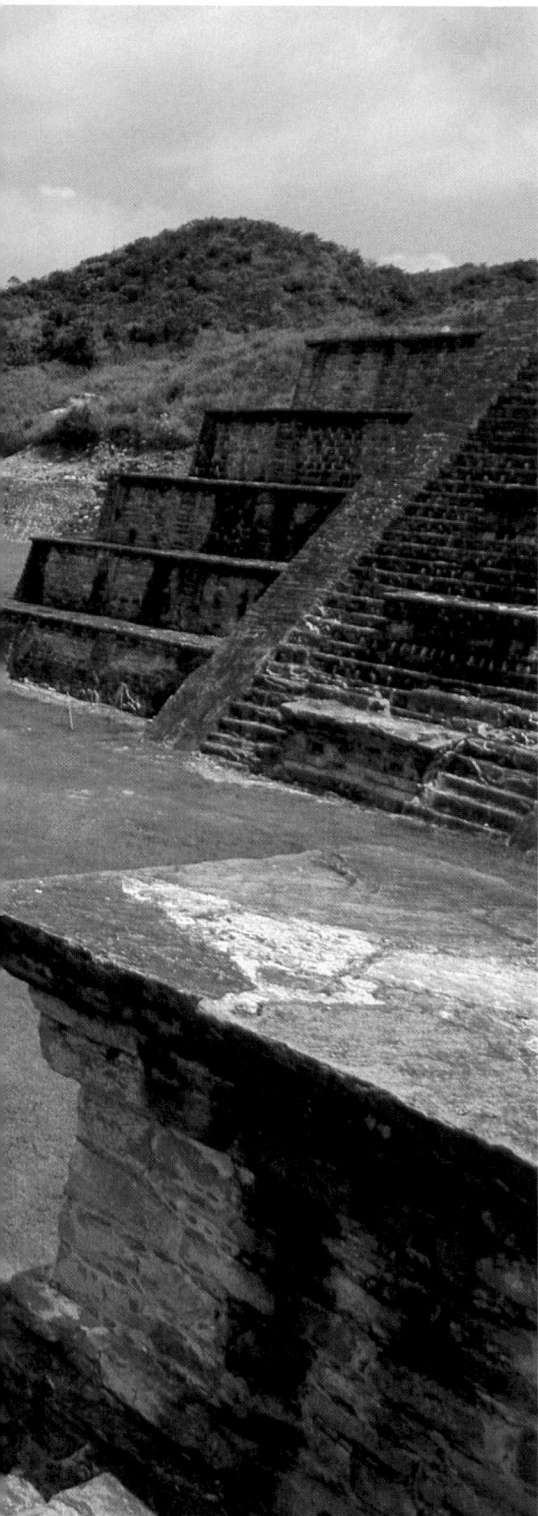

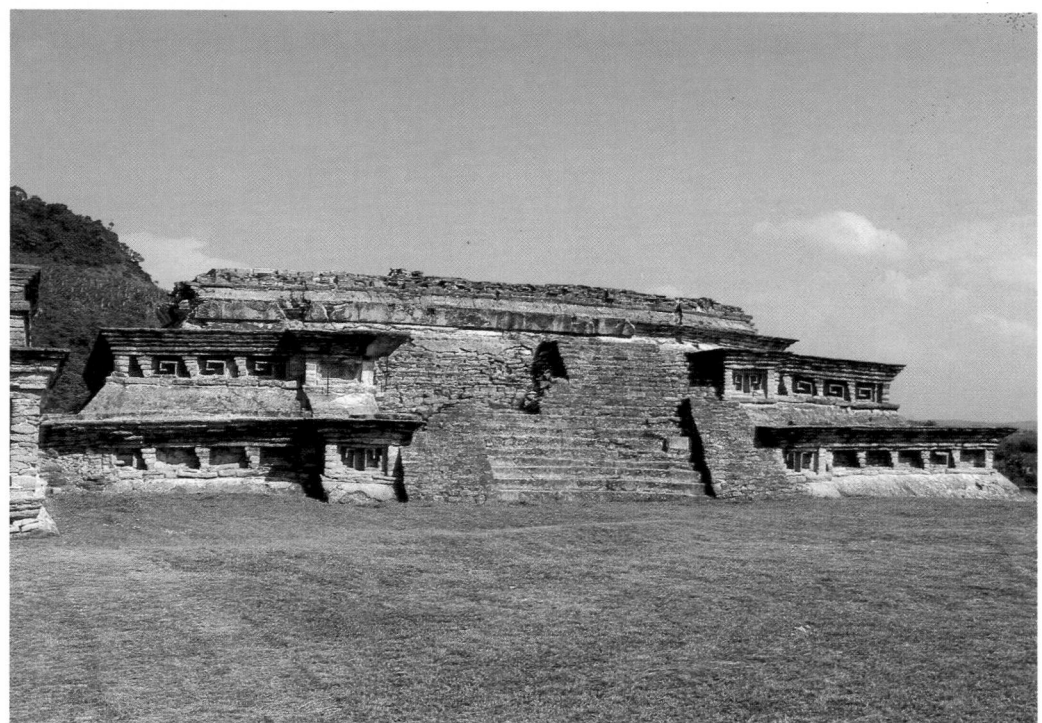

141

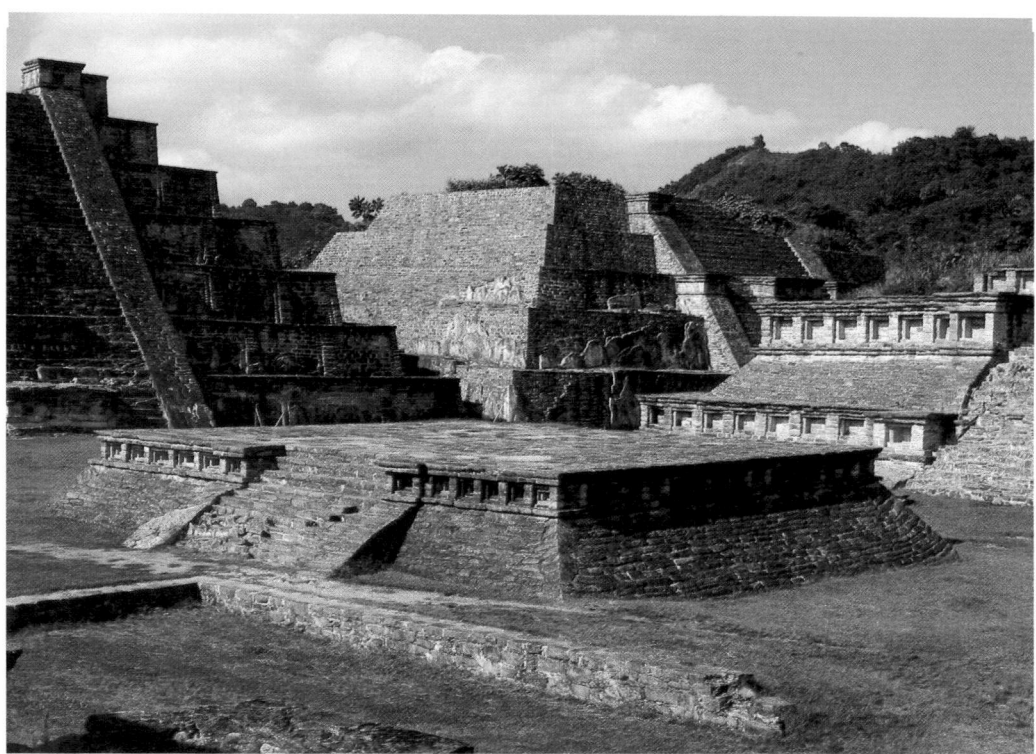

142

a stone vessel containing the fermented liquid. Squatting on the edge of this vat is another figure, presumably Tlaloc, who, with a pointed instrument, pierces the plant, causing the sap to flow towards the spirit of pulque. Above and to the left, on the roof of a temple adorned with stepped merlons, is a partially defaced figure receiving thunderbolts from a deity floating overhead. The latter has a rabbit's head symbolizing the moon, or pulque goddess. It will be noted that the S-shaped thunderbolt sign is a larger version of the speech scrolls issuing from the figures' mouths, indicating, perhaps, that thunder was the speech of the gods. The whole of the left-hand side of the panel is occupied by a plant showing the various stages of growth of the maguey (a theme exactly repeated on the right-hand side of the northern central panel). In both cases the panel is lined by four decorative bands and above it, apparently hovering, is a being with two bodies and one head. Representing the principle of duality or confrontation, it may have indicated the place half-way down the court where the two teams clashed.

In the northern panel (B) the pulque vat recurs but now a masked personage, with speech scrolls issuing from his mouth, reclines beside it in the posture of a Chacmool. Above him are stepped merlons, suggestive of a temple, upon which two deities are seated. The one on the right, wearing a conch pectoral symbolizing air, represents Quetzalcóatl, while the figure on the left, armed with a thunderbolt, is Tlaloc, the avatar of Hurakán. He is handing the thunderbolt to a standing figure on the far left who carries a vessel, presumably full of pulque, under his right arm and points with his left at the Chacmool. The maguey plant and the symbol of duality also recur here.

In the present state of our knowledge these two scenes are far from easy to interpret. However they demonstrate that the gods were present

143 Pyramid of the Niches at El Tajín. With its six stages and its great stair lined with ramps and interrupted by five 'landings' supported by triple niches, it attains a height of 25 m. Its first phase is ascribed to the fourth century, when it had no niches, a characteristic decoration it only acquired during the second campaign of construction in the seventh century.

144 The well-known bas-relief of a sacrifice entailing the excision of the victim's heart. Situated at the far end of the north-west wall of the southern ball-court at El Tajín, it is typical of the post-Classic art of Veracruz during the eleventh to thirteenth century, the time of the Toltec renascence.

Drawing of bas-relief panel at the centre of the south wall (A) of the ball-court at Tajín (after M. E. Kampen).

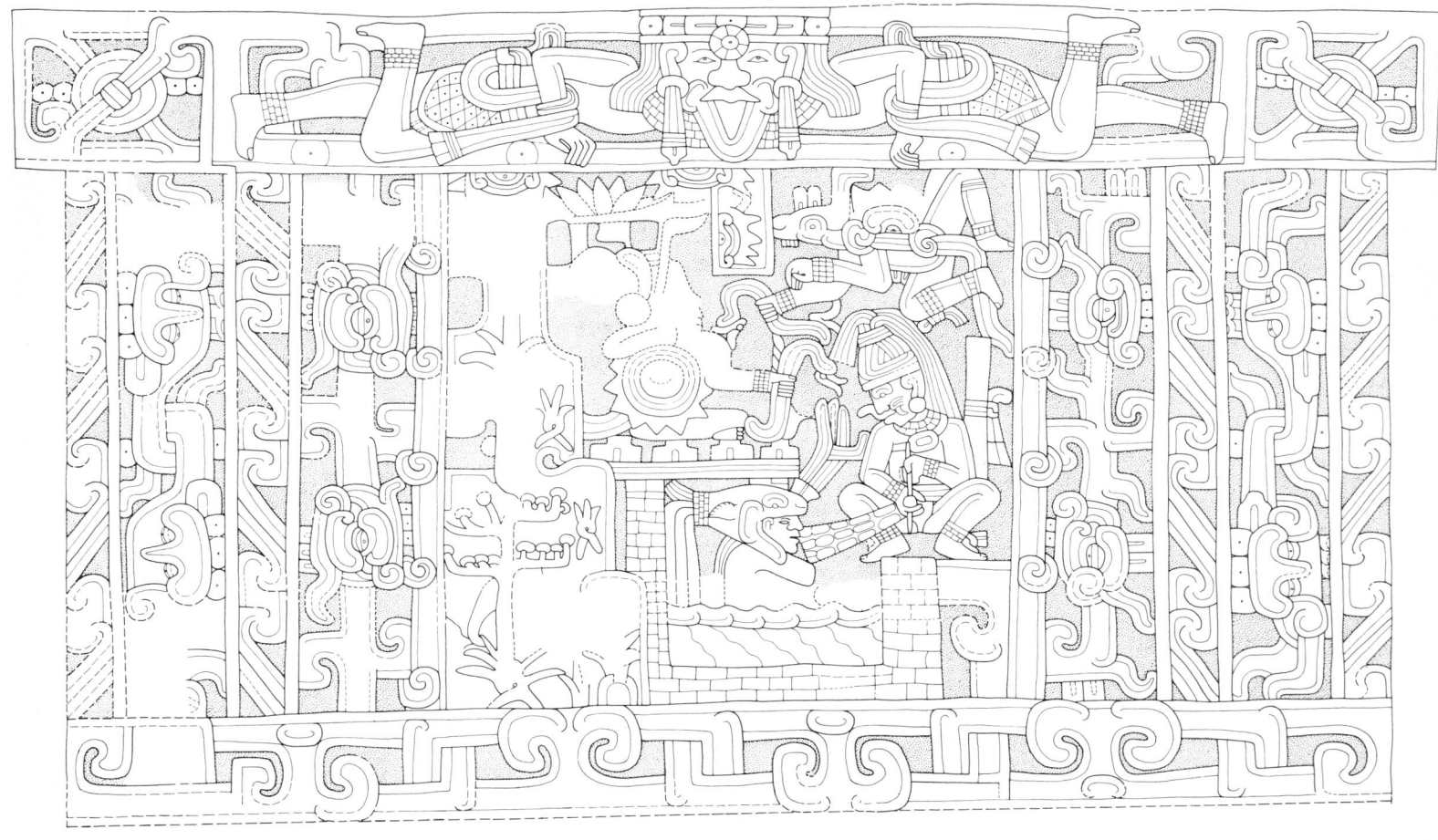

143

144

in pulque and that the drink possessed supernatural powers. Alcohol may have endowed the drunken Chacmool figure with the gift of prophecy, making him the messenger of the gods and selector of the protagonists in the ball-game, and hence of the sacrificial victim (?).

We shall now turn to the four bas-reliefs, each measuring about 1.80 by 2 metres, which occupy the ends of the ball-court walls.

At the centre of the south-east panel (1), which is in a relatively poor state of preservation, stands a single figure who is apparently connected with a small personage seated on the left. Between them, a bundle of what may be darts or rays descends from a celestial symbol in the shape of a large square mask supported by an object resembling a spinal column. On the right, a small, partially defaced figure is seated on a kind of throne and may be acting as a witness. This scene may perhaps represent a transfer of power in which the standing figure, possibly a king, has just handed over the insignia of his office to his son. On the right, in a separate section, a skeleton emerges from a pot of pulque (?). The upper frieze displays a series of interlaces, meanders and scrolls typical of Tajín art; enclosed in a buckle is a link motif symbolizing *ollin,* or motion and change.

The north-west panel (2), diagonally opposite, shows two personages standing face to face. Besides the accessories of the game—thick protective clothing in the shape of the yoke and attached *palma* worn at the waist—they are arrayed in ceremonial attire consisting of head-dresses made of large quetzal feathers and, at their backs, a train. The two protagonists, with their attendant speech scrolls, are challenging each other over a ball above which is a sign indicating movement and confrontation. The sacrificial obsidian knife carried by the figure on the right is a portent that the match will end in the death of one or the other of them.

145 Ceremonial *hacha* in volcanic rock from San Andrés Tuxtla (Central Veracruz) depicting a ball-game player whose helmet is in the form of dolphin with a skull-like head. This Classic work, which is 28 cm high, is remarkable for the vigour of the carving and must once have been enhanced by polychrome encrustations, notably round the eyes. National Museum of Anthropology, Mexico City.

Drawing of bas-relief panel at the centre of the north wall (B) of the ball-court at Tajín (after M. E. Kampen).

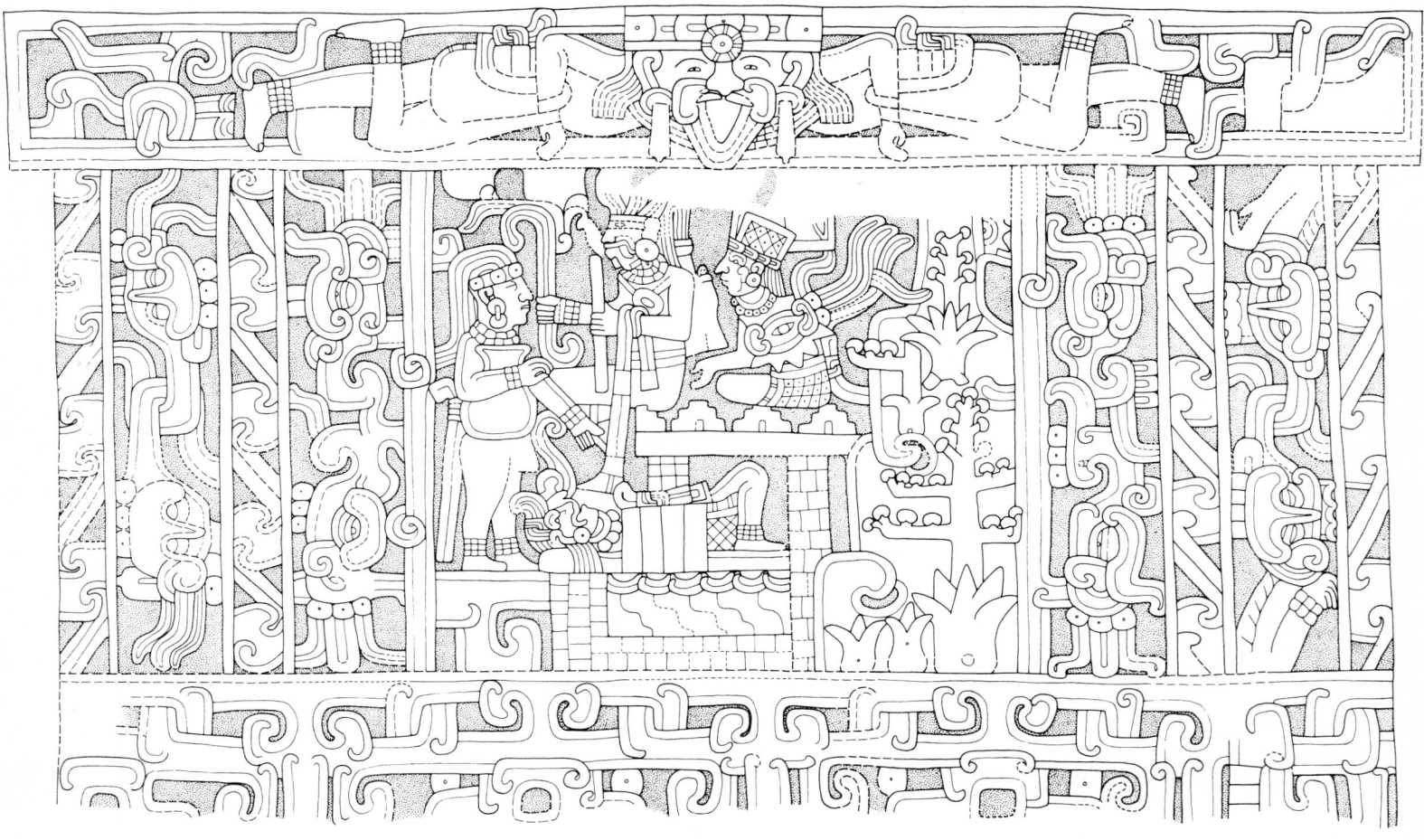

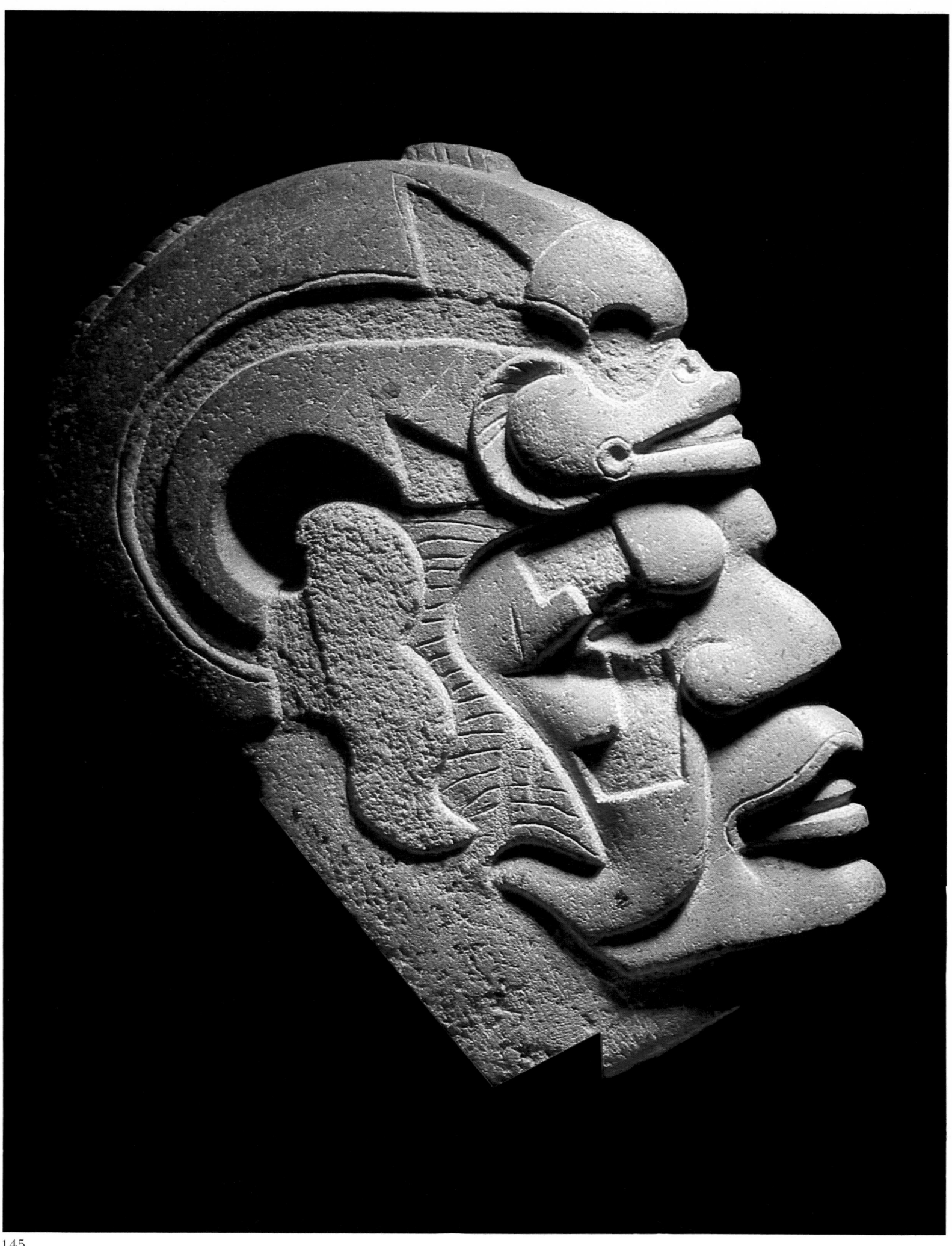

The left-hand personage, arms folded, takes stock of his opponent. In attendance are two other figures, one seated and one kneeling, on the benches on either side of the court. The one on the left holds a sceptre and wears a round head-dress, while the one on the right is masked with the effigy of a jaguar or a coyote (symbolizing the guide who conducts sacrificial victims to the other world). In a separate part of the panel there is a repetition of the skeleton emerging from a pot.

The south-west panel (3) immediately opposite presents a most interesting scene. On a double-stepped platform a figure is seen lying with arms crossed over his breast and one leg drawn up. Above him a priest dressed as an eagle spreads out his arms as if casting a spell. Arrayed in a head-dress of long feathers, he holds the great symbol of the sun, lord of the ball-game. On either side stands a musician, one shaking maracas, the other striking a wood-block with a mallet. It is an incantatory scene in which the sacrificial victim, having drunk a large amount of pulque, is being prepared by the shaman for his confrontation with death. On the left, the skeleton and pot recur as before.

Having crossed the ball-court diagonally, we come to the north-west—and most famous—panel (4), which is also the easiest to interpret. The scene here depicted is that of a player whose sacrifice entails the excision of his heart. The left-hand protagonist, having seized the victim's arms from behind, is holding him down on the sacrificial stone. The third player, standing on the right, is about to plunge the obsidian blade into the chest of the victim, whose eyes are already closed, while from the sky there descends the symbol of death. Seated on a bench on the right is a figure whose sceptre and round head-dress identify him with the left-hand personage in the north-west panel. Once again the skeleton and pot appear (Pl. 144).

We shall now attempt a reading of the bas-reliefs based on our view of the sacrificial victim as the winner of the ball-game to whom death

Diagram of the ball-court at Tajín showing the position of the bas-relief panels.

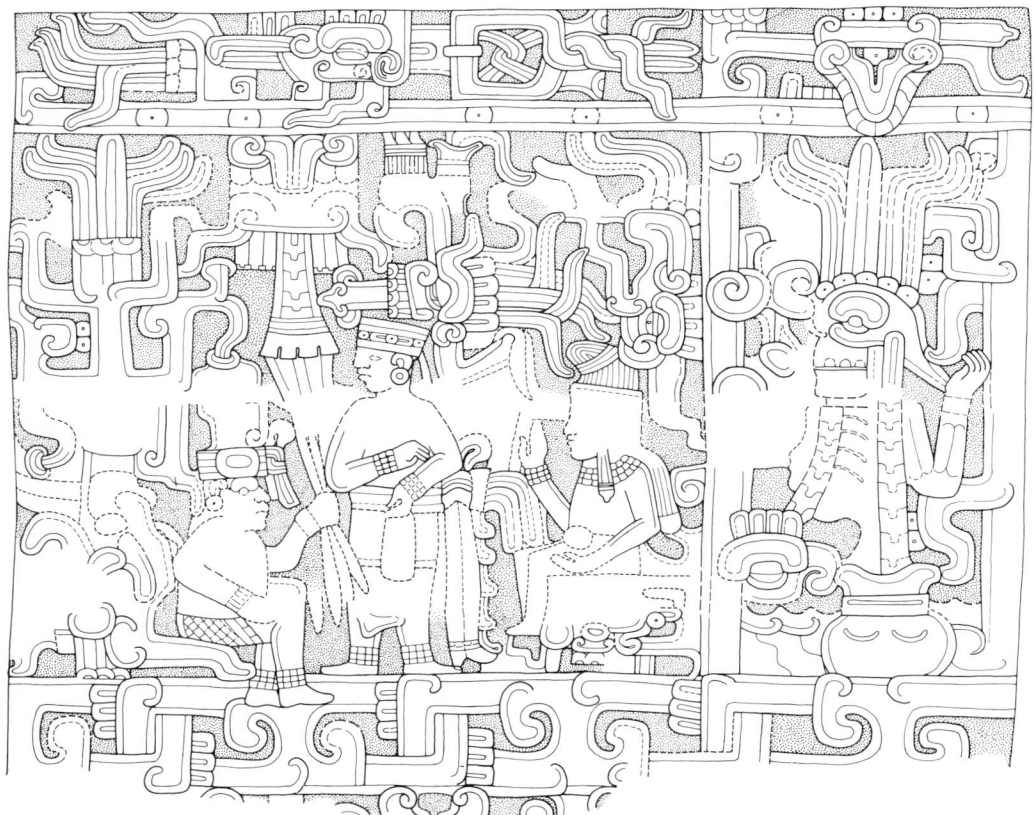

Drawing of south-east bas-relief panel (1) in the ball-court at Tajín (after M.E. Kampen).

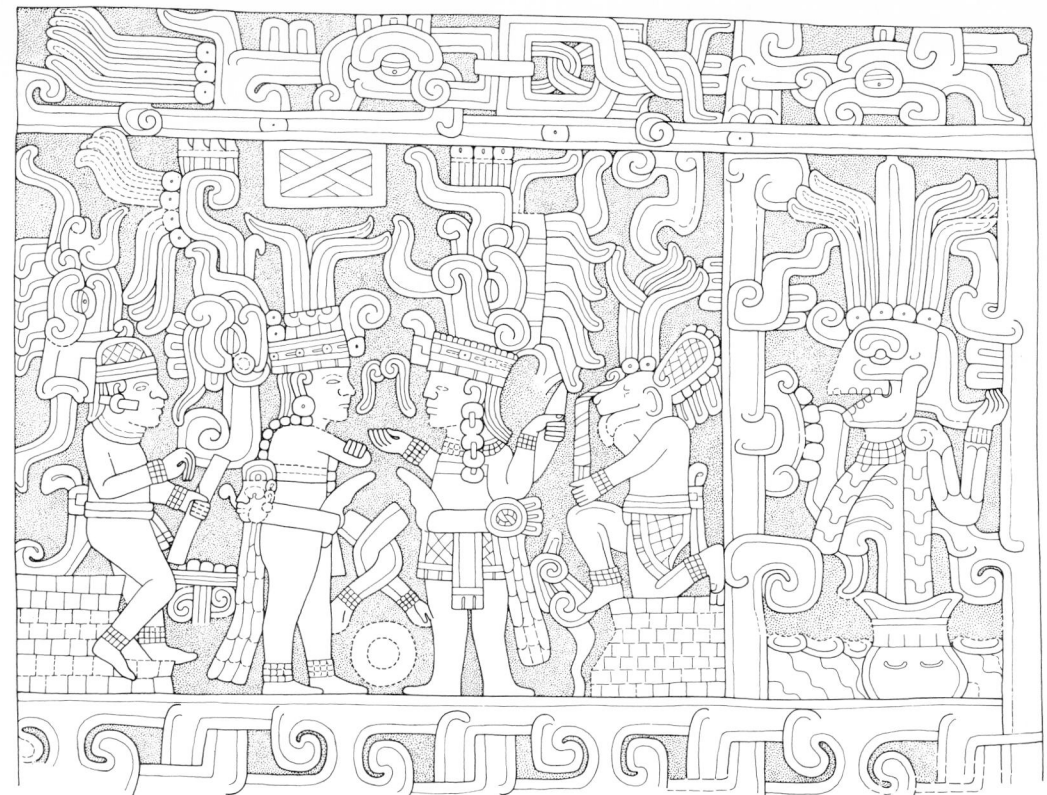

Drawing of north-west bas-relief panel (2) in the ball-court at Tajín (after M.E. Kampen).

is a means of acceding to the pantheon. We are well aware that our interpretation cannot be anything other than hypothetical, yet it may help us to understand the series of events taking place under the aegis of the pulque gods, Tlaloc–Hurakán and Quetzalcóatl.

Yet we should not lose sight of the theme, already adumbrated in the Mixtec codices, in which a king is shown ascending the sacrificial stone on reaching the 'centennial' age of fifty-two. In the first scene, depicted on the end panels (1), the king, at the end of his cycle, is about to trans-

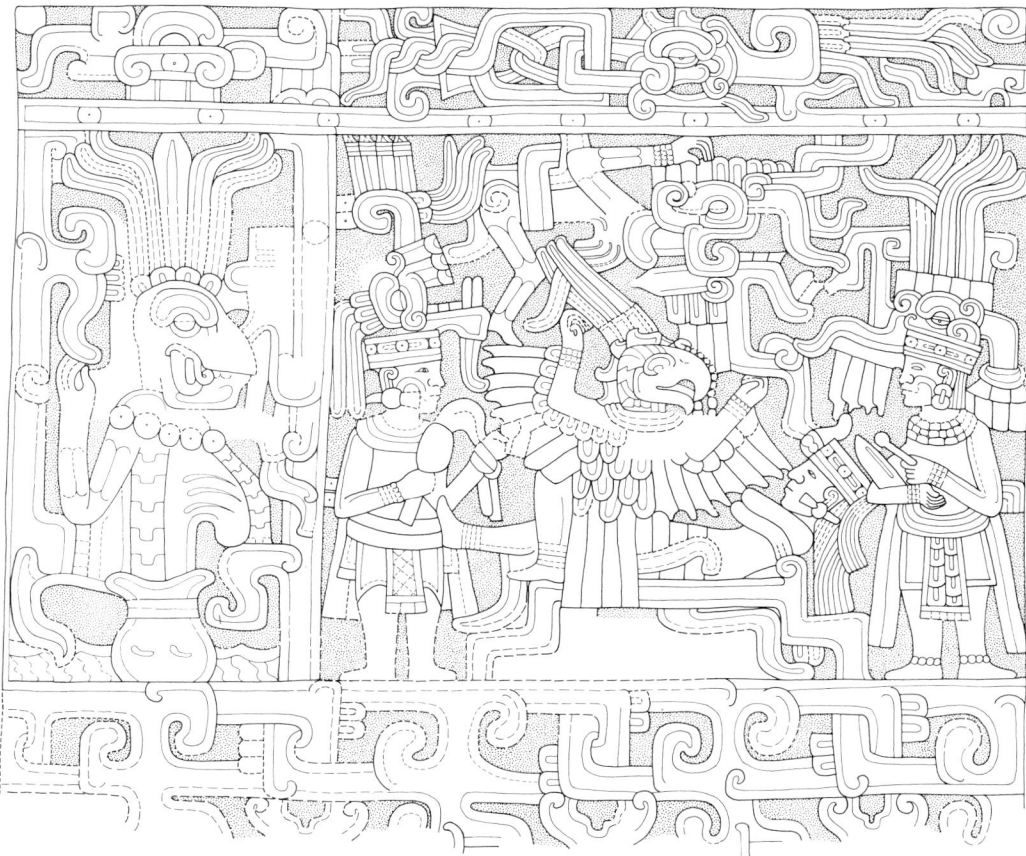

Drawing of south-west bas-relief panel (3) in the ball-court at Tajín (after M.E. Kampen).

146

147

148

Drawing of north-east bas-relief panel (4) in the ball-court at Tajín (after M.E. Kampen).

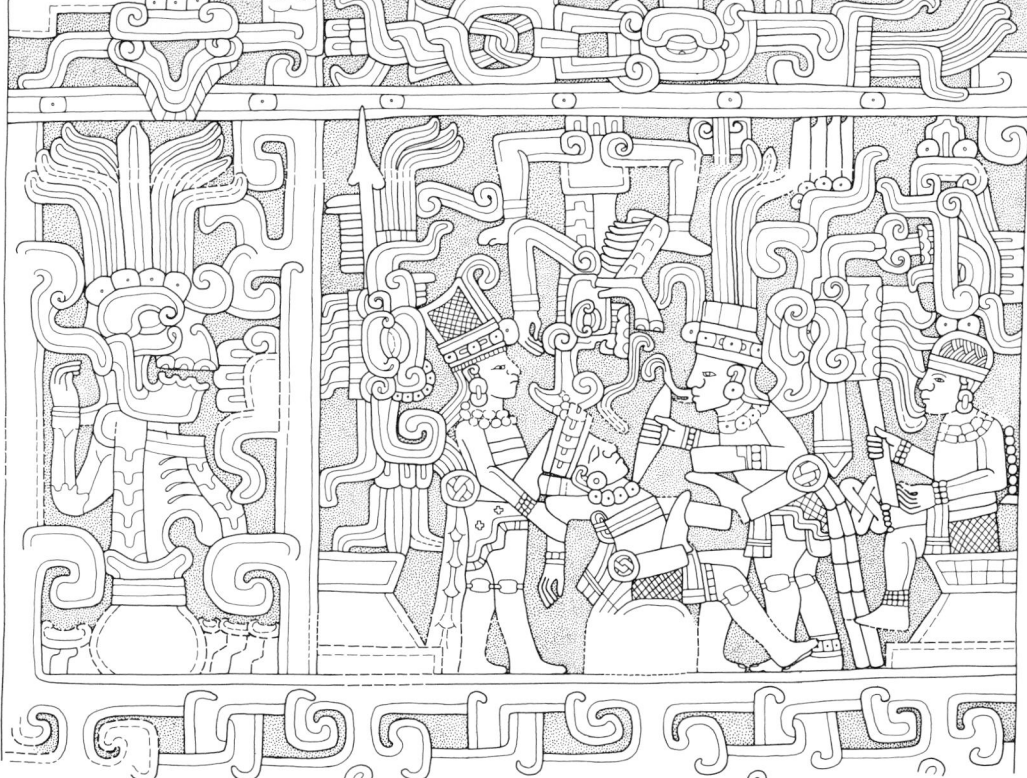

146 Detail of a bas-relief motif on a yoke from Central Veracruz. The figure shown in profile, his eyes closed, may be a sacrificed ball-game player. This Classic work in highly polished diorite was produced between the sixth and ninth century A.D. Jalapa Museum.

147 Ceremonial *hacha* depicting a coyote's (?) mask in volcanic rock. A particular feature of the head-dress is a hand, possibly severed. The piece is from the Perote region and the detail here shown measures approximately 22 cm. Jalapa Museum.

148 Ceremonial *hacha* from Veracruz, known as Orlando Gaya Montini, depicting a dead warrior with a tall crest of feathers. This Classic work, 42 cm high, is from Pueblo Viejo in Perote. Jalapa Museum.

fer his powers to his successor (son?). Next, in the north-west panel (2), he is seen in the ball-court, selecting and challenging the opponent he must vanquish, and displaying an obsidian knife to indicate what is going to happen at the end of the game. The challenge is made in the presence of the new ruler, already in possession of the staff of office.

The ensuing game is not depicted since it takes place within the compass of the walls adorned by the bas-reliefs. It should be remembered that, according to the centre panels A and B, the invocation of the gods plays a major rôle in the proceedings, all of which, including the sacrifice, occur within the context of the pulque ritual.

The south-west panel (3) displays the victorious king who has earned the right to enter the pantheon; he lies, intoxicated with pulque, while musicians play percussion instruments and a shaman dressed as an eagle utters incantations over him. In the sequel on the north-east panel (4), the king lies on the sacrificial stone while his opponent in the ball-game plunges the knife into his breast in the presence of the new sovereign, who sits nearby with his staff of office.

Though perhaps open to criticism, this interpretation commends itself in that it provides a key to the mythical game and postulates a correlation between the latter, the sun and the sacrifice. For the divine intoxication induced by pulque puts men in touch with the gods and not only helps them to enter the pantheon, but eases the moment of their passing.

We might add that the bas-reliefs are executed on four large superimposed monoliths. Weighing anything from 12 to 15 tons, some are as much as 11 metres long, 1.5 metres wide and 0.5 metres deep. Thus it will be seen that these post-Classic architects were quite prepared to tackle really large-scale structures.

In the course of the Toltec renascence, the Pyramid of the Niches and the north ball-court were also given historiated bas-reliefs with figurative themes alongside scrollwork typical of Totonac decoration in the Gulf region.

The Buildings of the Toltec Period

Not only were existing buildings decorated during the period of Toltec influence, but new ones were put up. Indeed this renascence, which began in the eleventh century and lasted until the end of the twelfth, was responsible for some of the most interesting works of pre-Columbian architecture, notably the cluster of buildings on the hill in Tajín Chico which includes Building Q, a curious edifice with a peristyle fifteen columns long and four columns deep. Also known as the Building of the Colonnettes, it is situated on the edge of the esplanade above which the Toltec complex rises. An extremely light and airy structure, it carried the principle of the Tula hypostyle to its logical conclusion, and was a forerunner of the Court of the Thousand Columns at Chichén Itzá. Based on all-too meagre remains, our graphic reconstruction of the building is evocative of Greek architecture and shows what rapid strides were made in this field during the final phase of development in Tajín.

It reached its peak, however, in the great temple surmounting the pyramid whose construction had entailed the wholesale remodelling of the natural eminence forming the highest point of the south complex of Tajín Chico. A wide stair ascends the east and west faces of the three-storeyed pyramid, measuring some 100 (on the east-west axis) by 60 metres, while the east face of the narrow cella is preceded by a vestibule and hexastyle portico 40 metres wide. Only the ruins of this columnar building remain, notably some large drums, 1.2 metres in diameter, covered with bas-reliefs that are very similar in style to those of the south ball-court.

The whole complex is orientated at an angle of 17° west of north, which would seem to have been dictated by the direction of the setting sun on the days when it reaches its zenith. As we have shown, such an orientation indicates the influence of Toltec ritual, itself a legacy from Teotihuacán, and differs from the cardinal orientation of the earlier assembly in the Lower Town.

Stone Sculpture

Having discussed the ball-court bas-reliefs, whose quality we need not stress, we must now return to the emblematic stone objects associated with the game, such as the yoke, the *palma* and the *hacha,* if only to draw attention to their astonishingly high standard of workmanship. This form of sculpture would seem to have developed without a break from the start of the Classic era, beginning with the undecorated yoke which may date back to the late Olmec period, and ending with an early post-Classic piece that is almost baroque in character and in which scrolls, interlaces and fillets create an abstract play of decorative forms of a high order as well as of considerable stylistic originality (Pls. 145–52).

In the field of sculpture, then, as in that of pottery, Veracruz workmanship is of the highest quality. We have only to consider the sobriety of certain *palmas* portraying hands, or the luxuriance of others, almost reminiscent of Indian temple art. Or again, the strength and authority of the faces inscribed in the rigorous forms of the *hachas,* a notable example of which has a crest in the shape of a skull-like dolphin's head.

Building of the Colonnettes at Tajín, a peristyle structure reconstructed by Garcia Payón.

149 A very fine *palma* from Veracruz. The piece is covered with a delicate spiral fret possibly indicative of clouds. The personage is seated at the top of a structure similar in style to the Niches Pyramid at Tajín, and is probably Hurakán, god of thunderbolts and tempests. Height 39 cm. Jalapa Museum.

150 A remarkable *palma* depicting two hands. It will be seen that this stone sculpture from Tlacolula, Veracruz, has a concave base similar to that of the preceding piece. Height 36 cm. Jalapa Museum.

151 Fine diorite yoke displaying the head of a toad or earth monster. This Classic sculpture from Veracruz, 45 cm in length, is a rendering in stone of what was probably a wooden accessory used in the ball-game. National Museum of Anthropology, Mexico City.

152 Large post-Classic *palma* of volcanic rock from Veracruz decorated in a style reminiscent of the bas-reliefs in the south ball-court at El Tajín. The piece should be compared with the article worn in the belt of the sacrificial victim in the following plate (Pl. 153). The concave base is typical of this ball-game accessory. Height 75 cm. National Museum of Anthropology, Mexico City.

149

150

151

152

These sculpted stones display a feeling for material and form which, in the more sober and archaic works, would appear to derive from Olmec art. It was a form of sculpture whose steady development was to result in a rich ornamental repertory of which the formal density betokens a most complex mode of thought. The pre-Columbian carvers, who often worked in hard stone, attained an exceptional degree of technical mastery. The Classicism we find here is spare, firm, yet opulent, and is dominated by a tendency towards abstraction which imparts a highly distinctive and unmistakable flavour to the products of Veracruz.

Also worthy of note is a very fine polygonal stela, 1.5 metres high, standing in its original position in front of the stairway of Building 5 in Tajín. It portrays a full-round stylized figure identified as Tlaloc–Hurakán by his crown of feathers and the S-shaped thunderbolt emblem in his hand. Here Tajín-type scrolls are applied to a three-dimensional and monumental work which provides us with a unique example of a synthesis of Maya and indigenous trends.

A post-Classic stela, carved in the likeness of a decapitated sacrificial victim, displays the gruesome image of a player from whose severed neck blood gushes to assume the form of snakes. In his belt he wears a superb *palma* (Pl. 153) similar to those in the 'fillet' style often found in late examples (Pl. 152). In his hand is an unadorned 'sabot' not unlike certain emblematic *hachas*.

In this context we might further cite a fine sculptured slab discovered by Garcia Payón in 1970 (i.e. after Kampen had completed his work). Its decoration relates to a solar rite, probably connected with the ballgame. The slab, either the upper part or the face of an altar on Building 4, measures 1 by 2 metres. At its centre is an image of the sun with a hole in the middle and, below this, a turtle symbolizing the aquatic world. Four personages, whose treatment recalls the style of the ballcourt bas-reliefs, are engaged in sun worship. Between the two right-hand figures is a Maya numerical glyph which stands for 20 (three bars each denoting 5, plus 5 dots). This writing is interesting in that it shows how manifold were the influences exerted on the art of Veracruz, first by Teotihuacán and the Olmecs and, later, by Tula and the Mayas.

Here we have yet another instance of intensive and ceaseless cross-fertilization among the pre-Columbian cultures of Mexico, a process which underlines the importance of their common heritage.

An Incomplete Chronology

Any attempt to delimit the major artistic phases in Central Veracruz is greatly hampered by the all too sparse information we possess on the chronology of the local cultures. In any case it would seem very difficult to synchronize the data relative to Tajín with what is known of the history of the high plateaux (divided into pre-Classic, Classic and post-Classic periods). However, we shall here give a résumé of the various hypotheses upon which the chronology of Veracruz has hitherto been based, a task that will entail our synthesizing the results of work in the field, the accounts of the chroniclers and the various artistic styles.

The pottery of Central Veracruz would appear to be of very early origin, yet there is no sign of Olmec influences, as was the case on the high plateaux during the same period. This fact is in itself highly disconcert-

ing if we consider the proximity of the Olmec sites in territory immediately adjacent to southern Veracruz. As already mentioned, the earliest terracotta pieces date back to about 800 B.C. Known as Remojadas after a region particularly rich in pre-Classic and Classic examples, they were the work of a people of whose name and origins we are ignorant. By the end of the pre-Classic period, i.e. even before the founding of El Tajín, the expressive power of Remojadas ware was already at its peak.

In about 400 B.C. there would seem to have been a fresh influx, this time of a people belonging to the same stock as the Huastecs who, as we have seen, were a Maya offshoot living in northern Veracruz. The new arrivals initiated the use of durable construction materials in the Tajín region where they erected small, stone-faced buildings in about the first century B.C., a period contemporary with Teotihuacán II. Not until 300 A.D., the time of Teotihuacán III, did their architecture grow more ambitious with the building of pyramids, of which the chief is now known as the Pyramid of the Niches. In its original state, however, it had yet to be given the features to which it owes its name.

Between the fifth and the ninth centuries, a phase we may regard as Tajín's Classic heyday, the city grew rapidly. According to the chroniclers it would seem that, in about 818, a wave of Totonac invaders descended on Veracruz where they settled, remaining there until the Spanish Conquest some seven centuries later. Their arrival was one of the last repercussions of the great upheaval following the destruction in about 650 of Teotihuacán by barbarian invaders from the north. Yet an element of uncertainty is introduced by the afore-mentioned chroniclers who declare, somewhat ambiguously, that the Totonac peoples came by sea, from 'the land where the sun rises'.

After the Totonacs had settled in El Tajín, the place appears to have suffered a temporary eclipse. Two centuries later, in about 1000, the city was invaded by Toltecs who were making their way to Yucatán where they were to found Chichén Itzá and initiate the famous Maya–Toltec renascence. To judge by the strong influence they exerted on Tajín, they must have left a large contingent there. Indeed, the edifices at Little Tajín, in particular the columnar building, date from the Totonac–Toltec period, as do the fine reliefs of the south ball-court.

After a heyday lasting two centuries—for it is legitimate to speak of a Toltec renascence at Tajín as well as at Chichén Itzá—the town was invaded by barbarians. In 1230 it was put to the flames and finally abandoned, whereupon the jungle again took possession of the site. It was not until 1785 that Tajín was rediscovered beneath its pall of tropical vegetation.

There are undoubtedly some serious gaps in this sequence which we shall now attempt to reconcile with what we know of events in pre-Columbian Mexico. Its main drawback is that it does not altogether tally with the nomenclature now generally accepted by specialists, a nomenclature which, moreover, would call for revision were the name Totonac to be denied to the founders of the art of Central Veracruz. Similarly, to describe the great reliefs as Totonac–Toltec would be to assign them henceforward to the post-Classic phase, whereas they have generally been regarded as Classic. Whatever the case, neither the clear signs of Toltec influence nor kinship between the Tajín reliefs and those in the main ball-court at Chichén Itzá leave room for doubt that the works at Tajín were executed later than 1000 A.D.

154

155

153

Nevertheless, certain problems remain unsolved. The players depicted on the stelae and in the bas-reliefs of the south ball-court are wearing *palmas,* hitherto regarded as Classic. Are we to infer that they continued to be used after the arrival of the Toltecs? Since the answer would seem to be yes, we must ask whether it is possible to distinguish between the earlier, Classic *palmas* and those of post-Classic date.

Even more problematical are the yokes which, if undecorated, have been attributed to the Olmecs. The most recent examples may, however, be coeval with the post-Classic *hachas* and *palmas.* Hence it is possible that these objects were in production for at least fifteen centuries.

Interrogation marks are therefore not wanting when it comes to dating the artifacts of Central Veracruz. Moreover, the chronological information we shall attempt to provide here will call for modification in the future, when radiocarbon readings and better stratigraphic data have enriched our store of knowledge.

Totonac Works at Teayo and Cempoala

In the final phase, following the fall of El Tajín in the thirteenth century, it was the Totonacs who were the carriers of pre-Columbian culture in the Gulf region, both before and after their subjection by the Aztecs, an event that antedated the arrival of the Conquistadors by only sixty years. During that phase the Totonacs evolved an architecture in which, even before the Aztec invasion, we may discern the unified style of the Pre-Columbians of Mexico. Their temples and sanctuaries, inscribed in a general plan which is often less rigid than that of similar complexes on the high plateaux, display the chief characteristics of Aztec architecture, a convergence that may be attributed to the current intensification of trade between the Mesoamerican peoples. Thus there emerged a kind of syncretism, harbinger of the great cultural community which the rulers of the Aztec empire were to establish by force of arms.

Although local and regional peculiarities might persist, the trend towards formal, ritual and mythological uniformity at the end of the post-Classic period inevitably gathered momentum after the Aztec conquest. We shall not therefore dwell on this phase which will be discussed when we consider Aztec civilization in our final chapter.

Here we might add that the distinctions we have drawn between the various cultures of each region are rather too schematic. For on the Gulf Coast the works attributable to the Totonacs are not always easy to distinguish from those produced by the Huastecs, to which allusion will be made in the next chapter. In fact, much of the work from northern Veracruz might belong to either culture, since both were possessed of a similar talent for sculpture in stone.

The Totonac contribution to architecture during the final decades preceding the Conquest is exemplified by two sites, Teayo and Cempoala, both situated near the coast. The first was a Totonac centre close to the frontier of the Huasteca, a region occupied by the Aztecs at a relatively early date. Teayo's position on the route from the high plateaux to the coast meant that it figured largely in the strategy of the Aztecs and their designs upon the more southerly part of the Totonac country. The Castillo at Teayo, a three-storeyed pyramid, which is unusual in that it still retains its crowning temple, was built during the fifteenth century,

153 Stela from Aparício in the Veracruz post-Classic style. This fine sculpture, 1.22 m high, represents the god Chicomecóatl, or Seven Serpent, in the guise of a beheaded ball-game player whose blood, spouting from his arteries, is transformed into snakes. At his waist he wears a yoke to which the *palma,* seen on the right, is attached. His right leg is equipped with a knee-pad and in his right hand he holds a kind of sabot from which the ceremonial *hacha* probably derives. The god is seated on a two-storeyed platform or throne. Jalapa Museum.

154 This, one of the more curious sculptures from Veracruz, symbolizes the dualist principle. Of volcanic rock, it belongs to the post-Classic era (thirteenth–fourteenth century) and was discovered in the municipality of Veracruz. Height 55 cm. Jalapa Museum.

155 Alabaster jar in the form of a monkey whose body forms part of the vessel he supports. The eyes are encrusted with obsidian. There are similarities between this post-Classic work and certain Huastec and Aztec pieces. Height 23 cm. National Museum of Anthropology, Mexico City.

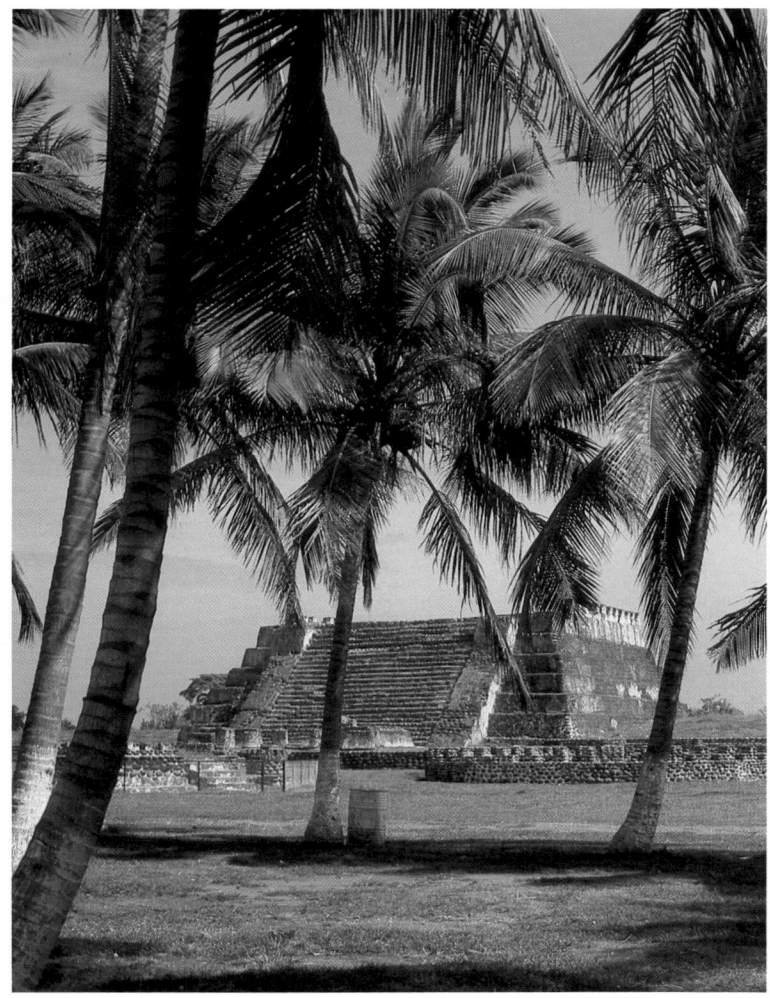

156

157

158

159

after the Aztecs had posted a garrison in the town to keep watch on a territory they had subdued. A characteristic of this architecture is the almost cubical appearance of the pyramid with its very steep faces of which the pitch increases near the top. However, the great stairway, lined with ramps, does not vary in pitch, so that it cuts into the main structure before reaching the platform on which stand the ruins of the cella, now once again roofed with thatch as, no doubt, it was originally. For this archaic type of roof persisted until quite late, more especially in the tropical zone (Pl. 156).

Cempoala was the place where the Spaniards landed in 1519 and first set eyes on a mainland Indian city, with its temples and inhabitants. Cortés, Bernal Díaz del Castillo and, later, Torquemada have given eye-witness accounts of this 'delectable paradise' shaded by palm trees on the banks of the Rio Grande de Actopán. Cempoala was also the scene of internecine strife between Cortés and Narvaez, from which the former emerged victorious on the eve of his final attack upon Tenochtitlán.

The Totonac site comprises eleven ceremonial centres, each consisting of a number of monuments enclosed within a precinct. The city had been an Aztec possession since its seizure in 1458 by Moctezuma I, who had previously found it a profitable source of trade. But having annexed the whole of Totonacapán, the Aztecs soon abandoned commerce in favour of tribute.

At Cempoala we encounter a number of temples supported by multi-storeyed pyramids (Pls. 157, 158). These are of two main structural types to which allusion will presently be made in connection with Aztec buildings, namely the circular pyramid dedicated to the wind god, Ehécatl, avatar of Quetzalcóatl, and the 'double' pyramid with twin temples and two parallel stairways. We also find here curious round edifices with crenellations (Pl. 159). The walls surrounding the various groups of buildings probably fulfilled the twofold function of separating the ceremonial centres from the residential quarters, and of protecting them against the floods that threatened when the river was in spate.

The sight of the ruins of Cempoala stirs the imagination because it was here, as also at Tulum in the Maya country, that the first Spaniards to disembark on the mainland had the opportunity of seeing the Indian people in their heyday, and of noting their customs, dress and habitations, their hierarchy, rulers and priests. Thus they were able to observe a civilization in full swing, an experience which was to be repeated throughout the campaign, culminating with their entry into Tenochtitlán. This amazing confrontation of two wholly different worlds and streams of development was characterized by a mutual misunderstanding so extreme that one of those worlds was bound to succumb to the dynamism of the other.

Cempoala itself fell victim to the internecine strife of the Spaniards. Subsequently the Indians, their numbers drastically depleted by fearsome epidemics, were employed as slaves on the great plantations. So rapid was their decline that in the early seventeenth century, less than a hundred years after Cortés's arrival, the city was abandoned. The jungle took over and Cempoala's very existence was forgotten until the end of the nineteenth century, when the site was first investigated. However no excavation or restoration work was undertaken there until after 1939.

156 Pyramid known as the Castillo of Teayo, a post-Classic building erected by the Totonacs in the fifteenth century, at a time when the Aztecs occupied this part of the Gulf. The upper temple, whose walls still stand, has been given a thatched roof of a kind probably identical with the original.

157 The Totonac site at Cempoala, not far from the sea, was the pre-Columbian capital of Veracruz and comprised a number of ceremonial centres surrounded by tropical vegetation. The great pyramid known as las Chimeneas (the chimneys) is of six storeys ascended by a great stair serving an upper platform that is lined with the crenellations from which the building derives its name.

158 Remains of the Templo Mayor or main pyramid at Cempoala. It was built early in the sixteenth century, shortly before the arrival of the Conquistadors.

159 A curious precinct at Cempoala surrounded by a wall crowned with crenellations, possibly symbolizing shells. It may have been dedicated to the wind god, Ehécatl, and is flanked by the pyramid known as las Chimeneas.

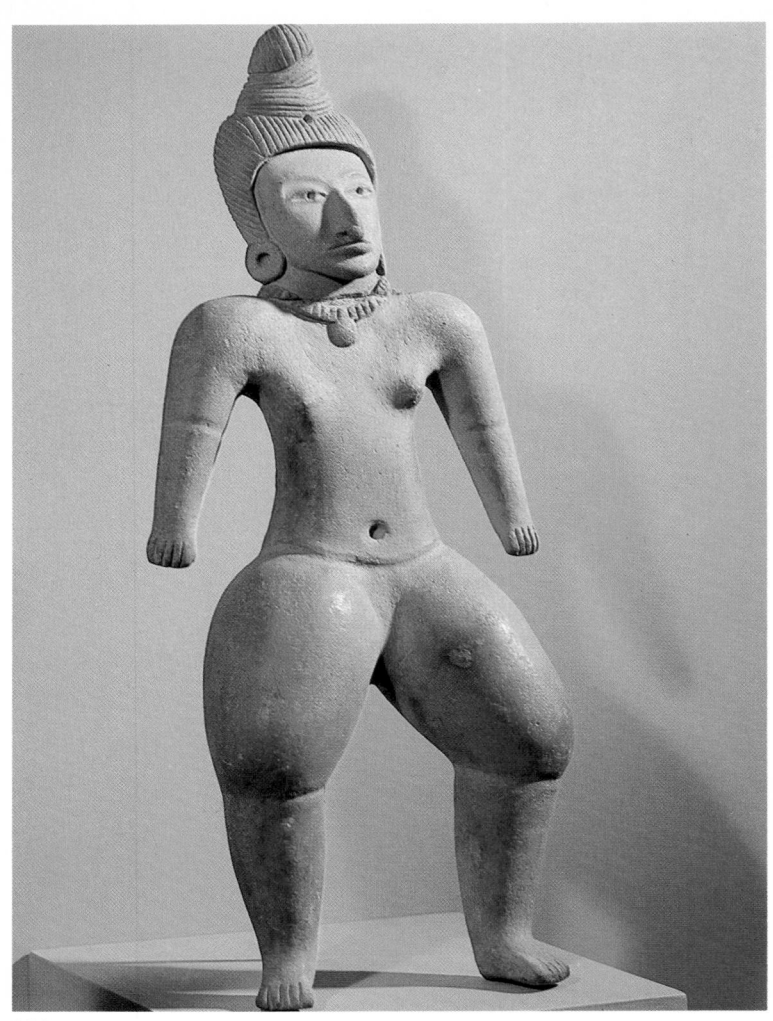

160

161

162

163

VII. From the Huasteca to the Pacific Coast

160 Huastec terracotta statuette of the Classic era depicting a naked woman wearing a necklace, ear discs and an elaborate head-dress. The breasts are diminutive and the thighs disproportionately large. Height 29 cm. National Museum of Anthropology, Mexico City.

161 Huastec anthropomorphic pot of the Classic era showing a highly stylized face. Schematization is here taken to extremes, resulting in remarkable purity of expression. Height 21 cm. National Museum of Anthropology, Mexico City.

162 Huastec-style post-Classic jug decorated with motifs in grey and red on a beige ground. The zoomorphic neck suggests a small rodent or a species of pig. The spout recalls similar Peruvian pieces. Height 21 cm. National Museum of Anthropology, Mexico City.

163 Large Huastec vessel of the post-Classic era depicting a kneeling woman with tattooed arms and dressed in a skirt. As in the preceding piece, the long spout in the form of a neck supported by a stirrup is reminiscent of Peruvian ware. National Museum of Anthropology, Mexico City.

This chapter will take us stage by stage across the breadth of Mexico, from the Huasteca of the Gulf Coast—north of the Totonac country—to the Pacific littoral. It presents in somewhat heterogeneous fashion the various cultures which flourished in the pre-Columbian world on the eastern and western fringes of the zones of high civilization. The lands are situated for the most part north of Tuxpan, Querétaro and Morelia, and take in part of Guerrero and the Río Balsas basin. In some cases they extend as far north as the 23rd parallel, comprising the Tampico region in the east and Mazatlán in the west.

These cultures might be regarded as peripheral, lying as they do well outside the great centres of civilization. Taken as a whole, however, they are of immense importance in that they were settled outposts in what might be called pioneer country, marking a transition between the densely populated areas of urban growth and the semi-arid zones, populated by less advanced nomadic tribes, which lie between the north of Mexico and the south of the United States.

Much of this vast region, consisting of a belt of more or less organized buffer states, has still to be investigated by archaeologists. While there are comparatively few architectural monuments of any importance, the other arts appear to have flourished with undiminished vigour, notably in the spheres of stone and terracotta sculpture where considerable originality is displayed. Virtually no archaeological restoration has been undertaken, which means that our knowledge is largely based on conjecture, while problems of dating have usually had to remain unanswered.

It would be otiose to seek to establish a link between the very diverse artifacts of these areas that extend for almost 800 kilometres from east to west. The levels of development of the cultures from which they sprang varied considerably. Hence it is not just for convenience's sake that we have chosen to group them together here, in order to give a brief survey of the art peculiar to each of these peoples. We can, however, identify three centres of particular interest: the first, the Gulf Coast, takes in the Huastecs, the Totonacs' northern neighbours, whose heyday lasted from the eleventh to the fourteenth century; the second, a central zone close to the Altiplano civilizations, embraces the art, not only of pre-Classic Chupícuaro, near Lake Patzcuaro, and of near-by Tzintzuntzán, the post-Classic Tarascan capital, but also that of Mezcala which flourished in the Classic era; finally, the third centre comprises the Pacific coast or Occidente cultures, as represented by the works of the

164

165

166

164 Vessel with vertical spout and a handle over the mouth. This white post-Classic pottery (thirteenth to sixteenth century) is of Huastec manufacture and was discovered on the Isla del Idolo near Tamiáhua, Veracruz. Jalapa Museum.

165 Like the preceding piece this Huastec vessel with its spout and bulging ribs calls to mind a tea-pot. These works betray a remarkable feeling for elegance and sobriety. Height 23 cm. Jalapa Museum.

166 A third example of these Huastec white ware 'tea-pots' from the Isla del Idolo (Veracruz). Here the ribs are so bulbous as to be almost spherical. Height 26 cm. National Museum of Anthropology, Mexico City.

167 The Adolescent of Tamuín, a masterpiece of Huastec stone sculpture. This post-Classic statue of a naked youth probably represents a solar deity. The right part of the body and the left arm are covered with fine tattooing. Height 1.17 m. National Museum of Anthropology, Mexico City.

168 Huastec stone sculpture, 1.4 m high, representing Ehécatl, avatar of Quetzalcóatl. Known as El Naranjó, it is of the post-Classic period and, in the face and the pointed head-dress, expresses the dualism of life and death. National Museum of Anthropology, Mexico City.

169 Stela from Tepetzintla, a Huastec work incorporating a number of symbols of the god of the Morning Star. The abstraction of forms corresponds to an exact cosmological content in accordance with a sculptural convention, examples of which may be found among the Aztecs (e.g. the statue of Coatlicue). Executed with great rigour, it dates from the post-Classic era and is 1.75 m high. National Museum of Anthropology, Mexico City.

great potters who lived in what are now the States of Colima, Jalisco and Nayarit.

In the vast stretch of country between the two coasts, the northern cultures occupied a semi-arid belt where they were dependent on remote oases in the vast expanses of the steppes. It was a world of fluid frontiers and fragmented populations, in which ethnic characteristics varied from place to place, a world of wide open spaces in which, at precise yet unexpected points, we may light on curious excrescences such as the formidable fortress of La Quemada or Chicomoztoc, 50 kilometres from Zacatecas and some 500 north-west of Mexico City. The town, which extends over an area measuring 1.5 kilometres by 500 metres, was an outpost of sedentary culture, a stronghold with a citadel, 150 metres high, which dominated the country round about. Toltec influence is indisputably in evidence—which is surprising in view of its great distance from Tula.

As we may see, the field is wide, varied and lacking in homogeneity. But it is devoid neither of interest nor of mystery, if only because of the lacunae that still remain unfilled.

The Art of the Huastecs

The transition from the Totonacs, whom we discussed in the previous chapter, to the Huastecs is an almost imperceptible one. It is not easy to distinguish between the artifacts of the two cultures, since their spheres of influence fluctuated with the centuries. Thus Teayo was subject now to one now to the other, a factor that must be taken into account when attributing works to either culture.

Before discussing the Huastecs, we should recall their Maya origins to which allusion has already been made. This people arrived in northern Veracruz in about 1000 B.C., that is to say in the pre-Classic or Formative period. Though speaking a Maya dialect, they were very early separated from their kinsmen in Chiapas, Yucatán and, *a fortiori*, the Petén and did not in consequence come under the influence of the Maya culture when the latter was at its height. The Huastec region covered a sizeable area between Tamaulipas and the Veracruz border. Its principal city was Tamuín where, on a 17-hectare site, archaeologists have discovered numerous mounds which have yet to be excavated. In particular, they have retrieved a circular structure in the form of a truncated cone as well as frescoes possibly dating back to the ninth century A.D.

But contacts must have existed at a very early date between the Huastecs and the Indian peoples in the south of what is now the United States. This is evident from cultural similarities, for mounds, shell-work and weapons are often identical.

They were evidently a people given to religious speculation, a nation of magicians, thaumaturges and soothsayers. They worshipped a wind god, soon to be identified with Ehécatl, whose powers overlapped with those of Quetzalcóatl. The influence of their cosmology extended as far as the Altiplano and, in particular, to Tula. It was in honour of the wind god that the round pyramids were built, a formula that recurs not only amongst the Totonacs but also amongst the Aztecs.

However, architecture was not their forte, the most original and impressive of their contributions being made in other fields of art, namely pot-

167

168

169

170

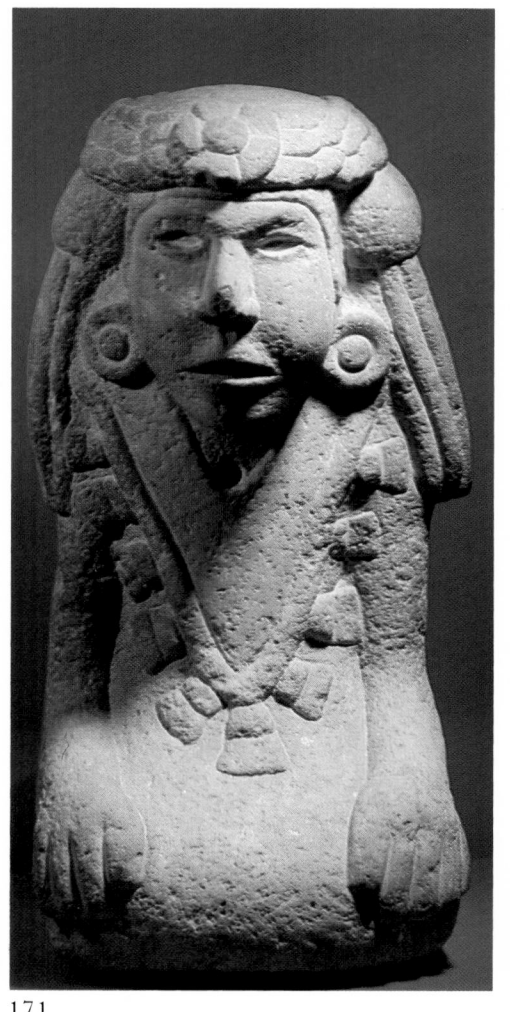

171

172

tery and stone sculpture, in which they may be said to occupy a well-defined position.

The Classic pottery of the Huastecs is chronologically somewhat problematical, for in the context of any other culture its forms would be described as 'pre-Classic' and, indeed, these works would appear to have suffered a 'time-lag'. The peripheral position of the Huastec country meant that the great artistic phases reached it only after a certain delay and that true Classicism was in its heyday there at a time when other cultures had already entered the post-Classic phase.

The earliest artifacts are terracotta figurines of women with small waists, diminutive breasts and short spindly arms, in contrast to their heavy thighs and broad hips. While the head-dress is often elaborate, nudity is the rule, as would have been only sensible in so hot and humid a climate, though it apparently scandalized the other pre-Columbian peoples (Pl. 160).

Some pots are so schematized that their anthropomorphic features are barely discernible. The face is reduced to two large eyebrows meeting above a nose-like protuberance with, below it, two horizontal lines to indicate the mouth (Pl. 160). The plastic quality of this light-coloured pottery underwent a change with the appearance, in the post-Classic period, of cruder polychrome pots displaying stylized animal or human forms, many of them reminiscent of Peruvian ceramics. In particular we would cite the stirrup-spout pots akin to Lambayeque ware. In this post-Classic period, figure pottery is not concerned with faithful representation. Rather it is an expressionist, allusive art of a popular nature (Pls. 162, 163).

The sobriety of the early white ware recurs in vessels found in the Isla del Idolo, a long island partly enclosing a lagoon, where a fine, monochrome pottery of delicate workmanship was produced. Some pieces, not unreminiscent of tea-pots, have a vertical spout and sometimes also a semicircular handle over the mouth. These white vessels, whose sides are adorned with bulging ribs, bear witness to the skill of the local potters. The economy of forms and the absence of painted decoration betray an austere approach that only serves to enhance the simplicity of these objects which strike a singularly modern note (Pls. 164–6).

Huastec sculpture represents one of the finest pages in the history of Mesoamerican plastic art. Little versed in architecture, the artists of this region would seem to give of their best when it comes to the art of bas-relief and sculpture in the round. The stela from the Huilotzintla (Pl. 172), in which Huastec characteristics and Totonac influences are combined, presents a superb scene of self-mortification (in accordance with a tradition well established amongst the Mayas). A priest of the Huastec god Ehécatl, recognizable as such by his fine pectoral in the shape of a section of a shell, has thrust a long, thorny stick through his tongue from which blood flows on to a kind of sceptre adorned with an alligator's head, a motif apparently repeated in the gorgeous head-dress. In his ears he wears large discs and round his hips a wide belt or loin-cloth. The rest of his otherwise unclad body is heavily tattooed with floral and geometrical motifs in a not easily intelligible decorative system. Between his feet is a small quadruped, possibly a dog. This magnificent stela, 2 metres high and carved in fine limestone, finds, as we shall presently see, an echo in the Adolescent of Tamuín.

A curious bas-relief from Tepetzintla shows a large, stylized effigy of a god, symbol of the ascendant Morning Star. The squatting, toad-like

170 Young god from Ajálpan (Queretaro). Similar in character to the Adolescent of Tamuín, this Huastec work of the post-Classic era is less well-proportioned. Height 82 cm. National Museum of Anthropology, Mexico City.

171 Stone statue, from Teayo, of Xochiquetzal, goddess of love and flowers. The Aztec style is already clearly in evidence and should be compared with that of similar Aztec pieces in Plates 89 and 91. Height 46 cm. National Museum of Anthropology, Mexico City.

172 Large stela from Huilotzintla, height 2 m. A post-Classic Huastec-Totonac work depicting a scene of self-mortification in which a personage in ceremonial attire thrusts a thorny stick through his tongue, whence the blood flows on to a small alligator-headed deity to produce a kind of staff of office. The priest engaged in this Maya-style act of self-mortification wears at his neck a section of a large shell symbolizing Ehécatl, the wind god. National Museum of Anthropology, Mexico City.

deity is probably the most baffling of these abstract representations which, with their numerous decorative elements, presage the terrifying Aztec sculptures of the gods. It is an art of signification in which the sculptor transcribes on stone a number of attributes the better to reflect a cosmological and symbolic view which has nothing to do with a realistic image (Pl. 169).

We shall now turn to the sculptures most typical of Huastec art, namely those showing a standing deity in a frontal pose. These figures stand four-square on thick, stocky legs and on their heads they wear a conical head-dress, doubtless connected with the wind god Ehécatl. In some examples the head is double-faced, like that of the Roman Janus, but in this instance one of the faces is alive and the other dead, in accordance with a dualist symbolism frequently found in the pre-Columbian world from the archaic period onwards.

This same dualism recurs in the Naranjó statue, but here the faces are superimposed and not addorsed. The god's face, believed by some to be the original Toltec form of Quetzalcóatl, is surmounted by a tall conical head-dress adorned with a naked skull symbolizing death. The figure wears an ample jerkin with, below it, a cavity containing a protuberance, presumably a heart, an emblematic motif which may be seen to recur in the necklace and pendant (Pl. 168).

We shall now proceed to the works for which the Huastecs are justly renowned, namely the stone statues of young standing gods, for they represent the most important contribution made by these people in the field of sculpture. The right hand of these deities rests on the breast, the left upon the hip, in accordance with a widely recognized convention. A typical example is the Ajálpan statue in which the figure is wearing a long apron and appears to be smiling benevolently (Pl. 170). In this piece the head and thorax are excessively developed by comparison with the stocky legs, a disproportion which, however, is not found in that masterpiece of Huastec sculpture discovered in Tamuín and known as the Adolescent. The statue, 1.17 metres high, is elegant and graceful in the extreme. The young god is quite naked, after the usual Huastec fashion so shocking to the Toltecs and Aztecs of the Altiplano. Tattooed on the right half of his body, his neck and his left shoulder is a series of superb motifs which harmonize perfectly with his physical forms (Pl. 167).

The figure leans slightly forwards, for on his back, in a shawl of a kind still worn today by Indian mothers, he carries a child with upward turned face, perhaps a symbol of the rising sun. So assured is the line that, despite the relatively massive legs and torso, his whole person is evocative of height and slenderness. There is no constriction at the waist, nor any sign of pectoral or shoulder muscles. Examined critically, the head is over-large, yet this sculpture has an air of elegance and refinement seldom met with in pre-Columbian art. The face with its understated eye-sockets and receding forehead—indicating the deliberate deformation of the skull practised by certain tribes—is markedly triangular, with full, well-defined lips. Large discs adorn the ear-lobes, thrusting them away from the head.

The style of the Adolescent of Tamuín is far from naturalistic and enables us to appreciate the degree of spirituality attained by the Huastec artist as he strove to express the freshness and the quiet, youthful assurance of this naked personage whose physical characteristics are

suggested rather than rendered in anatomical detail. For the respect due to a divine image precluded the placing of undue emphasis on materiality. A kind of reticence disembodies the subject by stripping it of its morphological attributes. What we see is not a body but a divine being in human form.

Subsequently, Huastec sculpture failed to maintain the same high standard, since Aztec influence is plainly discernible in the century preceding the Conquest. For instance, the statue of Xochiquetzal (Pl. 171), goddess of love, flowers and fertility, shows her kneeling in a pose commonly found in Tenochtitlán art (see Pls. 204 and 205) and is directly inspired by the work of that tribe. It was then that the unification inherent in Aztec imperialism began to take effect, extending even to the arts and eliminating from the empire the local peculiarities which so greatly enriched the patrimony of Mesoamerica.

From Lake Patzcuaro to the Río Balsas Basin

We shall now leave the coast and set off in a south-westerly direction towards beautiful Lake Patzcuaro, near which are two interesting but quite unrelated sites, for between them lies a gap of more than fifteen hundred years. The first, on the shore of this paradisal lake, is the post-Classic (fourteenth and fifteenth centuries) Tarascan town of Tzintzuntzán, the second is Chupicuaro, on the Michoacán–Guanajuato border, which has yielded pre-Classic pottery dating back to the period between 600 and 100 B.C. In the interests of chronology we shall begin with a consideration of the art of Chupicuaro.

The site was excavated in 1942 by Muriel Porter under the direction of Daniel Rubin de la Borbolla. They brought to light a quantity of pottery, notably some interesting terracotta figurines which fall into two distinct groups, the first consisting of stylized figures in grey clay without slip or colouring, the other in brightly coloured ware.

In the first we find frontally posed female figures, generally naked, the treatment of which is at once schematic and rigorously symmetrical. The arms are spindly and the hips broad, while the enormous head is surmounted by a complicated coiffure (Pl. 175). Along with incisions, the technique makes use of pellets (for the long, coffee-bean eyes) and fillets or pats (for the hair and for accessories such as necklaces and earlobe plugs). The emphasis on sexual characteristics relates these figurines to all those pre-historic artifacts which symbolize a kind of Great Mother or goddess of fertility and fruitfulness. Stratigraphic data suggest that these pieces go back to the earliest art of the region, somewhere about the middle of the first millennium B.C. (800–200).

The second group furnishes some of the most typical examples of Chupícuaro pottery, namely the polychrome pieces depicted in Plates 173 and 174. These terracotta figurines vary in height from 15 to 20 cm, and are brightly painted in black and red geometrical designs on a cream ground, suggesting opulent garments or, more probably, body-painting, since sexual characteristics are usually represented. These very obese personages are likewise governed by strict frontality and axiality. Some are given head-dresses and may be shown with their upper arms held clear of the body. The ear-lobes are pierced to permit the wearing of ear-rings or plugs. The use of slip and brightly coloured decoration indi-

173 Polychrome statuette with a black and white geometrical design on red slip, from Chupicuaro (Guanajuato). It dates from the pre-Classic era between 600 and 100 B.C. These female effigies of fertility and fruitfulness were placed in the tomb alongside the deceased. Height 17 cm. National Museum of Anthropology, Mexico City.

174 Another statuette from Chupicuaro, height 16 cm, accentuates still further an obesity that was intended to express opulence. The motifs would seem to indicate body-painting. National Museum of Anthropology, Mexico City.

175 Female terracotta statuette of the Middle pre-Classic period from Chupicuaro. The appliqué elements, coffee-bean eyes, disproportionately small body and strictly frontal pose, are characteristic of very archaic works. Height 18 cm. National Museum of Anthropology, Mexico City.

176 Late pre-Classic polychrome vase from Chupicuaro. The piece, which is of an anthropomorphic nature, exhibits a highly schematic treatment and great economy of line. In technique it recalls the two statuettes reproduced above (Pls. 173, 174). Height 23 cm. National Museum of Anthropology, Mexico City.

177 Small headless statuette of a woman from a tomb at El Opeño (Michoacán). Radiocarbon dating assigns it to *c.* 650 B.C. Height 8.5 cm. National Museum of Anthropology, Mexico City.

73

174

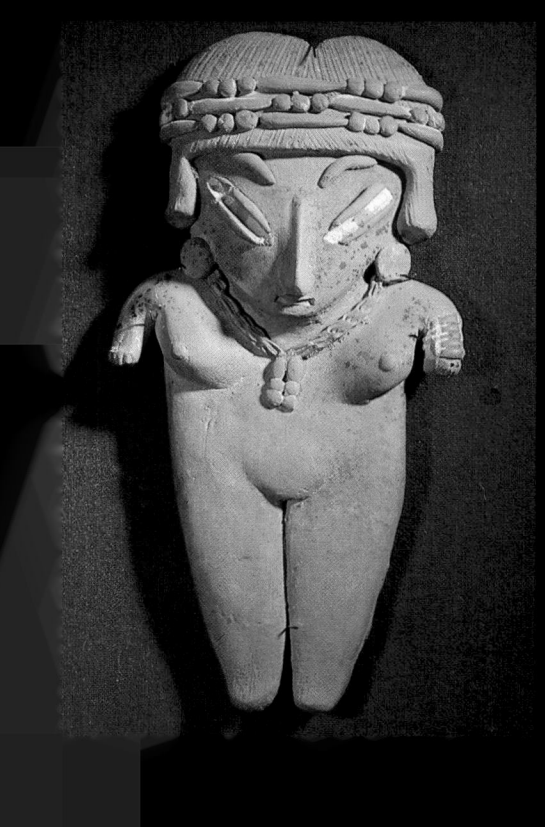

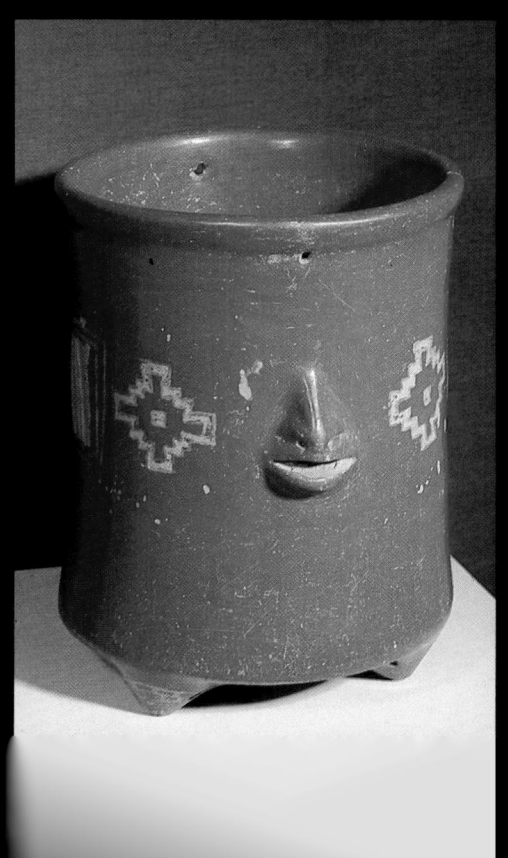

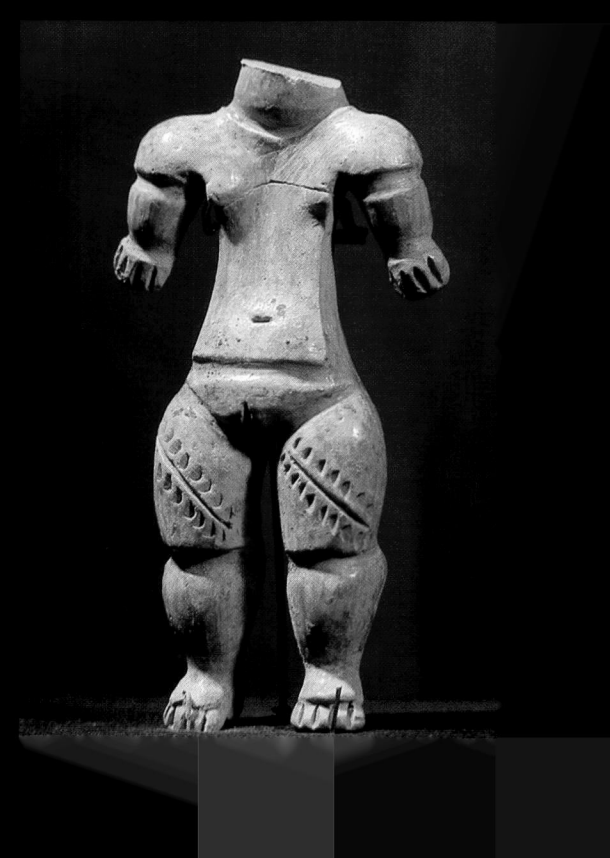

cates that this group is technically more advanced than the first, and probably dates from the end of the pre-Classic period (400–100 B.C.).

Other pieces from the same source are also worthy of note. The line is very austere, nose and mouth being no more than indicated in low relief, while geometrical motifs do duty for eyes, a technique that endows the simplest of pots with an anthropomorphic character (Pl. 176).

At El Opeño in Michoacán, tiny figurines made of very fine clay have been found in tombs which, according to radiocarbon datings, are 1300 years old, in other words the pieces were manufactured in about 650 A.D. Stylistically they have little in common with the Classic works of the Altiplano (Pl. 177).

The name Tzintzuntzán inevitably evokes the civilization of the Tarascans alluded to by the chroniclers of the Conquest. This savage people, who stubbornly resisted Aztec imperialism, reached their prime in the fourteenth and fifteenth centuries. Tzintzuntzán, in its idyllic setting, was the capital of the Tarascan kingdom which, in the late pre-Columbian world, enjoyed exceptional esteem amongst neighbouring peoples by reason of its highly skilled craftsmen. In addition to feather-workers (whose artistry enabled them to produce polychrome pictures in this medium) and carvers of jade and hard stone, the Tarascans, almost alone of Mesoamerican cultures, possessed copper-smiths. As in the case of the Mixtecs, this branch of metallurgy had probably originated in Peru, first reaching the Río Balsas region in the tenth century via Central America, whither it had been transmitted by sea through the medium of the coastal trade.

But here we must turn to the architecture found on the shores of Lake Patzcuaro in Michoacán, a region in which vast ceremonial centres were erected only by the Tarascan people. The main feature of Tzintzuntzán is a huge artificial terrace, measuring 425 by 250 by approximately 18 metres, which is reached by monumental stairways about 100 metres wide. On this esplanade, covering an area of 10 hectares, are five platforms set side by side and known as *yacatas*. Each consists of a rectangular platform and a structure in the form of a truncated cone which formerly supported a round temple with a thatched roof.

With its five *yacatas*, the ritual esplanade contains almost 1.5 million tons of material and is revetted throughout with dry-stone walls. The

178 This highly stylized stone sculpture from the Colima region probably dates from between 900 and 1000 A.D. The detail here reproduced (the clay-covered base is not shown) is some 55 cm high. National Museum of Anthropology, Mexico City.

179 Polished diorite mask from Mezcala in the Río Balsas region (Guerrero). The piece betrays the influence of Teotihuacán and probably dates from the Classic era (between 200 and 800 A.D.). Height 18 cm. National Museum of Anthropology, Mexico City.

180 Highly stylized stone mask from Mezcala (Guerrero). The schematized features on a disc, 18 cm in diameter, suggest a solar deity. National Museum of Anthropology, Mexico City.

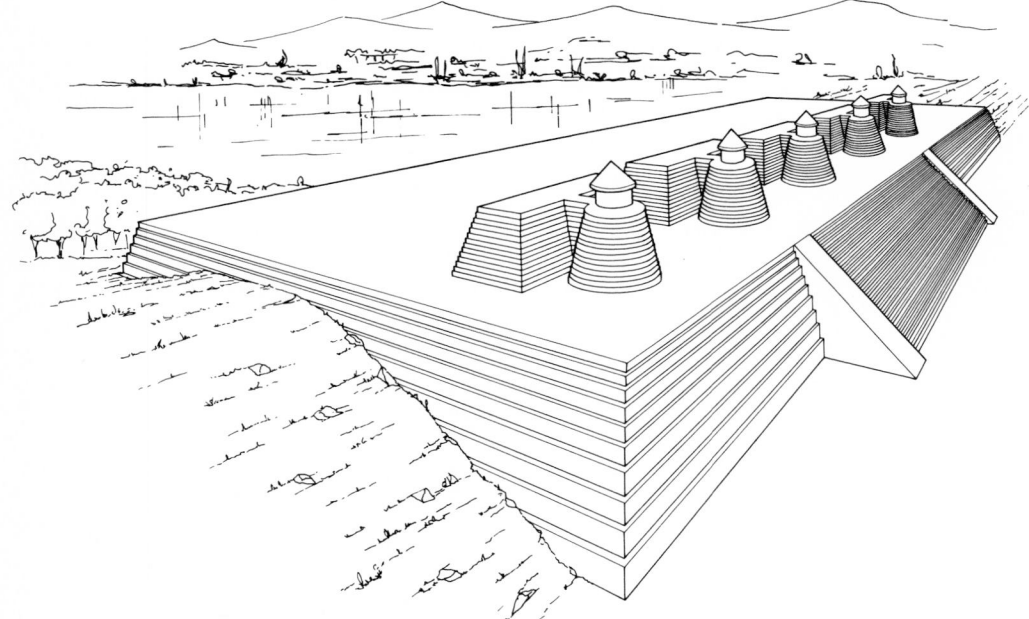

Reconstruction of the esplanade, comprising five sanctuaries or *yacatas*, built by the Tarascans at Tzintzuntzán on the shores of Lake Patzcuaro.

178

179

180

architects took advantage of the natural contours which they modified simply by accentuating existing slopes to produce this vast complex overlooking the lake. The *yacatas* are sizeable structures consisting of an avant-corps, measuring 66 by 22 by 12 metres, which precedes a truncated circular pyramid 29 metres in diameter. Thus each of these steep-sided, twelve-storeyed buildings comprises some 50,000 tons of material.

Astonishing though this grandiose complex, in its no less grandiose setting, may be, it is not unique of its kind, for at Ihuatzio (Michoacán) another platform of similar dimensions has been discovered. Measuring 400 by 300 metres, it supports three *yacatas* similar to those in the Tarascan capital. Moreover, the discovery of a Chacmool in volcanic stone is an indication of Toltec influence in this region.

The structural principle of the *yacatas* recalls that of the ceremonial centre at Tamposoque in the State of San Luís Potosí, further to the northeast. Here too we find an artificial terrace of considerable size (approximately 200 by 100 metres) with circular platforms, but presumably of Classic date. No doubt this remote site was subject to Huastec influence from the east coast, nor can the same inspiration be ruled out at Tzintzuntzán, carried there, perhaps, by Náhua peoples.

Leaving Lake Patzcuaro and moving further south into the Guerrero district, we find at Mezcala, in the Río Balsas basin, sculptures that betray the influence of the Classic art of Teotihuacán. These works in hard, polished stone, notably the fine masks of great linear sobriety, are difficult to date. Some authorities believe them to have been produced between 200 B.C. and 400 A.D., and others between 200 and 800 A.D., while Lothrop comes down firmly in favour of about 900 A.D. These estimates, ranging as they do over a period of more than a thousand years, testify to the perplexity of the specialists (Pls. 179, 180).

In this region certain pieces have come to light which can only be attributed to the Olmecs—indeed, Caso went so far as to maintain that Guerrero was the country of origin of that pre-Classic people. However, it was obviously the quality of the stone that attracted the Olmec sculptors to this mountainous district where traditional skills continued to survive for several centuries, being still practised in the Aztec era.

As may be seen from its art, the Classic civilizations left a strong imprint on the whole of this region lying to the west of the areas of high culture comprised in the valleys of Mexico and of Toluca. But in the part of Mexico known as the Occidente we find a wholly different cultural context. Here, in the present States of Colima, Jalisco and Nayarit on the Pacific littoral there emerged a popular form of pottery which we shall now proceed to examine.

The Great Potters of Popular Art

The arts that evolved in this Pacific coast region, whose cultures were far removed from the great Classic urban centres, were of a quite specific type, being confined almost exclusively to figural pottery, often of considerable size. In the present state of knowledge it must be assumed that these peoples did not build ceremonial centres in stone and were, indeed, ignorant of theocratic urban planning. Their architecture never got beyond the stage of the thatched hut such as may still be seen today in remote villages.

181 A fine example of Classic Colima pottery. This magnificent terracotta decorated with polychrome slip of remarkable lustre shows a drinker holding a bowl in both hands. The tiny legs and disproportionately large body, the highly schematized hands and the unforced attitude are characteristic of this art. Height 58 cm. National Museum of Anthropology, Mexico City.

182 Vessel in the shape of a dog in the Colima style. These animals, which were fattened for their meat, were almost entirely hairless. The superb piece, 28 cm in height, testifies to the all-round ability of the Pacific Coast potters. National Museum of Anthropology, Mexico City.

183 Sleeping figure with head resting on knee. The happy, unconventional art of Colima is here revealed in all its spontaneity. Height does not exceed 19 cm. National Museum of Anthropology, Mexico City.

184 Anthropomorphic vessel from Colima in the form of a water-carrier. The very stunted figure carries a large jar on his back, along with another receptacle suspended from a strap that passes across his forehead. Height 21 cm. National Museum of Anthropology, Mexico City.

181

182

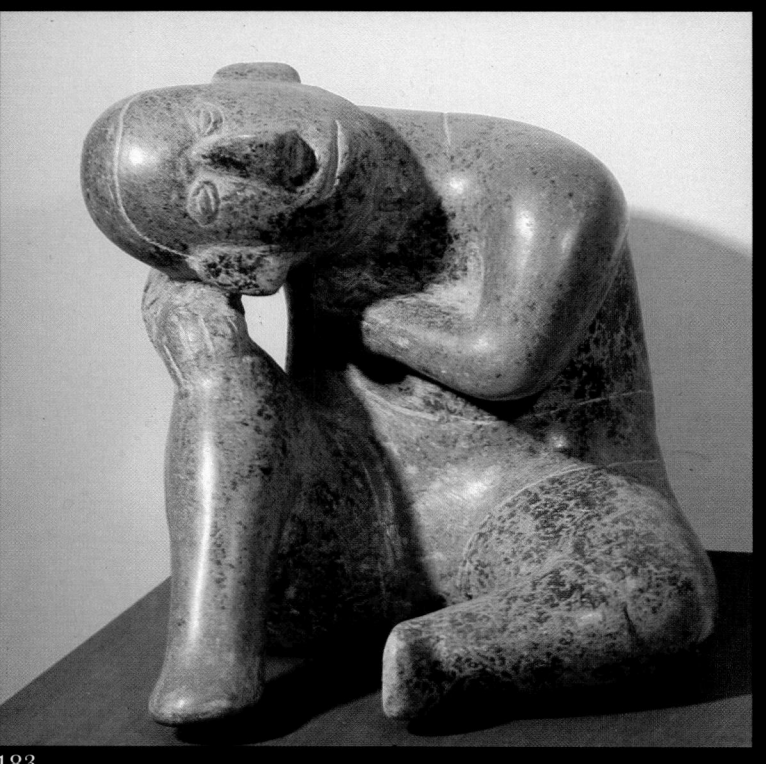

183

184

The pottery, most of which has come to light as a result of chance finds or clandestine excavations, occurs in shaft tombs, similar to those discovered in Columbia, and served as funerary offerings to accompany the deceased into the next world. The tombs consist of a small underground chamber only accessible by a narrow shaft that was filled in after the burial. On the surface nothing remained to betray the existence of the tomb beneath.

It would seem that the pottery of the Occidente evolved during the Classic phase, i.e. between 100 and 650 A.D. However, pieces of a similar type continued to be produced for several centuries (if, that is, we are to believe those who assign much later dates, between 900 and 1350, to individual works, as does José Alcina, for instance, to the great ballgame player in the Colima style). However radiocarbon datings of other tombs on the Morett site in the Colima–Jalisco region put them at 150 B.C., the implication being that the same style persisted for no less than 1,500 years. This would hardly seem probable, however, and underlines yet again the difficulties confronting archaeologists desirous of fitting into pre-Columbian chronology works whose places of origin were too remote from the great Classic centres to admit of the establishment of any real connection.

Specialists have named these ceramics after three zones corresponding to the present States of Colima, Jalisco and Nayarit, since there must perforce be stylistic differences in a region comprising 600 kilometres of coast-line. Yet in so far as the modern geographical divisions tally with the various styles, the differences are by no means as clear-cut as some would have us believe. For cases frequently arise in which a piece is attributed now to Colima, now to Jalisco, so imperceptible is the transition from one mode of regional expression to the other.

The differences become more marked, however, as we make our way up the coast to the Nayarit district where two types of sculpture are found. The first consists of large hollow vessels similar to those further south, but without the realism, polish or technical perfection of Colima ware. Formally, they are more akin to the Jalisco style, but painted in brilliant polychrome. The second are diminutive pieces in solid terracotta, often showing small personages in their social context—dancing, conversing, performing administrative functions, etc.—or in an architectural framework of tall-roofed huts, village squares or ball-courts (Pl. 187). Colima ware also comprises small solid terracottas, though these are of no more than marginal importance.

Thus it will be seen how difficult is any sort of classification, the more so since archaeological excavations are far outnumbered by clandestine digs, the sole aim of which is to despoil the tombs and place the best pieces on the profitable antiques market.

The hollow Colima-style figurines are works of remarkable technical quality, while the fineness of the clay and the polished surface give proof of an exceptional sense of plasticity. The full, lustrous forms, the simplification of volumes and the elegance of line are the hallmarks of an art of great freedom, unconstrained by any sort of symbolism, an art intent on recording people, animals and everyday objects. These characteristics set the Colima style in a category of its own in the pre-Columbian world of Mexico (Pls. 181–5).

The unexpected and comical poses of the figures, like the ordinariness of their gestures, bear witness to the peaceful existence of a peo-

ple seemingly untroubled by problems of any magnitude. Their art is neither metaphysical nor religious, but rather a gay, light-hearted form of expression in which, translated into terracotta, water-carriers, ball-game players, drummers, musicians, slumbering men and pregnant women mingle with a familiar and variegated fauna of dogs, ducks and crabs along with a flora consisting of large marrows, colocynths and ears of maize. The theme which inspires this art, therefore, is a world of the here and now, of imagery at its most commonplace. Coated with superb brown or russet slip, the large Colima figurines are usually between 20 and 35 cm high. One of their merits is the moving sincerity with which they bring to life the Indian people of the Occidente.

There is less realism, however, in the Jalisco style which nevertheless displays a fine plastic quality. At the same time humour is more strongly in evidence. Traces of polychrome are discernible in the apparel, a trait that becomes more pronounced in the Nayarit region. Thus the Jalisco figures mark a transitional phase between the realism of Colima and the expressionism of Nayarit, proof of the continuity obtaining between all these forms of figural pottery which came into being along the shores of the Pacific (Pl. 186).

Further north, in the Nayarit region, we encounter larger pieces—not so perfect, perhaps, but of great evocative power. While still reflecting humdrum occupations, the image of everyday life often verges on caricature and a sometimes ferocious kind of expressionism. Seated figures with tiny legs and a long torso, thick-waisted, squatting women with filament arms, 'thinkers', chin in hand, with large heads conveying a clown-like melancholy—all these are characterized by faces that tend towards the grotesque and are set off by nose ornaments, ear-rings and peculiar hats. Polychromy is much in evidence and some of the figures appear to be decorated with body-painting (Pls. 188, 189).

In the large Nayarit pieces, more than 70 or 80 cm high, we have what amounts to a terracotta statuary whose function is purely figurative, unlike that of the vessels of which Colima ware mainly consists.

It might seem surprising to discover close affinities between the art of Colima and Jalisco on the one hand, and some of the pottery of Peru and Ecuador on the other, exemplified more especially by the terracottas of the Occidente depicting erotic scenes in the Mochica style, and a few stirrup-spout pots similar to those found in Nazca. These affinities are attributable to Andean influence which reached Mexico via Central America, as we have already noted in the case of gold- and copper-work. But the dating of objects both of Peruvian and of Mexican provenance would seem to suggest that these contacts must have taken place more than ten centuries before the introduction of metallurgical techniques into Mesoamerica. In that case we should have to postulate, if not the existence of uninterrupted sea-borne exchanges between South America and the Mexican coast from about the beginning of our era, then, at the very least, a succession of Peruvian contributions affecting both the Mixteca Costa and the Occidente.

Learned and Popular Cultures

With regard to the ceramics discovered in the tombs of this region, it is uncertain whether they were intended as grave furniture, or whether

185 Ball-game player from Colima. This fine terracotta depicts a participant in the Pre-Columbians' ritual 'sport'. He carries a bat and wears a kind of helmet as well as a huge 'cuirasse' to protect him against what may have been a very heavy ball. The protection extends as far as the thighs and there would also appear to be heavy padding round the calves. Posed four-square on powerful legs, he exudes determination and assurance. Height 42 cm. National Museum of Anthropology, Mexico City.

they were simply pieces treasured during his lifetime by the deceased and placed beside him by his relatives for use in the next world. Since there is nothing religious about the appearance of such terracottas, we would incline to the second alternative.

Herein lies the singularly original aspect of this art for, unlike the religious works of the great theocratic civilizations of the Classic era, these are secular objects. Hollow ware is diametrically opposed to the forms of expression peculiar to religious civilizations, in as much as it is essentially decorative and concerned solely with depicting the everyday life of a very simple people who went almost naked and cared little for personal adornment or badges of rank. Its high degree of technical perfection nothwithstanding, the art of Colima, Jalisco and Nayarit is popular art, unlike that of the learned cultures, which is based on mythology and ritual. Nothing here seems to reflect the presence of the gods; rather, an amused and kindly view is taken of the men and women of the Occidente who, remote from the urban centres with their rigid organization, were able to lead a peaceful existence devoid neither of humour nor of *joie de vivre*.

The Colima-style face is usually smiling if not laughing and the body is well nourished, even if affected by some deformity. These people seem to be concerned only with themselves and their like, with their own activities and family life. Their existence is not governed by an omnipotent deity, nor are they oppressed by any mystery. It is a direct and lucid art indicative of the adaptation of the people to their environment and their rejection of the grandiose ambitions to which we owe the monumental edifices of ceremonial complexes, a rejection exemplified by the total absence of monuments and structures of any size.

The current of popular art which inspired the pottery of the Occidente is similar to that already noted on the east coast in the pre-Classic manufactures of Remojadas in Veracruz. However, in Colima, Jalisco and Nayarit that current is even more pronounced. For, being far removed from great religious centres such as Teotihuacán and Monte Albán, this pottery is the sole preserve of the popular artist. The gravity and austerity of the hermetic—one might almost say learned—arts are counterbalanced by the freedom of the Occidente potters who, in certain communities, are believed to have been women.

It would seem, then, that there was a profound disparity between the two types of existence upon which man embarked at a particular stage of his development. This contradiction finds expression in two types of culture and will repay closer examination in that it reveals the deep cleavage that existed, not only in communal life, but also and above all in the field of the arts. Here we should take note of the fundamental difference in attitude between societies based on a theocratic and hierarchical system whose art is symbolic and rigorously structured and those consisting simply of rural collectives whose art is both secular and more spontaneous.

These two tendencies present a striking contrast. On the one hand we have the ceremonial centre, often rigidly organized, and engendering vast ritual complexes dominated by pyramids with their attendant temples, ball-courts and palaces, the latter inhabited by priestly rulers, the fruit of whose astronomical studies was the ritual calendar; on the other, mere groups of huts of which the largest was, perhaps, the preserve of the locality's tutelary spirit. The growth of such a settlement was organic

186 Classic terracotta figure, in the Jalisco style, of a kneeling woman clad in a skirt and displaying prominent scarifications on the shoulders. The stunted arms and legs, thick torso and contorted features bring out the element of caricature found in certain pieces. Height 32 cm. National Museum of Anthropology, Mexico City.

and did not involve the building of large monuments. Unlike the imperious structures of the sacred cities, it was expressive of a freedom subject only to the laws of a society based on family ties. The formalism of symmetrical principles and rectilinear structures gives way to a play of forms which, while free from all restraint, is also entirely lacking in metaphysical significance. Rather than an attempt to give structural form to coherent cosmological concepts, what we have here is an expression of contentment with the charms of an everyday life by no means devoid of gaiety and humour, and contrasting strongly with the gravity imposed by sacerdotalism.

On the one hand, then, we find a hierarchical system of ritually based communities, on the other a more individualist system deriving from the nuclear family within the context of the tribe. In other words, the socio-religious infrastructure of the great theocracies of the Classic era that informed urbanism, architecture and art finds a complement in the Occidente among those peoples of unusual artistic sensibility whose lives were not divorced from their natural environment. In modern terms this might be described as the contrast between the 'developers'—the theocratic rulers who erected an artificial and monumental environment calling for thousands of workers and transforming the countryside by the displacement of millions of tons of materials—and the 'ecologists', i.e. settlers who quietly established themselves in surroundings which their presence did little or nothing to disturb.

Such are the reflections to which the societies of the Occidente give rise. Their existence makes us aware of the diversity of modes which, in pre-Columbian times, presided over the artistic expression of the New World.

VIII. The Apotheosis of the Aztecs

In this final chapter we plunge straight into a well-documented period of history, namely that of the Aztecs, the last pre-Columbian civilization in Mesoamerica to confront the Spaniards. Our knowledge of the previous cultures we have discussed derives largely from archaeological data, whereas in the case of the Aztecs we have a wealth of additional information. Accounts of the Conquest by Cortés and his companions are not wanting—for example, the letters from the Spanish commander to his king, the circumstantial history of Bernal Díaz del Castillo (a soldier turned historian), and the works of Sahagún, Motolinía, Diego Durán and Torquemada, from all of which we may learn a great deal about the nature of the Aztec world as it was in the sixteenth century when descended upon by European colonists. In addition, there are innumerable documents emanating from Hispanicized Indians desirous of describing their illustrious past while the evidence was still to hand. Of these we would cite Alvarado Tezozómoc, Chimalpáhin Quauhtlehuanítzin and Alva Ixtlilxóchitl.

But our chief concern here is not so much with the actual history of the final decades (or centuries) preceding the Conquest as with the art of that period. To obtain any useful information on this subject, we must draw on the eye-witness accounts of the first Europeans to arrive in Tenochtitlán and record their impressions of that fantastic city. Yet rich though these sources may be, it must always be remembered that the sixteenth-century way of looking at things is not necessarily the same as our own. Again, the art historian concerned with Aztec civilization is faced with a problem quite different from that presented by the earlier pre-Columbian cultures. For instead of mute archaeological finds—mute by reason of an almost total absence of writing—he has at his disposal the accounts of men who were alive at that time, and all that this implies in terms of subjectivity and ethical, religious and social prejudice. It is through this dense undergrowth that we must seek to beat a path that will lead us to the grandiose art of the Aztecs.

The Demise of the Toltecs

Before discussing the rise of the Aztecs, we must take a brief look at the history of the Altiplano since the fall of Tula in 1168 when, as already mentioned at the end of the third chapter, the Toltec capital had been sacked by barbarian invaders from the north. First we should emphasize the very considerable spread of Toltec influence. During the eleventh and first half of the twelfth centuries this people succeeded in extending

187 The Nayarit potters of the Classic period did not baulk at producing 'conversation pieces'. Here, in a hut with a thatched roof, life follows its daily round. Women talk to each other as they carry out their household chores, while others sit on benches outside. This solid terracotta piece is 31 cm high. National Museum of Anthropology, Mexico City.

188 Classic hollow ware figure from Nayarit wearing a pointed head-dress and short polychrome tunic decorated with geometrical designs. The subject has spindly arms and thick legs. Height 32 cm. National Museum of Anthropology, Mexico City.

189 Detail of head of a large terracotta sculpture from Nayarit. The hair, carefully parted in the middle, is indicated by fine incisions. Embellishments consist in ear-rings and facial scarifications. Height approx. 15 cm. National Museum of Anthropology, Mexico City.

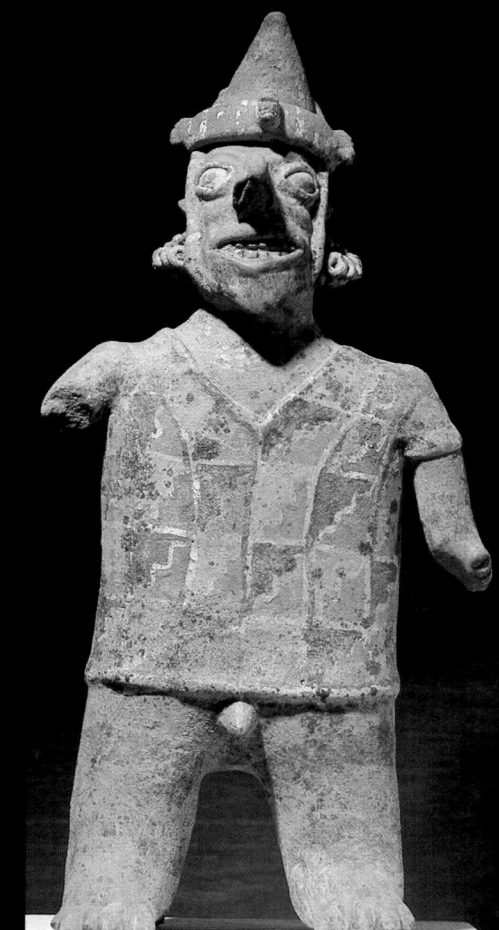

188

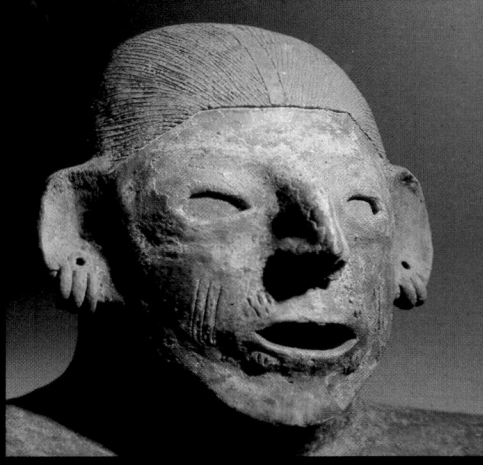

189

187

their sway over the greater part of Mesoamerica. From the *Historia Tolteca-Chichimeca* we learn that Tula had bases as far away as Panuco, Cempoala, Los Tuxtlas and Coatzalcoalcos on the Gulf Coast, and that Veracruz and the Huasteca were subject to the authority of the Toltecs (whose influence on El Tajín has already been discussed). But the Toltecs also controlled the Puebla–Cholula region as well as Teotitlán and Tenango, while further north their rule embraced not only Tzintzuntzán but even places as remote as La Quemada and Chalchíhuites. We would also recall their presence in Chichén Itzá, which stimulated the Maya–Toltec renascence, while evidence of their influence likewise exists in Guatemala and Belize, if not in Honduras. By 1000 A.D., therefore, Tula had become the geopolitical centre of Mesoamerica. The city was ruled by military orders, as Tenochtitlán would be later on, and the Toltecs, like the Aztecs, spoke a language of the Náhuatl family.

Thus the Toltec empire foreshadowed that of the Aztecs whose rise began 250 years later. Nor did the emperors of Tenochtitlán fail to claim legitimacy by assuming the title of Lords of the Toltecs. Furthermore this penetration of Mesoamerica by a Náhuatl language during the eleventh century paved the way for the Aztec hegemony which established itself in the fifteenth century.

After the collapse of Tula the Toltecs were overwhelmed by a wave of barbarian invaders from the north who came to be known as Chichimecs, a generic term for the ferocious nomads of the steppes, but soon attaching specifically to the new arrivals. They, too, spoke a Náhuatl dialect and hence were of the same stock as the Toltecs. Indeed, from now on, each wave of invaders that descended upon the sedentary cultures, shaking them to their very foundations, emerged from the melting-pot of Náhua peoples in the north-west of Mexico. Having taken possession of the ruins of the Toltec empire, and in particular of its capital, the Chichimecs became sedentary and eventually established themselves at Texcoco on the shores of the lake which was later to witness the rise of Tenochtitlán. Meanwhile the Toltec survivors took refuge in Cholula and in their fortress at Colhuacán in the valley of Mexico.

Tenayuca, City of the Chichimecs

Tenayuca, on the western shore of Lake Texcoco, was one of the earliest Chichimec settlements. The first pyramid was probably built there in 1247 and, indeed, several superimpositions have been discovered beneath the great 'double' pyramid on this site. While the final stage of the latter building, completed in 1507 (only twelve years before the arrival of the Conquistadors), is unquestionably Aztec in style, tunnels driven into the interior by archaeologists have revealed five earlier campaigns of construction. Evidently the earliest Chichimec pyramid was overlaid, probably after a fifty-two-year cycle, by a new structure which concealed and considerably enlarged its predecessor. Four repetitions of this operation at fifty-two-year intervals would therefore produce a total of five superimpositions. The earliest structure cannot have measured more than 20 by 32 by 12 metres, as compared with the present dimensions of 70 by 80 by 30 metres.

From the outset the pyramid possessed twin temples, dedicated no doubt to Tezcatlipoca and Quetzalcóatl, the two great deities worshipped

in Tula. The same principle was to be retained by the Aztecs who perfected it in the Templo Mayor at Tenochtitlán, built in honour of Tlaloc and Huitzilopochtli (i.e. rain and sun). There, as at Tenayuca, the edifice is encircled by a protective girdle of snakes, the Coatepantli. At Tenayuca, where they number 138, their bodies are constructed of masonry and their heads carved out of a block of volcanic stone. On the north and south sides of the pyramid lies a coiled serpent, its raised head surmounted by a kind of crest.

A consideration of the double pyramid at Tenayuca is interesting on more than one count. In the first place it reveals that the originators of the twin-temple principle were not the Aztecs but the Chichimecs; the latter did not inherit it from the vanquished Toltecs, along with the cult of that people's deities. It was a principle that was to enjoy considerable success because it gave material form to a dualism dating back to the prehistory of Mesoamerica and reaffirmed in the markedly stratified and inequable society of the Náhua peoples. We shall find it again in the Aztec empire, not only in the main sanctuary at Tenochtitlán, but also at Teopanzolco (Morelos) and even in the temple at Cempoala (Veracruz), erected during the Aztec period.

As already mentioned, the final stage of the Tenayuca pyramid also dates from that period. Two wide flights of parallel stairs ascend the west face of the four-storeyed, steeply sloping edifice. They once served two separate temples, square in plan, which have not survived. But their appearance may be reconstructed, not only from what remains of the walls and from sixteenth-century documents, but also from information yielded by temples found in the earlier layers. The two structures crowning the pyramid each possessed a triple entrance leading to a vestibule from which a single door gave access to the inner sanctum and was covered by a tall, square, slightly truncated roof lined with ornamental crenellations. Polychrome decoration was applied to the four faces of this covering, a different scheme being adopted for each temple so as to distinguish between the two deities concerned.

With the Tenayuca pyramid we have already made an incursion into Aztec art which here forms a natural extension of the Chichimec structure. But before proceeding any further, we must first give a brief outline of the historical and political evolution of the Mexica, the founders of Aztec civilization, and return to the events which preceded the latter.

The Rise of the Aztecs

On the eve of the Aztec conquest, the pre-Columbian world of Mesoamerica consisted of a mosaic of peoples at all stages of development and with widely differing social structures. Some northern districts, as well as parts of the virgin forest, were still inhabited by hunters and food-gatherers. These very primitive peoples had remained nomadic and might roam for considerable distances. Other, more evolved, tribes, as yet unaffected by the urban revolution, continued to lead an early Stone Age existence of an almost autarchic nature in remote valleys amidst the hills. Again, there were various cultures of a more highly structured type, ranging from the small urban centre to the capital of an independent state. Generally speaking, the great theocracies had disappeared by the fourteenth century. On the ruins of Teotihuacán, destroyed in 650,

Plan, elevation and longitudinal section of the pyramid at Tenayuca showing the six superimpositions built between 1247 and 1507.

189

there arose the Toltec empire which was to collapse in its turn in the twelfth century. What remained of Monte Albán was absorbed by the Mixtec civilization which, with the Puebla district, formed a kind of confederation favourable to commerce and manufacture. At El Tajín the Toltec renascence of the eleventh and twelfth centuries petered out, and the city, abandoned in the early thirteenth century, made way for other towns of the Totonac culture.

Among these various peoples centralized government had given way to the rule of a host of lesser potentates. Thus, on the eve of Aztec ascendancy, power was there for the taking and unification was still to be achieved. Indeed, since the fall of Tula, the Altiplano had been constantly ravaged by fresh waves of barbarians who descended from the north in the increasingly forlorn hope of plundering rich cities and raiding well-stocked granaries. For, if accessible and open to attack, these places had already been laid waste by earlier invaders, and those that remained were for the most part strongholds, protected by mighty escarpments and, in the absence of siege engines, invulnerable to assault.

Tradition has it that in 1168, the year of Tula's collpse, the Mexica tribe set out from a region somewhere to the north of the State of Nayarit. For the nomads who, 250 years later, were to found the great Aztec civilization, this marked the beginning of a long and arduous peregrination. The Aztecs, a small, poverty-stricken, but fiercely determined band, embarked on a journey which brought them to the neighbourhood of the Altiplano where they attempted to settle. Callous to one another and unmerciful to strangers, these barbarians had but one goal, namely to seize and hold arable land. In about 1215 they reached the vicinity of what is now Mexico City, where they first settled near Chapultepec. However they were soon defeated in battle and, forced to resume their wandering, attempted to subsist in the semi-arid regions by making forays into the cultivated lands nearby. Driven out once more by the not unnaturally hostile farmers, they retreated in 1325 to unstable, insalubrious islets in the middle of Lake Texcoco where they lived as fishermen. Toynbee has suggested that this wretched and marginal existence, in a setting little conducive to a sedentary life, made them more combative and sharpened their appetite for power.

Undisputed masters of their swampy domain—later the site of the splendid city of Tenochtitlán—they built rafts of reeds covered with mud on which they grew their meagre crops. Their existence was rude and harsh, eked out by raids on neighbouring cities. In the course of one hundred years they grew sturdy, multiplied and eventually formed a redoubtable army. In 1428 they scored their first major victory over their immediate neighbours, after which they remained consistently successful until the fall of Tenochtitlán before the muskets and cannon of the Spaniards, supported by tens of thousands of rebellious subjects. Thus the two key dates, 1428 and 1521, mark the beginning and end of a meteoric rise which lasted barely a century. Between their first victory and the last triumphal years when they controlled a powerful empire, they gradually expanded until their dominions comprised almost the whole of Mesoamerica, from the Gulf to the Pacific, and from the steppes on the Tarascan border to the Isthmus of Tehuantepec. But their triumph was short-lived, for the Capitol is but a short step from the Tarpeian Rock. Tenochtitlán was, in fact, on the brink of disaster at the very time when it seemed to be at the height of its glory.

190 Ring of serpents (coatepantli) surrounding the pyramid at Tenayuca. The original Chichimec structure was covered by Aztec superimpositions. The serpents, 138 in all, are constructed of masonry and have heads of volcanic rock. The final campaign of construction probably took place in 1507, shortly before the Spanish invasion.

191 Detail of the serpent Xiuhcoatl, symbolizing the sun. Surmounted by a perforated crest, he lies coiled beside the pyramid at Tenayuca in the suburbs of Mexico City.

192 The twin stairs dating from the penultimate campaign of construction of the pyramid built at Tenayuca by the Chichimecs and subsequently enlarged by the Aztecs. Layering has ensured the excellent state of preservation of this part of the building. The archaeologists' investigatory tunnel may be seen at the foot of the stairs.

190

191

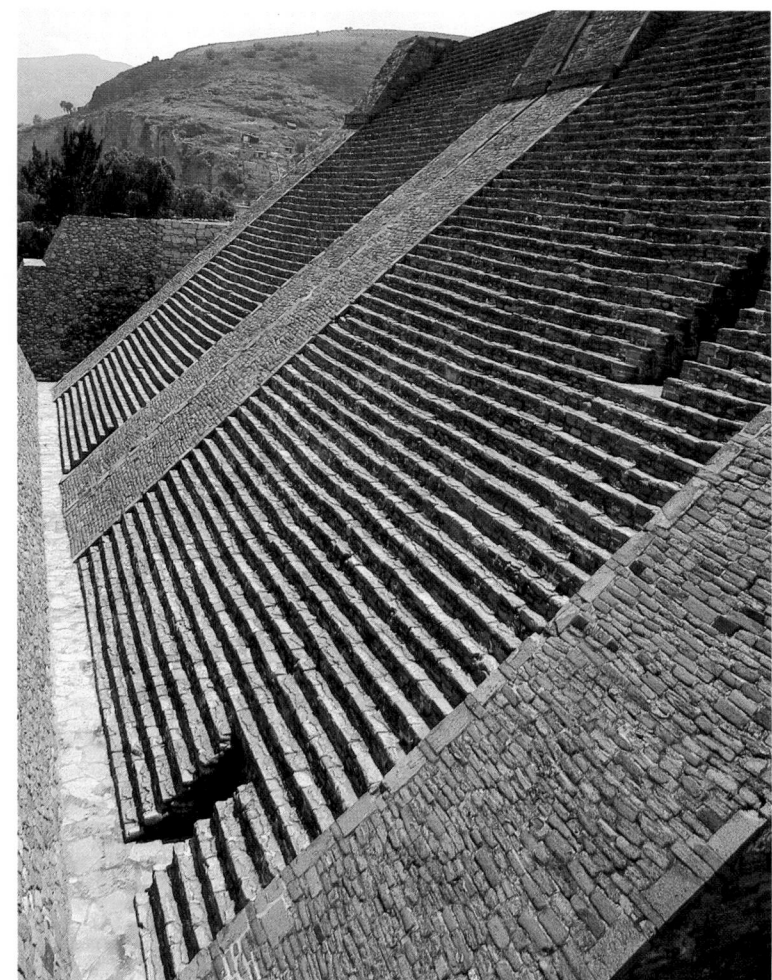

192

How, we might ask, did this powerful empire come into being, and what was the motive force behind it? Both questions are pertinent in view of its rapid rise.

The Motive Force of Imperialism

Sheer force of arms is not the only key to Aztec imperialism. Among the means they employed to acquire an empire, commerce took pride of place. Quite early on, when they had secured their *Lebensraum* on the Altiplano, the Aztecs established trading links, not only with their neighbours, but also and more especially with the Gulf region from which they obtained tropical produce. The commodities, rubber, cacao, exotic fruits and medicinal plants, were soon in brisk demand among the well-to-do.

The trade was entrusted to merchants who journeyed to distant parts in search of luxury goods and unusual foodstuffs. But these same men were also the 'eyes and ears' of the central government. They came back not only laden with highly desirable goods, but also armed with information on the autonomous peoples with whom they had concluded agreements. Nothing eluded them—social organization, military strengths, secessionist tendencies or dynastic troubles. Thanks to this intelligence service, the emperor was able to dictate the terms of the commercial treaties that were imposed upon communities coveted by Tenochtitlán. And woe betide those who proved recalcitrant! For a military expedition would be despatched and commercial exchanges give way to increasingly onerous tribute payments, all attempts at rebellion being promptly put down by garrisons whose numbers steadily grew. Such was the fate of Totonacapán, for instance, in the reign of Moctezuma I (1440–69), a monarch who succeeded in extending his empire, not only to the Gulf Coast, but also to the Pacific littoral.

However, this aggressive economic strategy went hand in hand with a policy subtly combining pacts, treaties, marriage contracts and betrayals, and well calculated to further the aggrandizement of the Aztec domain. Trickery, breach of faith, perfidy—nothing was shunned that might serve the expansionist aims of the emperors who succeeded each other at Tenochtitlán during the century in which the power of the Aztecs was in the making.

Finally, a decisive rôle was played by the religion of the Mexica, this being, perhaps, the real motive force in that it generated energy and inspired in the warriors a fanaticism such as was to make death seem of no account. The Aztecs, indeed, saw themselves as a chosen people destined to save the world by their cult of the sun, Huitzilopochtli, whom they had worshipped even before settling on the high plateaux and whose image had accompanied them throughout their long years of peregrination. Symbolizing the Day Star at its zenith, this idol had for his emblem an eagle, which bird, perched upon a cactus and devouring a snake, engendered the Aztec legend and marked the site of Tenochtitlán. It was to Huitzilopochtli that they dedicated their first temple, built in 1325 in the middle of Lake Texcoco, and here that they inaugurated the bloody ritual which thereafter was to govern the cult of this deity. On the sacrificial stone at the top of the pyramid, men had their chests ripped open with an obsidian knife and their still living hearts torn from

their bodies, for only by slaking his thirst on the blood of these victims could Huitzilopochtli summon the strength for his diurnal rebirth.

Originally, the Mexica may have numbered in their community men brave enough to face such a death, which ensured admission to the paradise reserved for those killed in battle or on the altars crowning the *teocalli,* or pyramids. In course of time the deity, whom only death could keep alive, grew ever more insatiable. Mass sacrifices took place, for which the victims were drawn from the ranks of the vanquished. Alternatively, wars might be arranged for the specific purpose of supplying the temples with these valiant warriors, for only those captured weapon in hand were considered worthy of immolation.

Thus the Aztec religion came to serve not only as a tool for the systematic oppression of peoples of non-Mexican origin, but also as justification for an increasingly rabid imperialism. The emperors of Tenochtitlán had turned their domain into a theocratic tyranny. The effect was cumulative, since each war of conquest yielded a higher proportion of victims and indeed, in 1487, when the double pyramid, known as the Templo Mayor, was dedicated, some 16,000 or 20,000 persons are said to have been sacrificed.

This incessant need to revitalize the sun with ever-increasing quantities of blood was the motive force behind the rapid expansion of the Aztecs. In fact, it may be said to have played much the same rôle as did the thirst for gold among the Romans, who were for ever searching for fresh treasure with which to pay their legions, to buy the exotic products of the East, and to provide the populace 'with bread and games at the circus'.

This, then, was the train of thought which underlay the imperialism of the Aztecs and was to make them masters of virtually the whole of pre-Columbian Mesoamerica by the time of the Spanish invasion. Their bloodthirsty religion exerted a profound influence on the art forms that evolved in its service. For among the Aztecs, even more than among other pre-Columbian civilizations, works of art were created for the greater glory of a militarist theocracy, and their sole function was ritual and sacred.

Tenochtitlán, Capital of a Centralized Empire

It does not come within the scope of a book, of which the main province is pre-Columbian art, to enter further into problems relating to the social, territorial and political organization of the Aztec empire. Nor shall we attempt to trace its development from a tribal structure to that of a hierarchy consisting of warriors, priests and merchants to whom the vast mass of craftsmen and peasants were subservient. Suffice it to say that the monarchy was not hereditary but elective, though the emperor was invariably chosen from the same family by an electoral council consisting of 'nobles'. He was attended by four councillors, themselves nominated by electors and occupying a place in the hierarchy immediately below the sovereign. This class of nobles formed a militaro-theocratic oligarchy in a centralized system run by a strong administration.

Tenochtitlán, the capital, was the heart of this empire in which the temples represented the pinnacle of the religious system, while the palace flanking the great pyramids housed the monarch and the country's

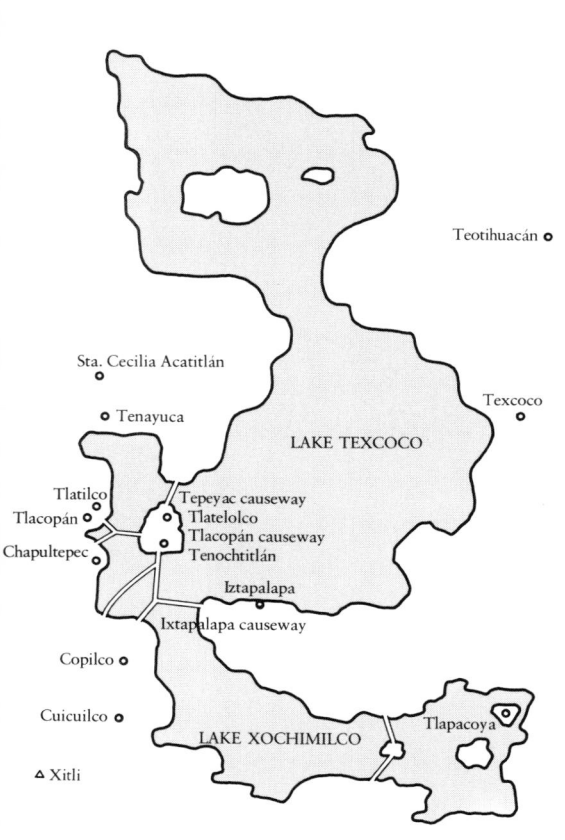

Map of Lake Texcoco showing the system of causeways that linked Tenochtitlán with the mainland at the time of the Conquest.

193

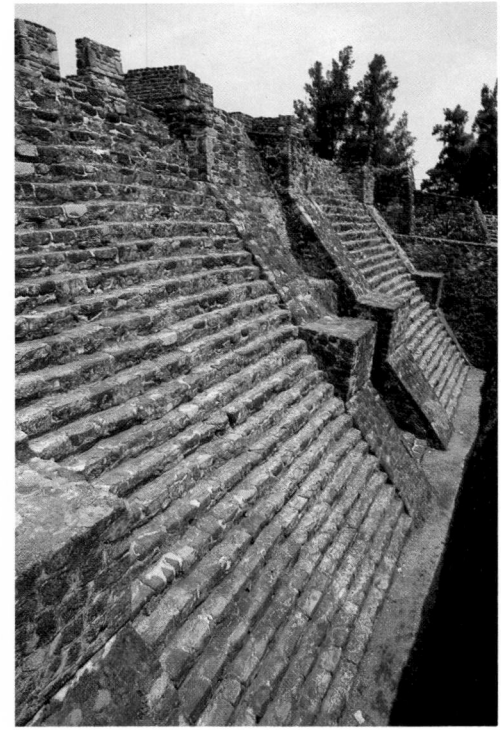

194

195

193 View of the northern platforms of the ceremonial centre at Tlatelolco in Mexico City. This important part of the Aztec metropolis was absorbed by Tenochtitlán shortly before the Conquest and uncovered by archaeologists in 1963.

194 Stairs of the twin pyramid at Teopanzolco (Morelos), an important Aztec centre on the outskirts of Cuernavaca. Here, as at Tenayuca, it is to layering that we owe the good state of preservation of these testimonies to an intermediate campaign of construction, subsequently concealed by the material used in the final building.

195 The little pyramid of Santa Cecilia Acatitlán near Tenayuca is rare among Aztec buildings in that it has retained the greater part of one its upper temples. Preserved by layering, the remains have been so restored as to give an excellent idea of the original appearance of these Aztec structures where human sacrifices were performed.

196 The pyramid at Calixtlahuaca near Toluca is a good example of an Aztec circular structure. The parts now visible belong to the ultimate and penultimate campaigns of construction of the building, whose upper temple has entirely disappeared save for certain fragments of the walls.

197 A plaza with three buildings in the upper part of Calixtlahuaca, an Aztec garrison in the valley of Toluca. The *tzompantli*, or skull altar, in the foreground, has a curious cruciform plan.

élite. Thus it was in a city built in the middle of a lake, itself the focal point of the high plateaux, that the country's political, military and religious power was concentrated. The same applied to its economy, for the wealth deriving from the resources of a vast territory was channelled into the capital. The assumption of a pre-eminent position by one particular city was nothing new in the pre-Columbian world where the most imposing monuments, the finest decorations and the most opulent works of art were accumulated in the seats of highly centralized systems. This is true, not only of Teotihuacán, which eclipsed all the other agglomerations in the Meseta central, and of its successor, Tula, but also of Monte Albán which held sway over Oaxaca. Yet never before had power and art been so exorbitantly concentrated in a single city as it came to be in Tenochtitlán. For this reason we propose to turn to the description of that city made by one of its first European visitors. Dazzled by its splendour, he saw it before it had been reduced to ruins and sacked, not only by the Spaniards intent on loot, but also by the latter's allies, the Tlaxcalans who, eager to avenge themselves on the Aztec people, sought to wipe out all memory of the latter's gods.

Impressions of an Eye-Witness

In a much-quoted passage, Bernal Díaz del Castillo, the chronicler of the Conquest, describes the extraordinary sight that met his eyes when, on 8 November 1519, he entered Tenochtitlán for the first time. He was one of an intrepid band of no more than 450 Spaniards who, with fifteen horse and seven cannon, were bold enough to venture into that vast city of perhaps 100,000 inhabitants (some recent estimates go as high as 250,000). But hackneyed though this historic description has become, it still retains its powers of evocation. Indeed, so unusual were the experiences of the Spanish invaders that anyone interested in this important historical period is advised to read the whole of the account.

The chronicler tells how the small party approached the capital to which they had been invited by Moctezuma II. 'Next morning', he writes, 'we came to a broad causeway and continued our march towards Iztapalapa. And when we saw all those cities and villages built in the water, and other great towns on dry land, and that straight and level causeway leading to Mexico, we were astounded. These great towns and *cues* (temples) and buildings rising from the water, all made of stone, seemed like an enchanted vision from the tale of Amadis [*Amadis of Gaul*, a Spanish romance of chivalry published in 1508, i.e. twelve years previously]. Indeed, some of our soldiers asked whether it was not all a dream. It is not surprising therefore that I should write in this vein. It was all so wonderful that I do not know how to describe this first glimpse of things never heard of, seen or dreamed of before.'

It was thus that Bernal Díaz del Castillo approached that vast megalopolis, Tenochtitlán, in the midst of a huge lake lined by a number of other towns which had gradually merged with the Aztec capital. For the city was built on a group of small islands joined to the mainland by three large causeways as well as a double aqueduct which brought fresh water from Chapultepec, for the lake itself was brackish.

Before arriving at Tenochtitlán, the Spaniards spent a night at Iztapalapa which stands on a promontory south-east of the capital. The men

196

197

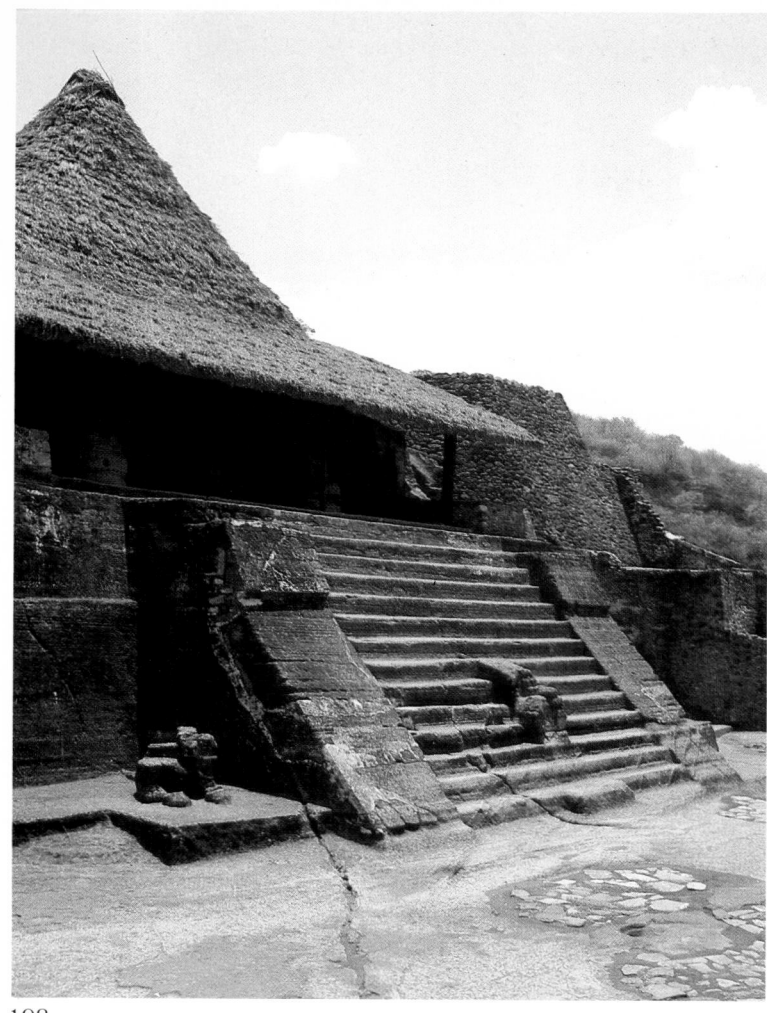

198

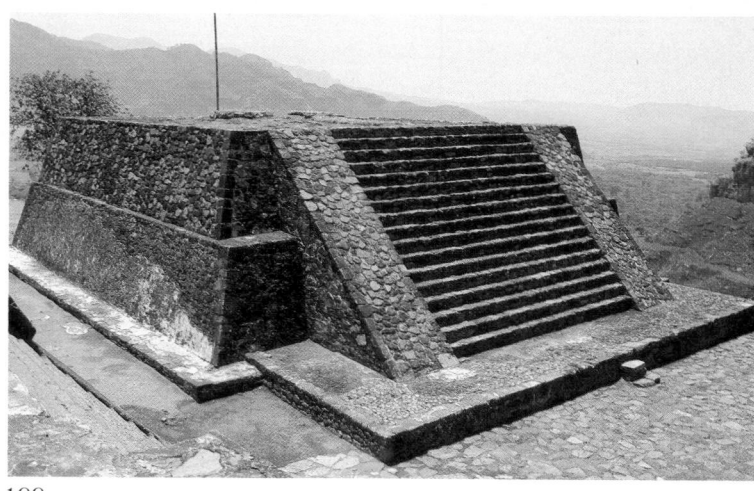

199

200

201

of the Renaissance marvelled at the quality of the dwellings: 'And when we entered the city of Iztapalapa, the sight of the palaces in which they lodged us! They were very spacious and well built, of magnificent stone, cedar-wood, and the wood of other sweet-smelling trees, with great rooms and courts, which were a wonderful sight, and all covered with awnings of woven cotton.'

But it was the gardens more than anything else which attracted the attention of Bernal Díaz. The one belonging to the palace in which the Spaniards stayed was 'a marvellous place both to see and walk in. I was never tired of noticing the diversity of trees and the various scents given off by each, and the paths choked with roses and other flowers, and the many local fruit-trees and rose-bushes, and the pond of fresh water. Another remarkable thing was that large canoes could come into the garden from the lake, through a channel they had cut, and their crews did not have to disembark. Everything was shining with lime and decorated with different kinds of stonework and paintings which were a marvel to gaze on. Then there were birds of many breeds and varieties which came to the pond. I say again that I stood looking at it, and thought that no land like it would ever be discovered in the whole world.'

The Spaniards then entered the city by the great south-east causeway. 'They led us to our quarters, which were in some large houses capable of accommodating us all and had formerly belonged to the great Montezuma's father, who was called Axayacatl... They lodged us amidst the great *cues* of their idols. All these palaces were most brilliant, washed with lime, swept and adorned with boughs... On our arrival we entered the large court, where the great Montezuma was awaiting our Captain. Taking him by the hand, the prince led him to his apartment in the hall where he was to lodge, which was very richly furnished in their manner'.

Later, the Spaniards visited an aviary where different types of bird were bred to provide the Indians with plumes for their feather-work. They were also shown a kind of zoo used for the breeding of beasts of prey, all of which were kept in their natural surroundings of ponds and trees. The gardens proved to be of particular interest: 'We must not forget the gardens with their many varieties of flowers and sweet-scented trees planted in order, and their ponds and tanks of fresh water into which a stream flowed at one end and out of which it flowed at the other, and the baths he had there, and the variety of small birds that nested in the branches, and the medicinal and useful herbs that grew there. His gardens were a wonderful sight, and required many gardeners to take care of them. Everything was built of stone and plastered; baths and walks and closets and rooms like summerhouses where they danced and sang. There was so much to see in these gardens, as everywhere else, that we could not tire of contemplating his great riches...'

There follows a description of the market and the temples: 'When we had already been in Mexico for four days, and neither our Captain nor anyone else had left our quarters except to visit these houses and gardens, Cortés said it would be a good thing to visit the large square of Tlatelolco and see the great *cue* of Huichilobos (Huitzilopochtli)... On reaching the market-place, escorted by the many *Caciques* whom Montezuma had assigned to us, we were astounded at the great number of people and the quantities of merchandise, and at the orderliness and good arrangements that prevailed, for we had never seen such a thing

198 The cave temple at Malinalco, hollowed out of the rock of the mountain side, was one of the Aztecs' last places of worship after the Conquest. A veritable eyrie, it was dedicated to the military orders of the Eagles and the Jaguars. The thatched roof is an attempted reconstruction of the original.

199 In front of the cave temple at Malinalco, a square, two-tiered pyramid stands at the edge of the precipice and overlooks the fertile plain.

200 Detail of jaguar's head at the back of the temple at Malinalco. At one time the eyes probably had obsidian pupils. The entire chamber as well as the sculpture is carved out of living rock.

201 Circular chamber in the temple of Malinalco seen from above. Opposite the door, which is nothing other than a serpent's jaws carved out of the façade, an eagle stands guard in the middle of the floor. Sculpted in relief on the semicircular bench are two eagles and a jaguar. An air of mystery prevails in this Aztec place of worship which was probably constructed at the end of the fifteenth or the beginning of the sixteenth century.

202 An exceptionally fine polychrome stone statue of Xochipilli, the Aztecs' prince of flowers and god of love and the dance. Though his garment is strewn with flowers, his face is concealed behind the skin of a sacrificial victim (the connection between whom and this god had already been noted by Sahagún). Amongst the Aztecs, horror and beauty were never far apart. The young god, who is seated cross-legged on an altar, is 77 cm high, the sculpture as a whole being 1.15 m high. National Museum of Anthropology, Mexico City.

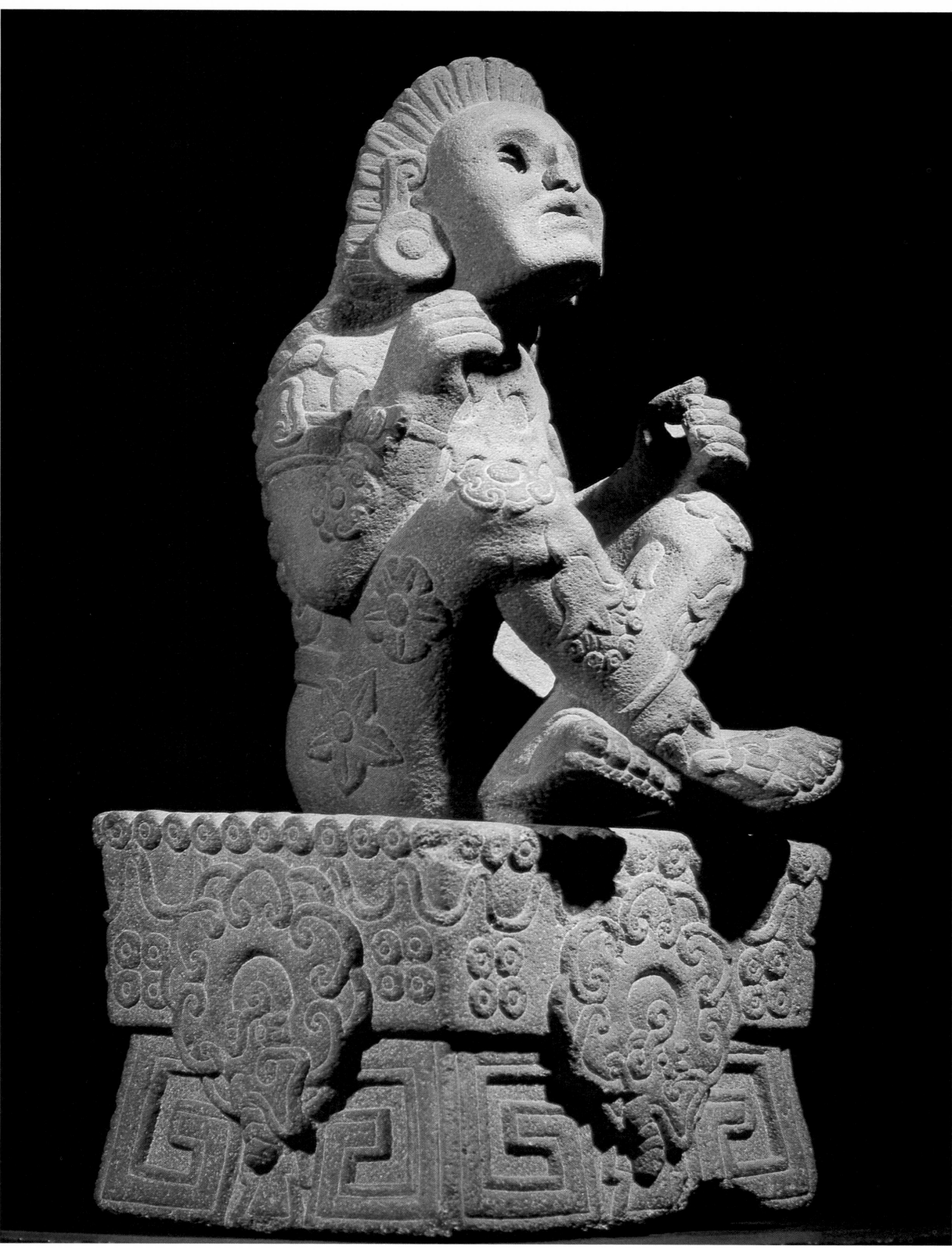

before. The chieftains who accompanied us pointed everything out. Every kind of merchandise was kept separate and had its fixed place marked for it. Let us begin with the dealers in gold, silver, and precious stones, feathers, cloaks, and embroidered goods, and male and female slaves who are also sold there. They bring as many slaves to be sold in that market as the Portuguese bring Negroes from Guinea. Some are brought there attached to long poles by means of collars round their necks to prevent them from escaping, but others are left loose. Next there were those who sold coarser cloth, and cotton goods and fabrics made of twisted thread, and there were chocolate merchants with their chocolate. In this way you could see every kind of merchandise to be found anywhere in New Spain, laid out in the same way as goods are laid out in my own district of Medina del Campo, a centre for fairs, where each line of stalls has its own particular sort. So it was in this great market. There were those who sold sisal cloth and ropes and the sandals they wear on their feet, which are made from the same plant. All these were kept in one part of the market, in the place assigned to them, and in another part were skins of tigers and lions, otters, jackals, and deer, badgers, mountain cats, and other wild animals, some tanned and some untanned, and other classes of merchandise.

There were sellers of kidney-beans and sage and other vegetables and herbs in another place, and in yet another they were selling fowls, and birds with great dewlaps [turkeys], also rabbits, hares, deer, young ducks, little dogs, and other such creatures. Then there were the fruiterers; and the women who sold cooked food, flour and honey cake, and tripe, had their part of the market. Then came pottery of all kinds, from big water-jars to little jugs, displayed in its own place, also honey, honey-paste, and other sweets like nougat. Elsewhere they sold timber too, boards, cradles, beams, blocks, and benches, all in a quarter of their own. Then there were the sellers of pitch-pine for torches, and other things of that kind...

But why waste so many words on the goods in their great market? If I describe everything in detail I shall never be done. Paper, which in Mexico they call *amal,* and some reeds that smell of liquid amber, and are full of tobacco, and yellow ointments and other such things, are sold in a separate part. Much cochineal is for sale too, under the arcades of that market, and there are many sellers of herbs and other such things... I am forgetting the sellers of salt and the makers of flint knives, and how they split them off the stone itself, and the fisherwomen... They sell axes too, made of bronze and copper and tin, and gourds and brightly painted wooden jars...

Now let us leave the market, having given it a final glance, and come to the courts and enclosures in which their great *cue* stood. Before reaching it you passed through a series of large courts, bigger I think than the Plaza at Salamanca. These courts were surrounded by a double masonry wall and paved, like the whole place, with very large smooth white flagstones. Where these stones were absent everything was whitened and polished, indeed the whole place was so clean that there was not a straw or a grain of dust to be found there. When we arrived near the great temple and before we had climbed a single step, the great Montezuma sent six *papas* and two chieftains down from the top, where he was making his sacrifices, to escort our Captain; and as he climbed the steps, of which there were one hundred and fourteen, they tried to

203 A frightening effigy from Tenochtitlán of Cihuatéotl Ce Cuauhtli, goddess of women who have died in childbirth. Like some spectre about to pounce on its victim, she is an evil spirit intent on vengeance. This stone sculpture is highly evocative of the terrorism of Aztec art. Height 75 cm. National Museum of Anthropology, Mexico City.

204 Stone sculpture of a female figure in the same traditional kneeling posture as the Aztec woman. In this work of great sobriety the subject displays a benevolent everyday face. The piece dates from the post-Classic era between 1325 and 1521, the heyday of the Tenochtitlán empire. Height 41 cm. National Museum of Anthropology, Mexico City.

205 Similar in inspiration to the piece above, this stone sculpture is also of a kneeling woman. She is, however, more richly adorned with a three-row necklace, ear discs and a triangular fringed shawl *(quechquémitl)*. Height 35 cm. National Museum of Anthropology, Mexico City.

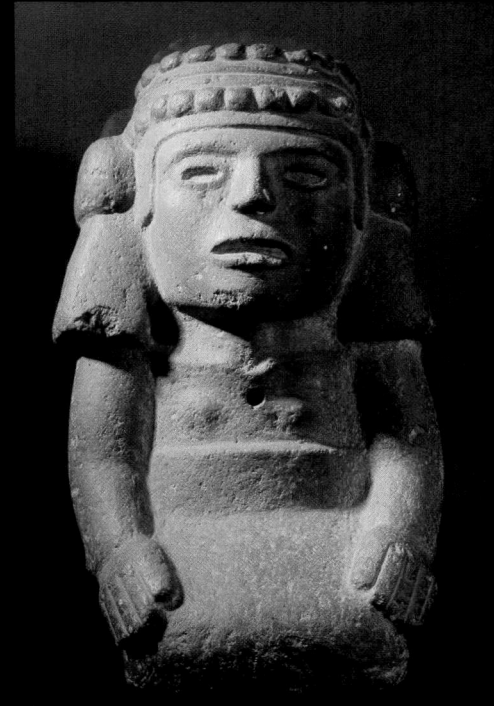

204

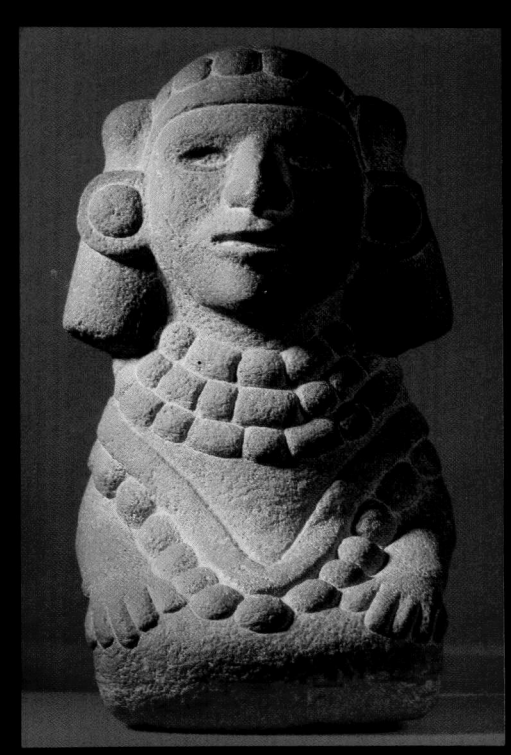

203

205

take him by the arms to help him up in the same way as they helped Montezuma, thinking he might be tired, but he would not let them near him.

The top of the *cue* formed an open square on which stood something like a platform, and it was here that the great stones stood on which they placed the poor Indians for sacrifice. Here also was a massive image like a dragon, and other hideous figures, and a great deal of blood that had been spilled that day... Then Montezuma took Cortés by the hand, and told him to look at his great city and all the other cities standing in the water, and the many others on the land round the lake; and he said that if Cortés had not had a good view of the great market-place he could see it better from where he now was. So we stood there looking, because that huge accursed *cue* stood so high that it dominated everything. We saw the three causeways that led into Mexico: the causeway of Iztapalapa by which we had entered four days before, and that of Tacuba along which we were afterwards to flee on the night of our great defeat... and that of Tepeaquilla. We saw the fresh water which came from Chapultepec to supply the city, and the bridges that were constructed at intervals on the causeways so that the water could flow in and out from one part of the lake to another. We saw a great number of canoes, some coming with provisions and others returning with cargo and merchandise; and we saw too that one could not pass from one house to another of that great city and the other cities that were built on the water except over wooden drawbridges or by canoe. We saw *cues* and shrines in these cities that looked like gleaming white towers and castles: a marvellous sight. All the houses had flat roofs, and on the causeways were other small towers and shrines built like fortresses.

Having examined and considered all that we had seen, we turned back to the great market and the swarm of people buying and selling. The mere murmur of their voices talking was loud enough to be heard more than three miles away. Some of our soldiers who had been in many parts of the world, in Constantinople, in Rome, and all over Italy, said that they had never seen a market so well laid out, so large, so orderly, and so full of people...

Cortés addressed Montezuma: "We have enjoyed the sight of your cities, and since we are now here in your temple, I beg of you to show us your gods." Montezuma... said that we might enter a small tower, an apartment like a sort of hall, in which there were two altars with very rich wooden carvings over the roof. On each altar was a giant figure, very tall and very fat. They said that the one on the right was Huichilobos, their war-god. He had a very broad face and huge, terrible eyes. And there were so many precious stones, so much gold, so many pearls and seed-pearls stuck to him with a paste which the natives made from a sort of root, that his whole body and head were covered with them. He was girdled with huge snakes made of gold and precious stones, and in one hand he held a bow, in the other some arrows. Another smaller idol beside him, which they said was his page, carried a short lance and a very rich shield of gold and precious stones. Around Huichilobos' neck hung some Indian faces and other objects in the shape of hearts, the former made of gold and the latter of silver, with many precious blue stones.

There were some smoking braziers of their incense, which they call copal, in which they were burning the hearts of three Indians whom they

had sacrificed that day; and all the walls of that shrine were so splashed and caked with blood that they and the floor too were black. Indeed, the whole place stank abominably. We then looked to the left and saw another great image of the same height as Huichilobos, with a face like a bear and eyes that glittered, being made of their mirror-glass, which they call *tezcat*... This Tezcatlipoca, the god of hell, had charge of the Mexicans' souls, and his body was surrounded by figures of little devils with snakes' tails. The walls of this shrine also were so caked with blood and the floor so bathed in it that the stench was worse than that of any slaughter-house in Spain. They had offered that idol five hearts from the day's sacrifices.'

Having left the capital in the course of the notorious *Noche Triste,* when they lost all their cannon, most of their horses and over half their men, the Spaniards returned to the Gulf where they regrouped for a fresh attack, being determined to capture Tenochtitlán. They returned and laid siege to the Aztec capital, after having built a flotilla of thirteen brigantines to patrol the lake. Meanwhile they had engineered a rising of the Aztecs' former subjects, notably the Tlaxcalans (already their allies), the Totonacs and the Matlatzincas. These tribes had been infuriated by the exactions of their masters whose demands for victims and tribute constantly increased.

On 26 May 1521 Cortés began the siege of Tenochtitlán which, after a terrible blockade, fell on 13 August. Having been plundered by the Spaniards the town was put to the flames and then abandoned because of the stench from the thousands of corpses, though not before Cortés's Indian allies had fallen upon and destroyed the temples of the gods they abhorred. What still remained standing was doomed when Cortés decided to found the capital of New Spain on the same site. For all the earlier buildings were completely demolished to provide material for the new city.

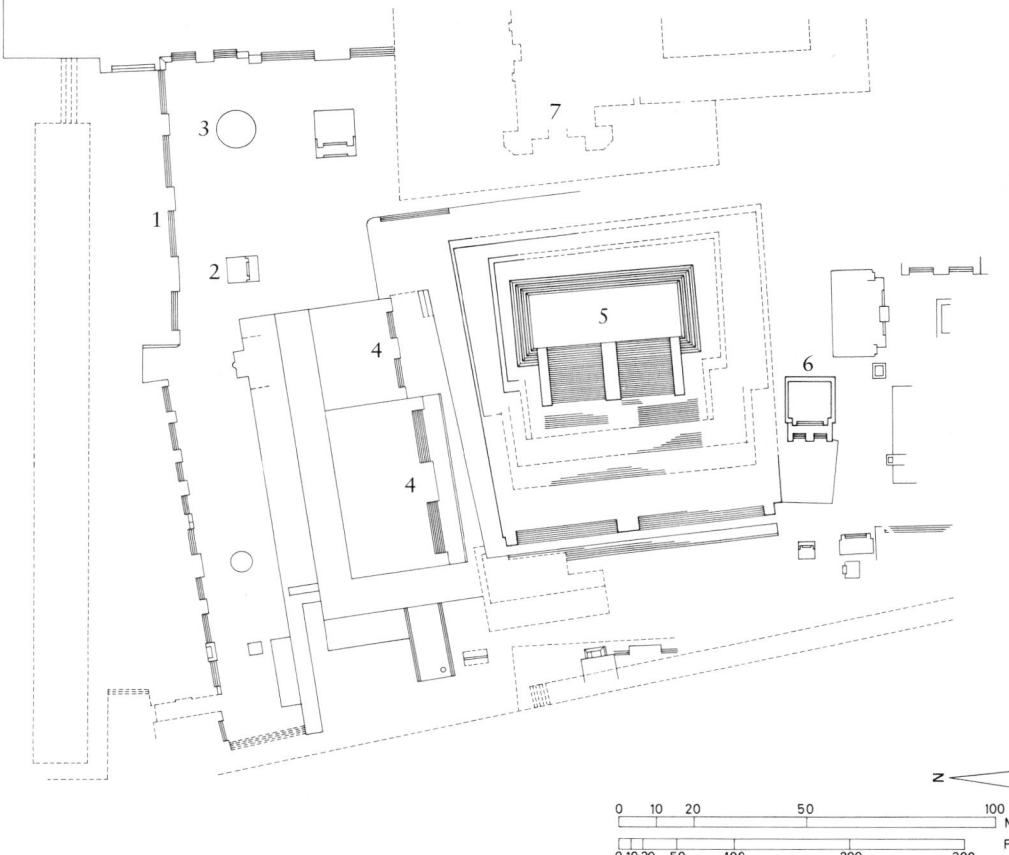

Plan of the ritual ensemble at Tlatelolco (Mexico City).
1 Platforms
2 Small pyramids
3 Platform of the Gladiators
4 Minor pyramids
5 Major pyramid
6 Pyramid of the Calendar
7 Church of Santiago Tlatelolco

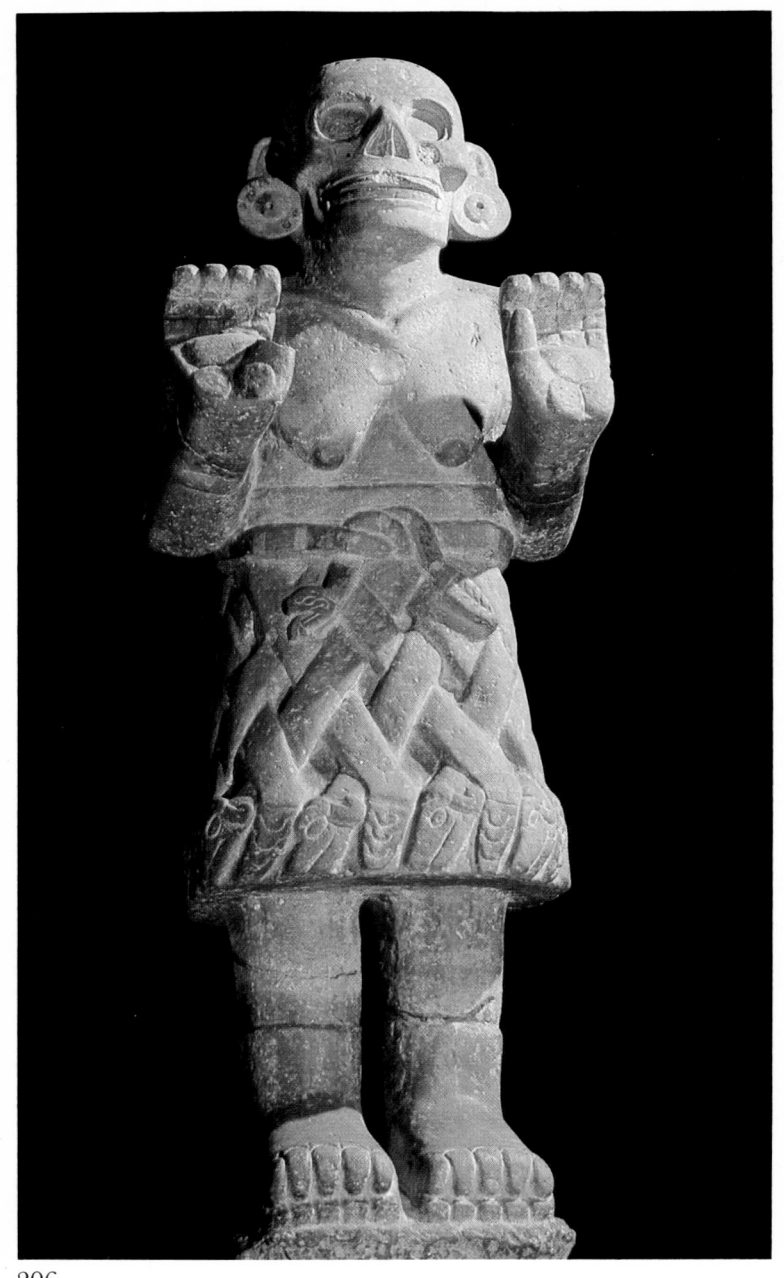

206

207

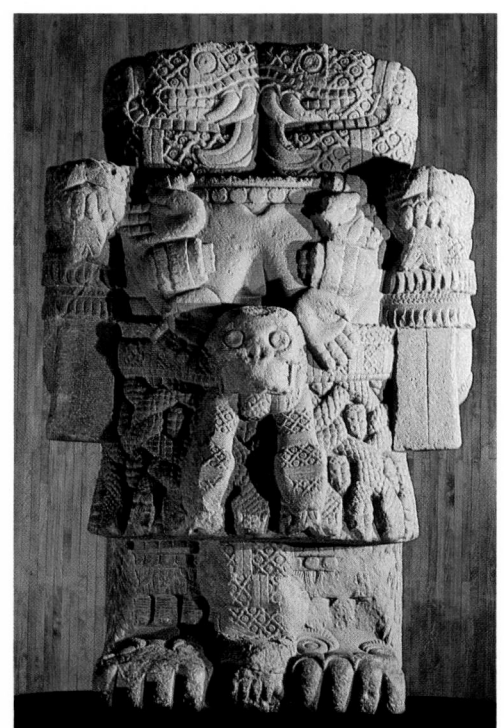

208

209

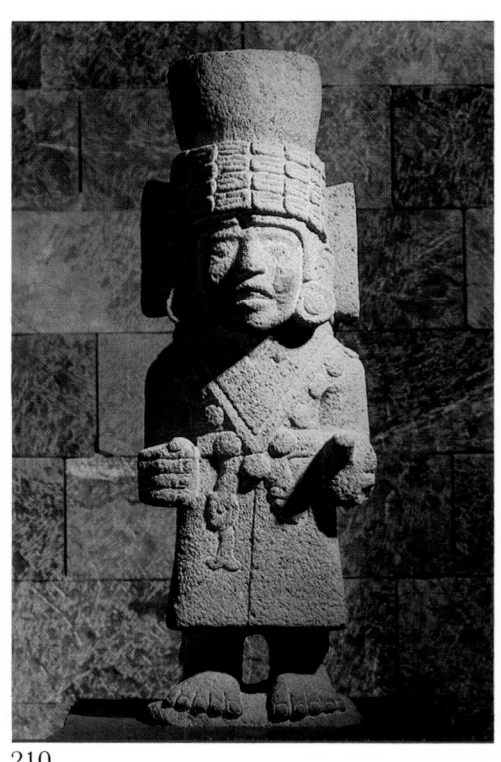

210

The speed and thoroughness of this work of destruction is remarked on by Bernal Díaz. 'Today', he writes, 'all of this town is ruined and razed to the ground, and nothing is left standing.' More serious still, the ecological balance had been disturbed. 'Today, men sow where once there was a lake; all is dry and so strangely transformed that, had I not seen it before, I could not believe that the place now set with seed might ever have been filled with water.'

Excavations in Mexico City

Indeed, the first discoveries made in Mexico City filled the inhabitants with astonishment. It was as if they had forgotten that they were living on the site of the old Aztec capital, for the past had been obliterated, as had the memory of the ancient rituals stigmatized by the church. The first find was made in 1790, outside the cathedral in the Plaza Mayor, or Zócalo, when the installation of a conduit brought to light an enormous monolith of the goddess Coatlicue (Pl. 208). But it was not until 1897, with the building of the Ministry of Justice, that the first excavations were made at the centre of the city, resulting in the discovery of the base of a stairway adorned with a huge serpent's head. Other finds were made during the early part of the twentieth century, while the major operation of salvaging Tlatelolco and creating the Plaza of the Three Cultures was put in hand in 1960 (Pl. 193). So numerous were the finds resulting from the construction of the Metro, begun in 1966, that it was decided to build a Museum of Tenochtitlán. In 1978 the discovery near the cathedral of the astonishing Coyolxauhqui monolith led to the adoption of the *Proyecto Templo Mayor*, an operation so extensive that it completely disrupted the old quarter adjoining the Zócalo. This vast enterprise was entrusted to the archaeologist Eduardo Matos Moctezuma, and its results to date have been spectacular, a considerable number of works having been retrieved that are of crucial importance to our understanding of the Aztec past.

In the domain of architecture and urban planning the campaign has brought to light the substructures of the Great Temple and of neighbouring sanctuaries, but nothing has yet been discovered that had not previously been described by the chroniclers with, it now transpires, remarkable accuracy. Indeed, Marquina's plan, based on the writings and sketches of Sahagún, with the addition of data obtained from a few isolated probes, is unlikely to be much affected by the work now in progress.

Tenochtitlán, the Venice of the New World, was connected to the mainland by three causeways (one about 8 kilometres long), and possessed a network of canals that crossed each other at right angles. At its heart was a ceremonial centre forming a vast quadrangle 400 metres square and symmetrical in plan. It was dominated by the Templo Mayor, a lofty pyramid with twin shrines dedicated to the rain and sun gods, Tlaloc and Huitzilopochtli. Recent excavations have shown that it was built in five campaigns and finally completed in 1487, when it measured approximately 100 by 80 metres at the base, and must have risen to a height of almost 60 metres.

To the north and south were two pyramids, the latter dedicated to Tezcatlipoca. These faced towards the Templo Mayor, opposite which stood the circular temple of Quetzalcóatl, itself preceded by a ball-court.

206 The goddess Coatlicue, the Aztecs' earth symbol or chthonic deity, with a serpent skirt. Her head, in the form of a skull, is enhanced with incrustations of turquoise and pieces of shell. The statue is from Coxcatlán, near Tehuecán (Puebla). Height 1.30 m. National Museum of Anthropology, Mexico City.

207 Unlike the terrifying goddess Coatlicue, this humble Aztec workman, or *macehualli*, advancing hand on breast to do honour to his gods, reveals the sobriety of which the last pre-Columbian sculptors were capable, once they turned their hands to the representation of the common people of Tenochtitlán. The piece, 75 cm high, was intended as a votive offering. National Museum of Anthropology, Mexico City.

208 A much larger version of the goddess Coatlicue. The monolith, 2.57 m high, was uncovered on 13 August 1790 in the Plaza Mayor, or Zócalo, in Mexico City. At once 'abstract' and symbolic, this typically Aztec work incorporates the characteristics of the earth goddess: two affronted serpents' heads surmount a body clad in a serpent skirt. Suspended from her neck are human hearts, hands, and the head of a sacrificial victim. National Museum of Anthropology, Mexico City.

209 Commemorative stone marking the dedication of the Templo Mayor to Huitzilopochtli in 1487. It shows the emperors Tizoc and Ahuizotl, who were responsible for its construction, proceeding to a self-immolation ceremony on the altar of the sun god. At its foot, this diorite sculpture bears the date Eight Acatl, i.e. Eight Reed. Height 85 cm. National Museum of Anthropology, Mexico City.

210 Chicomecóatl, or Seven Serpent, the Aztec goddess of agriculture, in the guise of a woman of the people. The statue, carved in volcanic rock, derives its inspiration from Toltec models. Height 80 cm. National Museum of Anthropology, Mexico City.

Adjoining this was the *tzompantli* or altar on which were displayed the skulls and bones of sacrificial victims. The ceremonial centre was completely enclosed within a crenellated wall and was the nodal point of a geometrical lay-out upon which converged the three main avenues. These were extensions of the north, south and west causeways, leading into the city, and corresponded to the Tepeyac, Iztapalapa and Tlacopán roads.

Immediately to the south of the temples was the enormous palace of Moctezuma II. According to eye-witness accounts this was a vast, square complex of patios and flat-roofed buildings, including halls capable of accommodating 3,000 persons. At a higher level were the emperor's private apartments and a terrace on which, if we are to believe the Conquistadors, thirty horsemen could have taken part in a tournament. From these contemporary accounts it will be seen that the concept of the building as a hollow volume, first adumbrated by the Toltecs at Tula, had been adopted and applied on a far larger scale by the Aztecs. In front of the palace was a huge square very similar to the Zócalo of today.

In the light of our present knowledge and of recent excavations, much of what Bernal Díaz says appears to be inaccurate. He evidently confuses the great Tenochtitlán pyramid with that of Tlatelolco, whose shrines he supposes to have been dedicated to Tezcatlipoca and Huitzilopochtli, whereas it was in the Templo Mayor that the latter was worshipped in association with the god Tlaloc. He also fails to discriminate

Huge monolith discovered in 1978 at the foot of the stairway of the Templo Mayor, near the cathedral in Mexico City. It portrays Coyolxauhqui.

between the sculptures he saw in the various temples. None of this, however, should be a cause of reproach, since he did not complete his memoirs—a real feat of reporting—until 1568, some thirty years after the event.

Temple Architecture

Generally speaking then, Aztec buildings must be looked for outside the capital. We have already mentioned the fine double pyramid at Tenayuca, now so admirably refurbished and restored. Not far away, on the northern outskirts of Mexico City, are the remains of the small double pyramid of Santa Cecilia Acatitlán. Dedicated to Tlaloc and the dead sun, it is an excellent example of an Aztec shrine. The work of reconstruction has been devoted, not to the final superimpositions, but to a shrine embedded in one of the lower layers and thus partially preserved. This edifice, identical in all respects to the image drawn by informants such as Sahagún, has a tall, square truncated roof, and is adorned with relief decorations displaying skulls, grains of maize or drops of water in accordance with the deities to which it is dedicated (Pl. 195).

As already mentioned, Teopanzolco (Morelos), near Cuernavaca, also possessed a pyramid with twin shrines. This interesting structure, whose name signifies 'deserted temple', measures 50 by 32 metres at ground level, and reveals two distinct superimpositions. On the upper platform are the remains of two cellas, now roofless. As at Tenayuca, Santa Cecilia and Teayo, the ramps lining the stairs become almost vertical towards the top, thus accentuating the very steep pitch of the pyramidal mass (Pl. 194).

Temples built on a round, Huastec-type plan are usually dedicated to Quetzalcóatl, the wind god and avatar of Ehécatl, as was the circular pyramid (part of which now lies beneath the cathedral choir) opposite the Templo Mayor at Tenochtitlán. Though the capital can boast few such remains, a fine example still survives at Calixtlahuaca in the valley of Toluca. This building of no less than four superimpositions has a wide stairway serving a circular pyramid composed of receding concen-

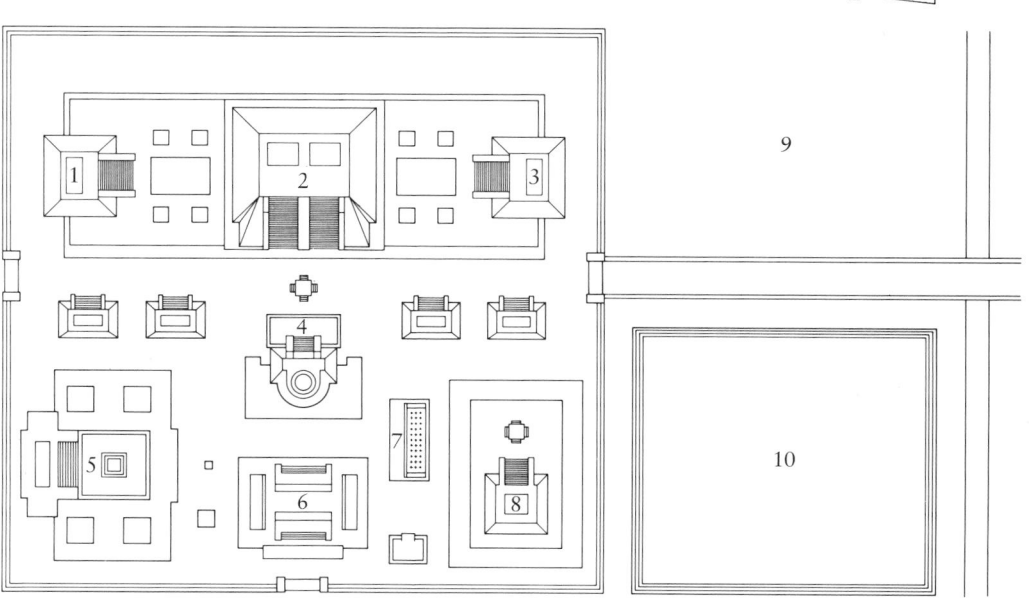

Plan of the ceremonial centre at Tenochtitlán, as reconstructed by Marquina.
1 Unidentified temple
2 Templo Mayor
3 Temple of Tezcatlipoca
4 Temple of Quetzalcóatl
5 Priestly dwellings
6 Ball-court
7 *Tzompantli* or skull-rack
8 Temple of Xipé
9 Moctezuma's palace
10 Great Plaza

tric steps. Nothing, however, remains of its crowning sanctuary (Pl. 196). On the same site is a ceremonial complex consisting of a small square plaza, a pyramid dedicated to Tlaloc and, facing it, a cruciform *tzompantli* or skull rack decorated with small skulls in full relief. The Aztecs kept a garrison here to hold down the rebellious Matlatzincas (Pl. 177).

Another exceptionally interesting example of a circular temple is found at Malinalco, in the mountainous country between Cuernavaca and Toluca, 225 metres above the settlement once garrisoned by the Aztec military orders of the Eagles and the Jaguars. The site, known since the Conquest as the Cerro de los Idolos (Hill of the Idols), comprises a square pyramid, dominating the country below, and several cave temples, of which the chief is in fact the Temple of the Eagles and Jaguars whose circular plan is evident only upon entering. From the outside, all that can be seen is a stair ascending a two-tiered structure ensconced like an eyrie in the wall of rock above the valley (Pl. 198). Opening into the cella that surmounts the platforms is a rounded doorway cut in the rock and representing the gaping jaws of a huge serpent (the 'jaws of hell', as Bernal Díaz described a similar doorway in the Temple of Quetzalcóatl at Tenochtitlán). The serpent's mask is suggested by a few lines incised in the rock, while its forked tongue is spread out on the ground like a carpet. To the left and right of the entrance, and further down, on either side of the stair, are full-round sculptures (partially destroyed) of jaguars, eagles and serpents. The stair leads down to a circular underground chamber hewn out of the living rock. Round its wall runs a stone bench upon either side of which, carved in relief, are two eagles and, between them, a 'tiger' or jaguar. All three face the entrance, as does a third, full-round eagle standing in the middle of the temple floor (Pl. 201).

This cave temple with its circular chamber undoubtedly fulfilled a function that was both cosmological and initiatory. The eagles and jaguars represent respectively the diurnal and nocturnal course of the sun, while the monster whose jaws frame the doorway symbolizes the earth, the cave into which the sun disappears on its subterranean journey. Here, then, we have a symbolic system with two referents—one the military orders inherited from the Toltecs, the other, the solar cosmology. Yet these two symbolic poles in fact constitute a single whole when we remember that the sun was escorted on its course by companies of warriors slain in battle. As a result of the intelligent reconstruction of its thatched conical roof, the temple at Malinalco has regained its aura of mystery and its powers of evocation.

Aztec Sculpture

The temple at Malinalco enables us to appreciate the extraordinary talent of the Aztec sculptors. For cave architecture is, in effect, sculpture, and here we find a sureness of touch, a technical perfection and liveliness of expression which testify to a high degree of mastery in the art of rock-carving.

The eye-sockets of the jaguar crouching at the back of this 'lair'—like those of the three eagles, whose heads have unfortunately been defaced—must at one time have been furnished with obsidian eyes, a technique commonly practised by Aztec sculptors, but deriving from Teotihuacán

Plan, section and elevation of the circular pyramid at Calixtlahuaca.

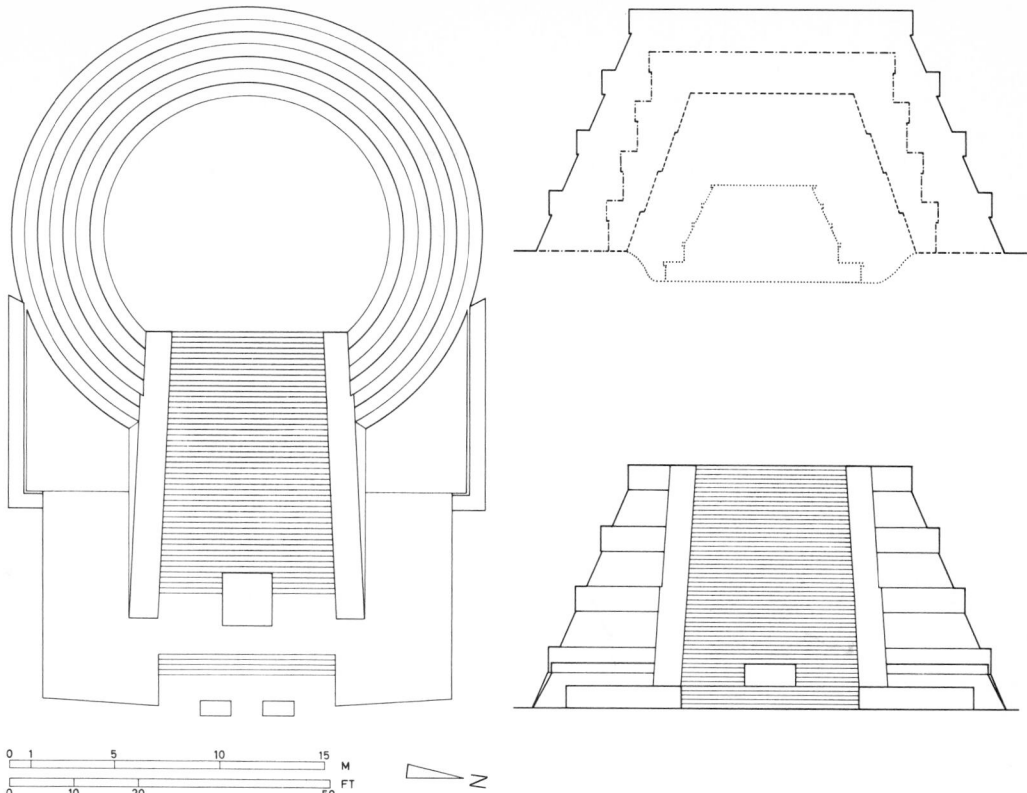

(Pl. 200). All these sculptures are heraldic rather than naturalistic; the jaguar is depicted almost flat, like a 'skin' rug with 'stuffed' head and paws in relief and tail carried vertically up the wall. The eagles are shown in bolder relief, their attitude being that of a flying bird about to swoop on its prey. The wings are partly folded and the claws neatly positioned on either side of the tail, the long feathers of which likewise rest against the wall.

In early Aztec sculpture we may discern a tendency to draw on Toltec forms and ideas, a legacy transmitted to the Tenochcan artists by the Colhuacáns. The affinities between the modes of expression of the two cultures are apparent, not only in the sculpted friezes (cf. the polychrome bas-reliefs at Tula and those in the temple of Huitzilopochtli), but also in full-round statuary (cf. particularly Pls. 57, 210). Similarly, a number of architectonic themes, such as Atlantean figures and standard-bearers, are of Toltec origin.

Most of the works that have come down to us were produced in capital cities. As we have already pointed out, where art is wholly at the service of a politico-religious system, it tends to concentrate in the same places as the emblems of power of the ruling class. That is why nearly all the great works originated in Tenochtitlán and Tlatelolco. Aztec art is therefore essentially metropolitan. Cut down in its prime by the arrival of the Spaniards, it never experienced a wide diffusion or succeeded in imposing itself in remote parts of the empire. The attempt to effect a powerful and original synthesis of earlier and contemporary styles lasted only a century, and the works resulting from it mostly came into being between 1450 and 1520—i.e. between the reigns of Moctezuma I and Moctezuma II, a flowering of no more than seventy years, or barely three generations.

Formal development was initially rapid and soon gave birth to an Aztec style with very marked conceptual and symbolic tendencies. For the function of art was political and imperialist as well as religious. A few notable

211 Coiled rattler. This fine Aztec sculpture of extraordinary perfection of form symbolizes the forces that stand guard round the temple. The work is also remarkable for its density and schematization. Diameter 75 cm. National Museum of Anthropology, Mexico City.

212 An interesting feature of this stone head of a man is the incrustation of the eyes and teeth. The Aztec sculptor has enlivened the face with eyes consisting of pieces of white and yellow shell and pupils of iron pyrite. Height 18 cm. National Museum of Anthropology, Mexico City.

213 This obsidian mask testifies to the consummate mastery of the Aztec sculptors in a medium so brittle that it could only be worked with the aid of abrasive techniques. Height 23 cm. National Museum of Anthropology, Mexico City.

211

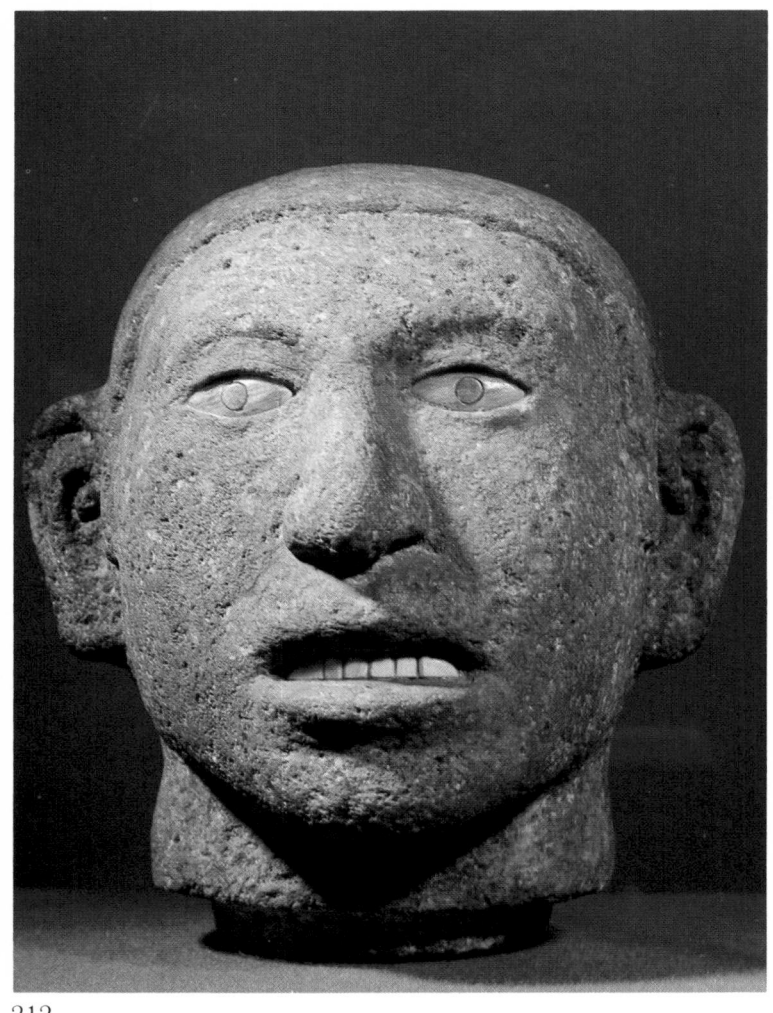

212

213

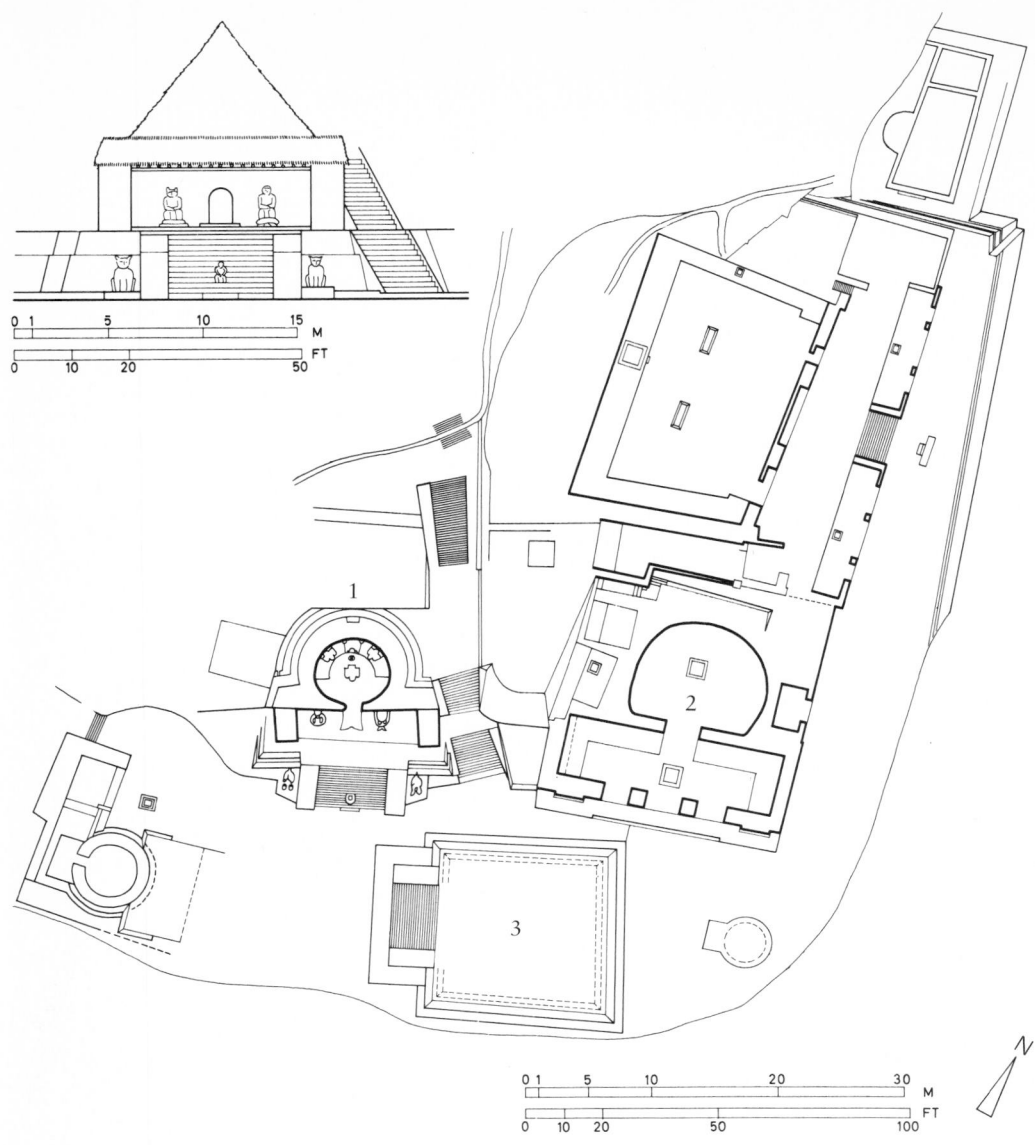

214 A truly remarkable Aztec sculpture showing a man's head emerging from an eagle's mask. Specialists have dubbed him Knight of the Eagle, a somewhat paradoxical description, given a civilization in which the horse was unknown. Originally, the eyes may have been incrusted. The work, from Texcoco, is 31 cm high. National Museum of Anthropology, Mexico City.

Elevation of the Temple of the Eagles and Jaguars and plan of the ceremonial centre at Malinalco.
1 Temple of the Eagles and Jaguars
2 Another cave temple
3 Square pyramid with two terraces

215 Polychrome terracotta relief from Colhuacán representing Tlazotéotl, the goddess of procreation, and known as the 'eater of sins'. The decorative motifs recall those on the head-dress of the Monte Albán gold pectoral (Pl.93). It is one of the few surviving examples of Aztec terracotta sculpture. Height 28 cm. National Museum of Anthropology, Mexico City.

216 Andesite sculpture of a plumed coyote. By the Toltec period this animal had already become associated with sacrifices involving hearts which it devoured in company with eagles and jaguars. National Museum of Anthropology, Mexico City.

217 Stone model of the Temple of the Sun, the 'teocalli' of sacred war'. In the centre is the emblem of the sun flanked by the gods Huitzilopochtli and Tezcatlipoca. This Aztec sculpture from Tenochtitlán was probably used as a sacrificial stone. Height 1.25 m. National Museum of Anthropology, Mexico City.

exceptions apart, this sculpture, representative of the gods, is intended to impress. It is a manifestation of superhuman powers in which death, bloody sacrifice and grisly images take pride of place. For one Xochipilli, god of flowers, love, pleasure, music and the dance (Pl. 202), we have many Xipé Totecs, clad in the skins of sacrificial victims, many deities with bare skulls for heads, severed hands for ornaments and entwined snakes for clothing. Nor should we omit the terrifying Coyolxauhqui (as portrayed on a circular stone that has recently come to light) with her girdle of skull and serpents, her dismembered body, severed head and neatly amputated arms and legs beneath whose flesh the joints are shown with anatomical precision.

The whole aim and object of this art is cultural intimidation. The message it conveys is one of violence, death and oppression. It reminds subject peoples of their condition and helps to keep the vanquished submissive and cowed. Moreover, it extols the superiority of a chosen people destined to subdue the whole of Mesoamerica by force of arms. Of that fine instrument of military oppression, the Tenochtitlán empire, it might be asked whether religion was regarded as an ends or a means. True, the great theocracies had been superseded by warrior states, yet it is far from easy to discover whether the sacrifices were in fact propitiatory, or whether their sole purpose was the more effective subjection of peoples already reduced to the rôle of assuring the well-being of the imperial family, the warriors and the nobles of Tenochtitlán.

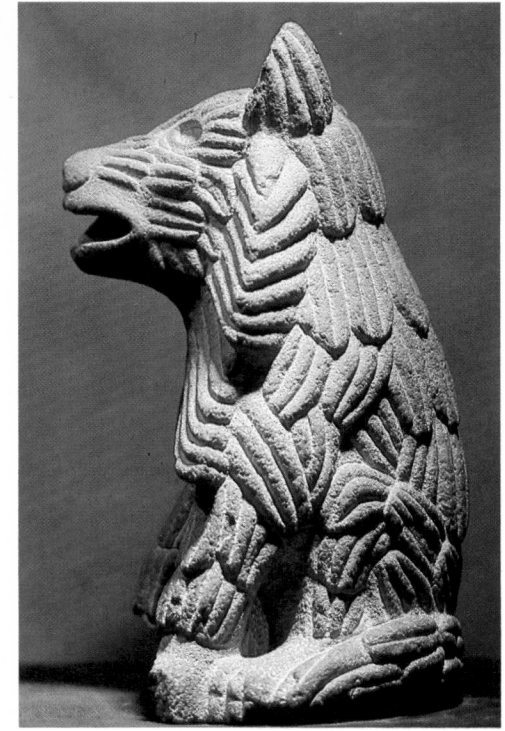

216

217

215

And yet there is no denying the achievements and virtuosity of Aztec art. Only very seldom did pre-Columbian sculpture attain such a degree of authenticity as in the figure of the *macehualli,* a humble workman who, hand on breast betokening respect, advances towards his god (Pl. 207), or that of a woman of the people, similarly engaged, but here in the guise of Chicomecóatl, or Seven Serpent (Pl. 210). Again, the lofty nobility of the Aztec warrior is strikingly evident in the magnificent face emerging from an eagle's mask and belonging, as some authors maintain, to a Knight of the Eagle, i. e. to a member of a military order deriving from Tula (Pl. 214).

Against these few pieces expressive of the ideals of nobility, sobriety and simplicity, we must set innumerable works glorifying what one might call salutary terror, works exalting horror and death. They range from the *cihuatéotl ce cuauhtli,* women who have died in childbirth and who haunt the other world (Pl. 203), to the fearsome earth and fertility goddess, Coatlicue, with her death's head and skirt of serpents (Pl. 206), or, again, to the other purely symbolic Coatlicue, with two affronted serpents' heads for a face, wild animals' claws for hands and severed hands and human hearts for a necklace (Pl. 208). All are expressive of a horrifying universe intended to inculcate dread of an after-life so terrible as to freeze the blood of the beholder. Indeed, we gather that this was precisely the effect produced by the Tenochtitlán idols on the minds of the otherwise far from namby-pamby Conquistadors.

This frightening tendency, a legacy of Mexico's distant past, had already manifested itself in the inhuman images of Tlaloc and of the dragon's masks at Teotihuacán. Its exacerbation in the final years of the pre-Columbian world may perhaps have been due to a kind of dull premonition of impending doom felt by a people conscious of the cyclical nature of civilization. The great rhythmic intervals, marked by the death of the four previous suns and expected to culminate in that of the fifth, may well have aroused in the Aztecs a virtual obsession with death which engendered an even greater proliferation of macabre emblems than that noted among the Mixtecs, the Toltecs, and the later cultures of Veracruz.

This enormous increase in human sacrifice, in which the flesh of the victims played the part of the elements in a collective Eucharist, was accompanied by an exaltation of blood and death that lent dramatic colouring to a culture later to be mercilessly crushed beneath the wheels of history. And the 'sacred horror' which Aztec art was intended to convey may be said to reach its highest pitch in the infinitely meticulous treatment of the striking and magnificent sacrificial knife, with its polychrome mosaic handle and flint blade, destined to be plunged into the breast of warriors immolated upon the altar (Pl. 218).

Conclusion

The further we penetrate into the Mesoamerican world, the greater our awareness of the diversity of artistic idioms, the variety of levels of social development, and the multiplicity of civilizations which co-existed, competed with, and succeeded one another. We see how fragmented and compartmentalized were the cultures that evolved in a territory only slightly large than France. And, despite the links established by their common heritage—which, of course, also included the Maya world—we cannot fail to be struck by the tremendous proliferation of forms developed in the course of two millennia of intense and feverish activity, a proliferation characteristic of a region in which an extraordinary variety of solutions would appear to have been attempted.

In a certain sense there is a strong resemblance between ancient Mexico and Europe. We find in both a diversity of cultures and modes of expression which came into being within the context of a fundamental unity, created by various reciprocal influences, by exchanges, contacts and a religion largely shared in common. For these pre-Columbian peoples established numerous links which provide additional evidence of the unified foundations upon which their societies arose. Maize was the basis of these great agrarian societies which remained ignorant of the technology indispensable to the development of the inhabitants of Eurasia, whether eastern or western. Iron and steel were unknown to them, as were draught animals, cattle, the wheel, the cart, the true arch and the lathe. Yet the art created by these men of pre-Hispanic America was of a high order—their statuary was grandiose and moving, their paintings of great originality, their towns exceptionally well-planned. Equipment we should regard as essential to our day-to-day existence was for the most part lacking, but art they possessed in abundance. It was as if man could not be fully human unless provided with images of himself and of his gods, as if he could not live without the additional spiritual nourishment afforded by aesthetic expression.

The development of the Pre-Columbians was almost wholly dominated by religious belief and was polarized by the image of the gods. With a few rare exceptions, the rôle played among the Mesoamerican Indians by those objects we describe as works of art in no way accords with modern artistic concepts. In pre-Hispanic Mexico the context in which the arts flourished consisted of the great theurgies and the solemnization of great feasts, of sacramental ritual, ecstatic cults and mystical liturgies. In a population naturally given to divine impulses and strong religious feeling, the means of expression were largely devoted to the service of

priestly hierarchies whose business it was to propitiate the gods for the good of the multitude. The wide-ranging pantheism of these religions, in which all the forces of nature were worshipped in the guise of innumerable gods, demanded not only the right words and gestures and an ability to ward off the powers of evil, but also an environment steeped in religiosity. The latter was provided by statuary in the shape of figures of supernatural beings, celestial creators and deified heavenly bodies, as also by ritual artifacts and by polychrome wall-paintings depicting tutelary beasts. Such, then, was the province of art whose function it was to represent these gods, to people that cosmogony, and to attract large crowds of votaries to the ceremonial centres.

The Pre-Columbians evolved a plastic vocabulary that was both varied and original. They provided a specific image of the countenance of man and of those of his gods, discovered and perfected a pictorial view of space, and fashioned everyday articles of remarkable quality and perfection. Yet art was not regarded as sufficient unto itself. It was not the beauty of a statue or divine mask that counted, but rather the extent of its efficacity in the supernatural order, and this more especially among the peoples of the great theocracies. Paradoxically enough it is the less advanced tribal societies who, in utilitarian pieces—such as decorated pots or ceramic figures—betray an undeniably aesthetic sense, a concern for beauty and a desire to escape the constraints of sacred art on the one hand, and of dry, austere and chilly functionalism on the other. Indeed, these potters appear to have felt a kind of need for art for art's sake which both moves us and evokes an immediate response.

Midway between these two tendencies we find a combination of mythical imperatives and aesthetic formulations. But in some cases the very message for which the work is the vehicle may stunt it artistically— where, for instance, the awe, fear or horror it is supposed to inspire are at least as important as adherence to an aesthetic canon. In such a case art is as if torn between antithetical assignments. Works which reflect the grimace of death or the fascination exercised by bloody sacrifices are unquestionably different in purpose from those which confine themselves to evoking a serene world.

This contradiction must be borne in mind when considering the pre-Columbian arts of Mexico in which works conveying fear and the exaltation of death, at its most macabre and brutal, co-exist with charming pieces not devoid of humour and gaiety. But this double image is rarely found in one and the same society; rather, it is we who produce it by confronting the two different streams.

In the cultures which arose after 1000 A.D., however, what predominates is the more sinister, bloodthirsty aspect. Everything appears to have been conceived in terms of gory massacre, of ritual decapitation and of mass sacrifice in which the still beating hearts of the victims were offered up as nourishment to the gods, while their lifeless, twitching bodies were sent tumbling to the foot of the pyramids. And it is in the context of these immolations that the ritual scenes recorded in stone and paint must be seen. It is the violence done to the victims, sacrificed to ensure the survival of the gods, which is exalted in this art. Small wonder, then, if the works inspired by these obsequies arouse in us a degree of horror if not revulsion, depicting as they do priests clad in flayed skins still warm from the sacrificial victims, bodies recently decapitated with an obsidian knife, their arteries spurting blood that instantly turns

218 Aztec sacrificial knife with obsidian blade and anthropomorphic handle covered with fine polychrome mosaic. It is a copy of the original in the British Museum. National Museum of Anthropology, Mexico City.

219 Page from the Codex Borbonicus, an Aztec manuscript of about 1530. The central scene shows the gods Tlachitonátiuh and Xolotl, while on the right are the days 8 to 13 of the sixteenth series of the ritual calendar. Xolotl, avatar of Quetzalcóatl, holds a section of a large shell, emblem of the wind. Bibliothèque du Palais Bourbon, Paris.

into so many snakes, or human hearts thrown as carrion to eagles and coyotes.

Sanguinary peoples, religions that fomented 'wars of flowers' with a view to obtaining ever more victims for the gods, ritual deaths which disgusted the Conquistadors—could all this, we may ask, have constituted an ideal setting for a flourishing and harmonious art? In fact, almost all the great works were theocratic, being wholly subservient to the gods, to the priestly hierarchies who worshipped them and to the monarch who was their worldly representative. Architecture and town-planning, sculpture, painting and pottery were the instruments of that cult and the catalysts of thought.

Only the primitive tribes of the Gulf Coast (the Remojadas) and of the Occidente escaped the otherwise ubiquitous influence of the gods. Here the common people, artisans and warriors, could be depicted in their own right, without religious connotations. In the virtual absence of architecture and urbanization, ceramic art could give itself up to humour, caricature and whimsy, as if cocking a snook at the grandiose and the austere.

Among highly structured, hierarchical peoples on the other hand, subject to the priestly dynasties, laughter gave way to a gravity verging on the tragic. Death was everywhere, like latent anguish, like a premonition of the ineluctable end of all things. Gaiety was frowned upon, for what was at stake was man's destiny, defined by the great cosmic cycles and rigidly planned in accordance with immutable rhythms.

This bent for planning found expression in the town. It is, perhaps, in urban terms that we can most fruitfully interpret the order imposed on the community, and the rigid imprint of a structure polarized by the gods in the ceremonial centres dedicated to them. It was here that the Indian genius manifested itself. These cities, whether highland or lowland, adopted systems which, far from being confined to the plazas, esplanades and pyramids, contrived to leave their imprint on secular undertakings, down to and including the road or canal networks. That these men of pre-Hispanic America were town planners *par excellence* is evident, not only from the great cities—Teotihuacán with its capability of growth, Monte Albán with its celestial citadel, Tajín with its platforms and ball-courts—but also from the innumerable sites found everywhere in Mexico, on the coasts as well as on the high plateaux. This form of urban organization was to reach its peak in that astonishing island capital, Tenochtitlán. Set in the middle of Lake Texcoco, this Venice of the New World was a model of balance, an ecological prodigy, a masterpiece of organization. Here we find religion blended with the sciences, sociological, hydrological, military and economic, in a verdant city intersected by navigable canals and served by causeways and dikes extending to the horizon and enabling it to distribute its aquicultural produce and to mulct an empire of its riches, to the greater glory of the gods.

And in so far as the achievements of the men of ancient America can be assessed, it is, perhaps, here that their greatest contribution lies. Rather than the masks of Teotihuacán, their faces haunted by eternity, rather than the enchanting urns, glorifying the multiform deities of the Zapotecs, rather than the austere basalt statues of Tula or even the cold and accomplished sculptures of Tenochtitlán, we should cite the towns, the theocratic cities, the immense agglomerations of the pre-Columbian

world. For the peoples of Mexico would seem to have placed a better interpretation on the concept of the town than did their European contemporaries. They conferred upon it a grandeur and wealth of expression, exploiting every kind of form, balancing space and solids and solving problems of organization and growth with an ingenuity and expertise almost inconceivable in peoples at their stage of development.

As a reflection of social and religious structures, the town bears witness above all to the aspirations of a people; it crystallizes the dreams man cherishes of creating a world that will embody his ideal. In this sense we have an important lesson to learn from the urban planning of pre-Columbian Mexico—a common denominator defined by the other arts which follow from it in logical progression. Thus architecture is no more than the vocabulary of the urban idiom, while sculpture, in its turn, is conceivable only as an integral part of the building, as are polychrome painting and ceramic decoration. This conceptual whole, this synthesis of the individual legacies of each culture, is the expression of the tremendous diversity of solutions arrived at by man in his attempt to fashion the world in his own image.

Chronological Table I

Dates	Periods	Olmecs	Mayas	Teotihuacán
25,000 B.C. 5000 to 2500 B.C. 2500 to 1700 B.C.	Paleolithic Proto-Neolithic Neolithic	First settlers arrive in North America by way of the Bering Strait Domestication of maize and emergence of earliest villages Spread of agriculture and emergence of pottery and polished stone		
1700 to 1300 B.C.	Lower pre-Classic	c. 1500: Settlement at San Lorenzo	c. 1500: Early settlements of Neolithic type	
1300 to 800 B.C.	Middle pre-Classic	1200: Urban occupation at San Lorenzo 1100–1000: La Venta I 900: Abandonment of San Lorenzo 1000–800: La Venta II: Ball-court, colossal heads, altars, etc.		Olmec influence on the pottery of Tlatilco
800 to 200 B.C.	Upper pre-Classic	800–500: La Venta III 700–500: Re-occupation of San Lorenzo 500–400: La Venta IV (tumuli) Wrestler of Uxpanapa, masks at Las Choapas 500: Second abandonment of San Lorenzo 400: Abandonment of La Venta Stela C at Tres Zapotes: probable date: 425 B.C. or generally accepted date: 31 B.C.	Birth of Maya culture 300: Early Miraflores at Kaminal-juyú	5th to 6th century B.C.: first pyramids on the Altiplano (Cuicuilco) 3rd to 2nd century B.C.: Eruption of the volcano Xitli 500 to 200 B.C.: Teotihuacán I: founding of the city
200 B.C. to 150 A.D.	Lower Classic		2nd century B.C. to 2nd century A.D.: Structure E VII at Uaxactún	200 to 150 B.C.: Teotihuacán IA: Pyramid of the Sun 150 to 50 B.C.: Teotihuacán II: Avenue of the Dead, Citadel 50 B.C. to 100 A.D.: Teotihuacán IIA: Temple of Quetzalcóatl 100 to 200 A.D.: Teotihuacán III: city covers 30 square kilometres
150 to 400	Middle Classic		292: First dated Maya stela at Tikal	c. 200: first barbarian onslaught 200 to 400 (or 420): Teotihuacán IIIA: Quetzalpapalotl Palace
400 to 650	Upper Classic		5th and 6th centuries: population movements from the high plateaux and influence of Teotihuacán c. 450: Temple of the Seven Statuettes at Dzibilchaltún 509: Lintel at Yaxchilán 541: Work begins on building of the acropolis at Copán 6th century: Lintel of Temple I, Pyramid of the Magicians at Uxmal 590: Disc at Chinkultik 613: Stela at Coba 642: Temple of the Sun, Palenque 649: Ball-court, Uxmal	Between 400 and 420: invasion of Teotihuacán by barbarians from the north; the population leaves for Kaminaljuyú 420 to 650: Teotihuacán IV: city partially restored
650 to 950	'Epiclassic'		672: Palace at Palenque 692: Temples of the Cross and of the Foliated Cross at Palenque 695: Slab in crypt at Palenque c. 700: Tomb in Temple I at Tikal 8th century: Temple IV at Tikal Palace of the Governor at Uxmal 762: Tribune of the Spectators at Copán 766: Lintel 53 at Yaxchilán 746–810: Stelae erected at 5-year intervals at Quiriguá 9th century: Abandonment of Tikal, Copán, Quiriguá 909: Last Maya date on the Caracol at Chichén Itzá	650: second wave of barbarians and destruction of Teotihuacán, abandonment of the city
	The years 650–950 were attended by shifts in population, the decline of the Classic civilizations and the emergence of what might be described as the pre-Columbian Middle Ages.			

Periods	Monte Albán	Gulf / El Tajín	Chupicuaro / Occidente	Dates
Paleolithic Proto-Neolithic Neolithic	First settlers arrive in North America by way of the Bering Strait Domestication of maize and emergence of earliest villages Spread of agriculture and emergence of pottery and polished stone			25,000 B.C. 5000 to 2500 B.C 2500 to 1700 B.C.
Lower pre-Classic				1700 to 1300 B.C.
Middle pre-Classic	1000 to 900 B.C.: first settlement on the site Monte Albán I	Remojadas: pottery *c.* 1000: Arrival of first wave of Huastecs		1300 to 800 B.C.
Upper pre-Classic	500 to 350 B.C.: Danzantes 350 to 150 B.C.: Appearance of first glyphs in association with the 'Danzantes' and 'town' symbols Monte Albán IA	Remojadas: pottery *c.* 400: Second wave of Huastecs, a people related to the Mayas	600 B.C. onwards: Chupicuaro pottery	800 to 200 B.C.
Lower Classic	*c.* 150 B.C.: arrival of Zapotecs 150 B.C. to 100 A.D.: Monte Albán II: Ball-game players of Dainzú Completion of esplanade at Monte Albán 100 to 150 A.D.: Monte Albán IIA: transitional period	Remojadas: pottery El Tajín: Work begins on the building of the stone pyramids in the 1st century B.C.	150 B.C.: Morett tomb Early Colima, Jalisco and Nayarit pottery *c.* 100 B.C.: Chupicuaro pottery ceases	200 B.C. to 150 A.D.
Middle Classic	Monte Albán III: the city's heyday Construction of ball-court	El Tajín: 4th century: Core of the Pyramid of the Niches	Heyday of Colima, Jalisco and Nayarit pottery	150 to 400
Upper Classic	Monte Albán IIIA: Zapotec tombs	El Tajín: Classic apogee 7th century: first superimposition, Pyramid of the Niches	*c.* 650: El Opeño tombs	400 to 650
'Epiclassic'	Monte Albán IV: decline of the Zapotecs and rise of the Mixtecs	El Tajín: 8th century: Decline *c.* 818: Arrival of Totonacs (according to the chroniclers)	Continued production of Colima, Jalisco and Nayarit pottery	650 to 950
The years 650–950 were attended by shifts in population, the decline of the Classic civilizations and the emergence of what might be described as the pre-Columbian Middle Ages.				

Chronological Table II

Dates	Periods	Maya-Toltecs	Xochicalco/Tula	Cacaxtla/Teotenango
			1st century: Xochicalco I 3rd century: Xochicalco II	300 B.C. to 100 A.D.: Earliest buildings at Cacaxtla From 100 onwards: Eclipse of Cacaxtla by Cholula
650 to 950		The years 650–950 were attended by shifts in population, the decline of the Classic civilizations and the emergence of what might be described as the pre-Columbian Middle Ages		
650 to 950	'Epiclassic'	879: Date on a Maya lintel, Chichén Itzá	From 650 to 950: Xochicalco III Temple of the Feathered Serpent, three stelae 856: Founding of Tula by the Toltecs	Mid-7th century: The Matlatzincas arrive in the valley of Toluca End of 7th century: The Olmec–Xicalancas arrive in the Cholula–Cacaxtla region c. 750: Occupation of the site of Teotenango Late 8th century: Cacaxtla frescoes From 800 onwards: Building of main pyramids at Teotenango
950 to 1200	Post-Classic	967: Quetzalcóatl leaves Tula for Chichén Itzá Late 10th or early 11th century: first Castillo, Chichén Itzá Late 11th or early 12th century: second Castillo 12th century: Ball-court, Chichén Itzá Late 11th or early 12th century: Emergence of metallurgy (gold and copper) In the Petén: re-occupation of Tikal from the 11th to 12th century 1194: Mayapán League begins	967: A group of Toltecs leaves for Chichén Itzá under Quetzalcóatl's leadership 1168: Destruction of Tula by the Chichimecs End of Toltec power	c. 950: Ball-court at Teotenango 1162: Chichimec invasion
1200 to 1519	Late post-Classic	1224: End of Toltec domination in Yucatán Invasion by the Itzas 13th century: Main buildings at Tulum 1263: Itzas at Mayapán 1283: Civil war with the Cocoms 13th century: Building of Mixco Viejo (Guatemala) 1441: Mayapán League ends 1470: Founding of Iximché (Guatemala)		1476: The Aztecs conquer the valley of Toluca
1519 to 1700	Spanish Conquest	The Conquistadors gain control of Mesoamerica and destroy the pre-Columbian civilizations		
		1525 to 1541: Conquest of Yucatán 1697: Fall of Tayasal, last independent Maya city		

Periods	Mixtecs	Gulf/Occidente	Aztecs	Dates
	The years 650–950 were attended by shifts in population, the decline of the Classic civilizations and the emergence of what might be described as the pre-Columbian Middle Ages			650 to 950
'Epiclassic'	692: Founding of Tilantongo, the Mixtec capital (according to the genealogies in the Mixtec codices) 800 to 1200: Monte Albán IV: decline of the Zapotecs Rise of the Mixtecs 900: Pyramids at Yagul	9th century: Huastec architecture at Tamuín 818: Arrival of the Totonacs on the Gulf Coast and decline of Tajín		650 to 950
Post-Classic	Monte Albán IV (continuation) 1000: Mitla, capital of the Mixtecs; links with Cholula From 11th century onwards: emergence of metallurgy (gold and copper)	967: Arrival in Tajín of the Toltecs of Tula under the leadership of Quetzalcóatl Late 10th, 11th and 12th centuries: Toltec renascence at Tajín Ball-courts with bas-relief decoration at Tajín Building of Tajín Chico: columnar buildings Final phase of the pottery of Colima, Jalisco and Nayarit (?) Huastec sculpture on the northern Gulf Coast	1168: Tula falls to the Chichimecs The Aztecs begin their wanderings	950 to 1200
Late post-Classic	Monte Albán V Mixtec tombs at Monte Albán 13th and 14th centuries: Palace at Yagul 1300 to 1455: Palace at Mitla and fortifications at Tepexi el Viejo 1330: Codex Zouche-Nuttall c. 1350: Tomb 7 treasure at Monte Albán 1357: Codex Vindobonensis c. 1400: Polychrome vessels at Cholula 1455: Aztecs conquer Oaxaca	c. 1230: Tajín burnt and abandoned 13th to 16th century: Huastec pottery 14th and 15th centuries: Tzintzuntzán, the Tarascan capital 1458: Annexation of the Gulf region by the Aztecs	1215: The Aztecs reach the neighbourhood of Mexico City 1247: Founding of Tenayuca by the Chichimecs 1325: The Aztecs retreat to the islets on Lake Texcoco 1370: Founding of Tenochtitlán by the Aztecs 1428: The Aztecs score a decisive victory over their neighbours 1430: Itzacóatl, the fourth Aztec monarch, sows the seeds of Mexican imperialism 1440 to 1469: Reign of Moctezuma I 1455: Conquest of Oaxaca 1458: Conquest of Veracruz (Gulf) 1469 to 1481: Reign of Axayacatl 1476: Conquest of the valley of Toluca 1481 to 1486: Reign of Tizoc 1486 to 1502: Reign of Ahuizotl 1487: Consecration of the Templo Mayor at Tenochtitlán 1502 to 1520: Reign of Moctezuma II	1200 to 1519
Spanish Conquest	The Conquistadors gain control of Mesoamerica and destroy the pre-Columbian civilizations			1519 to 1700
	1520: Codex Bodley 1560: Codex Selden (post-Conquest)	1519: Cortés's Conquistadors land at Cempoala 1520: Confrontation of Cortés and Narvaez at Cempoala	1519: Moctezuma II learns of Cortés's landing 1520: Moctezuma II dies while a prisoner of Cortés Retreat during the 'Noche Triste' 1521: Fall and sack of Tenochtitlán 1525: Death of Cuauhtemoc and collapse of Aztec resistance	

Acknowledgements

The author and photographer wish to thank the following individuals and institutions for their assistance:

The Mexican National Tourist Council, especially its Information Officer, Mexico City, and also Mme Goshi Masnata, head of its Geneva office.

The Director and staff of the National Institute of Anthropology and History, Mexico City.

The Administration of the National Museum of Anthropology, Mexico City, especially its Director, M. Mario Vasquez.

The Directors and staffs of the museums at Oaxaca and Jalapa.

M. Louis Necker, Director of the Museum of Ethnography, Geneva, and his staff.

The Swiss Society for American Studies, Geneva.

Two of the 219 colour photographs are from the archives of: Fulvio Roiter, Venice: no. 64, René Percheron (Ziolo), Paris: no. 219.

The publishers wish to thank Penguin Books Ltd. for granting permission to reprint extracts from Bernal Díaz, *The Conquest of New Spain*, trans. J. M. Cohen (Penguin Classics, 1963), pp. 214–15, 218–19, 231–6, Copyright © J. M. Cohen, 1963.

Select bibliography

Acosta, Jorge R., *El Palacio del Quetzal-papalotl*, Instituto Nacional de Antropología e Historia, Mexico City, 1964.

Alcina, José, *L'Art précolombien*, Mazenod, Paris, 1978.

Antropologia e Historia, Boletin del Instituto Nacional de Antropología e Historia, no. 24, Dec. 1978.

Bernal, Ignacio, *Mexique précolombien*, Bibliothèque des Arts, Lausanne, 1968.

Bernal, Ignacio, *Museo Nacional de Antropología de Mexico*, Daimon, Mexico City, 1977.

Bernal, Ignacio and Gamio, L. Yagul, *Le palais aux six patios*, UNAM, Mexico City, 1974.

Bernal, Ignacio and Seuffert, Andi, *The Ballplayers of Dainzú*, Akademische Druck- und Verlagsanstalt, Graz, 1979.

Boos, Frank H., *The Ceramic Sculptures of Ancient Oaxaca*, A.S. Barnes and Co. Inc., South Brunswick, N.J., 1965.

Caso, Alfonso, 'Explicación del Reverso del Codex Vindobonensis', in *Memoria de el Colegio Nacional*, vol. V, no. 5, Mexico City, 1950.

Caso, Alfonso, *Exploraciones en Oaxaca, Quinta y sexta Temporada 1936–1937*, Tacubaya, Mexico City, 1938.

Caso, Alfonso, *El Tesoro de Monte Albán*, Memorias del Instituto Nacional de Antropología e Historia, Mexico City, 1969.

Caso, Alfonso, 'Valor historico de los Codices Mixtecos', in *Cuadernos americanos*, no. 2, Mexico City, 1960.

Caso, Alfonso, *Interpretación del Codice Colombino*, followed by: Smith, Mary Elizabeth, *Las Glosas del Codice Colombino*, Sociedad Mexicana de Antropología, Mexico City, 1966.

Caso, Alfonso and Bernal, Ignacio, *Las Urnas zapotecas*, Memorias del Instituto Nacional de Antropología e Historia, Mexico City, 1953.

Caso, Alfonso, Bernal, Ignacio, Acosta, Jorge R., *La Cerámica de Monte Albán*, Memorias del Instituto Nacional de Antropología e Historia, Mexico City, 1967.

Díaz del Castillo, Bernal, *The Conquest of New Spain*, trans. J.M. Cohen, Penguin Classics, London, 1963.

Díaz del Castillo, Bernal, *Véridique histoire de la Conquête de la Nouvelle Espagne*, trans. José-Maria de Heredia, 4 vols. Alphonse Lemerre, Paris, 1877–87.

Ekholm, Gordon F. and Bernal, Ignacio, 'Archaeology of Northern Mesoamerica', in *Handbook of Middle American Indians*, vols. 10–11, University of Texas, Austin, Texas, 1971.

Garcia Payón, José, 'La Pyramide del Tajín', in *Cuadernos Americanos*, vol. 10, no. 6, Mexico City, 1951.

Garcia Payón, José, De la Torre, Concepción and Perez Elias, Antonio, *El Tajin, Official Guide*, Instituto Nacional de Antropología e Historia, SEP, Mexico City, 1976.

Gorenstein, Shirley, *Tepexi el Viejo, a Postclassic Fortified Site in the Mixteca-Puebla Region of Mexico*, The American Philosophical Society, Philadelphia, 1973.

Kampen, Michael Edwin, *The Sculptures of El Tajin, Veracruz*, University of Florida Press, Gainesville, Fla., 1972.

Krutt, Michel, *Les Figurines en terre cuite du Mexique occidental*, Université Libre de Bruxelles, Brussels, 1975.

Lehmann, Henri, *Arte Precolombino en Mesoamerica*, Ministerio de Educación, Guatemala, 1980.

Leyenaar, Ted J.J., *Ulama, the Perpetuation in Mexico of the pre-Spanish Ballgame Ullamalitzli*, Leiden, 1978.

Long, Stanley Vernon, *Archaeology of the Municipio of Etzatlan, Jalisco*, University of California, Los Angeles, 1966.

Lopez Portillo, José, *Quetzalcoatl*, Weber, Geneva, 1980.

Lothrop, S.K., *Les Trésors de l'Amérique précolombienne*, Skira, Geneva, 1964.

Marquina, Ignacio, *Arquitectura Prehispanica*, Instituto Nacional de Antropología e Historia, Mexico City, 1951.

Marquina, Ignacio, *Proyecto Cholula*, Instituto Nacional de Antropología e Historia, Mexico City, 1970.

Meighan, Clement W., *Archaeology of the Morett Site, Colima*, University of California Press, Berkeley and Los Angeles, 1972.

Nuttall, Zelia, *The Codex Nuttall*, Dover Publications, New York, 1975.

Pasztory, Esther, *The Iconography of the Teotihuacan Tlaloc*, Dumbarton Oaks, Trustees for Harvard University, Washington, 1974.

Piña-Chan, Ramón, *Teotenango, Guia de la zona arqueologica*, Estado de Mexico, 1981.

Porter, Muriel Noé, *Excavations at Chupicuaro, Guanajuato, Mexico*, The American Philosophical Society, Philadelphia, 1956.

Rivet, Paul and Arsandaux, H., *La Métallurgie en Amérique précolombienne*, thesis, Paris, 1946.

Scott, John F., *The Danzantes of Monte Albán*, Dumbarton Oaks, Trustees for Harvard University, Washington, D.C., 1978.

Séjourné, Laurette, *La Pensée des anciens Mexicains*, Maspero, Paris, 1966.

Séjourné, Laurette, *Un Palacio en la Ciudad de los Dioses, Teotihuacan*, Instituto Nacional de Antropología e Historia, Mexico City, 1959.

Séjourné, Laurette, *Teotihuacan, métropole de l'Amérique*, Maspero, Paris, 1969.

Stern, Theodore, *The Rubber-ball Games of the Americas*, University of Washington Press, Seattle, 1966.

Soustelle, Jacques, *L'Art du Mexique ancien*, Arthaud, Paris, 1966.

Soustelle, Jacques, *L'Univers des Aztèques*, Collection Savoir, Hermann, Paris, 1979.

Stierlin, Henri, *Art of the Maya, from the Olmecs to the Toltec-Maya*, Rizzoli, New York, 1981.

Stierlin, Henri, *Mayan Living Architecture*, Trans. K.M. Leake, Office du Livre, Fribourg, 1964.

Stierlin, Henri, *Ancient Mexican Living Architecture*, Trans. M. Shapiro, London, 1968.

Stresser Péan, Guy, 'Les Indiens huaxtèques', in *Huaxtecos, Totonacos y sus vecinos*, Revista Mexicana de Estudios Antropologicos, vol. 13, Mexico City, 1953.

Townsend, Richard Fraser, *State and Cosmos in the Art of Tenochtitlan*, Dumbarton Oaks, Trustees for Harvard University, Washington, D.C., 1979.

Vega Sosa, Constanza, *El Recinto Sagrado de Mexico-Tenochtitlan*, Excavaciones 1968–1969 y 1975–1976, Instituto Nacional de Antropología e Historia, Mexico City, 1979.

Winnings (von), Hasso, *Pre-Columbian Art of Mexico and Central America*, Thames and Hudson, London, 1969.

Index

The numbers in italics refer to the plates.

List of plates

List of figures, maps and plans

This book was printed in October 1982 by Héliographia S.A., Lausanne
Photolithographs:
Cooperativa lavoratori grafici, Verona
Binding: H. & J. Schumacher AG, Schmitten
Layout: Henri Stierlin
Production: Emma Staffelbach